The Many Faces of Art Forgery

From the Dark Side to Shades of Gray

William Casement

ROWMAN & LITTLEFIELD
Lanham • Boulder • New York • London

Published by Rowman & Littlefield
An imprint of The Rowman & Littlefield Publishing Group, Inc.
4501 Forbes Boulevard, Suite 200, Lanham, Maryland 20706
www.rowman.com

86-90 Paul Street, London EC2A 4NE

Cover images (left to right) © Getty Kouros, Courtesy of the J.Paul Getty Museum; *Scientia e Metaphysica* by Richard Bell, Courtesy of Richard Bell and Milani Gallery, Brisbane; *Woman Reading Music* by Han van Meegeren, Alamy Stock Photo; *The Annunciation* by Albrecht Dürer, Courtesy of the Metropolitan Museum of Art, New York; Tony Tetro with his rendition of Rubens's *Peace and War*, Courtesy of Tony Tetro; John Myatt in his studio with his version of Van Gogh's *Starry Night*, Courtesy of John Myatt.

British Library Cataloguing in Publication Information Available

Library of Congress Cataloging-in-Publication Data

Names: Casement, William, 1947- author.
Title: The many faces of art forgery : from the dark side to shades of gray
 / William Casement.
Description: Lanham : Rowman & Littlefield, [2022] | Includes
 bibliographical references and index.
Identifiers: LCCN 2021035447 (print) | LCCN 2021035448 (ebook) | ISBN
 9781538158005 (cloth) | ISBN 9781538158012 (epub)
Subjects: LCSH: Art--Forgeries.
Classification: LCC N8790 .C374 2022 (print) | LCC N8790 (ebook) | DDC
 702.8/74--dc23
LC record available at https://lccn.loc.gov/2021035447
LC ebook record available at https://lccn.loc.gov/2021035448

Contents

Acknowledgments

\mathscr{A} number of people have provided valuable assistance as I prepared this book, and I owe them my gratitude. In particular are those who read the manuscript, or parts of it, and offered their ideas and commentary: Lawrence Nees, Professor of Art History and H. Fletcher Brown Chair of Humanities, University of Delaware; Michael Wreen, Professor of Philosophy, Marquette University; Saskia Hufnagel, Reader in Criminal Law, Queen Mary University, London; Amy Von Lintel, Professor of Art History, West Texas A&M University; Robert Wittman, founder and former Senior Investigator, FBI Art Crime Team; Claude Piening, Senior International Specialist, Nineteenth Century European Paintings, Sotheby's. Also of considerable importance is the help I received in the gathering of materials and from those who contributed specialized information: Lee Berthelsen and the Johann Berthelsen Conservancy; Tony Tetro, artist and former art forger; Carolann Adams, Collier County Public Library; Samantha Deutch, Center for the History of Collecting at the Frick Art Reference Library; Jennifer Maas, Scientific Analysis of Fine Art; Duane Chartier, International Center for Art Intelligence; Douglas Komen, Great Masters Art, Science and Engineering; Ross Bowden, Cultural Anthropologist; Arthur Beale, Chair Emeritus of the Department of Conservation and Collections Management at the Museum of Fine Arts, Boston; Patricia Failing, Professor Emerita of Art History, University of Washington; Jack Ellis, US Postal Inspection Service, retired; and Dan Mihalko, US Postal Inspection Service.

I am grateful as well to Jane Friedman for her copyediting expertise and to my editor, Charles Harmon, and the team at Rowman & Littlefield for their guidance and expertise in bringing my writing project to fruition. And especially I would like to thank my wife, Andrea, for the proofreading and editorial expertise she provided along with her art dealer's sensibility for my topic and for indulging my enthusiasm for a solitary and time-consuming scholarly pursuit.

Introduction

\mathcal{A} friend sent me a photo of a painting he thought could be a find, and he wanted my opinion. Could it be an original Corot? I responded by citing some of my favorite statistics. *Newsweek* magazine in 1940 said Corot made twenty-five hundred paintings, seventy-eight hundred of which are in the United States. In 1957, London's *Guardian* put the numbers at five thousand and ten thousand. During my twenty-five years as an art dealer and gallery owner, my partners and I often came across Corot, but we were wary of the fakes and never dealt in his works. Two widely faked artists we were more knowledgeable about and did sell, however, are Edouard Cortès and Antoine Blanchard, both known for their Paris street scenes. I recall a phone conversation with a dealer who began by declaring he wanted to sell me a Cortès and had one hundred in inventory. By the end of the call, the number had grown to two hundred. Mathematical bravado aside, I believed he held quite a few pieces because his business location was near that of a known forger who had once talked up his expertise on Cortès. With Blanchard, a number of collectors offered us paintings to purchase, and often we had to tell them that what they owned were, in the idiom of art dealers, "wrong." Savvy dealers will put the number of fakes at more than half of the paintings carrying the artist's name.

Three cases of artists who are known to be subject to forgery are merely anecdotal evidence in the vast world of art. But there is much more that speaks to the presence of forgery. I got a sense for this as I talked with other dealers, watched the auction market bulge with the works of certain artists who appeared to be extraordinarily prolific, and occasionally fielded questions from well-traveled gallery visitors who asked, with a chuckle, how many of the Dalí and Picasso prints in existence I thought could possibly be authentic.

1

Then, beyond practical experience, I took a scholarly approach, following my research bent as a philosopher and former professor, and, over the years, made an extensive study of forgery. The phenomenon has a long history and is indeed widespread. While much of the art found in commercial venues, museums, and in the hands of private collectors is legitimate, there are many exceptions. They occur regularly and can be found in all types of art and at all price points. To state it in capsule form, forgery is not everywhere in the art world, but the uncomfortable reality is that it can be anywhere.

Attention to its presence is instrumental in understanding art forgery, but there are other key factors as well. The matter of what constitutes forgery, and of what constitutes authenticity, is subject to equivocation. Whether a particular art object is actually an original by the named artist is not always determined merely by examining it as connoisseurs would for how it looks or as scientists would for the materials in its makeup. Definitions, theories, and legal statutes and decisions may come into play. And the values surrounding forgery, too, are equivocal. How forgers individually, and art fraud generally, are judged under the law as well as in public opinion varies according to moral perspectives, and the aesthetic and economic worth of forgeries, particularly of exceptionally good ones, draws contrary and competing estimations. To assemble a comprehensive picture of art forgery, then, involves several disciplines, from history and philosophy to law, psychology, and economics. This book presents such a study. I offer an overview of forgery's past and present along with provocative questions about its nature and how it is evaluated. As the title indicates, art forgery shows many faces: it can be looked at from several directions, and when judgments are made about it, they range from condemnation to toleration to permissiveness.

Understanding the presence of forgery today begins with recognizing its past. Part I of the book traces the history of fake art from its onset in antiquity, explaining which artists and types of artwork have been widely faked, and naming culprits and relating their tricks of the trade. Over the centuries, numerous forgers became known to their contemporaries, and their misdeeds were documented. From Michelangelo in the Renaissance to Eric Hebborn, Wolfgang Beltracchi, and others in recent times, a few forgers have drawn major public attention, while many with less notoriety have produced large numbers of false works. I highlight thirty forgers from the last several decades. All of this emerges from a background of social conditions that breed forgery wherever they are found. Art forgery is a function of admiration for particular artists, collectors who want their works, and a market that makes those works available. These conditions have developed and expanded over time through increased public exposure to art through museums, along with the rise and proliferation of art dealers and the growth of wealth to a point where

a greater number of people today than ever before can afford to purchase art as collectors. On the other hand, with the reach of forgery becoming more extensive, counteracting forces have appeared in response. A number of museums, large and small, have organized special exhibitions of fakes, highlighted by a blockbuster at the British Museum in 1990 of hundreds of fakes in its own collection that demonstrated a new attitude of institutions admitting the fallibility of their own experts. The Carabinieri in Italy and law enforcement agencies in other countries have established special units to combat art theft and forgery. An array of scientific techniques is available for detecting fakes by analyzing the materials artworks are made from. And the Internet, which has been an asset for fraudsters in selling their fakes, also has been a vehicle for finding them. Overall, my historical survey demonstrates that art forgery has been with us more than two millennia, while following a crescendo of importance and sophistication to reach a high point in the later twentieth and twenty-first centuries. And beyond being a freestanding history, it foreshadows various issues discussed in the following parts of the book and introduces key forgers and forgeries that appear there as examples.

History offers numerous clear-cut cases that conform to common understanding of what forgery consists of, such as fabricating a painting in the style of Monet and selling it as an original by the master, or making a mold from a Remington bronze and casting a look-alike from it that is presented as the real thing. But there are also cases that create confusion because what may identify an artwork, or the activity of its creator, with forgery is ambiguous. Part II is about the meaning of forgery and, more broadly, of authenticity. Various situations are introduced in which competing views about the nature of fake art demonstrate shades of gray where it may seem as if the classification of certain artworks lies somewhere between genuine and false. The term "forgery" itself can cause confusion when applied to art. Besides the dictionary definition commonly accepted in everyday language, there are legal statutes and certain experts and professional groups that employ their own, more specialized meanings. And beyond understanding the term "forgery," questions arise regarding "authenticity." When a work has more than a single creator, as in restoration, collaboration, and the posthumous production of prints and casts, what happens to authenticity if someone other than the artist of record is responsible for much (most, all) of the production? As with Rubens in the Baroque era and Warhol in the twentieth century, many examples exist of works by studio assistants that bear little of the master's touch but the all-important signature. There are sculptural fragments that were hyperrestored to their former appearance while retaining their designation as genuine, and prints made long after the death of an artist from prototypes that remain in a weakened and altered state. Are these works authentic? Should they be called forgeries? The ambiguity

they highlight has been problematic for centuries, while more recently concerns have arisen about appropriation art and cultural appropriation. When Jeff Koons or Richard Prince copies an image from another artist and justifies the new version as presenting a different meaning, what relationship is there between the authenticity of the original work and that of the new one? What separates appropriation from plagiarism, a close cousin of forgery? With cultural appropriation, the issue is whether it is legitimate to adopt an approach to art identified with an Indigenous people and describe the resulting works with the same label they do. Elizabeth Durack was denounced for her Australian Aboriginal paintings, while Jimmie Durham has drawn praise for his American Indian works. In what sense, or in what cases, does the cultural heritage or bloodline of an artwork's maker determine its authenticity? I consider each of these problem areas in light of philosophical concerns and legal precedents as they apply in concrete cases.

Then, following the discussion of ambiguities in the nature of forgery and authenticity, I turn to values, moral and aesthetic. The focus in part III is again on emerging shades of gray. What moral values do forgers hold (as seen through their psychological profiles)? How does society judge forgery in conventional moral and legal terms as well as alternative views offering mitigation and apologetics? What is the aesthetic value in fake art of exceptional quality? Reports from forgers themselves reveal a range of motives for their activity, particularly revenge and pride, while they often deny or downplay the primary one of making money. After being discovered, they face various outcomes. Some avoid prison, as with Hebborn and Ken Perenyi, who were never arrested, and Edgar Mrugalla and William Toye, who received suspended sentences, but most spend time in prison of varying durations. After that, some become recidivists while others pursue art legitimately, and those who have gained notoriety parlay it into book contracts, television appearances, and exhibitions at respected galleries. Forgers' works that are recovered also face a spectrum of outcomes, from being destroyed to being returned to their owners, archived, or exhibited as famous fakes and sold to collectors. Public reaction to forgers is mixed, including censure for their criminal activities as well as approval for challenging an art establishment that is seen as pretentious and overly commercialized. History's most famous forger, Han van Meegeren, was declared the second-most popular person in the Netherlands by a public opinion poll after his trial in 1947. Another often-expressed view is that victims of forgery are well-heeled collectors who can afford to take a loss. In fact, many fakes are sold for a few hundred to a few thousand dollars to people without substantial means, but financial loss in general is accounted for in an alternative economic theory that sees the harm done to victims as balanced in the grand scheme of things by beneficial forces that include increased commerce for the

art industry and greater pleasure for art lovers in having more artworks to appreciate. Finally, regarding the aesthetics of forgery, I take up the topic of the "perfect fake," one so outstanding in quality that experts certify its authenticity. Should a work of this type be respected as equivalent to an original? If it is eventually discovered to be a fake, the aesthetic worth assigned to it plummets (along with its commercial worth), although the work itself is physically the same. What accounts for the difference? Philosophers and art historians have weighed in with various answers. This topic and others in part III demonstrate the overall message that the presence of forgeries in the art world is seen in equivocal terms: the works themselves are subject to competing judgments about their value, and the forgers who make them receive treatment ranging from condemnation to respect.

Before I go further, an explanation about terminology is in order. I use the word "forgery" in the way everyday language does when speaking about art, and in contrast with the more restrictive definitions that it was noted previously are preferred by some specialists. In particular, they distinguish a "forgery" from a "fake," with one pairing of the terms separating a work that is false at its inception from the fraudulent alteration of an existing work and another pairing that differentiates copying an artistic style from making a replica of a specific work. Although these conceptual differences are important in understanding false art, attaching them to the terms "forgery" and "fake" to demarcate one from the other leads to confusion. I prefer, along with a number of experts, to avoid that problem and use the terms interchangeably, along with related words such as "counterfeit," "false," and "fraudulent." Readers are spared the burden of grappling with specialized vocabulary to describe the main topic of the book.

Where my study does place a limit on the notion of forgery is in the types of art that are included. Broad-stroke examination of art fakes sometimes encompasses archaeological hoaxes, furniture, wine, designer handbags, and other items, and in aesthetics, discussion may extend to literature, music, and beyond. I concentrate on the making of paintings, sculptures, and other works the term "art forgery" typically invokes. And my attention is restricted as well in that it concentrates on the art of the Western world, although I occasionally look outside its parameters. Non-Western art, which also has been subject to forgery, is, for the most part, left as a study for others to conduct. But within Western art, I focus broadly on the widespread presence of forgery in history, especially in recent decades, and on various angles for perceiving the nature of forgery along with values associated with it. To refer again to my chosen metaphors, art forgery has many faces that make understanding it complicated and prone to shades of gray.

• 1 •

The Presence of Art Forgery

In the decade and a half that I was with the Metropolitan Museum of Art I must have examined fifty thousand works in all fields. Fully 40 percent were either phonies or so hypocritically restored or so misattributed that they were just the same as forgeries.

—Thomas Hoving, Director of the Metropolitan
Museum of Art, 1996

Picture dealers, like horse dealers, well versed in trickery, palm off worthless trash and copies on young and inexperienced collectors as valuable originals.

—Justus van Effen, Dutch journalist, 1736

Just as some statuaries do in our day, who obtain a much greater price for their productions, if they inscribe the name of Praxiteles on their marbles, and Myron on their polished silver . . . Carping envy more readily favors the works of antiquity than those of the present day.

—Phaedrus, Roman fabulist, first century AD

Forgery is a major presence in the art world. As the preceding commentary suggests, fake art is widespread and has a long history. That history, however, is not coextensive with the history of art per se. Forgery is not found universally throughout humanity, as art is, but it is far reaching: once certain social and economic conditions arise, the counterfeiting of beautiful objects follows. The combination of artists who are revered for their originality, collectors who want their works, and a market for buying and selling those works

invites devious practices. In the Western world this happened notably in ancient Rome, and after a pause during medieval times (although occasionally medieval faking was done for the purpose of enhancing ecclesiastical authority), reappeared in Europe with the Renaissance and continued from then on without interruption.[1]

The continuation still unfolding today consists of enlarged markets and sophisticated marketing techniques, increasing wealth allowing more people to buy more art, and the production of fakes in great abundance. Materially speaking, the expanse of fake art has advanced far beyond its roots. But that evolutionary view of history has sometimes been broadened to encompass the human mindset, and the result is a distorted interpretation. A follow-up sentence in Thomas Hoving's epigraph for this chapter, which appears in the introduction to his best-selling book *False Impressions: The Hunt for Big-Time Art Fakes*, asserts, "What few art professionals seem to want to admit is that the art world we are living in today is a new, highly active, unprincipled one of fakery." He cites the "get-rich-quick attitude of the times and the raw commercialism of so much of contemporary life" as a main reason for the plight of perverse activity affecting art.[2] Working from a different perspective toward locating a new mentality about forgery is art theorist Thierry Lenain, who in *Art Forgery: The History of a Modern Obsession*, holds that the notion of fake art as offensive has emerged from a less harsh view of it only as a trend of late modernity.[3] Both of these theories fail to recognize that opinions about forgery seem to be more recurring than changing over time. The impetus to create fake art is indeed largely financial gain, but that circumstance is as old as the beginnings of forgery. And the notion of forgery as offensive also dates to the origins of the practice, although a simultaneous undercurrent has accepted it as a form of freethinking mischief or antiestablishment protest. Once a threshold of prerequisite conditions has been met and forgery arises, basic attitudes toward it seem to be a function of fundamental human nature rather than of a dynamic system. Where a true difference in outlook lies is between an absence of the conditions that give rise to forgery and the presence of those conditions. Without them not only is there no practice of forgery, but even a conception of it is also lacking. Here is where an understanding of the history of art forgery begins.

Observing tribal societies in current and recent times makes this point. Not even the first of the conditions occurs, as personal inventiveness by artists is severely limited by conventions. Thinking, in overall terms, is founded on a demand for order,[4] and creative expression is institutional rather than individual. Typical of such societies are the Kwoma of Papua New Guinea, who, although they have experienced acculturation in many ways, today continue the beliefs of their ancestors concerning artistic creativity. The making of art thereby consists of copying prototypes, with their source believed to be su-

pernatural rather than human.[5] Artists are not seen as presenting new perspectives on the world but as reproducing what has existed before them. Although respected and even celebrated during their lifetime for their skill as copyists, they fade into anonymity a generation or two after their death. The significance of an art object, then, is not in who made it but in what is represented by its image. It is understood that a new construction of the image may vary slightly from a previous one, but that circumstance is accepted as an aberration rather than as evidence of praiseworthy ingenuity. Similarly with the historical tradition of the Māori of New Zealand, newly made artwork is based on institutional models. Apprentice sculptors memorized complex patterns to execute on various objects through carving. Master craftsmen might earn prestige, but the ultimate source for the act of carving was believed to derive from the gods.[6] When, in societies such as the Kwoma and Māori, artistic achievement is seen to consist of copying in which a replica holds as much cultural value as a previous occurrence of an image, there is no inducement to present a replica as something other than what it is, and forgery is unknown.

Following a somewhat different tradition, some tribal societies have made room for individuation of images by their artists, although with careful restrictions. The Sioux tribes of North America painted the exterior of their tepees with representations devised by their owners. Each owner portrayed his own experiences, but only experiences from dreams were allowed, and then only after the dream was approved by a shaman and determined to fit within certain cultural patterns. Although dreaming was the source, the ideas derived may have been induced from preapproved myths.[7] In other cases, dreams have been recognized to be the vehicle through which myths and their prototype images first emerge and enter mainstream cultural representation. According to Tsimshian (Pacific Northwest) lore, the bear totem began with an ancestor's dream of what seemed like an actual event, after which a ritual painting was made that became the model for future reproductions of it.[8] Thus, even with the contributions of individuals from their dreaming, the creation of images is highly controlled. Artistic achievement is accepted as divinely inspired and as constituting communal knowledge rather than singular genius. The idea of a virtuoso artist, whose unique works have value that might encourage copying them with fraudulent intent, is absent.

BEFORE THE RENAISSANCE

It is in the more advanced societies of the ancient world that dealings in fake art are said to have begun, although claims about Egypt, Phoenicia, Babylonia, and Greece have scant evidence in support.[9] Rome occupies the center of at-

tention, with various writings attesting to the necessary conditions for forgery and reveal a public concern about art fraud. Recognition of individual artists for their accomplishments and particular styles was a carryover to Rome from Greece, where the practice of signing artworks (at least some of them) began in the sixth century BC. Phidias, Myron, Praxiteles, and others were held in high regard by the public for their unique creations. When Roman armies defeated the Greeks in the third and second centuries BC, confiscation of artworks was a common occurrence, and many boatloads were sent to Rome, exposing the population there to cultural treasures superior to what they had ever seen. Public displays encouraged a reverence for the "Old Masters," whose works were now several hundred years old, and aristocrats eagerly established private collections that would show off their stylishness. Caesar, Lucullus, Lucius Crassus, and other prominent figures were avid collectors, sometimes paying exorbitant prices as a market developed complete with dealers specializing in art and auctions devoted to it.[10] Roman authors wrote books describing the styles of the great artists and cataloging their works, following several earlier ones (that do not survive today) written by Greeks.[11] Art criticism was popular and often presented through the medium of ekphrastic poetry.[12] As public connoisseurship grew, the demand for Greek works available to purchase outstripped the supply, and artisans obliged by producing large numbers of copies fashioned after Greek masters.

As historians have described the situation, some of the copies were passed off as originals. This finding is backed up by comments from Roman authors about forgery done in the fashion of Greek artists. Phaedrus's quoted remark points out the practice of artists signing their works with famous names from the past so as to command higher prices.[13] Satirical writers provided social commentary by mocking the notion that the historical works popular with Roman art enthusiasts were all truly genuine, as in Martial's quip about a collector, "You alone have the productions of Phidias' graver, and the labors of Mentor. . . . Yet, amidst all your silver, I wonder Charnus, that you possess none pure,"[14] and Petronius through his narrator in *The Satyricon* on observing a public picture gallery where supposed antiques appeared in perfect condition and poor imitations were accepted as the works of masters: "I beheld works from the hand of Zeuxis, still undimmed by the passage of years, and . . . the crude drawings of Protogenes, which equaled the reality of nature herself."[15]

Beyond literary commentary is physical evidence in the form of artworks connected to the Roman period that bear the inscribed signatures of famous Greek artists from prior centuries. The sheer volume of these works is suspicious, as well as the fact that multiple artists produced works under the same name: at least five sculptors fashioned works by "Myron,"[16] and several more claimed the label "Phidias."[17] Further, many of the works carrying prominent

names exhibit stylistic features that are incompatible with those names, such as a "Praxiteles" sculpture in the Louvre bearing a Roman Imperial look[18] and the "Callimachus" relief at the Capitoline Museum in Rome that displays a mannerist design consistent with late Hellenistic times.[19] More instances of incompatibility are found with gems bearing the names of Greek masters such as Pheidias, Skopas, and Polykleitos, who are not known to have worked in that medium.[20] Examples like these raise red flags about authenticity: works carrying the names of famous artists who did not create them suggest fraud.

Although many scholars have accepted that ancient Rome was the first point in history where art fraud featured prominently in the fabric of the culture, a skeptical view has emerged that urges caution about viewing the past in terms of modern thinking. Accordingly, the "old master" names inscribed on Roman sculptural copies are not thought to have given the appearance of originals, but instead to have designated the particular artists who were being copied.[21] Rather than being forgeries, then, those works would have been legitimate reproductions with helpful labels. Another interpretation suggests a complicated system of patronymics in which multiple artists turning out works in the name of a deceased master were slaves or other workers who were legally bestowed with the name they signed on their artworks, or they were members of the master's family continuing the famous workshop through multiple generations.[22] The challenge to the assumption of fraud continues by noting that Roman law had no provisions for dealing with art forgery, while there were specific prohibitions against counterfeit documents and currency. The implication is that counterfeit art was not a significant concern. And while the literature of the day offers fictional examples and sarcastic statements about phony artworks being passed off as authentic, there is an absence of reported real-life instances to match them.[23]

Taking account of the skeptical view, it is still reasonable to conclude that art forgery was present in ancient Rome, although the extent of that presence is a matter for speculation. An art industry abundant in legitimate copying does not preclude the creation or marketing of certain works as forgeries. Even if "old master" names were inscribed on certain works merely as labels, or if they were the legitimate signatures of multiple artists with the same name, the demand for originals (evident in the enormous sums collectors sometimes paid) encouraged the presentation of at least some newly made works as genuine antiques. And having famous artists' names attached to styles and mediums they never worked in is not answered by the theory of patronymics. The absence of recorded instances of forgery may be due to the scarcity of documents remaining after two thousand years, as well as the Romans' lack of means for detection available today through scientific testing and an advanced level of connoisseurship. As for Roman law lacking any provisions for art forgery, it

should be noted that even today art forgery is not named as a crime in highly developed legal systems such as in the United States, the United Kingdom, Australia, and Germany.[24] Art forgers are prosecuted for fraud and other crimes such as (in the United States) tax evasion. (This point is discussed in part II.) The overriding takeaway here is that Roman society harbored a concern about false artworks that is difficult to explain without their physical presence. Statements by various Roman writers about forgeries in their midst, coupled with the existence of the necessary social and economic conditions, signal the presence of art forgery as a feature of the cultural landscape.[25]

In addition to outright forgery, the Roman milieu included another dubious tradition that foreshadowed an attitude toward art restoration in the future and relates to questions of authenticity. Artworks were repurposed and reused, sometimes with restoration, constituting what today is considered a variety of spolia. The reuse of building materials such as foundations and pillars was generally accepted as long as they were taken from abandoned sites, but artworks were more problematic. Artistic spolia often appeared in the form of portraits, usually sculptures and occasionally paintings. The emperor Claudius had the faces of two portrait paintings of Alexander the Great redone as Augustus,[26] the features of the Colossus of Nero were changed three times,[27] and Mark Antony had two large statues relabeled in his own name.[28] Tribute likenesses of family members were common in private homes, and were sometimes recycled by reconfiguring and renaming them or by renaming without alteration. Use of spolia for portraits was accepted by some Romans and disparaged by others, with Cicero declaring, "I detest deceitful inscriptions on other people's statues"[29] and Livy, "I am inclined to think that history has been much corrupted by means of funeral panegyrics and false inscriptions on statues."[30] The practice was not illegal, did not cause devaluation in the commercial value of an art object, and was an open secret rather than hidden, but it was offensive for being deceitful. The significance of this use of spolia lies in the attitude it represents about authenticity in refashioning artworks for further use: an openness to altering images beyond restoring their original appearance.

With the passage from Roman times into the medieval era, appropriating spolia for use in artworks was common. Works from the past were plentiful and respected for their beauty and workmanship, and depending on their imagery, denounced as pagan. Some that were considered unacceptable were destroyed, others were put on display, and many were refashioned, such as a figure bearing a toga made into a tonsured priest[31] and a Madonna that was given a new head and located to a fountain.[32] As with their predecessors in the ancient world, the people of the Middle Ages were accustomed to liberality in changing the image of an existing artwork, a feature that would be common

in the practice of art restoration for centuries to come and, at times, blur the distinction between forgery and authenticity.

Although art objects from antiquity were often admired in medieval times, the activity of forging them for material gain ceased. The necessary condition of a market with collectors wanting to purchase scarce artworks was lacking. Fraud was a common occurrence, but the objects of attention were documents such as deeds and wills and, more famously, religious relics such as fragments of saints' bones, particles of their clothing, dust collected from their tombs, and so on. Medieval artists did not achieve fame like that of their predecessors. The works they created were sometimes signed, with the practice varying widely by location and medium—Spanish tenth- and eleventh-century manuscript illuminations, for instance, were signed regularly, whereas French Gothic sculptures rarely were[33]—but artists who identified themselves on their productions were in the minority, and their names were easily forgotten over time. Artists did have latitude for innovation in their work, but the notion of originality as a respected accomplishment was missing and would appear again only with the Renaissance.[34] An affinity for possessing artworks outside of devotion to religious objects, and regarded in terms of worldly acquisitiveness and monetary value, was missing in the medieval mindset.

While this characterization of the medieval period holds generally, certain exceptions can be cited. Charlemagne amassed numerous works of art that included carefully selected pieces imported from Italy to his palace in Aachen, and he sponsored workshops of artists in various locations to produce new works that often were styled after classical antiquity. The holdings he accounted for at his palace alone, no less other locations, can be described as a collection, although the habit of assembling a grouping of art objects separate from a variety of other items would not gain traction for several centuries. When in the twelfth century Henry of Blois, brother of King Stephen of England, traveled to Rome on a political mission and left for home with an assemblage of classical sculptures he had selected, his behavior was considered eccentric even in a preeminent center of culture. A member of the papal curia mocked the project as a throwback to ancient times, quoting from a satire by Horace about an art dealer with a dubious reputation, "Damisippus has gone mad buying ancient statues."[35]

Late in the medieval period, a few collectors followed Charlemagne's example and began to amass groups of art objects. Collecting gained popularity gradually among monarchs and the nobility, although records of early activity are available only for isolated cases. In the early thirteenth century, Emperor Frederick II Hohenstaufen signified the coming trend as he compiled a collection of classical sculptures along with antique coins and carved gems.[36] Oliv-

iero Forzetta, who amassed a library of classical manuscripts in the fourteenth century, is said to have had considerable holdings in the same mediums as Frederick II,[37] and Jean Duc de Berry in the fourteenth century established an extensive collection that specialized in illuminated manuscripts but included many other objects as well, with an unusual emphasis on medieval rather than classical art forms.[38]

Although during the medieval period collecting did not spur the making of deceptive artworks, another motive accounted for the presence of a few of them. In the city of Venice, culminating in the thirteenth century but beginning earlier, stone carvings were fabricated that, in conjunction with phony documents, would give the city an appearance of greater age. In particular, works were created to make the Basilica of San Marco trace to several hundred years older than when its construction began in the ninth century. A story emerged of a predecessor building, the remains of which would have displayed artistic features common to an earlier period and which were preserved and incorporated into the succeeding structure. Included among other deceptive objects are a façade depicting the Labors of Hercules and another with the miracles of Christ, both styled as sixth-century Byzantine, along with a pair of marble columns long mistaken as fourth or fifth century.[39] Although archaism in the making of medieval art is not in itself a sign of deceitful intention, the degree to which it is found in Venice is unusual, and points to the city's desire to connect with an early Christian heritage that would rival what other cities possessed legitimately or at least claimed to possess. Ecclesiastical prestige and the power it bestowed were the ultimate prize.[40]

Further cases of deceptive medieval artworks turn up in two groups of twelfth-century thrones: a Roman group and a Southern Italian group. Several scholars have weighed in on individual works that are said to evoke the tradition of the past for the purpose of bolstering ecclesiastical and political stature.[41] The Throne of Urso at Canosa di Puglia (see Figure 1.1) bears oddly unfunctional qualities for a construction designed to be used by the bishop for whom it was named, suggesting it was made later as a connection to past ecclesiastical glory. The throne at the Salerno Cathedral is also deceptive, with lions characteristic of the third or fourth century. In Rome, the Basilica of San Lorenzo, the Basilica of San Clemente, and the Basilica of Santa Maria in Cosmedin all bear inscriptions that belie their date of construction. These examples are among others that pose puzzling anachronistic features from antiquity, with some of the work consisting of spolia highlighted within a newly created whole. These various features might be explained as innocently paying homage to the past, and many viewers astute enough to recognize their archaic appearance have made this assumption. However, as with the artificial aging of Venice, finding an unusual pattern of artworks that simulate earlier times

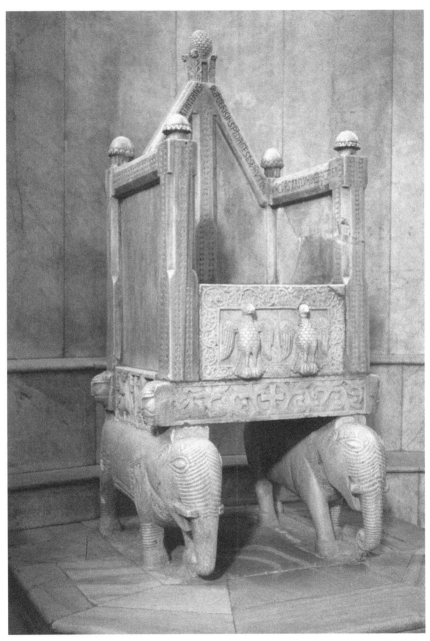

Figure 1.1. Throne of Urso, Canosa di Puglia, Italy. Scholarship questions the claim that it was made in the eleventh century for the bishop whose name it bears. John Heseltine/Alamy Stock Photo

arouses attention. It is not difficult to suspect fraudulent intent with works created in conditions where deceitfulness is known to have been widespread with documents and relics, especially once a motive for falsifying history is recognized. As art historian Lawrence Nees has asserted about the thrones,

> Such works were created as documents inscribing memories of the past, but improving upon the historical record, in effect forgeries. They should be considered at least at one level as analogous to the many forged charters and other documents so particularly characteristic of the eleventh and twelfth centuries.[42]

For this sort of deception with artwork to have been present in medieval culture, complete secrecy was not necessary. Rather, it could have been known to an inner circle of clerics, artisans, and local residents yet not to other people, and carried out the intended effect of seeping into historical consciousness. Over time, traces of insider knowledge would diminish and eventually vanish, and even if recorded, might go undiscovered later.

RENAISSANCE THROUGH THE SEVENTEENTH CENTURY

Art collecting grew in popularity during the Renaissance, losing its image of eccentricity, and by the sixteenth century it had become fashionable. Notable collections were amassed by monarchs Francis I of France and Holy Roman Emperor Rudolf II, and the Gonzaga family in Italy, where Isabella d'Este and her sister-in-law Elisabetta Gonzaga represented the role of cultured women in collecting. Above all, the Medici family led the way. When Lorenzo the Magnificent died in 1492, an inventory of his vast holdings showed the ancient works to be valued at many times those of contemporary artists.[43] This price differential was typical of the time. Coupled with works by talented contemporary artists that were available at a more reasonable cost, it gradually brought Renaissance artists into popularity with collectors.

Art dealers came on the scene at least as early as the early fifteenth century,[44] although at first not dealing exclusively in art, and were a part of the cultural landscape by the sixteenth century. High-end marketers served monarchs and others of wealth. Among them, Giovanni Battista della Palla acted as a procurer for Francis I as well as other clients. Jacopo Strada, who did much of his business from Venice but also lived in Nuremberg and Vienna, counted Holy Roman Emperors among his clientele along with nobility from several countries.[45] The rest of the market, too, included international trade, as merchants specializing in art sold antiquities, copies of antiquities they com-

missioned, and works by Renaissance masters that owners were willing to part with. Artists often represented themselves from their studios, and sometimes functioned as dealers in selling the works of others. The guild system required that art sellers be members of the artists guild, but strictness in enforcement varied by location. Guild control was typically suspended during special auctions and fairs sponsored by municipalities, and over time, variations on this loophole grew into year-round marketing possibilities.[46]

The studio system of the day tended to blur the identity of original artworks as opposed to legitimate copies, collaborations, or outright fakes. Many works were collaborative efforts in which assistants performed much of the workmanship. Other pieces were copies of an original done by the master or by an assistant. El Greco employed many assistants and sometimes produced four or five duplicates of the same painting in various sizes. However, his inventory list distinguished his autograph originals from versions involving his studio employees.[47] Raphael, too, had a large studio with talented assistants whose contributions leave questions as to who the principal artist was for various works.[48] And in addition to their own works, artists often took commissions for exact copies of paintings by other artists. It has been estimated that as many as half of all commissions for paintings in the late fifteenth and early sixteenth centuries in Northern Europe were for copies. Originals were still the most prized pieces, selling for two and a half times the price of an autograph copy. Artists sometimes found it profitable to keep originals for display in their studios while they built up their value by selling copies.[49]

The studio system was subject to manipulation by artists and their assistants, who sometimes gave clients less than the degree of originality they bargained for. But it was later in history that much confusion arose over which pieces were authentic one-offs by a master and which were collaborations or copies by employees. As centuries passed, recognizing a genuine Rubens or El Greco or works by other masters became more difficult: something that was old and well executed, and perhaps with a signature that was added later, looked good to many authenticators and was attractive to dealers who were unknowledgeable or unscrupulous. This, however, is only part of the problem of mistaken identity that can be traced to the Renaissance. Besides studio works with a questionable pedigree, some artists performed restoration to an extent that compromised authenticity, and others made entirely new forgeries.

Restoring artworks was done with an attitude of liberality that carried over from the Middle Ages and continued until the nineteenth century. Typical of the time was a statement by painter Neri di Bicci about the work he did to renovate a panel painting: "altered the cusps of the arches, repainted four new cherubs, retouched and repainted almost all of the old figures, and turned

San Frediano into Saint Margaret."[50] Substantial alteration of an image was acceptable as long as it was in good taste, judged by its fulfilling the principle of "grace."[51] A graceful painting or sculpture that resulted from reworking it was a desirable product, and inventiveness could be part of the process. The famed Laocoön sculpture from antiquity, for instance, was unearthed in 1506 in Rome with several missing pieces, most notably the right arm of the main figure, which was restored in 1520 to an awkward position consistent with the figure's physical predicament and tortured look. The arm was later replaced with an outstretched version that seemed more aesthetically pleasing. Benvenuto Cellini, an accomplished sculptor, restored many pieces while working for Cosimo de' Medici, including a torso for which he produced arms, feet, and a head, and added an eagle to turn the figure into Ganymede.[52] On rare occasions, however, the principle of grace could be invoked to justify non-intervention on a damaged work such as the Belvedere Torso, which awed even Michelangelo to the extent that he recommended it remain untouched.[53]

Despite this liberal attitude, deceptive practices occurred that were considered to be either on the borderline of unethical or outright fraud. Practitioners devised more advanced means of creative restoration for existing works and production of new ones with artificial aging.[54] Lorenzetto di Lodovico ran a large workshop in which sculptural pastiches were sometimes assembled using fragments from several different works that were combined into one and smoothed and polished to appear as carved from a single block. Whether these products were presented as pastiches or as originals may have varied according to the occasion,[55] and determined their designation as acceptable restorations or forgeries. And taking the restoration process even further were artisans who created and damaged new works so they could restore them to look old. Pietro Maria de la Brescia, an engraver of precious stones, worked on the side creating porphyry vases and heads that he buried in the ground and subjected to cracking before making the necessary repairs to simulate antiques.[56] Bronze sculptors are known in one case to have cast a statuette with arm stumps to give the appearance of damage, and in another case, to have broken off the arms intentionally from a cast that had gone awry and left it disfigured.[57]

At least in the early Renaissance, attitudes about forgery varied among the people who made art, collectors, and the general public. A tolerant approach appreciated faking as a talent and saw practitioners as picaresque figures who wanted to show off as they tricked connoisseurs in a spirit of gamesmanship. Giorgio Vasari in his famous *Lives of the Artists* relates several stories in this vein that have been recounted often. Michelangelo, we learn, gained fame at an early age when he borrowed original drawings to use as models, made copies that were indistinguishable from them, smoked the copies to simulate

age, and then handed them back while he kept the originals.[58] He also tried his hand at sculpture by making a life-size Cupid figure that two of his mentors suggested could be passed off as ancient, and one of them sold it to Cardinal San Giorgio in Rome. After the cardinal learned the truth, he hired the brilliant young artist to work for him.[59]

Another story from Vasari features Andrea del Sarto early in the sixteenth century. An Italian duke was smitten by a portrait by Raphael that he saw in the Medici collection, and contrived a way to own it by convincing the pope (a senior member of the House of Medici) to tell Ottaviano de' Medici to present it as a gift. Ottaviano agreed but secretly had Del Sarto paint a duplicate of the portrait and put it in the original frame, which is what the duke received. After the work was verified by the duke's expert, Giulio Romano, Vasari revealed the hoax, which he had been aware of from the start. Romano defended himself by declaring that he valued the painting he possessed, which seemed good enough to be authentic, as if it were by Raphael's own hand.[60]

Tales like these portray forgery in a lighthearted way as a tribute to the forger and with indifference to right and wrong. But there is a counterpoint, the perspective of the victim, that disapproves of artistic duplicity on moral and economic grounds. That perspective is evident in the background with Michelangelo and Del Sarto. Although the cardinal who was tricked by the Cupid sculpture offered its maker a job, he was not amused about being swindled. He demanded that the sale of the sculpture be voided, and his money returned. With the Raphael portrait, too, there is another interpretation: the owner who commissioned the fake did it because he valued the original enough to engineer a sham that would keep it in his possession, and the duke who ended up with the fake was in a financial position to be indifferent because he had paid nothing for it. To whatever extent forgery as mischievous gamesmanship was appreciated, it was not a match for the economic hazard that resulted from it. In some instances, the practice was undertaken for the challenge and the glory, but in the main, it became a business enterprise.

There are many accounts of false art appearing in the Renaissance. Tommaso della Porta specialized in marble busts of Roman emperors. He was praised by Vasari, who owned one that was often mistaken for an antique.[61] Whether the artist sold his sculptures as deceptions, or honestly as a copyist to other people who sold them as deceptions, is unclear, but his work contributed to the large number of fake Roman busts on the market that may have outnumbered the genuine pieces.[62] Another artist whose works were sold as ancient originals, although historians tend to give him the benefit of the doubt about his intention, was Giovanni da Cavino.[63] As a skilled craftsman, he made bronze medallions of Roman figures during a longtime collaboration

with the humanist scholar Alessandro Bassiano, who provided information for historical accuracy.

Although the prices commanded by Renaissance masters were less than for antiques, forgeries of their works were also prevalent. Denis Calvaert produced drawings in the manner of Michelangelo and Raphael, giving them the appearance of being prototypes for elements found in their later works, including *The Last Supper* and *The School of Athens*. Calvaert passed his creations on to an art dealer who doctored the paper to show signs of age and rough handling and then sold them to collectors as originals.[64] Many other artists of the sixteenth century were targeted by forgers, with varied reactions from the victims. Some accepted their fate and hoped the publicity brought by having their names spread widely would make their commissioned works more valuable. Another answer was to create works of a type that forgers would have difficulty copying. Hans Bol, an accomplished landscape painter who was victimized by forgers, devoted himself to a popular line of miniatures that required special expertise and touch.[65]

Perhaps the most victimized artist of the time was Albrecht Dürer. He complained bitterly about the flood of counterfeit pieces that were damaging his business and announced on the title page of a series of woodcut prints, "Be cursed, plunderers and imitators of the work and talent of others. Beware of laying your audacious hand on this work."[66] Most Dürer fakes were prints, although there were oil paintings as well. In some instances, the forgers developed pastiches, such as *Virgin at the Gates*, which copied and reversed the images of the Madonna from one woodcut, God the Father from another, the landscape from a third, and a plant in the foreground from an engraving. A phony self-portrait copied the head from one painting and the arms and legs from another.[67] Many counterfeit works, however, were exact copies in full. They were sold in direct competition with the pieces turned out by Dürer himself and often were indistinguishable from them without close examination.

In what is sometimes described as the first attempt to prosecute copyright infringement in art, as related by Vasari, Dürer went to Venice in 1506 to lodge a complaint against printmaker Marcantonio Raimondi for selling copies of his prints there. As a skilled copyist, Raimondi is remembered for working collaboratively with Raphael but for running afoul of Dürer for unauthorized copying of his prints and reproducing the famous Dürer monogram (see Figures 1.2a and 1.2b). The ruling was that Dürer's monogram was off-limits and Raimondi must cease using it. However, copyists were allowed to appropriate his images.[68] Raimondi went on to produce several dozen more works by Dürer, and a number of other artists added to the output throughout the sixteenth century and later. Dürer also brought a claim against a copyist in his home city of Nuremberg in 1512, where the decision was similar to what he received in Venice.[69]

Hieronymus Bosch, too, was a widely faked artist of the time. The public was fascinated with his grotesque fantasy scenes portraying moral themes about folly and sin. A large output of fake wood-panel paintings was produced in Spain, which, although they were smoked to give the appearance of age and included Bosch's monogram, were of poor quality. To unknowledgeable Spanish buyers of Dutch art, a low price and the name of a famous artist would have made these works attractive.[70] Counterfeit works claimed to be by Bosch also appeared in other locations throughout Europe. In a double deception, noted printmaker Hieronymus Cock copied a drawing titled *Big Fishes Eat Little Ones* by Pieter Brueghel, before Brueghel achieved fame, and marketed it in 1557 as an engraved print under Bosch's name in the city of Antwerp, where Brueghel was then living. When Brueghel's reputation grew, the same image was copied again by an opportunist who put Brueghel's name on it.[71]

As the Renaissance drew to a close, various factors were in place that prefigured the presence of art forgery in future centuries. There were revered artists, avid collectors, and a lively market for art. Newly made works that simulated the ancients were sold as long-lost originals. Recent and contemporary artists were copied as well, often with confusion regarding the difference between legitimate and illegitimate use of existing images, and sometimes with collaborators in the background. The perpetrators of forgery were known or suspected artists whose names and techniques often were public knowledge. Attitudes toward forgery ranged from respect for skilled workmanship to an outcry over the harmfulness of commercial fraud, and the rudimentary state of prosecution against forgery under the law acknowledged an element of wrongdoing but often allowed blatant actions to occur with impunity.

During the seventeenth century, the cultural factors underlying art forgery developed further. In a historic sale, art dealer Daniel Nys arranged for King Charles I of England to purchase the massive collection of the Duke of Mantua, for which he is estimated to have received a personal profit of more than 30 percent, all the while negotiating secretly but unsuccessfully to keep certain key pieces for himself.[72] Also noteworthy was the personal collection Abbé Michel de Marolles amassed in France of 123,000 prints that he sold to King Louis XIV, which he followed up with a new collection of more than one hundred thousand works over the next decade, including ten thousand original drawings.[73] The king's fame as a collector was preceded by that of his advisor Cardinal Mazarin, who also assembled two large collections, the first of which was confiscated and sold when he was forced to leave France during a time of political turmoil. Two years later, he returned to his post, and at his death, left more than five hundred paintings (by Raphael, Titian, Tintoretto, and other Renaissance masters) and 250 statues.[74]

Beyond this grand scale, collecting art was recognized as a form of investment[75] as well as a means of entertainment. Publications in several coun-

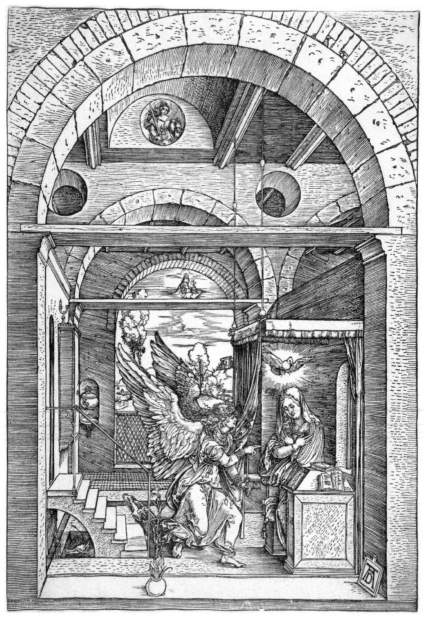

Figure 1.2a. *The Annunciation* by Albrecht Dürer, 1503, woodcut, 29.7 × 21 cm. Courtesy of the Metropolitan Museum, New York

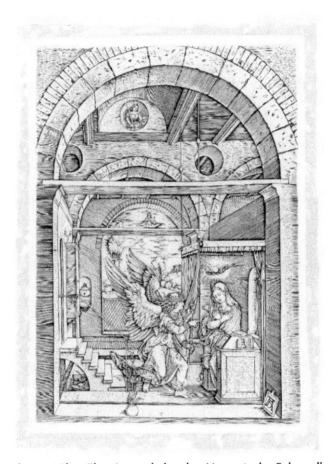

Figure 1.2b. *The Annunciation* by Marcantonio Raimondi, 1510, engraving, 33 × 24 cm. Bears Albrecht Dürer's monogram. The Trustees of the Chester Beatty Library, Dublin

tries listed many private collections whose owners proudly opened them for viewing on request, and paintings from that era that are in existence today present images of collectors receiving visitors.[76] The possession of artworks for enjoyment was common among the general population and reached substantial proportions in some locales. During English diarist John Evelyn's travels on the Continent, he remarked in an entry at Rotterdam about farmhouses filled with pictures,[77] and public records show that in the city of Delft during the mid-seventeenth century, paintings could be found in two-thirds of the households, with an average of seven or eight in each, including landscapes, biblical subjects, still lifes, portraits, marine scenes, and genre scenes.[78]

The studio system continued practices that were confusing for buyers who wanted original works by a master. Rubens employed many assistants, and astute clients who commissioned him knew enough to specify in their contracts exactly which parts of the paintings they were purchasing were to be done by the master.[79] Rembrandt had a large studio where he had collaborators on many of the works his inventory listed under his name. Determining which works are his alone has led to many disagreements among experts over time.[80]

Forgery of renowned artists grew during the seventeenth century. Rubens was prolifically faked. His paintings and prints were copied during his lifetime, and the practice continued in later decades with production numbering in the thousands. He took legal action by petitioning the Netherlands States General. In 1620 it was declared that for a period of seven years duplications of his works would carry the penalty of a fine along with confiscation of the copperplates used for making prints. Later, Rubens took his case to a French court, which issued a similar decision, and in 1634, he sought action against a forger of his works in Germany. The verdict was in his favor, but the accused appealed to a higher court, with the final verdict unknown.[81]

Typical forgers were copyists who supplemented their legitimate business with the production of outright fakes. Pietro della Vecchia imitated Giorgione, Titian, and other noted artists with such skill that his paintings appeared in royal collections as originals.[82] Sébastien Bourdon in France had a reputation for forgery, as did Jean Michelin. They imitated the styles of well-known painters, put chimney soot into their paints for a darkening effect to mimic age, and rolled the finished canvases to create craquelure.[83] Terenzio da Urbino, said to have been a gifted painter who turned to forgery early on instead of pursuing a legitimate career, used deceptive varnishes, painted on old canvases, sought out old frames complete with wormholes, and treated the finished products with smoke. His downfall came when he tried to pass off a false Raphael to his patron, Cardinal Montalto. The cardinal admired the painting, but some of his knowledgeable friends informed him that, despite the artist's impressive execution, it was a forgery—a "pastichio" of elements from several of Raphael's works. As the story has been told, the cardinal took the situation in stride and maintained the dignity of his office. On learning he had been victimized, he replied (playing on the double meaning of the word as also "pie" or "pasta dish") that if he wanted a pastichio, he would order one from his cook.[84]

Still another strategy prevalent in the seventeenth century was the practice of signature forgery. Dürer suffered this fate often when his monogram was copied on many works done by other artists. Andrea Mantegna's name appeared on many works that were not his, and Johannes Vermeer's *The Painter in His Studio* was signed "Pieter de Hoogh" by an enterprising signature forger who

took advantage of an artist whose works sold for higher prices at the time. Some signature specialists removed part of the lettering from an existing name and filled in the blank space with a more valuable name that bore similarity. Thus, for example, Hans Schäuffelein's "HS" became Hans Holbein's "HH," and Reynier van Gherwen's (a student of Rembrandt's) signature transformed into Rembrandt's own.[85] A particularly ingenious ploy with signatures was contrived by Neapolitan artist Luca Giordano, who painted a fake Dürer but also included his own signature written small at the extreme edge of the painting where it was covered by the frame. After experts authenticated the piece as an original Dürer, and it was sold, the forger told the buyer the truth. The buyer sued but lost when the judge said the painter could not be blamed for being able to paint as well as a famous master. Having established his modus operandi and gained legal support, Giordano went on to use the same ploy for fakes of many artists, among them Tintoretto, Rubens, Rembrandt, Veronese, and Caravaggio.[86]

With copyright protection under the law limited to signatures, and even then subject to inconsistent enforcement, artists and collectors were on the defensive, and forgers were emboldened. When questions of attribution arose, general practice followed the tradition of consulting experienced artists rather than seeking the expertise of collectors and connoisseurs of art, which would become customary later. The artist-experts often disagreed with one another. In a major scandal, more than fifty artists gave opinions about the authenticity of a collection of thirteen paintings (mostly bearing the names of Italian artists) that was offered for sale by dealer Gerrit Uylenburgh in Amsterdam in 1671. Painter Hendrik de Fromantiou, who was a veteran of the "painters' gallies" (copy shops) and formerly employed by Uylenburgh, declared the paintings to be copies and specified where the originals could be found. Fromantiou found experts who agreed with him, and Uylenburgh countered with a larger number who disagreed. The dispute continued until the dealer auctioned the paintings with great fanfare in 1673.[87] Uylenburgh represented a gradual trend toward the pursuit of dealing art as a full-time profession, while sales were often conducted by people from various backgrounds who worked the art market as a sideline. Rubens had a reputation not only for his skill as a painter but as a major collector and shrewd seller, and his countryman Balthazar Gerbier was an accomplished collector-agent-dealer. Diplomats often became opportunistic go-betweens through their travels and personal connections.[88]

EIGHTEENTH AND NINETEENTH CENTURIES

Faking of antiquities and Renaissance and Baroque masters continued during the eighteenth century, with contemporary artists being targets as well.

As before, the practices of legitimate copying and liberal restoration created confusion over artistic originality. Bartolomeo Cavaceppi in Rome "restored" antique sculptures to their original form and in some cases supplemented with more replacement material than the remains to which it was added. One twentieth-century art historian likened his work to modern dentistry or plastic surgery.[89] Cavaceppi's handiwork today can be found in major collections in Rome and elsewhere,[90] defying experts to determine how much of an original is needed to carry that label. Cavaceppi was one of many sculptors working in questionable antiquities. Another was Francis Harwood, an English artist living in Rome who turned to forgery on the side.[91] A particularly attractive enterprise was making false works from Pompeii and Herculaneum. When the sites were excavated in the mid-nineteenth century, frescoes taken from them became popular with collectors, and forgers cashed in as original works became scarce. English artist Richard Evans made a number of the fakes,[92] and many more of lesser quality were produced by Giuseppe Guerra and exposed as false after connoisseurs and antiquaries examined them over a period of several years.[93]

One of the most faked artists at this time was Rubens. Beyond the confusion over works from his studio that involved his assistants, there were outright forgeries as well as other pieces that were genuine but substantially altered. These works were sold regularly during Rubens's lifetime at the well-known "Friday Market" in his home city of Antwerp, where his studio was located. Around the beginning of the eighteenth century, Nicholaes Pieters took advantage of the plentiful Rubens engravings that were available by adding color and selling them in the higher-priced category of colored sketches. Rubens's counterfeits made by Pieters and other forgers of the time continued to be sold into the twentieth century.[94]

At the other end of the continuum from forgers producing plentiful fakes is the fraudulent duplication of a masterpiece, something tried only rarely in the history of art forgery. The Nuremberg town hall displayed a self-portrait of Dürer as a young man, and the image was well known and copied legitimately on various occasions. The painting was loaned to Abraham Wolfgang Küfner for this purpose, after the precaution was taken to place a seal and other markings on the back of the wood panel. The borrower sawed through the panel parallel to the front and back surfaces so they became separate pieces. He then glued the copy he made to the back half, returned that painting to hang in the town hall, and sold the original.[95]

In America, none other than Paul Revere was accused of fraud in appropriating images from two contemporary artists. One case involved his copying a published image of the Indian fighter Benjamin Church, adding a powder horn and using it as the frontispiece for a book. In the other case, Revere sold his own original prints of an image that was similar to a drawing of the

Boston Massacre done by Henry Pelham. The angry artist wrote a letter saying
he believed his copyist was incapable of creating such a complicated image by
himself, and that he had been wronged "as truly as if You plundered me on
the highway."[96] Revere, who was primarily a silversmith rather than an en-
graver, met an ironic fate both in his own day and later in history as his famous
and valuable works have themselves been widely counterfeited.[97]

Beyond relating acts of forgery in themselves, the art-historical writings
of post-Renaissance times demonstrate the degree to which art forgery was
recognized to be part of the culture. During the seventeenth century, writ-
ings by Giulio Mancini and Abraham Bosse addressed the main principles of
connoisseurship for distinguishing good art from mediocre and one artist from
another, as well as (at least in brief accounts) how to spot copies, and Giovanni
Baglione wrote a biography of Terenzio da Urbino that explained the process
forgers used to simulate old oil paintings.[98] Francisco Pacheco, Roger de Piles,
Jean-Baptiste Du Bos, and Jonathan Richardson followed with further state-
ments on copying and faking early in the eighteenth century that detailed how
an expert's eye would discern the difference between an original and a work
made to look like one.[99] This expertise was meant to be passed on to connois-
seurs, who gradually came to be respected as authorities (more than artists) for
making determinations about the authorship of artworks. Conflicting opinions
arose about the possibility that knowledgeable parties could be fooled by excel-
lent copyists, with de Piles suggesting, "the truth sometimes hides itself from
the deepest science,"[100] and Richardson proclaiming confidence that "The
Best Counterfeiter of Hands cannot do it so well as to deceive a good Con-
noisseur."[101] These opinions foreshadow a debate that continues today among
aestheticians about the possibility of a "perfect fake" (discussed in part III).

Less formal writings, too, spread the word about art fraud and darkened the
reputation of art dealers, without the confidence that experts like Richardson
expressed about detecting forgeries. Typical of the eighteenth-century skeptical
commentators was journalist Justus van Effen, a Dutchman who decried cor-
ruption in the art market, saying, "Picture dealers, like horse dealers, well versed
in trickery, palm off worthless trash and copies on young and inexperienced
collectors as valuable originals."[102] On the humorous side was Samuel Foote's
stage production *Taste*, featuring a disreputable auctioneer and a forger of Old
Masters who is his accomplice in preying on aristocrats while they mocked them
for being ignorant dilettantes.[103] And to sum up the dangers of buying at auction,
there is a verse by the chaplain of Britain's Royal Academy that names one of
today's most powerful auction houses (founded in the 1760s):

> When good master Christie tricks out his fine show,
> All is not pure gold which there glitters, we know;
> But with pompous fine titles he humbugs the town,

If the names are but foreign, the trash will go down:
For this purpose, some shrewd picture-merchants, they say,
Keep many a good Raphael and Rubens in pay;
And half the Poussins and Correggios you meet
Were daubed in a garret in Aldersgate-street:
There with pencils and brushes they drive a snug trade;
There Ancients are form'd and Originals made;
New trifles are sheltered neath an old name,
And pictures, like bacon, are smoked into fame.[104]

Cartoonists joined the protest against art fraud and mocked the industry of spurious artworks. In England, William Hogarth's popular prints were widely faked, causing him to respond with a caricature on the topic (see Figure 1.3). He also banded together with fellow engravers to approach Parliament in a demand for a legal remedy that resulted in the Engraving Copyright Act of 1735, an early form of copyright law also known as Hogarth's Act.[105] This measure was limited to the protection of engravings and did not apply to other forms of art.

Public exposure to art continued to grow in the nineteenth century, contributing to an expanded market and a further proliferation of forgeries. The advent of public art museums was a key factor. Since the late Renaissance, some private collections of "curiosities" (eclectic assemblages that might include art among such other items as manuscripts, jewels, and specimens of natural history) were made available on occasion for public viewing. Private collections of art per se occasionally followed this trend. The Ashmolean, Uffizi, and Capitoline museums are examples of precursors to the movement that developed predominantly in the nineteenth century to open key collections to public viewing on a regular basis and to place them in civic control. The 1790s saw the founding of the Louvre and the national galleries of Austria and Sweden, followed in the early 1800s by the Rijksmuseum, the Prado, the British National Gallery, the Hermitage, and New York's Metropolitan Museum of Art (1870), among others.[106] The opportunity to view collections of important art for pleasure was available to the masses.

The growing number of people with the wherewithal to purchase art found a number of outlets to satisfy their interests. Christie's auction house in London had sold art since the latter eighteenth century, as had Drouot in Paris, and lesser-known auctions were available, some conducted by individual artists of their own works.[107] Shops selling artworks, often among other luxury goods, became a regular feature in the commercial districts of major cultural centers, and by midcentury, they were proliferating to the extent that sixty-seven were listed in the Paris commercial almanac of 1850.[108] By the turn of the twentieth century, New York was home to forty art galleries[109]

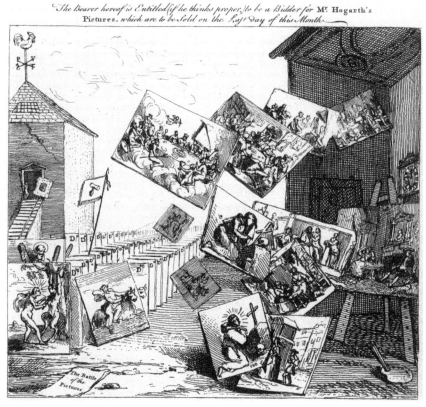

Figure 1.3. *The Battle of the Pictures* by William Hogarth, 1745, engraving. Promotes Hogarth's own studio and artworks (on the right) and satirizes the auction trade in art as corrupt (on the left). The auction house bears a symbolic crack on the front wall, while the paintings lined up in front are copies and fakes. Wikimedia Commons

as well as various other dealers. The profession matured to the point where star dealers were sometimes as well known as famous artists. By the latter nineteenth century and into the early twentieth century, Paul Durand-Ruel, who represented the Impressionists in France, and Ambroise Vollard, who represented the Post-Impressionists, secured their names in history as promoters of an upstart movement that would set artistic sensibility on a new course. Stefano Bardini in Florence and New York became known as a bold and savvy salesman who provided historic works to major museums and private collectors while influencing the development of their taste in art. Colnaghi and Company in London and M. Knoedler and Company in New York established reputations as premier galleries. Several of these leading lights would

eventually find their reputations tarnished by questions about the authenticity of their inventories. Bardini (who was also a painter and restorer) was accused of disreputable dealings in overly restored works and suspected for outright fakes.[110] Colnaghi was embarrassed in the late twentieth century by British forger Eric Hebborn when he revealed in the newspapers and his memoir his habit of selling them counterfeit Old Master drawings.[111] And Knoedler closed in 2011 in the throes of a scandal over the sale of forgeries made by Chinese painter Pei-Shen Qian.[112]

Not only was there a growing familiarity of the public with art, but an awareness of forgery was also reinforced during the nineteenth century through books and magazine stories by fiction writers.[113] Henry Carl Schiller in "Who Painted the Great Murillo de la Merced?" plays on an artist's remorse for innocently creating a commissioned painting that he later discovers is owned by a collector who takes it to be an original by a seventeenth-century master.[114] "The Capitoline Venus" by Mark Twain similarly presents an artist who inadvertently creates a fake. A friend, knowing the artist needs money, damages one of his sculptures and creates artificial aging, and then sells it as an ancient original, with the artist receiving the proceeds.[115] In "Pierre Grassou" by Honoré de Balzac, a professional art forger, whose paintings are sold to the nouveau riche, lives in bitterness that he lacks the talent to make his own originals.[116] Themes in other writings include forgery as a leveler of pretentiousness and corruption among the elite, acclaim for the knowledge of expert authenticators, and condemnation of crooked dealers.

Nathaniel Hawthorne's story "Edward Randolph's Portrait" and his novel *The Marble Faun* deal with the prevailing attitude toward art restoration.[117] Hawthorne preferred works to be restored to their original appearance. However, there was a growing sentiment away from this position and toward the display of old and damaged works as they were found, with minimal or no intervention, rather than to produce a stylized re-creation or attempt an accurate rendering of the original. This preference for caution about restoration had a basis in the eighteenth century, especially as spoken for by Johann Winckelmann, whose authority was widely respected. Even Cavaceppi, a friend of Winckelmann's, came to espouse the new philosophy of the importance of preserving authenticity, although his workshop turned out various pieces that were heavily restored, and other restorers did so as well. This disparity between theory and practice continued through the nineteenth century. In what is often described as a watershed event, the decision was made not to restore the fragmented Elgin Marbles that had been removed from the Parthenon and transported to England, with Antonio Canova and other respected sculptors refusing to do the work.[118] Art critic John Ruskin gave support to

the new way of thinking in his campaign to avoid renovating decaying old buildings, taking an aggressive stand.

> Do not let us talk then of restoration. The thing is a Lie from the beginning to end. You may make a model of a building as you may of a corpse and your model may have the shell of the old walls within it as your cast might have the skeleton . . . but the old building is destroyed, and that more totally and mercilessly than if it had sunk into a heap of dust.[119]

Rather than restore, the alternative was, if not to abandon or demolish à la Ruskin, to preserve with special care. However, as in the past, art collectors and museumgoers continued to want refurbished works that gave the appearance of original condition. Paintings were retouched to fill in damaged areas and undamaged parts were sometimes repainted as well, ancient Greek vases were made to look like new, prints were treated with bleach to whiten the paper,[120] and other forms of art were dealt with analogously. Overall, the new aesthetic gained ground, with innovative re-creations clearly unacceptable. Debate continued over how much, if any, restoration was appropriate in a given case, and there was an emphasis on caution.

Along with growing public knowledge of art, and stories about forgery appearing in popular culture, connoisseurship gained a newly devised method for recognizing the authorship of an artwork and for detecting fakes. Italian critic Giovanni Morelli focused on seemingly inconsequential elements such as earlobes, fingernails, and folds in drapery that artists repeat faithfully and copyists are unlikely to duplicate exactly.[121] Authentication became a scientific process of observation that was available to many people, at least in amateur fashion. It acted as an intellectual cousin to Sherlock Holmes's deductive thinking and to Sigmund Freud's psychoanalysis,[122] with Freud himself saying both he and Morelli looked for "secret and concealed things from despised or unnoticed features, from the rubbish heap, as it were, of our observations."[123]

Despite the broader scrutiny artworks were subjected to, a surge of forgeries appeared throughout the century. Journalists wrote about copy shops in the United States as well as Europe that produced artworks for fraudulent sales, some of which used methods of mass production and employed female artists:

> With a few hasty strokes one girl does the hair, and the copy is taken to the next, who puts on the face; it goes then to a third, who gives arms, and so it traverses the workshop until the whole has been obtained.[124]

A newspaper account described a factory in a New York City suburb that specialized in Jean-Baptiste-Camille Corot, whose French landscape scenes

were in vogue with American collectors as well as in Europe. According to a leading artist of the day, "you can obtain works of this master in any size or in any quantity you please, either by the dozen or single copy."[125] Another account tells of 235 fake Corots that were exported to France in a single year (1888) from a single workshop in Belgium.[126] Beyond the factory approach, the Corot phenomenon was complicated by the circle of painters who worked remarkably like the master in his easy-to-imitate style and whose products might easily pass for his with a simple change of the signature by an unscrupulous dealer. Another factor was Corot's habit of putting his signature on paintings done by followers who approached him for his critique and approval.[127] He also collaborated with various assistants and other artists and with studios that produced his paintings, with the amount of work he actually performed on those pieces unknown.[128] Unknown, too, is how many finished studio versions were produced after the artist's death.

Also prolifically faked in the nineteenth century were ancient Greek Tanagra figurines, tiny terracotta images of everyday people in casual poses. Thousands were produced originally for religious devotion (sometimes buried with the dead) and personal enjoyment. After local villagers discovered them in tombs in the 1870s, they became popular with art enthusiasts throughout Europe. Private buyers flocked to own a Tanagra, and leading museums amassed whole collections. When demand exceeded supply, forgers set to work, and over time, suspicions arose about the presence of fakes even in carefully vetted collections. The fakes often can be detected by knowledgeable observers who spot features such as poorly executed faces and folds in the clothing, or single-piece casts (originals were made with a separate base).[129] Scientific procedures also can be employed to measure age. In 1994, laboratory testing using thermoluminescence to determine the date of production found that 20 percent of the Tanagras in a major collection in Berlin consisted of fakes. Testing in 2003 on 140 pieces held by the Louvre showed only a few that were not authentic.[130]

The demand for ancient artworks also included Egyptian sculptures and reliefs, after European museums early in the century imported them and created intrigue with their displays. Sales shrunk the number of available originals, and forgers in Cairo filled the void, along with Italian craftsmen who shipped their wares to Egypt.[131] A French dealer who was frustrated with the fakes flooding the market penned an open letter in 1843 to a member of the French Academy, saying, "What, for Christ's sakes was to be done in order to supply antiquities to so many amateurs, interested and curious parties?"[132] He continued on to describe how false wooden sculptures were produced (carved from sycamore wood, boiled in tobacco juice, and treated with bitumen to create the smell of a mummy), as well as statues made from plaster. Although these

fakes generally were not of high quality, they satisfied the crowds of European and American tourists visiting Egypt.

While the volume of fakes made in the nineteenth century was large, only a few of the forgers responsible for them were recorded at that time or discovered later. Englishmen **William Smith and Charles Eaton** are remembered for producing fake medieval medallions along with a variety of other objects such as small statues and reliquaries they claimed to have found buried in the mudbanks of the Thames River.[133] The works were sold by antiques dealer George Eastwood and soon were spotted by archaeologists as forgeries for bearing odd and meaningless letters and symbols, and dates from the eleventh century in the form of Arabic numerals (which were not used in Europe until the Renaissance). Eastwood sued *Athenaeum* magazine for an article reporting that he had sold forgeries, and although the judge decided against him, an expert witness declared the objects were genuine because no forger would be so blatantly wrong or could produce the wide variety of objects involved. Several years later, when the plaster molds used by the forgers were discovered, they escaped prosecution, but their business dwindled. An estimate of the number of "Billy and Charleys" produced suggests there were several thousand over the period of a decade, although how many were sold is unknown. With time, Billy and Charleys became collectible forgeries, and in the twenty-first century are held in twenty-five British museums as well as appearing on the auction market occasionally, at prices of a few hundred dollars each.[134]

In the area of drawings, Italian artist **Egisto Rossi** forged the works of Renaissance masters and nineteenth-century artists. His activity seems to have been unknown during his lifetime except for a brief entry in a book on Italian artists published in 1892.[135] Notes recorded in a folio of Lorenzo Bertolini drawings at the Ufizzi identify some of those works as Rossi fakes, which provided clues for later investigations that revealed forgeries also of Raphael, Andrea del Sarto, and Antonio Canova.[136] Keys to detecting the fake works include the artist's mark along with his use of red chalk and bright blue ink, and a habit of mounting sheets on a blue background using gold tape.[137]

Beginning around midcentury, **Reinhold Vasters** embarked on his career in Germany as an artist, restorer, and forger. Working in gold and other metals, jewels, and rock crystal, he turned to fraud in an arrangement with art and antiques dealer Frédéric Spitzer that lasted until Spitzer's death in 1890 and went undetected for nearly one hundred years. Besides Vasters's legitimate business, he produced a wide range of items, including chalices, crosses, pendants, vases, candelabras, reliquaries, ewers, and more that were sold as Renaissance originals. He amassed a substantial personal fortune and a collection of five hundred art objects, pieces of furniture, and other items that

he put on public display. After his death in 1909, his art library was sold at auction and became part of the archives at the Victoria and Albert Museum.[138] It was not until 1979 that the discovery was made in his records of more than one thousand drawings of works simulating Renaissance style, accompanied by detailed instructions for assembly in Vasters's handwriting. Within a few years New York's Metropolitan Museum of Art reassessed its prized Cellini Cup (also called Rospigliosi Cup), thought to be an original by the sixteenth-century master, and announced that several dozen more of its Renaissance holdings were forgeries created by Vasters.[139] His works have been found in other major collections as well.

Forgery of Renaissance paintings continued in the nineteenth century, with a ready supply of fakes of great masters available in Italy and a continuous market consisting of well-heeled young Europeans and Americans taking the Grand Tour to round out their cultural awareness. A traveler to Italy with a knowledge of paintings and dealings in art there recounted the experience he found to be typical for Grand Tour novices. A young tourist is taken by a valet to a picture dealer and shown retouched and repainted old paintings bearing the signatures of Del Sarto, Giotto, Fra Angelico, and other notable artists. The dealer then presents two pieces of special quality by Raphael and Leonardo da Vinci, which he was entrusted to clean and repair and which would be sent back tomorrow. The next day, the valet mentions casually that the owner of the two paintings is an acquaintance of his who is in need of money and could be persuaded to sell. An incredible sum is asked.

> Negotiations ensue, such as can alone be carried on and understood in Italy. Twenty people appear who seem to have an interest in the matter and are ready to advise and assist you. After squabbling, cajoling, losing your temper and ordering your post horses twenty times the whole sum in dispute being at length probably reduced to about five shilling—you bear off with your prizes in triumph . . . provided with documents signed by illustrious families, and authenticated by well known professors of the academy to prove their genuineness.[140]

Renaissance sculpture, too, was in demand. Sculptors found ample work making busts of famous men, women, and saints in the style of fifteenth-century masters. Florence was a center for production, and **Giovanni Bastianini** became its most famous practitioner. He was employed by art dealer Giovanni Freppa to sculpt works he was paid little for and at least some of which were sold as copies rather than originals. Because of the high quality of his artistry, the truth about his works went undetected for nearly two decades. When the owner of a Bastianini bust of Girolamo Benivieni resold

it to the Louvre as a sixteenth-century original for twenty times what he had paid for it and failed to give the artist and his dealer their promised cut, they went public. Experts refused to believe the bust was a forgery, along with the possibility they may have been fooled by the sculptor's work on other occasions, and contentious remarks appeared in Italian newspapers over the naivete of the French and in French newspapers about a costly fraud perpetrated by Italians. A wealthy supporter of the Louvre offered a greater amount of money than the museum had paid for the sculpture if Bastianini would prove himself by making a comparable one. He accepted the challenge but died suddenly at age thirty-seven before he could do the work.[141] Further scrutiny convinced skeptics of Bastianini's claim, but barring his admission, his secret might have gone undiscovered for many years. Eventually other works thought to be Renaissance originals were found to be his. Later experts have been split on their assessment of Bastianini. Some rate him to be equal or nearly equal to the Old Masters he was emulating, and others emphasize the characteristics in his style that are giveaways. Some believe he was a legitimate copyist who was taken advantage of by unscrupulous buyers, and others see him as a forger.

Many other examples could be added to these highlights from the nineteenth century. Besides traditionally popular paintings and sculptures, forgers turned out Gothic ivory carvings, Byzantine enamels (figures painted on plaques and medallions), French eighteenth-century ceramics, and works of other sorts in response to the art-minded public's broad demand for collectible items. Some commentators have called this period the "great" or "golden" age of faking,[142] which is apt relative to what preceded it. But looking forward reveals that counterfeit art in the twentieth century and to the present has evolved into an even larger and bolder enterprise. A growing population and potential art-buying public provides the impetus for forgeries in larger numbers: more forgers turning out more fake art.

INTO THE TWENTIETH CENTURY

The early 1900s saw a continued demand for Egyptian antiquities, which led to more and better forgeries. Europeans operating at home and in Egypt were active producers, with one ring of forgers centered in the Egyptian Museum in Cairo.[143] The most accomplished of these forgers was **Oxan Aslanian**, who came to be known as the "Master of Berlin." Of Armenian heritage, he lived in Egypt as a young man, where he learned to fashion sculptures and reliefs. After 1920, he worked in Germany and specialized in the Amarna period. By 1930, Aslanian's activity was noticed by several experts, but without direct evidence against him, his name was not revealed until after his death in

1968.[144] After that time, telltale signs of his work became known, and many Egyptian sculptures in European and American museums have been identified as fakes attributed to Aslanian.[145]

Also active in the early twentieth century, and whose identity has never been known, was the "**Spanish Forger**." The name derives from the discovery in 1930 that a fifteenth-century panel painting attributed to the Spanish artist Jorge Inglés was instead a recently made fake.[146] The forger, who is believed to have been French or to have worked in Paris, painted on original panels and parchments, sometimes doing page illustrations for text and music (see Figure 1.4). Once the forger's distinctive style was recognized, other fakes held in many museum collections were detected. A catalog for a special exhibition of seventy-five of the forger's works in 1978 brought the known total at that time to about 150, with the tally growing gradually to nearly 350 in the early 2000s.[147]

Icilio Federico Joni is the best known of a group of skilled craftsmen working in Siena, Italy, who presented themselves as legitimate copyists (including Umberto Giunti, known for fake fresco fragments) of historical Italian works, but eventually were labeled as forgers.[148] Joni began his career by doing interpretations of sixteenth-century book covers and worked his way into a specialty in Renaissance paintings.[149] On various occasions, he fooled noted art historian Bernard Berenson, and published a book (translated into English from Italian in 1936) titled *The Affairs of a Painter* in which he spoke openly about the techniques of forgery.[150] Tales about Berenson were originally written into the book, and although they were removed before publication, there was speculation that he and his dealer-employer, Joseph Duveen, bought up and destroyed most of the available copies.[151] Duveen's business relied heavily on Berenson's authentication of Italian Old Masters, which were backed up by his outstanding reputation.

Italian sculptor **Alceo Dossena** shocked the art world in 1928 when, like Bastianini before him, he revealed his identity as a forger out of anger over an unsatisfactory financial arrangement with his dealer-associates. At first, art experts refused to believe one person had created dozens of sculptures in various styles from the ancient period to the Renaissance, in mediums from terracotta to wood to marble, that were held in many major museums and important private collections. As proof, the artist produced photographs of his work in progress and the hand he had broken off from one of his masterpieces to make it look worn. Once exposed, Dossena enjoyed brief popularity as an artist under his own name, but found that even with exhibitions in Paris, Berlin, London, and New York, his sculptures sold for small amounts. He died in a pauper's hospital.[152]

Figure 1.4. *Musician Harping for a Recumbent Queen* by the Spanish Forger, on parchment, 225 x 195 mm. Courtesy of Les Enluminures.

As Dossena's career was ending in Italy, **Lothar Malskat**'s was begin-
ning in Germany. A talented young copyist, he was hired at a cheap hourly
wage by an art restorer for a cathedral project, where they found it easier to
do a complete repainting job on the damaged medieval murals than the careful
restoration that was commissioned to preserve a religious landmark. Working
in isolation, the artist finished the job, his employer took the credit, and the
method that was used went unnoticed. Malskat's career continued when, after
serving in the German army during World War II, he went to work for his
old employer's son, turning out six hundred fake paintings over several years
ranging from Renaissance masters to Corot, Renoir, Degas, Picasso, Munch,
and others. He was discovered only when another cathedral job was offered,
and history repeated itself. He secretly whitewashed the walls of the Lübeck
Cathedral, which had been damaged in the war, and painted new murals, with
his employer taking all of the credit and most of the payment. The project
drew accolades, and two commemorative postage stamps were issued to honor
the supposedly refurbished paintings.[153] Malskat, angry at being mistreated,
demanded that both he and his employer be prosecuted, confessed to his years
of illegitimate activity, and received a prison sentence of eighteen months
(twenty months for his employer). He lived thirty more years, painting under
his own name as an Expressionist and earning little money,[154] although his
story was widely known through a German biographical film as well as Günter
Grass's novel *The Rat*.[155]

Another post–World War II scandal rocked the art world when Dutch
artist **Han van Meegeren** revealed that he was the creator of several paint-
ings thought to be by Johannes Vermeer. Those paintings, along with a dozen
other forgeries he made (mostly of Vermeer but also Frans Hals and Pieter de
Hooch), have been regarded by many commentators to constitute the greatest
art fraud in history. Van Meegeren, the subject of a dozen books and numer-
ous other publications as well as several films,[156] is known for the estimated
$50 million to $100 million (in the currency of the early twenty-first century)
he earned,[157] the ingenious methods he used, the false chapter he wrote tem-
porarily into art history, the scheme in which he fooled Nazi leader Hermann
Göring, and his high-profile trial.

Van Meegeren was arrested by Dutch police in 1945 when it was dis-
covered that during the war he had sold (through an intermediary) a Vermeer
painting to one of Adolf Hitler's chief officers. Facing a charge of collaboration
with the enemy and a possible death sentence, the artist had no recourse but
to admit that the painting in question was a forgery and he was the forger. As
the case unfolded, he confessed to counterfeiting other paintings, and to prove
his claim, he created another Vermeer in front of a court-appointed panel of
experts. After the legal charge was reduced to fraud, he was tried and found

guilty while also becoming a celebrity. His trial drew international attention and culminated in a one-year prison sentence that he never served due to his death from ill health.

As a young man, Van Meegeren enjoyed brief success with art critics before being dismissed as an unimaginative traditionalist. While he continued to sell his own works (including commissioned portraits), he turned to forgery to provide income for an expensive lifestyle and as a means to exact revenge on his critics. What made his scheme so striking was its boldness. With Vermeer's paintings regarded as national treasures, and his known output numbering only about three dozen, to add more would draw considerable attention. After previous attempts that yielded subpar Vermeers (although some were sold), the forger refined his approach to circumvent scientific testing and the fact that he was less skilled with a brush than the artist he was imitating. He was careful to make his paints from pigments used in Vermeer's time, and he discovered that adding phenolformaldehyde (sold commercially as Bakelite) and then heating a canvas brushed with his concoction in an oven at 250 degrees Fahrenheit, would simulate the hardness of centuries-old paint.[158]

The final and most cunning part of the hoax was to conjure a period early in Vermeer's career when he painted *Christ in the House of Martha and Mary*.[159] This was the artist's only work with a religious theme, but it was enough to lead experts to believe there could have been more. It spurred Van Meegeren to create *The Supper at Emmaus* (see Figure 1.5) in 1937, which was heralded by some commentators at the time to be Vermeer's greatest masterpiece, followed over the next decade by six more paintings of biblical subjects. The style in these pieces is different than in Vermeer's paintings, which deflects attention away from the lack of his customary level of workmanship. The faces of the figures appear wispy and unworldly, clearly different than those in Vermeer's noted works such as *Girl with a Pearl Earring* and *The Milkmaid*, as well as *Christ in the House of Martha and Mary*. While not all experts were fooled—Joseph Duveen's representative sent to view *Emmaus* called it a "rotten fake"[160]—the desire to fill in a little-known period in Vermeer's work held enough sway to be convincing until Van Meegeren's unusual admission of forgery.

Still another early to mid-twentieth-century forger who simulated historical works was **Jef Van der Veken** in Belgium. Trained as a copyist, he began his career prior to World War I by painting legitimate Old Master decorative paintings, and opened an antiques shop where he also sold his works as Renaissance originals. After the war, he shifted his career to become a restorer and perfected the approach he termed "hyperrestoration," which often meant extensive overpainting on damaged panels and canvases that had little paint remaining. Some of the figures in his imaginative restorations were drawn from photographs of his gardener's daughter as a model.[161] With his

Figure 1.5. *The Supper at Emmaus* by Han van Meegeren, 1937, oil on canvas, 115 × 127 cm. Forgery in the style of Vermeer. Heritage Image Partnership/Alamy Stock Photo

dark side still unknown, Van der Veken's skill earned him employment with museums, where he tended to follow more traditional restoration techniques and developed a reputation for excellence. He was called to be an expert witness at the Van Meegeren trial, and was commissioned to paint a replacement copy for the famous *Mystic Lamb* panel of the Ghent Altarpiece that was stolen in 1934 and never recovered; the copy remains today as a permanent part of the display.[162] During the 1920s, Van der Veken restored and hyperrestored a number of pieces for collector Émile Renders, some of which the owner sold to Hermann Göring during World War II. In the 1990s, many of Renders's holdings became suspect for their authenticity and were a key to unmasking the restorer's lifelong pattern of deception. The extent of that deception is still in question as twenty-first-century investigators search through Van der

Veken's personal archives and examine works held in various museums and private collections.[163]

Van der Veken's hyperrestorations were considered forgeries by twentieth-century standards. The artist understood that his work would be judged that way and took measures to disguise his techniques. Inventive restoration was clearly unacceptable, and extensive restoration continued to be questioned, as the philosophy associated with interventions tightened in light of an increasingly complex set of issues. Should fill-in material be added to an original work, and if so, with what limitations? How does a restorer know what the original work looked like? Should old restorations be removed, and if so, should they be replaced? Should signs of aging (such as discolored varnish) be removed, or should they be left as is?[164] With these questions and others under debate, discussion of them became organized and institutionalized as national and international organizations formed over concerns about historical preservation. The International Institute for Conservation of Historic and Artistic Works (IIC) was established in 1950, and the American Institute for Conservation of Historic and Artistic Works (AIC) grew out of it as an independent group in 1972.[165] According to the AIC "Guidelines for Practice," compensation for physical loss must be "detectable" using at least one of three examination methods: visible light, ultraviolet light, or low-power magnification. Compensation must be "reversible," employing methods and materials that do not adversely affect the original material, and covering as little of the original surface as possible. And the work performed must be "documented" in written and graphic form, with identification of the materials used.[166] For example, a sculpture with missing arms would have them reattached in a way that makes clear what was added to the original: the adhesive and any newly created parts would appear in a different color, if not to the naked eye then at least when simple scientific means of detection are used. The adhesive should not cause deterioration or discoloring on the original sculpture, and should be removable in the future without adverse effect. With a painting, if color is added to fill areas of paint loss, it should be done with material that is distinguishable from the original paint and can be removed later if desired.

This cautionary approach describes current ideals for restoration as defined by leading figures in the profession. In practice, however, determinations about the what and the how of restoration are made by the parties commissioning the work they want done. Private collectors and dealers, in particular, may be inclined toward minimal compliance with the standards, if with compliance at all, following a different perspective on what they value in aesthetics and salability. As in prior times, during the twentieth century and forward to the present, there have been appreciable differences in attitudes toward what constitutes appropriate practice in art restoration. Whether a restored work has

retained or lost its authenticity, then, becomes a matter of debate and interpretation. This topic will be discussed further in part II.

FORGERY'S REACH

During the twentieth century, the underlying social conditions that invite forgery expanded. Public and private viewing was more available than ever for the general population, and collectors and dealers bought and sold in an ever-growing art market. By the 1910s, London was home to more than three hundred galleries, and the number of equivalent businesses in Paris (with a considerably smaller population[167]) was well over one hundred.[168] More star dealers appeared, engaging in competition for the high end of the market. With commerce in art disrupted by two World Wars, and wealth being amassed by American industrialists, many artworks flowed westward across the Atlantic. Joseph Duveen is often quoted for his statement that "Europe has a great deal of art and America has a great deal of money," which he and his counterparts heeded in selling numerous works to such figures as Henry Clay Frick, Isabella Stewart Gardner, J. P. Morgan, Andrew Mellon, William Randolph Hearst, and Gertrude Vanderbilt Whitney. Many of their acquisitions were eventually donated to establish or enhance museum collections. Among their dealers were the Wildenstein family, Jacques Seligmann, and the Rosenberg brothers, all of whom opened New York galleries in addition to their original European locations and dealt in both Old Masters and modern art. Duveen focused on historical works, and as perhaps the best-known dealer of his era, was bestowed with British knighthood, although eventually a number of the paintings he sold (including those authenticated by Bernard Berenson) came into question for their authenticity.[169]

By the latter half of the twentieth century and into the twenty-first century, a new group of financial moguls took their places as prominent art collectors. Their focus was on modern and contemporary art, although not exclusively. François Pinault (France), Bernard Arnault (France), Eli Broad (United States), Charles Saatchi (Britain), the Al-Thani family (Qatar), Reinhold Würth (Germany), and others who donated private holdings continued the tradition of establishing new museums for public viewing. These examples represent the upper end of museum growth, which extended broadly to many smaller institutions to total more than twenty-five hundred in the United States alone in the 2000s.[170] And as a related form of display, corporate collections multiplied and expanded, making viewing available to employees and sometimes to visitors, as well as on a few occasions to the general public through special exhibitions. Corporate collecting is not a recent phenomenon;

it is a centuries-old tradition for art to be displayed on the walls of boardrooms and to be used as a marketing strategy. But there was a great increase in corporate buying, and by the turn of the twenty-first century, despite periodic economic downturns there were more than two thousand collections in existence internationally.[171]

Art dealers, too, were in expansion mode. Leading names opened galleries in multiple locations, such as Gagosian (eighteen spaces in seven countries), Pace (nine spaces in five countries), Perrotin (ten spaces in six countries), and the Nahmad family with its far-reaching sales operations. Art fairs headlined by Basel, Miami, Frieze (London), and Maastricht became large international attractions. The Internet came into play with websites for dealers, and organizations such as artnet.com and others acting as information umbrellas to offer forums for galleries and auctioneers to connect with buyers, databases for past auction sales, congregations of artists to enhance their visibility, timely news about art, and other services. Added to all of this visibility for art and opportunities to buy it has been the growth of wealth and spending. Estimates (numbers vary from one organization to another and year to year) put the size of the global art market at $50 or $60 billion annually.[172] Although much of that amount is accounted for by a relatively small number of works sold in the million-dollar-plus range, works valued at less than $50,000 (many of them far less) make up 90 percent of all items sold.[173]

What this snapshot demonstrates is that the conditions conducive to art forgery identified at the beginning of part I are present today to a striking extent. Artists are revered by name, with a few achieving iconic status that generates extremely high value. Collectors are actively involved in buying art, and numerous opportunities exist for them to do so. Although these conditions have existed for centuries, as has forgery, in recent decades escalation has been especially apparent. No more originals will be produced by any artists but those alive now and in the future (with certain exceptions for prints and sculptures made from existing plates and molds). With more collectors, and a fixed supply of artworks by the artists for which they compete, it is not surprising to see prices rise. The auction market again serves as an example, where record prices for single works in the 1960s and 1970s were in single-digit millions of dollars and by the 2010s had risen to the hundreds of millions.[174] All of this has encouraged forgery at an unprecedented level.

Given these conditions, the expectation is for many fakes to have been added to the limited supply of original artworks. One perspective for understanding the overall phenomenon looks at what kinds of art are affected: which artists, mediums, genres, and price points. Another perspective is to focus on the forgers themselves and the kinds of artworks they made, as well as their estimated output. There is a long lineup of known forgers who collectively

are responsible for fake art in large quantities. Some of them have become famous, and others range from the less famous to the obscure, with a question remaining as to how many more forgers there are who are entirely unknown.

In 2005, *ARTnews* magazine surveyed a group of experts to ask, "Who are the ten most faked artists in history?"[175] The nearly unanimous choice for number one was Corot, whose reputation has been amplified by a quip that appeared over the years in modified versions in several major publications. Corot, *Newsweek* said in 1940, made twenty-five hundred paintings, seventy-eight hundred of which are in the United States. London's *Guardian* in 1957 put the numbers at five and ten thousand, and *Time* in 1990 estimated Corot's output more conservatively at eight hundred pictures, four thousand of which had made their way to American collections.[176] That bit of humor pales next to the assertion of Sir Caspar Purdon Clarke, director of the Metropolitan Museum of Art in the early 1900s, that he was informed by a customs official that twenty-seven thousand Corots had entered the United States.[177] Further estimates for the number of forgeries in existence go as high as one hundred thousand.[178] One collection in France of twenty-four hundred Corot paintings, watercolors, and drawings was found to consist entirely of fakes.[179]

Whatever the true total is for Corot fakes, the designation of most faked artist might more accurately belong to Salvador Dalí. The market is flooded with forged prints bearing his name. In New York City in 1991, a single seizure by court authorities from an American source accounted for eighty thousand false prints, including fifty thousand of Dalí.[180] A French source is known to have sold at least eighty-five hundred false Dalí prints through a California outlet in the 1980s,[181] and in the late 1990s, it was found that one hundred thousand had been sold through the cumulative efforts of seven art publishers in France.[182] Late in life, Dalí complained that there were thousands of limited-edition fakes of his work, but he had contributed to the problem himself by signing stacks of blank sheets of paper that were used for printing after the fact. He earned $40 per sheet, and it has been claimed that with aides sliding them in and out in front of him, he could sign one every two seconds. Estimates of how many sheets were signed range from fifty thousand to three hundred fifty thousand.[183] Some of the presigned sheets became legitimate prints, and others were used for counterfeit creations. They share the market with a large number of photomechanical reproductions made in a similar fashion to posters and sold as originals. A fake signature is easily added: Dalí's legitimate signature came in many variations that often make it difficult to say that his scrawled name is not authentic. The monetary toll all of this has taken on the art market—the amount paid for Dalí fakes—was estimated in the 1980s by New York's attorney general to be $625 million.[184]

Another name found in the survey of the most faked artists is Auguste Rodin. While famous for his bronze sculptures, he also produced ten thousand drawings, more than four thousand of which are held in the Musée Rodin in Paris.[185] And there is a large volume of forgeries. Nearly one thousand drawings were done by Ernest Durig, who claimed an association with the artist and said the works were gifted to him.[186] Durig may also have produced a few fake Rodin sculptures, although most have come from other sources. Some of the bronzes are copies similar to those sold by legitimate vendors, including the Musée Rodin, while others are created from original molds used without authorization and from aftercasts that have been inscribed with false foundry marks. Several thousand pieces are thought to have been made, many of them still in circulation.[187]

Maurice Utrillo's name is also featured among the *ARTnews* top ten. He has been disparaged by many art critics, but his loose impressionistic Paris scenes were popular early in the twentieth century and command substantial prices today. One of his copyists declared, "Utrillo has no talent. I paint better than he does,"[188] and forgeries made by another were accepted as Utrillos, while genuine Utrillos were sometimes thought to be forgeries. The artist himself often was unable to tell his own work from inauthentic look-alikes, while a dealer-friend of his with a better eye compiled a list of one thousand false paintings.[189]

The remaining names on the *ARTnews* list include Giorgio de Chirico, Honoré Daumier, Vincent van Gogh, Kazimir Malevich, Amedeo Modigliani, and Frederic Remington. Many others could be cited to rival them or be close in the running. The list was merely an expression of opinion, although an informed one. There are many stories of counterfeit Russian avant-garde paintings mimicking Malevich, Wassily Kandinsky, and others from the early 1900s. When the Soviet Union collapsed, art that had been banned as bourgeois modernism suddenly became available and rose in popularity and value. Some experts estimate that more than half of the existing paintings of that genre are forgeries,[190] prompting one to remark that "if you burned all the fakes of Russian avant-garde now hanging in galleries and private collections around the world, the West would obtain a valuable new energy source."[191] The French Impressionists, too, have been targets, as would be expected with their fame and high prices. One man alone was found to have sold six hundred fakes in Switzerland in a two-year period. He was connected to a gang of smugglers who accounted for hundreds more in other countries. Even more notorious are fake prints of Picasso, Miró, Chagall, and Rembrandt. Along with the false Dalís, there are so many in existence that galleries and auctioneers sometimes refuse to deal in prints by those artists.

The artists noted here as major targets include some of the most prominent names in history, and their works sell at the high end of the art market. The business of forgery extends much further to take aim at less famous names and lesser monetary values as well. Antoine Blanchard, a twentieth-century French artist who painted bustling street scenes depicting life in Paris circa 1900, has been popular with British and American collectors for several decades. During his lifetime, his works sold for modest but rising prices, and today list in galleries from around $15,000 to $30,000. Opportunists noted his popularity even when prices were low, and more than half of the considerable number of paintings bearing his name are not authentically his.[192] What makes his case particularly interesting, besides the large volume of fakes on the market, is that "Antoine Blanchard" is a pseudonym the artist adopted (real name Marcel Masson) but may not have registered legally, a circumstance that could have emboldened copyists to use the name.

Another often-forged artist with values similar to Blanchard's is Johann Berthelsen, a mid-twentieth-century American painter known for his snowy scenes of New York City. Today the artist's son, Lee Berthelsen, who painted with him for many years, serves as an authenticator. He estimates the number of fakes to be in the hundreds at least. When asked once to review fifty-five paintings for a retrospective that was being planned, he found fifty of them to be inauthentic. The forgeries first appeared in the 1950s when Berthelsen's paintings were carried by respected dealers at inexpensive prices, and more recently, there appears to be an influx of fakes from China and Russia. The artist's son also has recounted that on two occasions he knows about (suggesting the likelihood there were others), his father was recruited by respected galleries to produce forgeries of popular artists, but he declined.[193]

Further down the economic ladder, with artworks that sell in the range of a few hundred to a few thousand dollars, forgery is also a common presence. The artists who are copied are recognizable to regional buyers or to those collecting in lesser-known genres and mediums. The Highwaymen, so called because they often sold their works from the trunks of their automobiles along major highways, were a loose-knit group of more than two dozen African American artists in Florida in the 1950s through the 1980s who made oil paintings of local landscapes with bold colors and bright skies. They worked quickly (sometimes a dozen or more pieces by a single artist in a day), sometimes leaving their products unsigned. Original prices ranged below $50 and the number of works sold has been estimated to be one hundred fifty thousand or more.[194] In recent years, Highwaymen paintings have become popular as collectible items, encouraged by several books about them[195] and the group's (twenty-six named painters) induction into the Florida Artists Hall of Fame in 2004. Many of their paintings are available at art shows, small auction houses,

and online, especially through eBay. Along with the artists' rising popularity, there have been numerous warnings of Highwaymen forgeries. The group's size and its particularly large output, along with claims that some artists not on the Hall of Fame list are still true Highwaymen, and the fact that numerous originals went unsigned, make authentication murky even though some of the artists are alive today.

A collectors' niche in a similar price range to the Highwaymen, and with many reports of fakes, is cartoon and animation art. Magazine articles, blogs, expert collectors, and dealers have announced alerts about faked drawings and animation cels on the market. One gallery carrying thousands of works was accused by the widow of Charles M. Schulz (creator of the *Peanuts* comic strip), and the directors of two leading museums of cartoon art, of selling fakes.[196] eBay has been named as another source, with an expert on *The Simpsons* estimating that 90 percent of the television show's cels found on the site are fakes.[197] Another expert declared that "Most Disney Drawings on eBay are Forgeries!"[198] Although fraud in this sector of the market does not generate headlines like those given to forgeries of famous artists selling for high prices, cartoon and animation art have numerous and avid followers as well as qualified experts, and are subject to being falsified.

The works of cartoon and animation artists, along with those of the Highwaymen, Berthelsen, and Blanchard, although not at the center of the art world's attention, nevertheless have derived their popularity and sales from established reputations. They trade on name recognition among certain populations of collectors. Successful artists, as known quantities, are likely targets for forgers, who follow the attention gathered by someone else and redirect it to their own ends. Fraud is built on the perception of established value. At least that is the conventional pattern. But in a counterintuitive twist, a virtually unknown painter in 2009 was dubbed "Britain's most forged artist."[199] Mandy Wilkinson, who in her late thirties had labored for a decade and a half placing paintings in exhibitions but without gallery representation, found that bright abstract works in her style and bearing her signature were being made in a Chinese copy shop (marked as copies) and distributed in several countries as originals. Her obscurity enticed opportunists to sell paintings made with brush on canvas and signed on the front, whereas Wilkinson's originals were done with palette knife on board and signed only on the back. Some pieces were marketed door-to-door by women impersonating the artist.[200] Hundreds of buyers were duped, and thousands of fakes were on the market. The culprits had not chosen this artist because her works had an established place in the standard sales model. They plucked her from nowhere and created her value, contrary to standard practice for art fraud.

CELEBRITY FORGERS

The second half of the twentieth century onward saw the appearance of an abundance of forgers. The most notable among them have been the subject of not only many news articles but also interviews, television and film documentaries, book-length portrayals in memoirs and biographies, special exhibitions, and promotional campaigns through their own websites. Like Van Meegeren and Malskat before them, these forgers have reached celebrity status. Each has drawn attention for one or a combination of factors including the importance of the artists they faked, the volume of their output, the monetary value they accounted for, their artistic skill and ingenious methods, and the effect of their fraud on the historical record. Oil paintings and works on paper are their most popular mediums. The focus for some of these forgers is pre-twentieth century, but many have concentrated on the latter nineteenth and twentieth centuries. As Impressionism, Post-Impressionism, and subsequent movements came into vogue among museums and private collectors, and their commercial value increased, they became natural targets for forgery. Modern and contemporary works also carry the advantage for forgers of requiring materials that are less difficult to obtain or fabricate than those for faking earlier artists, although failing to be careful in this regard has sometimes been their undoing.

One of the most celebrated forgers is **Elmyr de Hory**, whose story is told in his biography *Fake: The Story of Elmyr de Hory, the Greatest Art Forger of Our Time*; his personal assistant's book, *The Forger's Apprentice: Life with the World's Most Notorious Artist*; and two documentary films.[201] During three decades after World War II, De Hory produced an estimated one thousand fake drawings and paintings[202] imitating Monet, Van Gogh, Picasso, Dufy, Bonnard, Vlaminck, Van Dongen, Matisse, Chagall, and others.[203] For the first half of his career he was his own salesman, using many aliases as he lived and traveled in Europe, the United States, Canada, Brazil, and Australia, always eluding authorities. Later, he sold through the agent team of Fernand Legros and Réal Lessard, who employed a sophisticated scheme of bribing experts for authentication and well-known collectors for fake bills of sale. They acquired engraving stamps that would duplicate the impressions of experts who could not be bribed, and a set of French and Swiss customs stamps that allowed for international transport of what appeared to be high-value works under export restriction (indicating authenticity). Still another trick was to locate out-of-print art books that held detachable reproductions and replace them with reproductions of De Hory's fakes.

De Hory was never prosecuted for art fraud (although he was incarcerated briefly for other offenses), and he spent his last years living on the Spanish island of Ibiza while painting under the signature "Elmyr." His death in 1976

was a suicide when he feared that Spain would extradite him to France to stand trial.[204] His fame drew attention from other forgers, and several hundred works appeared on the art market bearing the false signature "Elmyr," creating a phenomenon of faking the fakes.[205] Legros and Lessard served prison time for art fraud, and each published a book claiming his own version of events in contradiction to De Hory's account: Lessard declared himself to be the painting forger (with De Hory doing the signatures), and Legros presented De Hory as an art critic.[206]

During the 1960s, **David Stein** experienced meteoric success at forging drawings, watercolors, and pastels of Matisse, Picasso, Chagall, Van Dongen, Derain, Dufy, Braque, Laurencin, and Cocteau. His wife, Anne-Marie Stein's, book, *Three Picassos Before Breakfast*, calculates his output as "thousands of forgeries" over a four-year period beginning in 1964.[207] She describes him as working so rapidly as to complete a Picasso drawing in fifteen minutes, forty Cocteau drawings in one evening, and a Chagall watercolor in forty-five minutes.[208] He avoided painting in oil because of the longer drying time as well as the smaller clientele for sales and greater attention those works would attract from experts.[209]

A native of France, Stein moved to New York and established a gallery where he mixed his forgeries with legitimate artworks. He was caught when three of his Chagalls were labeled false by Chagall himself, pleaded guilty and served eighteen months of a three-year prison sentence, and then was extradited to France, where he served a sentence of two years and was released in 1972.[210] Capitalizing on the media attention he received, Stein painted successfully under his own name and had a role in a Hollywood movie about an art forger where he was also a technical advisor and provided a number of artworks. He is said to have continued forging by making fake collages of *Superman* signed "Andy Warhol 1960," which were discovered in New York and France.[211]

Another forger who targeted Post-Impressionist masters is **Geert Jan Jansen**, a gallery owner in the Netherlands who turned to fraud by signing Karel Appel posters and selling them as original lithographs, then moved on to making paintings and works on paper. A 1981 brush with the law turned up a cache of Appel lithographs, but no charges were brought. When the art market was saturated with Appel prints in 1998, and Jansen was again suspected, he moved to France and continued his operation using several aliases to sell regularly through the Drouot auction house in Paris. A few years later, sixteen hundred works were seized from his residence, including forgeries of Dufy, Picasso, Miró, Matisse, Cocteau, and several Dutch artists, including Appel, along with a few originals.[212]

The legal case against him withered away when victims who purchased the forgeries were reluctant to press charges. The confiscated works were

designated to be destroyed, but Jansen's attorney argued successfully against it because experts were uncertain as to which works were originals mixed in among the forgeries.[213] Jansen was sentenced to one year in prison with four years' suspended sentence and exile from France for three years.[214] Today, he lives in an elegantly restored thirteenth-century Dutch castle that also houses his studio and exhibition space. His website sells his autobiography, *Magenta: Adventures of a Master Forger* (printed in Dutch)[215] and presents a list of his interviews along with recent and upcoming exhibitions of his works, some of which are simulations of well-known artists while others are done in his own abstract style.[216]

In France, **Guy Ribes** forged paintings of modern masters for three decades until his arrest in 2005. He targeted Renoir, Picasso, Braque, Dalí, Modigliani, Bonnard, Matisse, and Chagall, and has claimed that forty of his fakes are pictured as originals in three authoritative books on Dufy, and ten are included in the catalogue raisonné of Tsuguharu Foujita. Expert opinion estimates there are one to two thousand Ribes forgeries in circulation.[217]

Ribes's life and career are presented in his autobiography, *Self-Portrait of a Forger* (printed in French), and a film documentary, *A Genuine Forger: Portrait of an Art Forger* (in French with English subtitles).[218] There he speaks of his painting techniques, fraudulent art dealers, and millions of dollars of lavish spending, and claims that a number of dealers and police were aware of his identity as a forger. At his trial in 2010, he admitted to his activities, including the three hundred fakes submitted in evidence by the prosecutor. His sentence was three years in prison. He was released after one year, and hired on the set of the French film *Renoir*, where he created seventy-three artworks for the production, instructed the actor portraying Renoir on the proper posture with a brush, and in close-up scenes did the brushwork himself.[219] He has brazenly suggested he will continue with forgery, telling an interviewer that if a new fake is uncovered he will attribute it to being made prior to his conviction: "Yes, I made that. That's a fake, yes. They just sold that one? That's not me. Because the trial had limits, I could bring out 50 new fakes. I made them ten years ago, but I was sentenced for that."[220]

American forger **Tony Tetro**'s career lasted for two decades beginning in the early 1970s. Self-taught in art as a copyist, he found inspiration in reading Elmyr de Hory's biography[221] and went on to fake oil paintings, watercolors, drawings, and lithographs, particularly Chagall, Dalí, Picasso, Miró, and Rockwell. When a gallery owner he had done business with was arrested for selling fakes in 1989, he named Tetro as the forger and provided evidence and court testimony in return for a sentence of probation. Tetro's trial stretched over four and a half years, costing $500,000 and forcing the sale of his possessions. It ended in a hung jury due to his persistence in maintaining that he

was a legitimate copyist who sold his works without fraudulent intent. Rather than undergo a second trial, he pleaded "no contest" and served nine months in a work-release program teaching art to high school students and making paintings for a traffic safety program.[222]

Today, Tetro speaks openly to interviewers about the illegal activities in his past, no longer maintaining his claim to innocence.[223] His website bills him as "The World's Greatest Art Forger," and includes details about how he forged Dalí along with a listing of interviews, articles, and images of paintings he has done as commissions.[224] After a period of years to promote himself as a legitimate copyist, he became successful selling replicas and stylistic "emulations" (often large-scale) of masters from the Renaissance through the twentieth century (see Figure 1.6) to private collectors and museums. In 2019 Tetro identified publicly three works he painted on commission as emulations in the styles of Monet, Dalí, and Picasso for a collector who claimed them to be originals valued at $136 million and loaned them to Prince Charles of England for display.[225]

Figure 1.6. Tony Tetro with his rendition of Rubens's *Peace and War*, oil painting, 213 × 396 cm. Courtesy of Tony Tetro

From 1986 to 1994, the team of **John Myatt** and **John Drewe** in England created and sold about 250 fake paintings bearing the signatures of Chagall, Matisse, Dubuffet, Le Corbusier, Giacometti, and other modern masters.[226] Myatt was the painter, while Drewe forged the provenance and arranged to sell the works to collectors and galleries and through Sotheby's

and Christie's auction houses at prices ranging from the tens of thousands to the low hundreds of thousands of dollars. In a hurry to turn out completed works to market, Myatt avoided the drying time of oil paint and instead used common house paint, with lubricant jelly added to make it more pliant and a finishing coat of varnish for sheen. Many of the paintings also lacked the technical quality expected of the masters they imitated, but with the impeccable documentation created by Drewe, they passed through the authentication process, without careful physical inspection, as inferior works by famous names. Posing as a physicist and wealthy art collector, he donated money and fake paintings to the Tate and Victoria and Albert Museums, and gained access to their archives. Over a period of years, he removed briefcases full of materials he used as models and for information to create false documentation for Myatt's paintings: certificates of authenticity, bills of sale, personal letters, and catalogs he took apart and reassembled with replacement pages showing Myatt's forgeries as originals. He then returned the original documents along with newly created fakes.

The scheme unraveled when several of Myatt's paintings were examined closely enough to question their authenticity on qualitative and technical grounds, and Drewe made small mistakes on the accompanying documents. At their trial, nine fraudulent works were presented in evidence from the eighty that had been recovered from various collectors, auction houses, and dealers. Police estimated that Drewe had earned $2 million from the partnership and Myatt less than $200,000,[227] but the greater significance of their activity lies in the extensive corruption to the art-historical record. Myatt admitted his guilt and professed repentance for his crimes, and served four months of a one-year prison sentence. Then he capitalized on his fame through two television series in which he demonstrated how to paint in the styles of great artists, and through exhibitions and gallery representation selling his works for prices in the tens of thousands of dollars.[228] Drewe declared his innocence and wove a bizarre tale of government-sponsored arms trafficking funded through the sale of fake artworks. He served four years of his six-year prison sentence.[229] In 2012, he was sentenced to eight years in prison for defrauding an elderly woman of her savings of $1 million.[230]

Two of the highest monetary-value forgery operations in history played out simultaneously during the 1990s and early 2000s, focused on abstract paintings. **Wolfgang Beltracchi**, first in Germany and later in France, forged stylistic imitations of Van Dongen, Léger, Braque, Campendonk, Molzahn, and other notable Cubists and Expressionists that his wife, Helene Beltracchi, and two associates sold to dealers and through Sotheby's, Christie's, and other auction houses. In New York, Pei-Shen Qian simulated paintings by Pollock, Rothko, De Kooning, and other Abstract Expressionists. He was employed

by a three-person team that sold his paintings primarily through the Knoedler Gallery.

Beltracchi's paintings were claimed to have come from an art collection inherited from his wife's grandfather that lacked documentation because it was purchased from a Jew who fled Germany under the Nazis and was forced to sell.[231] After nearly being caught in 1995 for three suspicious pieces that were beyond the law's statute of limitations, in 2010 the group was arrested when a forensic analysis of a Beltracchi painting revealed an anachronistic paint pigment. At trial in 2011, fourteen criminal counts were submitted for forged works valued at more than $40 million and which the accused had sold for $21 million. Authorities later reported that fifty-three forgeries had been discovered that were attributable to Beltracchi, with twenty more likely to be designated as his.[232] Beltracchi himself has estimated that over the course of his career, he created "hundreds" of forgeries by fifty artists.[233]

The trial ended with a plea agreement when prosecutors became concerned about potential complications in proving their case. Wolfgang and Helene Beltracchi received terms of six years and four years of incarceration, to be served in "open prison" with confinement at night and release during the day for employment. One of the confederates was sentenced to five years, and the other to twenty-one months' suspension.[234] The Beltracchis commenced work on a documentary film and two autobiographical books, and Wolfgang began painting under his own name.[235] He was released from prison in 2015 and Helene in 2013, facing more than $20 million in lawsuits by parties they swindled.[236] Beltracchi's legitimate paintings have sold in various gallery exhibitions and through his website at prices in the tens of thousands of dollars.

As the Beltracchis were netting tens of millions of dollars in Europe, **Pei-Shen Qian**'s forgeries in New York sold for a total of $80 million. Qian was a successful artist in China who emigrated to the United States, and in the early 1990s, was recruited by José Carlos Bergantiños Diaz to create stylistic imitations of Abstract Expressionists including Rothko, Pollock, and Motherwell, among others. His partner, Glafira Rosales, presented them to the Knoedler Gallery, which paid over $20 million for approximately forty works between 1994 and 2009, and sold them for a profit of more than $40 million. Twenty-three more paintings went to Julian Weissman Fine Art for $12.5 million and were sold for $17 million. Rosales claimed provenance for most of the paintings to be a Swiss client who wished to remain anonymous, and the rest from a Spanish collector.[237]

Rumblings about the questionable authenticity of some of the works prompted scientific examination that revealed paint pigments that were not in existence during the artists' lifetimes, along with evidence of the removal of old paint from canvases before the fake works were painted on them. The

signatures on some works were questioned, and one was spelled "Pollok" rather than "Pollock."[238] Rosales pleaded guilty in 2013 to charges of fraud, money laundering, and tax evasion. She was sentenced in 2017 to jail time already served (three months) and nine months of home detention, along with financial restitution of $81 million. The judge's decision for the unusually brief incarceration was due to intimidation and abuse Rosales had been subjected to by Bergantiños Diaz. The prosecutor did not object, saying the defendant had provided "instrumental" evidence in the case.[239]

In 2014 charges were brought against Qian, Bergantiños Diaz, and his brother Jesus Angel Bergantiños Diaz, who was named as a co-conspirator. Qian left the United States for China, with which there is no extradition treaty. In interviews he claimed his paintings were made as legitimate copies and that he was paid no more than $8,000 for each.[240] In 2014, the Bergantiños Diaz brothers were arrested in Spain, where they hold citizenship, and avoided extradition to the United States. In a 2020 interview in Spain, José Bergantiños Diaz declared that Rosales was "the ambitious one" who masterminded the scheme and that he had not mistreated her.[241] The Knoedler and Julian Weissman Galleries were not indicted in the conspiracy, but both, along with Knoedler's director, faced lawsuits from defrauded collectors (see Figure 1.7). Knoedler closed in 2011 under the weight of scandal and financial ruin.[242]

Figure 1.7. Trial testimony against the Knoedler Gallery, 2016. Courtroom sketch. The Mark Rothko fake pictured here was sold by Knoedler for $8.3 million. Courtesy of Elizabeth Williams

Among the most notable forgers of recent decades are several whose range was broad and can be described as eclectic, spanning various time periods, movements, and, in some cases, mediums stretching from works on paper to sculpture. Each of these forgers was active for a number of years before being exposed. Over three decades beginning in the 1950s, British art restorer **Tom Keating** made at least two thousand fake paintings and drawings in the names of more than one hundred artists, from the seventeenth through the twentieth centuries, who are listed in an appendix to his book *The Fake's Progress* (authored with the journalist who exposed him). His most frequent targets include Samuel Palmer, Cornelius Krieghoff, Degas, Renoir, Sisley, Rembrandt, Turner, Goya, Modigliani, and Expressionists such as Feininger, Nolde, and Munch.[243]

For a period of ten years, Keating partnered with Jane Kelly, who created a provenance for his numerous Palmer fakes as coming from her family collection, which was recently returned to England from Ceylon. After Keating admitted his forgery activities to the press in 1976 and his book appeared the following year, he and Kelly were charged in 1979 with fraud for false Palmer paintings totaling $30,000, with Kelly pleading guilty and agreeing to testify against her accomplice. She received an eighteen-month suspended sentence. His charges were dropped because of his serious physical condition.[244] He recovered and hosted a popular television series in which he demonstrated how to mimic the styles of famous artists.[245] Keating also was notorious for the unusual practices that he included in creating his fakes. Although typically careful to use appropriate materials and apply artificial aging, he often placed "time bombs" under the surface of paintings that would reveal their falsity in the future. In some cases an underlayer of glycerin was applied so that the paint would disintegrate during the process of cleaning. In other cases he wrote a message in white lead paint—a swear word or an expression such as "This is a fake"—that could be discovered by X-ray.[246] Since his death, paintings known to have been done by Keating have acquired market value extending into the tens of thousands of dollars.

Keating's successor as a celebrity forger in Britain was **Eric Hebborn**. Known for making one thousand fake Old Master drawings (van Dyck, Poussin, Tiepolo, Rubens, Piranesi, Boucher, and others), he also faked oil paintings and sculptures. His memoir, *Drawn to Trouble: Confessions of Master Forger*, describes incidents from his career as a forger interwoven with a philosophy aimed at justifying it. A second book, *The Art Forger's Handbook*, provides details about how to work as a forger in several mediums.[247] In other projects, he translated and illustrated poetry by Michelangelo, Giuseppi Belli, and Federico García Lorca, and occasionally exhibited artworks done in his own name.

Hebborn made his living as an art dealer, although he looked disdainfully on dealers in general for accepting works of questionable authenticity and for taking advantage of forgers by paying them small sums for fakes that produced large profits. In 1964, he moved permanently to Rome and opened a gallery where he mixed his fakes with legitimate works. For a decade and a half beginning in 1963, he created his first five hundred Old Master drawings, selling many of them in London through Sotheby's and Christie's along with the Colnaghi gallery. In 1978, Colnaghi made a public statement that they had unknowingly sold a number of forged drawings, all from one source. Hebborn was not named, but his identity became known among insiders in the trade. At that point he vowed to do five hundred more drawings of even better quality than the previous ones and later claimed to have accomplished his goal.[248] Hebborn was never arrested, although during the 1980s he spoke publicly about his deeds as a forger. His death in 1996 at age sixty-one came from a blow to his skull on a street in Rome, with conflicting stories citing a fall during a state of drunkenness and murder at the hands of the Mafia.[249]

Another forger who evaded arrest during a decades-long career was **Ken Perenyi**, an American who as a teenager was inspired by reading a book about Van Meegeren.[250] He learned about old paintings by working for a painting restorer, began faking unsigned sixteenth-century Dutch paintings, and then opened his own art restoration business and expanded his range of fakes to nineteenth-century American artists such as John Peto, William Aiken Walker, Charles Bird King, Martin Johnson Heade, James Buttersworth, and Antonio Jacobsen. When the FBI began tracing Perenyi, he operated for two years in England, where he faked eighteenth- and nineteenth-century British sporting art (John Herring Sr., James Seymour) and marine scenes (Charles Brooking, Thomas Buttersworth). After returning to the United States, he continued selling through auctions in New York and London, mostly works in the tens of thousands of dollars, although one Heade painting netted more than $700,000. By the 1990s, the FBI was on his trail for several Buttersworth forgeries, and he turned to selling his works as reproductions.

With his forgery career over and hundreds of fakes in circulation,[251] Perenyi waited until the statute of limitations for prosecution had passed before writing his memoir, *Caveat Emptor: The Secret Life of an American Art Forger*. There, he speculates on why he remained free from legal action. Proof was lacking that he had sold his fakes as originals because he was careful to leave attribution up to dealers and auction houses rather than assert it himself. And the number of fakes he produced would have been embarrassing to the people who sold them, leaving them hesitant to support a case against him.[252]

The most versatile of forgers for the range of mediums he attempted, as well as genres and styles, is **Shaun Greenhalgh**. From the 1970s until the

early 2000s, he created oil paintings (from Rembrandt to Impressionism to Remington), eighteenth- and nineteenth-century watercolors, fresco frag-ments, drawings (Old Master, possibly hundreds in pastel of L. S. Lowry), ceramics (Pre-Columbian, Ming dynasty, Gauguin), sculptures in stone, terra-cotta, bronze, and ivory (ancient Roman, Mayan, African, a Buddha head, portraits of Thomas Jefferson and John Adams), Lalique glass, gold and other metal works (Bronze Age, Japanese, Islamic, ancient Roman silver plates, Gothic crucifixes), and nineteenth-century majolica.[253] He sold many of his forgeries for small amounts of money, although a few fetched large prices, including more than $700,000 for the Amarna Princess (see Figure 1.8), an ancient Egyptian sculpture. In the postscript to his book, *A Forger's Tale: Con-fessions of the Bolton Forger*, he claims to be the creator of the much-discussed portrait *La Bella Principessa*, attributed by some experts to Leonardo da Vinci and with a potential value as an original of $200 million.[254]

Early in his career, Greenhalgh sold often to an antique dealer and later worked with his parents, dubbed the "Artful Codgers" by the press. His mother made phone contacts, and his father (presenting a sympathetic figure of an elderly man in a wheelchair) met with potential buyers to sell artworks claimed to be from an inherited collection. The scheme unraveled in 2005 when Bonhams auction house examined three ancient alabaster relief tablets and found an oddly rendered horse's harness along with a misspelled cunei-form inscription.[255] Scotland Yard confiscated many artworks from the family's home and the crude garden shed that functioned as the forger's studio, finding that despite the $1 million to $3 million the operation is said to have earned, they lived together in public housing without a computer and maintained a frugal lifestyle.[256] Court proceedings revealed 120 fakes known to have been placed on the market. With his mother and father given suspended sentences, Greenhalgh was sentenced in 2007 to four years and eight months in prison, and since his release in 2010, he has sold his works as reproductions.[257]

Perhaps the most unusual among the high-profile forgers of recent de-cades is **Mark Landis**, who from the mid-1980s until 2010 donated his fake artworks to fifty museums throughout the United States (mostly local and regional institutions including universities). He used several aliases, sometimes showing up in person dressed as a Jesuit priest, and talked of family wealth that included an art collection. The FBI investigated Landis but determined that since he never sold his forgeries and never claimed their donation for a tax advantage, his activities were not subject to prosecution. The artists he faked span the range of Impressionism, American Western art, Ashcan School, Surrealism, Expressionism, Fauvism, Rococo, and cartoon art: Mary Cassatt, Charles Courtney Curran, Maynard Dixon, René Magritte, Everett Shinn, Louis Valtat, Antoine Watteau, Charles M. Schulz, and others.

Figure 1.8. Amarna Princess by Shaun Greenhalgh, style of Egyptian Amarna period, c. 1350 BC, alabaster, 51 cm high. Courtesy of the Bolton Museum

Landis's income is from an inheritance. He suffers from mental illness (diagnosed schizophrenia) and says that due to attention deficit disorder he prefers to complete an artwork within an hour.[258] Although some works are done freehand, many consist of photographic images or tracings that are simply painted over or drawn over. They would not fool experts under close examination, but as gifts they faced less scrutiny than if they were offered for purchase. In 2008, the Oklahoma City Museum of Art noticed that two works donated by Landis were identical to those at other institutions, and when his modus operandi was uncovered, other museums were alerted. His story made headlines, and in 2012 the University of Cincinnati held a one-man show of Landis's forgeries, many of them provided by the forger himself, who also loaned his priest's outfit and appeared in person at the opening.[259] A documentary film about him, *Art and Craft*, was released in 2014.[260] Landis today makes commissioned pieces from photographs, with a portion of the proceeds donated to mental health awareness.[261]

FROM THE LESS NOTORIOUS TO THE VIRTUALLY UNKNOWN

The "celebrity" forgers discussed here give a public face to the production of fraudulent art. However, there are many other forgers whose activity, taken collectively, extends much further. In addition to those whose output has been predominantly in paintings and drawings, some have worked in other mediums. The impact of the fraud from these figures is considerable. Their notoriety is less, however, because the level of attention they have received has been limited by media judgments about how compelling their stories are, or because they have chosen to avoid the limelight rather than seek fame and fortune by publicizing their exploits.

During the 1970s and 1980s, German artist **Edgar Mrugalla** forged three thousand paintings and prints by fifty artists ranging from Rembrandt to Renoir, Klimt, and Nolde. When the market was flooded in 1987 with fakes of his favorite target, Picasso, he was arrested and sentenced to two years' probation in exchange for his cooperation in locating his forgeries and identifying the works of other forgers. Mrugalla claimed to have earned only a small amount of money from his large output, while dealers made enormous profits. He wrote a memoir, *King of the Art Forgers* (in German),[262] and was interviewed occasionally by the German press. He continued to paint, selling under his own name but with limited success, saying in 2008, "When the Ministry of Economics in Kiel exhibited my pictures, there were protests from all sides. I am considered a worthless artist."[263] It has been estimated that two thousand Mrugalla fakes are undiscovered.[264]

In Australia from the 1960s to the 1990s, **William Blundell** produced, by his own estimation, thirty-five hundred to four thousand paintings and drawings that simulated the styles of twentieth-century Australian artists including Brett Whiteley, Arthur Streeton, William Dobell, and others. He sold hundreds of fakes to dealer Germaine Curvers, which she sold from her gallery and through auctions as originals. When Curvers died in 1997 and her will was challenged, Blundell admitted to painting two hundred suspect works held in the estate but said they were "innuendos" and that Curvers was well aware they were not originals.[265] Records from Curvers's files showed that over a ten-year period she paid Blundell a total of $40,000 for numerous paintings at prices of $100 to $200 each, which she marketed for figures in the thousands to tens of thousands of dollars.[266]

Another sector of Modernism targeted for forgery is the Bombay Progressive Artists Group. For five years beginning in 2009, British forger **William Mumford** created paintings in the style of Sayed Haider Raza, Francis Newton Souza, and Maqbool Fida Husain (sometimes called "the Picasso of India") along with works by other artists. The fakes were distributed by Mumford's wife and four more intermediaries, mostly through auctions, for prices of a few thousand dollars each. The ring was exposed when Bonhams alerted Scotland Yard, and a raid of Mumford's garage uncovered hundreds of paintings along with materials for creating documents of false provenance. Mumford admitted to producing as many as one thousand fake paintings, sales from just some of which would have totaled hundreds of thousands of dollars. He was sentenced to two years' imprisonment for fraud and money laundering, his wife to one year, and the other co-conspirators to terms ranging from one year to twenty-one months. It has been estimated that hundreds of Mumford's forgeries were sold as originals.[267]

American forger **William Toye** is known to have produced Impressionist and Post-Impressionist fakes, but he specialized in the works of twentieth-century folk artist Clementine Hunter, known as the "black Grandma Moses." His wife, Beryl, provided false provenance by claiming she bought many original paintings from Hunter in the 1960s and 1970s.[268] Toye was arrested in 1974 when twenty-two Hunter paintings in his possession were confiscated, twenty-one of which proved to be fakes, but he was not prosecuted. In 1997, the Toyes consigned a fake Matisse painting to an auction in Louisiana that was halted when it was found that 125 entries from other sources also were likely to be forgeries. In 2009, they were indicted along with art dealer Robert Lucky, who was said to have sold hundreds of fakes he obtained from them. The Toyes were sentenced in 2011 to two years of probation and $425,000 restitution when they agreed to cooperate in the investigation of Lucky, who was sentenced in 2012 to twenty-five months in prison and $325,000 restitution.[269]

Christian Goller was a talented painting restorer and copyist working in the styles of Old Masters. He has also been labeled as one of the world's most important forgers. The stylistic copies he created were noticed in the mid-1970s in Germany by expert authenticator Hubertus von Sonnenburg, who recognized similarities of technique in paintings accepted as originals by Dürer, Lucas Cranach, Matthias Grünewald, Hans Holbein, and others. When Von Sonnenburg went to the press, Goller identified himself as the painter but said he sold the works as imitations and had no control over their resale. When a Grünewald painting the Cleveland Museum of Art had purchased for $1 million was found to be a fake, Goller declared it as his work.[270] In a 1985 interview with *Art and Antiques*, he held to his assertion that he was merely a copyist with outstanding skills, and said so again in a 1991 television documentary about his technique, which described his meticulous creation of false craquelure, the use of old pigments and old canvases, and the transfer of layers of paint using intermediate layers of gauze in a way capable of fooling X-ray detection.[271] In 2014, Goller was investigated by German authorities for the sale of fifty-five Cranach fakes along with paintings by other artists.[272] That action was suspended in 2017 due to Goller's ill health,[273] and he died in the same year.

Renato Peretti's name has been raised periodically in connection with forgeries of paintings by Giorgio de Chirico, particularly his "metaphysical" works. In the late 1970s, Peretti was arrested in Italy for selling fraudulent art, and although he died before his trial concluded, he produced a list of works appearing in De Chirico's catalogue raisonné that he claimed to be fakes made by himself, including sixty he was certain of and fifty-seven more he suspected.[274] The De Chirico Foundation, responsible for the catalogue, has described Peretti as a "mythomaniac" who made unfounded grand claims, but still admitted that there are fakes among the many works in the catalogue and that Peretti was a longtime forger. An opposing organization, the Archive of Metaphysical Art, has taken a skeptical position, noting that many works in the catalogue were examined only by photograph and that De Chirico himself questioned the accuracy of the catalogue. Observers of the controversy have pointed out that the foundation owns three hundred works by De Chirico (suggesting self-interested partiality) and that the president of the archive was convicted of selling De Chirico forgeries.[275]

Another case of expert opinion entangled with concern about forgery involves **Christian Parisot**, president of the Modigliani Institute in Rome. He has authored several books on Modigliani's life and works as well as a catalogue raisonné, and he holds the French *droit moral* (moral right bestowed by law) for authentication. In 2010, he was convicted in Paris for exhibiting seventy-seven forged drawings he claimed to have been made by Jeanne

Hébuterne, Modigliani's mistress, and given a two-year prison sentence (suspended) as well as a $70,000 fine.[276] Also in 2010, the investigation of an exhibition of Modigliani's works that Parisot organized in Italy found twenty-two forgeries that carried certificates of authenticity and a total value of $8.7 million.[277] He was convicted in 2012 and reportedly served a sentence of house arrest that ended in 2016.[278] Parisot's catalogue raisonné is one of six competing volumes by dueling experts, each of which has been criticized for what has been included or left out.[279]

In the medium of bronze sculpture, **Guy Hain** has been a major source of forgeries. Using his own foundry as well as others in France in the 1980s, he produced fakes of many artists such as Antoine-Louis Barye, Jean-Baptiste Carpeaux, and Aristide Maillol by creating aftercasts using silicon molds taken from existing works. Most notably, he secured permission from the Rudier family to use original Rodin molds for recasts, and then substituted the name of Alexis Rudier, Rodin's official caster during the artist's lifetime, for that of Georges Rudier, who made later editions. He flooded the market with several thousand sculptures that earned him $18 million and led to his arrest in 1992. In 1997, he was sentenced to four years in prison, and served eighteen months.[280] After his release he continued with forgery and was arrested for a second time in 2002. His trial involved eleven hundred sculptures of ninety-eight French artists that were seized or cited. He again received a four-year sentence. An investigator who followed Hain's career closely estimated that he produced six thousand sculptures beyond those taken into possession by authorities.[281]

Another major forger of sculptures is **Robert Driessen**, whose early career was spent making one thousand fake paintings of Hague School artists and noted Expressionists. In the 1980s, he turned to casting bronzes, using latex molds he had purchased, to produce the works of Degas, Rodin, Matisse, and others. In 1998, he began making Giacometti bronzes in images of his own design, partnering with dealer Herbert Schulte and front man Lothar Senke, aka the Count of Waldstein, in Germany for sales of more than $10 million.[282] The false provenance included a limited-edition book bearing Waldstein's name and claiming that Diego Giacometti had secretly produced casts of his brother's models. After moving to Thailand (where he was free from extradition) in 2005, Driessen continued producing Giacometti forgeries, and he has estimated his total output for ten years at thirteen hundred (a figure similar to police estimates). Senke and Schulte were arrested in 2009 for selling fraudulent art and received prison sentences of nine years and seven years, four months, respectively, along with heavy fines. In 2012, more than one thousand of Driessen's Giacometti fakes had been located and destroyed.[283] In 2014, he traveled to Europe, was caught, tried in Germany in 2015, and

sentenced to five years and three months in prison. Since his release in 2017, he has made sculptures, drawings, and paintings under his own name.[284]

During a four-decade career as a forger in France, **Eric Piedoie** served prison sentences of ten months in 1985 for producing fakes of Chagall and Miró, and eighteen months in 1991 for fakes of Henri Michaux. He then turned to works by César (Baldaccini) and was warned by the artist to cease his counterfeiting activity. After César's death in 1998, Piedoie flooded the market with César sculptures and drawings for two years, claiming later that in producing two thousand works he equaled the artist's own output. Estimates for the value of those works run to about $20 million.[285] In 2001, an investigation began, ending in a conviction in 2009 and carrying a four-year prison sentence for the forger, with three accomplices sentenced to three years, one year, and one year suspended.[286] Today, Piedoie is an art dealer, and in 2019, he released his memoir, *Confessions of a Forger: The Hidden Face of the Art Market* (in French).[287]

Mexican ceramicist **Brigido Lara** produced thousands of individually fashioned clay figures that simulated Pre-Columbian styles, including Mayan, Aztec, and his specialty, Totonac. His works were sold as originals to tourists and collectors, with many reaching major art museums, among them the Saint Louis Art Museum, the Dallas Museum of Art, and New York's Metropolitan Museum of Art, as well as important collections in various European countries. Lara used wooden tools like those from centuries earlier and an assortment of clays taken from the locations where he claimed his fakes were discovered. After two decades at his craft, he was arrested in 1974 for trafficking in Pre-Columbian artifacts, and served seven months of a ten-year sentence before being allowed to prove by demonstration that he was an artist working as a copyist and not a smuggler. He was released and hired by the Xalapa Museum of Anthropology as a restorer and authenticator. Today, he works as a consultant as well as an artist making figures designated as copies.[288]

In the realm of fake prints, the **Amiel family** was responsible for placing an unspecified number on the market that reaches into the hundreds of thousands. In the 1970s, New York art publisher Leon Amiel, who knew Dalí, Picasso, and Miró personally, among other prominent artists, and produced prints legitimately for them, began mass-producing copies of their original lithographs. The reproductions, made on machinery capable of turning out thousands per hour, were sold to dealers who knew they were buying fakes.[289] When Amiel died in 1988, his wife, Hilda, daughters Kathryn and Joanne, and granddaughter Sarina carried on the business until 1991, when federal agents arrested them and seized more than eighty thousand prints, mostly of Dalí and Miró but also including Picasso and Chagall. Hilda Amiel died before their

trial in 1993, which resulted in prison sentences of seventy-eight months for Kathryn, forty-six months for Joanne, and thirty-three months for Sarina.

The Amiels' conviction was a key piece in the US government's Operation Bogart (for "bogus art") that began in 1984 and eventually involved a number of dealers and auctioneers in several US cities with direct or indirect ties to the Amiels. Authorities estimated that in its entirety, the operation represented more than $500 million in sales of forgeries.[290] One hundred thousand false artworks that were seized were destroyed (see Figure 1.9).[291] In a related case nearly two decades later, Leon Amiel Jr. (Leon Sr.'s grandson) was arrested for selling prints from a supply of the family's forgeries that had been overlooked by Bogart investigators. The sentencing judge in 2010 issued a two-year prison term, noting that Leon Jr. was "raised by criminals."[292]

Figure 1.9. Postal Inspector Jack Ellis with prints from Operation Bogart. Courtesy of United States Postal Inspection Service

The printing process used by the Amiels was surpassed in technical quality with the invention of the giclée in the 1990s, in which a digital file controls a fine-spray inkjet application to paper or canvas.[293] **Kristine Eubanks**

produced thousands of giclées, which she passed off as original works by rec-
ognized artists such as Picasso, Dalí, and Chagall, mixing them with other fake
prints and works in other mediums she purchased from suppliers, all of which
were sold in television auctions she organized from 2002 through 2006 and on
Princess Cruise ships.[294] Eubanks's husband, Gerald Sullivan, and auctioneer
James Mobley were involved in the scheme, which also included false cer-
tificates of authenticity created by Eubanks along with shill bidding and fake
ringing telephones on television. When many complaints surfaced about the
authenticity of the artworks sold, the three co-conspirators were arrested and
pleaded guilty. Sullivan was sentenced to four years in prison, and Mobley to
five years. Eubanks, who at the time of her arrest was on probation for credit
card fraud, received seven years. Total fraudulent income was estimated at $20
million taken from ten thousand buyers.[295]

Although lithographs and etchings are the types of prints most likely to
be targeted by forgers, other types are subject to falsity as well. It has been
reported that since 1998 as many as sixty thousand woodblock prints made
by **Earl Marshawn Washington** have been sold in galleries and auctions for
prices between $20 and several hundred dollars. The works are of high qual-
ity, with many depicting scenes from the lives of African Americans ranging
from the Bible to lynchings to erotica. They are sold as the creations of Earl
Mack Washington, the seller's great-grandfather and master wood engraver
and printer, giving them historical appeal. There is no evidence of the latter
Washington's existence. Although buyers who learned of the true nature of
their prints have lodged complaints with police in Michigan (where Washing-
ton lives) and with the FBI, he has not been arrested.[296]

The advent of the Internet in the late twentieth century brought major
changes to the buying and selling of art, including a proliferation of online
sales through auctions. Forgers have capitalized on the fact that the art objects
sold in this way are not available for potential buyers to examine directly, and
that implausible claims about provenance and authenticity reach large enough
numbers of interested parties that there may be some who believe them. An
added factor is that shill bidding incognito can be done with the click of an
electronic device. The eBay sales forum has been exploited often, although
its administrators have taken various preventive measures.[297] A significant case
involved **John Re**, who in 2015 was convicted of wire fraud and tax eva-
sion, carrying one prison sentence of five years and another of twenty-seven
to eighty-four months, and with $2 million in restitution.[298] Re was arrested
in New York for an eBay enterprise in which he sold more than sixty fake
Jackson Pollock paintings to four collectors for a total of $1.9 million. In all,
the FBI connected him to 150 false works of Pollock and De Kooning and to
shill bidding during auctions. He claimed the Pollocks came from a trove he

discovered in the house of a widow whose husband acquired them from the artist. Forty-five paintings were examined and declared to be forgeries, based on stylistic features and scientific testing.[299] Re was known to be an artist who painted in an abstract style, but he refused to admit to making the fakes he sold or to reveal another source.

Between 1998 and 2000, the California team of attorney **Ken Walton** and con man **Ken Fetterman**, with Scott Beach as a shill bidder, duped hundreds of art buyers on eBay for a total of $450,000 in eleven hundred auctions employing forty user IDs.[300] Their modus operandi was to buy inexpensive paintings at flea markets and antique shops and present them with attractive descriptions suggesting the works might be by recognized artists. They often forged signatures and bid on their own auction items to drive up prices. Typically, their sales made high-percentage profits on small investments, such as $275 for $60 and $380 for $80, and on rare occasions prices reached the tens of thousands of dollars.[301] When a painting that bidders took to be by Richard Diebenkorn sold for $135,000, the operation drew scrutiny and legal action. Fetterman was sentenced to forty-six months in prison. Walton and Beach avoided prison in return for their cooperation in the investigation of the case. The trio owed restitution that totaled $95,000,[302] and Walton lost his license to practice law. He wrote a book, *Fake: Forgery, Lies, and eBay*, and became a successful software designer and entrepreneur, with a key project that developed a tool used by eBay for transparency in their sales.

Although the Internet provides a forum for forgers to exploit, it can also be their downfall. Information with the potential to identify fakes is available on the web and accessible immediately. In particular, duplicates of existing works are subject to being noticed on a gallery or auction website. New York gallery owner **Eli Sakhai** found that a scheme he worked successfully for nearly twenty years came undone by the art market's practice of posting catalogs and images online. Sakhai attended auctions at Sotheby's and Christie's where he purchased minor paintings by major Impressionist and Post-Impressionist artists and then had exact copies made by immigrant Chinese artists in a shop he set up directly above his business.[303] The certificates of authenticity for the originals were attached to the fakes, and the works were sold in Asia (mostly Japan) for prices ranging from the tens of thousands of dollars to $500,000.[304] After a waiting period of three or four years, the originals were sold at auction in London or New York with verification by specialists who were told the certificates of authenticity had been lost. Eventually, complaints arose about the discovery of duplicate paintings, and when a work by Gauguin was to be sold at Sotheby's (the original) and Christie's (the fake) at the same time, the trail was traced to Sakhai. On pleading guilty he was sentenced to forty-one months in prison and $12.5 million in restitution.[305] Estimates for

the number of false works put onto the market range from two hundred by an FBI expert to "hundreds" by a federal prosecutor.[306]

All of the forgers who have been discussed here have some degree of notoriety. There are others further down the scale of visibility whose stories failed to extend beyond a brief news cycle, or whose coverage was limited to one language, or for some other reason drew little attention. Cases such as the following serve as examples.

- Australia, 2007. Pamela and Ivan Liberto were sentenced to nine months in prison (with two years and three months suspended) for earning more than $300,000 selling paintings they had forged bearing the name of Rover Thomas, a noted Aboriginal artist.[307]

- Germany, 1992. Wolfgang Lämmle was discovered to have forged about two hundred paintings in the late 1980s imitating Egon Schiele and various twentieth-century German artists, with many of the works sold through leading galleries and auction houses. He was given a suspended sentence and required to pay $24,000 in compensation.[308]

- United States, 2016. Larry Ulvi was sentenced to a year in prison for defrauding twelve victims of $65,000 with fake paintings of Northwest School artists (mostly Mark Tobey). One hundred sixty artworks were confiscated from Ulvi's apartment.[309]

- Russia, 2013. Alexander Chernov forged and sold over eight hundred paintings and graphics of Kazimir Malevich and other Russian avant-garde artists to two buyers for $600,000. He was sentenced to four years in prison.[310]

- Czech Republic, 2008. Libor Prášil was given a two-year suspended sentence for creating nearly fifty paintings in the style of Czech artist Jan Zrzavý. He claimed he had been paid small sums for the works without knowing they would be sold as originals. Dealer Jan Trojan, who sold the forgeries as part of a scheme involving 150 works in all imitating several artists, was sentenced in 2009 to seven and a half years in prison.[311]

- Finland, 2018. Members of a forgery ring were fined and sentenced to jail time for the distribution of more than two hundred fake canvases of Matisse, Monet, Kandinsky, Léger, and others valued at €15 million. The forger, Veli Seppä, was given a suspended sentence.[312]

- Switzerland, 2011. Three co-conspirators whose names were not published in the press were convicted of selling 120 fake paintings of artists such as Matisse, Braque, and Giacometti for $450,000. The forger was given a suspended sentence, and the two sellers each received eighteen months in prison.[313]

How many forgers like these exist, and how many forgeries they account for, can be no more than conjecture without an extensive search of journalistic and legal records in many countries. And even if those figures could be tallied through research, the presence of forgery in the art world would not be accounted for fully. There are remaining concerns that suggest it is more expansive yet, perhaps considerably so. How many forgers are there who have been discovered but not arrested, or if arrested not prosecuted, due to the often time-consuming and expensive process of gathering a solid case? Vernon Rapley, former head of the Art and Antiques Squad for New Scotland Yard, has estimated that a case of twenty fake artworks involving a forger and three accomplices will take about eight hundred hours of detective work, without accounting for the efforts of experts and prosecutors.[314] And how many fake works have been created by known forgers beyond the ones they have admitted to or are suspected of? A partial answer to these questions lies with fraudulent art dealers caught selling fakes. There are many such dealers who could be revealed in a search paralleling that of obscure forgers, but they are unlikely to be forthcoming with information unless it secures them favorable treatment in legal proceedings. And beyond all of this potential information is the ultimate question of how many forgers, and how many fakes they have produced, have never been discovered and perhaps never will be.

CONFRONTING ART FORGERY

The extensive presence of fakes in the art world has drawn an increasing level of response during the twentieth and twenty-first centuries. Several trends have emerged, one of which is organization among professional specialists with various forms of expertise to confront forgery. Targeted law enforcement units, information-sharing organizations, comprehensive and online catalogues raisonnés, and permanent authentication boards developed from earlier precedents to greater levels of sophistication. A second trend is for museums and, occasionally, commercial galleries to mount special exhibitions of counterfeit art. These forums offer education on a provocative subject that attracts not only dedicated aficionados but also visitors less inclined to attend art exhibitions. Masses of people have had the opportunity to learn about art forgery by viewing its products firsthand. A third trend embraces new technologies in art authentication. Laboratory science offers a number of possible tests for discovering false artworks that were not previously available in history. This approach is often successful, but it is subject to limitations that prevent it from being a comprehensive answer to counteracting art forgery.

Many countries and a few major cities, as well as Interpol, established specialized law enforcement units during the latter 1900s and 2000s to combat art crimes consisting of theft, illicit trafficking in cultural goods, and fraud.[315] Italy's Carabinieri T.P.C. is often held up as a model. Founded in 1969, it is the oldest and by far the largest of these units, consisting of nearly three hundred officers located in thirteen regional offices. By comparison, the FBI's Art Crime Team, existing since 2004, has twenty special agents.[316] Counterparts at New Scotland Yard and the Netherlands' KLPD were created several decades ago, but like units in other countries, they have faced uncertain budgets and downsizing when law enforcement's tightening finances are devoted to violent crimes.[317] Although typically these specialized forces are small, and forgery is only one of their responsibilities, the training and grouping of specialists represents a step beyond an ad hoc approach in law enforcement's pursuit of forgers.

Besides law enforcement, other organizations have been formed as watchdogs to disseminate information about art crime. The Museum Security Network, online since 1996, allows museum officials to learn about specific incidents and best practices, and is also consulted by attorneys, academics, insurance companies, journalists, auction houses, and police. The Association for Research into Crimes Against Art (ARCA), established in 2007, concentrates on educational programming. It approaches art crime as an interdisciplinary field of study, sponsoring symposia and a postgraduate certificate program as well as publishing a journal. While these organizations, like the targeted law enforcement units, deal with art crime in its several facets, and attention often goes to theft and cultural preservation, the International Foundation for Art Research (IFAR), also multifaceted, places a greater emphasis on forgery-related activities. Founded in 1969, IFAR holds extensive information for provenance research and an online database of legal cases, publishes a journal, and provides an authentication service that has been directly involved in uncovering numerous fakes. Among them are more than one hundred forged Jackson Pollock paintings linked to three important cases, including the Knoedler affair, which involved cooperation with the FBI.[318]

IFAR maintains an online database of catalogues raisonnés with a listing of twenty-five hundred entries. A similar database devoted to prints is held by the Print Council of America. Having developed historically from the business practice of artists and dealers maintaining inventory lists, the catalogues are an asset in authentication, especially as they have come to be illustrated through photography. In the 2010s, some were digitized and put online, making continuous revision possible, while giving immediate access for viewing collections of images that have been verified by experts and that can train the eye in connoisseurship as well as identify newly found works that are duplicates.

A further attempt at organizing expertise for counteracting forgery was the establishment in the late twentieth century of authentication boards for prominent artists commanding especially high prices. Experts from academia, the commercial side of the art world, and artists' families converge (under the banner of a foundation, estate, museum, or research project) to form an on-going panel whose declarations regarding the authenticity of works submitted to it are considered to carry greater weight than the determinations of other parties. Although their purpose is to give stability in the difficult process of deciding which artworks are genuine, the boards are subject to criticism for conflict of interest since many of their sponsoring organizations hold collections of works by the artists they authenticate. Another difficulty has been the finality of the pronouncements issued, such as the Warhol Board's indelible red-ink stamp "DENIED" placed on rejections. Due to the cost of lawsuits against them by dissatisfied authentication seekers, a number of boards disbanded after a decade or two of operation, including Pollock, Warhol, Lichtenstein, Rauschenberg, Rembrandt, Basquiat, Haring, and Noguchi.[319] The Warhol Foundation issued the statement that "We won every single one of those lawsuits, but the process was extraordinarily expensive, costing us at least $10 million defending ourselves. . . . we wanted our money to go to artists and not to lawyers."[320]

While the Museum Security Network, ARCA, IFAR, and catalogues raisonnés are consulted by specialists in the art world, a movement toward mounting special exhibitions of fake art has targeted a broad population of collectors and the general public. This approach diverged from what had been typical policy among museums to remain silent about forgeries so as to avoid embarrassment about their collections and prevent fear about fraud. The new posture was to educate people about forgery. Exhibitions of fakes have been sponsored by public and private museums, universities, law enforcement agencies, and commercial galleries.

Three museums in Europe today are dedicated to the permanent display of art fakes: the Fälschermuseum in Vienna (which includes works by Edgar Mrugalla, Tom Keating, Elmyr de Hory, and other noted art forgers), the Museum Valse Kunst in Vledder, Netherlands (which includes works by Geert Jan Jansen among others), and the Museo d'Arte e Scienza (which features scientific instruments used in determining authenticity) in Milan. All stipulate that their purpose is to educate and warn the public about the presence and danger of fake art.[321] Beyond these permanent displays are numerous temporary exhibitions, with a few precedents in the early 1900s and a proliferation since midcentury and especially the last several decades. The international library catalog *WorldCat* lists more than 150 catalogs of special exhibitions on art forgery, with the likelihood that there were other exhibitions for which catalogs were not available to be recorded or were not produced.

Among notable examples is a 1952 exhibition titled *False or True*, which began in Amsterdam and continued on to Switzerland, Germany, and the United States. Originals and forgeries were displayed side by side to promote the idea that false works are different and inferior and can be spotted. A key display lined up several sculptures by Giovanni Bastianini to demonstrate how they are similar to one another and unlike the works of Renaissance masters he was accused of copying.[322] The *Salon of Fakes* exhibition in Paris in 1954 similarly used prominent names to attract public interest and emphasize the criminality of the forger's enterprise. Eight fake *Mona Lisa* paintings were featured.[323] False Rodin drawings were the subject of an exhibition that began at the National Gallery in Washington, D.C., in 1971 and continued the following year to the Guggenheim Museum in New York. Genuine drawings were intermingled with fakes, and museumgoers were given scorecards to mark T or F as they tried to determine authenticity. The purpose of the exhibit was to promote connoisseurship, both a desire to learn more about it and an appreciation for the difficulty in detecting forgeries.[324]

In 1990, the British Museum held a blockbuster exhibition of six hundred fake items, mainly artworks but also extending to coins, perfume, and athletic shoes. Beyond the catalog, a three-hundred-page book, *Fake? The Art of Deception*, was issued to provide much historical material about forgery. The items on display were borrowed from various sources and included many from the museum's own collection that were acquired as originals and only later found to be fakes. This exhibition signaled a leading institution's willingness to display its vulnerability in an effort to inform the public that forgeries not only lie hidden in the art world but often fool experts.[325] In the following decades, other institutions made similar admissions on a smaller scale, such as the Brooklyn Museum's exhibition in 2009 that revealed that a third of its thirty-one Coptic sculptures were false,[326] and the Detroit Institute of Arts' 2011 display of fifty inauthentic or questionable objects from its holdings, including, among other items, an ancient Egyptian sculpture, a Botticelli painting, and a Ralph Blakelock painting.[327] The show's curator offered a confident statement about the museum's reputation after admitting it unknowingly harbored forgeries:

> As one of my colleagues emailed me recently, "Times have changed, and we are all more enlightened about these things now" . . . after 125 years of acquiring art extremely well we transparently acknowledge that we have made some mistakes and that this is part of the process of the DIA's successful collecting history.[328]

Some exhibitions have delved into the scientific aspects of detecting forgeries. The National Gallery in London in *Close Examination: Fakes, Mistakes, and*

Discoveries (2010), presented forty-one paintings drawn from the institution's Old Master collection. Viewers saw (and later could access online) numerous photos showing paint layers close-up from a side view, cracking patterns, underdrawings, and the difference before and after cleaning.[329] An exhibition at the Winterthur Museum in Delaware in 2018 presented artworks and various other objects to show how they were created as well as how they were detected as fakes. One room was devoted to scientific evidence, while the overall message was that science works in conjunction with provenance and connoisseurship in investigating authenticity.[330]

Another strategy for drawing visitors to exhibitions of fakes has been to focus on celebrity forgers. One-man shows have featured Elmyr de Hory (Gustavus Adolphus College, 2010),[331] Mark Landis (University of Cincinnati, 2010),[332] and John Myatt (various galleries in the 2010s),[333] while on a larger scale, Myatt and Shaun Greenhalgh were highlighted in *Fakes and Forgeries*, which appeared at the Victoria and Albert Museum in London in 2010 and the Bolton Museum in 2011. Works by both forgers were displayed along with documents of false provenance created by Myatt's partner, John Drewe, and a life-size replica of Greenhalgh's garden-shed studio.[334] *Intent to Deceive*, which displayed works by De Hory, Landis, Myatt, Van Meegeren, and Hebborn, began in Springfield, Massachusett, in 2013 and traveled to several other midsize museums in the United States. The stated purpose of the show was to contradict the sympathetic images forgers sometimes are afforded in the media, and present a "cautionary tale for any serious collector" as well as a "wake-up call to those interested in preserving the cultural heritage."[335] Exhibitions such as these that feature individual forgers humanize those figures and afford viewers insights into their minds and personalities. At the same time, despite an intention to ward off a sympathetic attitude toward forgery, the effort toward personalization may lead to a mitigated outlook on their criminality.

Other exhibitions have advanced a perspective that purposely counters conventional thinking about art forgery by questioning the meaning and worth of the concepts of uniqueness and authenticity. In a nod to postmodern thinking, the Musée d'Art Moderne de Paris in 2010 presented *Second Hand*, which employed the method of hanging fakes beside originals that has often been used to point out their differences. In this case, nonoriginals were labeled as "look-alikes" or "avatars" and presented in favorable comparison to what they were copying. Regarding the objective of the exhibition, the museum director declared that if it "raises questions about the notions of originality and masterpiece, then the museum will have fulfilled one of its missions: to foster critical thinking."[336] In a similar vein of breaking down traditional views, the SAW Gallery's exhibition *F is for Fake* (Ottawa, 2014) showed an assortment of authentic and fake works of Picasso, Modigliani, Chagall, and others. The

curator's stated goal was to call attention to "all these ideas around original-
ity and authenticity in an art world that seems more and more confused by
artifice. I think the show makes a very contemporary statement about the art
world today." A highlight among the items displayed was a counterfeit ten-
pound note made by underground graffiti artist Banksy (replacing the Queen's
head with the head of Princess Diana, and the words "Bank of England" with
"Banksy of England") that, it was pointed out, is worth more than a real ten-
pound note.[337]

As exhibitions of fake artworks became usual fare, with some of them
moving in the direction of postmodern aesthetics, others have continued to
present a traditional message about the wrongdoing of forgery. Law enforce-
ment agencies have been willing contributors and sponsors. Police in Aarhaus,
Denmark, in 2007, having completed the investigation of a decades-old case
of a forger who had since left the country and avoided arrest, warned the pub-
lic about her fakes by collaborating with the Bornholm Art Museum to put
them on display.[338] In 2013, Fordham University in New York hosted *Caveat
Emptor*, sponsored by the FBI, which supplied a carefully selected group of
forgeries from the many discovered during the bureau's investigations. Among
the items included were fakes of Rembrandt, Chagall, and Warhol, as well as a
James Buttersworth painting made by Ken Perenyi and a Renoir fake involved
in the undoing of Eli Sakhai's long-running scheme of making direct copies.[339]
Interpol, too, has engaged in exhibitions, supplying forty fake paintings that
were shown at the Argentine Finance Ministry in 2016. The artworks were
made in the styles of noted South American artists, drawn from 240 pieces
seized in a recent raid and designated for use in court proceedings before be-
ing destroyed.[340]

As some of the special exhibitions cited here have demonstrated, sci-
entists in the twentieth and twenty-first centuries have employed various
means for exposing art forgeries. The field of materials science in particular,
as it is applied in art conservation, lends itself to determining attribution and
authenticity. Many large museums today house laboratories for conservation,
as do certain universities and independent commercial enterprises. Scientists
working at these institutions engage in forensic analysis as one of their func-
tions and sometimes as their main or only function. In an action demonstrating
concern about dealing with forgeries in the auction market, in 2016 Sotheby's
acquired leading forensics firm Orion Analytical.[341] The capability of science
to uncover falsity in artworks continues to expand with the development of
new technologies, although some of the mainstays have been in use for many
decades and undergone refinements.[342]

X-rays were used to examine paintings as early as 1896, shortly after
their discovery. In the high-profile trial of art dealer Otto Wacker in 1932 in

Germany, X-rays demonstrated the difference between the fake Van Gogh paintings he was selling and the artist's authentic works.[343] Additionally, chemical analysis of the paints revealed a resin that was foreign to Van Gogh's materials.[344] In the Van Meegeren case in the 1940s, an analysis of the paints he used to make his false Vermeers revealed the presence of cobalt blue, a pigment not found in seventeenth-century paints, as a contaminant in the natural ultramarine pigment he had made a special effort to obtain.[345] In 1992, pigment analysis combined with X-rays, high-intensity microscopy, and dendrochronology (which dated the wood to the late fifteenth century) solved the mystery of *The Man of Sorrows* panel painting in the Metropolitan Museum of Art's collection that was thought to be an outright fake, suggesting it is one of Jef Van der Veken's clever hyperrestorations.[346] More recently, pigment analysis was the factor that revealed a Pollock painting sold by the Knoedler Gallery for $17 million to be a forgery, with the gallery announcing its closing in 2011 the day after the buyer presented the forensics report.[347] Wolfgang Beltracchi, too, was tripped up by an anachronistic pigment, as well as a dendrochronology report that the wooden stretchers for four of his canvases, each faking a different artist, originated from the same tree (although this finding was disputed later).[348]

For mediums other than paintings, various tests are available. Chemical analysis has been employed with works on paper. When Tom Keating was under scrutiny before being exposed, one of his Palmer drawings was submitted for examination that revealed the paper was made later than the artist's lifetime.[349] Similarly, in a key legal case in the United States when a number of fake photographs claimed to be by photographer Lewis Hine were discovered on the market in the 1980s and 1990s, forensic tests were done that dated the paper to show the works could not be vintage.[350] With ceramic artworks, thermoluminescence can be applied as a way to determine age by measuring the amount of radioactivity absorbed since they were fired. The process has been used since the mid-twentieth century, with a notable finding in 1968 that a prized Etruscan terracotta figure of Diana displayed at the Saint Louis Art Museum, and praised by many experts, was only forty years old. Its creator was Alceo Dossena, who had photographed the completed sculpture in his studio.[351] Also based on measuring radioactivity to determine age (loss over time in objects containing organic material), carbon dating has been a staple procedure for anthropologists since midcentury. With later advances in the process, it can be applied to a sample size small enough to be removed from many artworks without appreciable damage. In 1991, the Louvre announced that a wooden Egyptian head of a harp, displayed for several decades until the 1980s as one of its main exhibits, had been determined by carbon dating to be a product of modern craftsmanship rather than ancient.[352]

These examples describe only a few of a great many instances where science has uncovered forgery in artworks. And the tests noted are not all of the laboratory means available, which also include infrared imaging, X-ray fluorescence, stable isotope analysis, and more, with some coming in several variations (such as types of mass spectrometry for analyzing pigments).[353] In their collective effort to look closely at and beneath the surface of objects, such tests point in two directions: determining what materials were used to make an artwork and what the artist's process entailed in creating with those materials. Materials analysis may discover anachronisms such as a pigment not yet in use when a painting was claimed to have been made, or anomalies such as (using stable isotope analysis) that the marble in a supposedly ancient Greek sculpture was quarried in a location that is a giveaway. Detecting the creative process may reveal features such as the number of paint layers or the presence of an underdrawing in a painting. Beyond the tests mentioned so far lies a different scientific approach gaining ground in the twenty-first century—pattern analysis—which uses digital photography and computer recognition to find statistically consistent patterns in artists' styles that can be applied to distinguish fake artworks from authentic ones. Variations on this approach, which is still experimental, concentrate on brushstrokes ("wavelet decomposition"), curves in paintings where brushstrokes are not visible ("curve elegance"), and a combination of several features ("sparse coding"). Each has been demonstrated to be successful in limited trials at an accuracy rate of roughly 80 percent or higher.[354] A related project was the analysis of Pollock drip paintings by looking for geometric patterns (fractals, based on chaos theory in mathematics), with one researcher declaring success, and others claiming the method is flawed.[355]

Scientific testing provides an impressive vehicle for detecting art forgery, but it also faces limitations. The expense and inconvenience of hiring technical expertise means that most artworks are not subjected to analysis. A simple study can easily run to several thousand dollars, as paint analysis alone may cost several hundred dollars per pigment. A more thorough study runs to tens of thousands of dollars.[356] Beyond the analysis itself is the cost (including insurance) of sending an artwork to a laboratory or for an expert to travel to examine an artwork on-site with portable equipment or to take a sample. The time frame for scheduling an examination to receiving a completed report can range from weeks to months. To subject works other than high-priced ones to testing would add a significant layer of cost for dealers, which would be passed on in purchase prices to buyers and slow commerce in art considerably.

Another factor that limits the effectiveness of science in examining artworks for authenticity is the type of knowledge it provides. Materials analysis has the capability to falsify an artwork's claim to be authentic, but not to

verify it. Finding a pigment invented in the twentieth century on a painting purported to be three hundred years old can label it a forgery, and likewise with determining the wood panel an artist supposedly painted on was cut after the artist's lifetime. But if the pigments are the same ones used three hundred years ago by the artist in question, and if the wood is of the right age and the variety the artist favored, that evidence does not determine the artwork to be genuine. Expert forgers are careful about the materials they use and sometimes go to great lengths to obtain them. Analyzing materials in art authentication can detect anachronisms and anomalies and definitively say "no," but it cannot say "yes." As for determining the particular way an artist used materials, again, science can point in the direction of authenticity but not establish it with certainty. Knowing the technique of how a finished product was put together may show that the creator followed habits like those of a famous artist, thus confirming something beyond the materials being appropriate, but assessing the image that was created is still crucial. That assessment is the domain of connoisseurship, although the science of pattern analysis follows a similar principle by applying artificial intelligence and aims to provide a conclusive decision about authenticity.

It is often the case that scientific assessment is sought only after an artwork has been judged to be authentic by connoisseurship. When science then runs its course, a collective decision is made that is stronger because it brings together two distinct ways of knowledge. Still, the thoroughly informed result sometimes is not decisive but inconclusive. A well-known example is the dispute over the Getty Kouros (see Figure 1.10), a larger-than-life-size ancient Greek marble sculpture purchased by the Getty Museum in 1985 for $9 million and put on exhibition the next year as one of its most important holdings. The Kouros was examined many times by the museum's staff, guest specialists, and at a 1992 special conference in Greece where it was shipped for the occasion. Over time, the provenance documents were found to include forgeries, although they may have been created for the purpose of smuggling an original artifact. Scientific analysis employed microscopy, spectrometry, and X-ray analysis to examine the surface, and isotope analysis located the quarry for the stone to be on the northeast coast of Thasos. It was at first determined that the marble had undergone the process of dedolomitization (the conversion of dolomite to calcium), occurring over thousands of years. A later finding was that dedolomitization could be simulated over months in laboratory conditions, although the likelihood that a forger would know this, and, even further, be able to carry it out successfully, is remote.[357] Connoisseurship, which initially was ambivalent, swayed against authenticity, with the general opinion that the style lacks the uniformity seen in other kouroi. It is seen as a pastiche in which the feet are anomalous with the hair and the shoulders and waist are

Figure 1.10. Getty Kouros, Archaic Greek style, c. 530 BC, dolomitic marble, 206 cm high. Taken off view in 2018 as opinion mounted that it is a forgery. Courtesy of the J. Paul Getty Museum

uncharacteristically narrow, among other questionable features.[358] With scientific evidence pointing to an ancient origin and connoisseurship seeing a fake, the Kouros remained on display at the Getty, with the attribution of "Greek about 500 B.C., or modern forgery,"[359] until it was put into storage in 2018.

Science and connoisseurship came to disagreement over the status of the Getty Kouros. On other occasions, the disparity may lie within the realm of science itself, pitting one laboratory against another. In 2006, Christie's sold a Boris Kustodiev painting for $3 million to a buyer who later declared it to be a fake. A legal case was brought in London, with a decision in 2012. The buyer submitted a scientific report from a Moscow firm stating that the paint in the signature was faulty because under microscopic examination it could be seen as having seeped into underlying craquelure (implying the signature was added later than when the painting was made), and it contained an anachronistic thickening agent. The scientific analysis commissioned by Christie's asserted that no paint could be detected in the cracking, and there was no evidence of an anachronistic substance. Further analysis by Christie's compared the painting with two other works by Kustodiev, finding strong material and technical similarities including the presence of brushwork sketches and use of the same pigments. The buyer's counterargument was that Christie's sampled only two other paintings, while their own testing of ten more showed less consistency with pigments, and in both of Christie's other works but not in the painting in question there were underdrawings and thin, translucent paint layers. The arbiter in this high-stakes face-off over art authenticity was a single justice, who accepted Christie's finding on the signature and the buyer's view that Christie's comparison using two paintings was based on too small a sample and failed to account for significant differences found in the larger sample. With inconclusive scientific analysis, and a lack of provenance that is common with Russian art, connoisseurship was the key in a decision favoring the plaintiff.[360]

Beyond occasions where science is in dispute with connoisseurship or with itself, other factors may be problematic in the authentication process. When establishing that a pigment is anachronistic, confusion can arise over when it was first available. Was it the date when it was patented or when it was invented and might have been in limited use, or when it was first put into commercial use?[361] With a pigment that clearly does postdate a painting, its presence may be the result of a restoration. The dendrochronology test is not viable with poplar wood, a favorite of Italian Renaissance artists. Thermoluminescence can sometimes be beaten by seeding the object with radioactive material in locations likely to be tested.[362] And more important on a broad scale, searching for anomalies to rule out an artist as the creator of a work, or for similarities that strengthen a case for authentication, requires a database of

practices for each artist under scrutiny. To know that someone typically applied a certain number of paint layers, was fond of certain paints or pigments and never used others, or worked with a regularity that pattern analysis could search for, requires that a number of works have been studied and data made available. For most artists who are not renowned, that data does not exist and would be complicated and costly to create. And when the data is available, the habits that have been detected may be subject to exceptions. Knowing, for instance, that an artist was particular about using a certain brand of paper does not exclude the possibility of an authentic set of drawings made on another type of paper when the regular stock was unavailable.

Notwithstanding the various limitations science faces in detecting forgeries, it is often successful. Artists who create high-value fakes confront an array of tests that can be used against them. On the other hand, it is possible that those tests may be employed in the service of forgery. Nothing prevents the maker or holder of fake artworks from submitting them, with an air of innocence and perhaps through an intermediary, for testing that would reveal just what improvements need to be made to pass for authentic. When those improvements are accounted for, the same works can be submitted to a different laboratory for analysis. And new works can be made that avoid the hurdles from the start. Even with works that still fail examination, there will be other laboratories to try in the hope of finding one that is less diligent and identifies no disqualifying features.

Another direction in which science has moved in recent years goes beyond the detection of forgery and points toward prevention, with artists taking strategic measures as they create new works. One developing technology is to mark each artwork with synthetic DNA, with a unique version designed for each artist and available in small stickers with material that will seep into an artwork permanently when attached to it. The material is said to be unreplicable, and tampering to remove it will leave microscopic forensic evidence. Artist's DNA markers are stored in a dedicated database, which can be consulted by art professionals after they use a scanner to read the sticker on an artwork.[363] This database dovetails with another technology for collecting and storing information, which is valuable in provenance searches. Blockchain data storage creates comprehensive records, made available to any interested parties, by chaining together all entries in a given file in a way that prevents alteration and can show possession of a work from the artist through successive owners. This method has been promoted as inexpensive, secure, and transparent,[364] but it shares with DNA markers the limitation that it applies only to creations by current and future artists, and not to the vetting of earlier works. Both methods also rely on conscientious artists, dealers, and collectors who

will participate and carry through with them routinely, a prospect that even proponents find doubtful.

Forensic analysis of artworks will continue to evolve given the nature of science to undergo constant change, resulting in improved knowledge. Perhaps in the future, less expensive and less time-consuming means of materials analysis will make it feasible for a greater portion of works to be examined. Pattern analysis may advance. And perhaps synthetic DNA or other systems of markers will be perfected and popularized. These possibilities add to other measures in an overall effort to counteract the activity of forgers. The popular trend of presenting special exhibitions of fakes will continue to educate the public about them. And organizations and databases can be expected to increase their role in a watchdog effort to expose inauthenticity. It is reasonable to assume that all of these means will advance to provide more scrutiny in separating authentic artworks from fakes. The potential of science combined with the dissemination of information offers optimism in confronting the significant presence of forgeries in the art world. But it can be expected, too, that forgers will keep up with measures that are used against them. History says as much through the expansive forgery industry that exists today in the art world. Practitioners of fraud will look for ways to steal or duplicate sophisticated identification markers, pattern analysis may be used to understand what patterns need to be duplicated in making convincing fakes, and a single laboratory could serve multiple forgers looking for methods to improve their fakes against the latest means of detection. Added to all of this, hackers may find ways to insert false information into digital files. In sum, the presence of forgeries can be expected to remain in spite of improved vigilance. The struggle between the forces of false art and those of authentic art will be ongoing.

· 11 ·

What Is a Forgery? What Is Authentic?

It would be a dangerous undertaking for persons trained only to law to constitute themselves final judges of the worth of pictorial illustrations, outside of the narrowest and most obvious limits.

—Oliver Wendell Holmes, US Supreme Court Justice, 1903

The spots I painted are shite. The best person who ever painted spots for me was Rachel. She's brilliant. The best spot painting you can have by me is one painted by Rachel.

—Damien Hirst, in reference to his famous spot paintings, 2008

Whether we like it or not, much of the desire for Aboriginal art crystallizes around . . . a cocktail of exoticism, primitivism, redemption and innocence, which in turn perpetuates derogatory ideas of Aboriginal art as a racial curio fetishised as the production of an authentic spirit.

—Benjamin Genocchio, art critic, 2001

If an artist produces an artwork in the vein of another artist, signs it with the other artist's name, and sells the piece as an original by the other artist, that artwork is a forgery. If an artist makes a unique creation and signs and sells it as his or her own, that work is an original. These situations are clear-cut. But some situations are not. There may be complicating factors that result in ambiguity and require judgment in separating authentic art from inauthentic. While determining one from the other is often thought of as an exercise in detection through examining materials and workmanship, sometimes it is a matter of definition according to law or custom. And with definitions being subject to interpretation and shades of gray, it may seem as if certain artworks

are not fully fake or fully original but somewhere in-between. Instead of envisioning a binary separation, a more helpful model for understanding this puzzle may be a continuum, with each end offering a definite determination but with degrees of confusion when moving toward the middle.

The confusion is caused by factors of several types. The first to be addressed is the linguistic complication that the meaning of the term "forgery" is subject to variations. There are specialized definitions that can leave ordinary-language users disoriented. Then comes the atmosphere in which an artwork was created, sometimes making it difficult to separate legitimate copying or emulation from outright fraud. The turmoil that results can give cover for artists to get away with forgery. Another concern arises over what happens to the authenticity of an artwork when more than one person has a hand in the process of making it. As part I has shown, this question has troubled the attribution and authentication process for centuries. If a sculptural torso is given new arms and legs and a mostly new face, is it still an original by its first maker, or should the restorer be named as the (or an) artist of record? If two artists collaborate to make a painting, should both names go on it, even if one is a studio employee of the other? When an engraving plate is recut and printed from after the artist's death, does the result lose authenticity? What if the factor connecting two artists to a particular work is not the workmanship but the image? If one artist appropriates an image from another, what happens to originality and authenticity? And what if what is appropriated is not a specific image but a style identified with an Indigenous people? An artist's ethnic and cultural identity can raise a tangle of concerns about authenticity. Taking stock of these factors involves knowledge in several fields, from law to philosophy to commerce to art history, criticism, and restoration.

SEMANTIC VARIATIONS

Understanding the difference between a forgery and a legitimate artwork begins with the meaning of the term "forgery." Typical dictionary definitions say it is "the act of reproducing something for a deceitful or fraudulent purpose,"[1] and "the act of forging something, especially the unlawful act of counterfeiting a document or object for the purposes of fraud or deception."[2] The crux is that something is produced with the intention to deceive. Terms with like meanings include "counterfeit," "falsification," "fake," "phony," "fraud," "bogus," and "impostor," among others. Beyond its general meaning, "forgery" is sometimes subject to more restricted technical usage by specialists. Artworks that commonly are described as forgeries would not, in many cases, be labeled that way in legal terms. In certain contexts other than the law, such

as works of pewter, philately, and among some art theorists, a distinction has been made between forgery and fake, although by definitions that are inconsistent with one another.

US federal law follows the standpoint of English common law, and is similar to the law in various other countries as well, in denoting forgery as pertaining to documents and not to artworks. Items it does cover include deeds, stock certificates, wills, money orders, currency (where the term "counterfeit" also appears), identification cards, etc.[3] The makers and sellers of false art can be charged with a variety of other offenses such as fraud, money laundering, and (notably in the United States) tax evasion. In the 2013 high-profile case of phony paintings in New York that were claimed to be by Jackson Pollock, Mark Rothko, and others, and sold for tens of millions of dollars, the charges against the defendants (artist Pei-Shen Qian and three co-conspirators who sold the works) included conspiracy to commit wire fraud, wire fraud, conspiracy to commit money laundering, money laundering, making false statements to the FBI, and submitting false tax returns.[4] The term "forgery" does not appear in the court documents. The phony paintings are designated as "the FAKE WORKS" and referred to by that term repeatedly.[5] However, for public consumption, the US attorney in charge of the case talked more loosely of "modern masters of forgery," and the IRS special agent-in-charge described "the sale of counterfeit paintings."[6] In other federal cases, a range of terms for phony artworks can be found within the official court documents. The judge's decision in the case of James Kennedy, who was found guilty in 2013 of mail fraud and wire fraud for the sale of phony prints attributed to Dalí, Picasso, Miró, and others, uses the terms "fake," "counterfeit," and "fraudulent" often and synonymously to describe the false works, seemingly as a linguistic strategy to avoid frequent repetition and monotonous reading. The word "forgery" appears several times in describing how the prints acquired false signatures, but not in substitution with the terms for the phony prints themselves.[7]

State laws tend to mirror federal laws on forgery, although with some exceptions. At the state and federal levels it is forgery to copy another person's seal or handwriting, and in some venues, this provision has been applied not only to documents but also to artworks. When Tony Tetro was arrested in California in 1989, he was charged with thirty-eight counts of "felony forgery" of lithographs and twenty-nine counts with watercolors.[8] Besides the artworks, of particular interest to authorities when they searched Tetro's home were tablets on which he practiced artists' signatures.[9] And occasionally in other state-level cases, where the charge is not forgery, the term is still used to describe phony art. For instance, when the Parke-Bernet auction house in New York was sued over the wiggle room their catalog's fine print included that gave protection against mistakes they made in authenticating phony

paintings as Raoul Dufy originals, the judge's decision called the paintings "forgeries."[10]

Outside of the legal realm, when "forgery" is differentiated from commonly accepted substitute terms, the one it usually is paired against is "fake." In his 2015 book, *The Art of Forgery: The Minds, Motives and Methods of Master Forgers*, art historian Noah Charney declares that forgery is "the wholesale creation of a fraudulent work," whereas a fake is made by "the alteration of, or addition to, an authentic work of art."[11] With both terms there is an intention to deceive by suggesting the work was done by an artist other than the one(s) who actually did it, so that the value is enhanced. The difference is in being made as a phony from scratch versus being turned into a phony later. Following this distinction, an existing painting by a lesser artist that was refashioned to be a Monet, then, is a fake, whereas one painted from the start to look like a Monet is a forgery. A marble sculpture with the artist's name removed and replaced by Henry Moore's name is a fake, and a newly carved marble signed with Moore's name is a forgery.

Charney's book is about fine art, although he briefly discusses phony literary works as well as religious relics and fossils. The distinction he presents is sometimes found in the decorative arts. With postage stamps, phonies made as duplicates of existing stamps are called "forgeries," with the term sometimes restricted to those used to defraud collectors, and "counterfeit" describing those used to defraud the government by being put into public circulation. A fake is a genuine stamp that has been altered to change its design or has been subjected to a false cancellation mark to make the result appear rare.[12] A similar two-part distinction, without a separate category for counterfeit, is found with works made of pewter. As explained by the Pewter Society, "A forgery is a piece of modern pewter which is made specifically to deceive the purchaser." An existing work is copied. A likely process is to use molds of genuine items that will include blemishes and wear marks found on originals. Fakes are made by "using a legitimate unmarked item and embellishing it with inscriptions or decoration" such as adding a false maker's mark or combining parts of existing works into a "marriage" item.[13] The difference between replica and alteration is also explained by Brian Innes in his 2005 book, *Fakes and Forgeries: True Crime Stories of History's Greatest Deceptions: The Criminals, the Scams, and the Victims*.[14] However, a forgery is identified as an existing item that has been altered, such as by adding a false signature, and a fake is "a copy of something genuine that already exists."

This reversal leads to the question of whether one of the two terms "forgery" and "fake" belongs specifically with one of the two concepts they represent rather than the other concept. Is there a good reason to think of forgery as new creation and fake as alteration, instead of the other way

around? Or is the connection arbitrary? A greater problem, however (which is highlighted later in part II in the section on restoration), is that the difference between a phony made from scratch and one made by alteration is not clear-cut but subject to a middle ground that creates confusion. If an existing work is altered so greatly that little of it is evident in the final product, how is this different than starting from scratch?

A second approach to the forgery-versus-fake distinction separates copying an exact image from copying a style. Anthony Amore, in *The Art of the Con: The Most Notorious Fakes, Frauds and Forgeries in the Art World* (2015),[15] defines forgeries as "paintings created by an artist in another's style and name without authorization," whereas fakes are "exact unauthorized replicas of existing works passed off as the original." Amore does not say so directly, but the intention to deceive is implied when he speaks of paintings made "without authorization" and "passed off," all within the context of his discussing "fraudulent art." Applying this distinction tells us that an exact copy of one of Monet's haystack paintings is a fake, and a painting of haystacks done in Monet's style but not duplicating an existing Monet is a forgery. Similarly, a duplicate of a carved sculpture by Henry Moore is a fake, and a sculpture that follows Moore's style without copying one of the artist's images outright is a forgery.

There are several drawbacks to this distinction. It is more applicable for some artistic mediums than for others. With multiple originals like bronzes and prints, most phonies are exact copies. To create a stylistic image—one attributed to a named artist but that the artist never made—runs a greater risk of detection than to add more to the quantity of something that is known and already in circulation. To discover that a duplicate of a particular image exists is not a cause for concern when the original was made in multiples. On the other hand, for a one-off such as a painting, drawing, or carved sculpture, finding that another just like it exists is an obvious problem. False works in these mediums are usually made to be stylistically similar rather than exact copies.

Other difficulties with this distinction are similar to those for the difference between creation versus alteration. Whatever medium it is applied to, this version of forgery versus fake, like the first version, is subject to a middle ground. The middle here is a pastiche. A false artwork often includes directly copied elements from one or more existing works without copying a work in its entirety. A newly created Monet might duplicate the meadow from one of the artist's paintings, haystacks from two others, and a tree from a fourth. Is this painting a forgery? Or is it, instead, a fake? Much direct copying is involved, but the result is not a complete duplicate of an existing work by Monet. A further drawback to this approach to parsing the terms is that, as with the first approach, its proponents disagree about which word refers to

one concept and which to the other. Does forgery link to an exact copy or to a style? Literary critic Stuart Kelly reverses Amore's usage by asserting that "forgery implies a copy of a pre-existing work," whereas "fakes are original works in the style of another artist."[16] Similarly, the Spurlock Museum (University of Illinois) has stated, "A forger makes an *exact copy* of an object, like a painting," and "A faker makes objects that *resemble the style* of another."[17]

There are still other ways of differentiating forgeries from fakes. Art historian David Scott suggests that "a fake is a copy or work in the style of an artist that is not made to be passed off as the genuine article." A fake Van Gogh might be part of the backdrop for a stage performance, "but if the fake is offered for sale or given as a genuine van Gogh, it is classed as a forgery."[18] In other words, a fake lacks the intention to deceive. Art authenticator and theorist David Cycleback sees "fake" as an all-inclusive term both for works intended to deceive—which he calls "forgeries" if they are stylistic interpretations, and "counterfeit" if they are replicas—and for innocently misidentified works where no deception is intended.[19] Both of these ways of expanding the meaning of "fake" to include legitimate works face the same difficulty: they abandon the factor of deceit and, in so doing, go against standard usage of the term in the realm of art. That is not to say that there is no precedent for this approach. The word "faux" is often used to describe leather goods that are meant to mimic genuine leather but are not claimed to be of the genuine material. The term "fake leather" is common as a synonym. And fake luxury goods bearing names such as Gucci and Rolex are common. However, in the realm of art, especially with valuable fine art where one-of-a-kind or limited-edition items are at a premium, both fake and forgery generally include the factor of deceit.

The several distinctions that have been offered between forgery and fake are problematic. They face the difficulty of not being clear-cut but subject to a confusing middle ground, or they fail to include the factor of deceitful intention that has been traditionally understood as an underlying assumption when describing phony artworks. Beyond this, the unconventional meanings, which are likely to be confusing to someone confronting them for the first time, require constant attention to be consistently applied as an alternative rather than follow the broader and better-known equivalence the terms have in general parlance. For instance, the reader of a book that designates forgery merely as stylistic copying (while excluding direct copies) may be misled when picking it up again at a later date and not remembering the author's specialized terminology. And further yet, the various forgery-versus-fake distinctions are incompatible with one another and require readers and listeners to know precisely which of several specialized meanings is in play: Does the speaker now at the lectern mean the same when using the word "forgery" as the previous

speaker did? Does a writer who announces a difference between forgery and fake apply it consistently when describing phony art?

There are certain limited domains where using one or another of the specialized distinctions can be expected. Attorneys in a court of law must apply the term "forgery" with the precision required by the particular venue where a case is drawn, and within the domain of philately, someone reading a catalog listing of an item for sale had better know whether what is being referred to is a duplicate of an existing stamp or is instead the result of a false cancellation mark. In a limited domain, where people are in agreement about a distinction and apply it consistently, the result will be refinement in communication and not the confusion invited by multiple interpretations of forgery versus fake as they are applied outside of those domains. It may be the confusion that lies in separating the terms that has led many experts and writers on forgery (as is the case for this writer) to use them synonymously. Art historian Otto Kurz, philosopher Nelson Goodman, art theorist Thierry Lenain, art critic Jonathan Keats, and philosopher Sándor Radnóti[20] are only some who prefer to interchange the word "forgery" with "fake" and other terms.

INTENTION

When art forgers are caught, a defense they often present is that their intention was not to deceive. They say they only intended to copy an image or a style, and not to commit fraud. Copying is a time-honored tradition, and if copies are claimed to be just that, rather than originals, no wrong has been done. Even though this defense may be hard to believe, it is also hard to disprove. The creators of false artworks hope they can duck out by putting the onus on dealers they sold to, saying the dealers knew they were getting copies, or should have, and passed those works on as originals. By the same token, the people who buy works from self-described copyists and resell them may claim they thought they were dealing in the real thing. When a piece is resold more than once and a chain of buyers and sellers is created, it becomes increasingly difficult to identify the culpable party or parties. Maybe all of them knew what they were buying and selling was phony, or maybe just one or some of them did, but it is likely that none will admit it. So, although a work of art may be a fake, pointing to the person who made it as culpable rather than a legitimate copyist, or to a person who sold it as being a fraudster rather than an innocent believer, may be an exercise in futility.

Tony Tetro's defense is a classic demonstration of a plea from intention. When he was put on trial for faking several dozen paintings and lithographs by

Dalí, Miró, Norman Rockwell, and Hiromichi Yamagata, and suspected of at least hundreds more by those artists and others, he held steadfastly that he was a copyist who never sold his works as originals. They were merely "reproductions" (direct copies) or "emulations" (in the style) of the work of famous artists: "Forgery indicates intent to defraud . . . and I never sold anything as real." He claimed his intention was public knowledge: "Every one of my friends knew what I did. You know: What do you do for a living? I copy masters. I even had business cards which said: Anthony Tetro, Art Reproductions."[21]

Prosecutors presented evidence that Tetro was in business with art dealer Mark Sawicki, who had been arrested and offered leniency (he ended up with no jail time) in return for his testimony. In a meeting with Tetro he wore a concealed recorder that picked up the statement, "I did a Chagall," and a response of "Yeah" when asked if he had other fakes in progress. Sawicki also said he witnessed Tetro practicing signatures of the artists he was copying, and that he did between $75,000 and $100,000 of business with him each year from 1984 to 1989.[22] In response, Tetro testified that he was unaware his works were being sold as authentic. It was established that Sawicki had paid him amounts in the hundreds of dollars per artwork, while price tags in galleries were many times that: The Yamagata works ranged from $3,000 to $16,000.[23] While this price disparity could lend credence to Tetro's claim that his intention was not to be a forger but merely a copyist, Yamagata revealed that he was paid only $1,000 for similar works.[24] The upshot of the case was a mistrial, with jurors unable to decide on guilt. Having spent all of his money on attorney's fees, Tetro avoided a retrial by serving a nine-month jail sentence and community service.[25]

Well aware that intention is the key to a guilty verdict before the law, forgers sometimes go to greater lengths to forestall trouble than Tetro did in printing business cards advertising his copying services. Because false signatures are another legal impediment, forgeries may be left unsigned, and even with signatures, they may be presented to potential buyers with an air of innocence in not claiming their authenticity and perhaps not knowing their potential value. The detection of a phony work, then, would not point definitively toward the intention of fraud. Eric Hebborn, in making a thousand fake Old Master drawings, capitalized on the fact that the artists he faked seldom signed their works on paper. He was known in London and Rome to be knowledgeable about art and active in searching out old works, and often approached potential buyers with his "finds" while leaving the determination of authorship up to them. (In other situations, he appeared as a dealer and expert.) He asserted that he believed the reason he continually evaded the law, along with the art establishment's fear of a loss of public confidence in the market from the bad publicity that would be generated if he was exposed, was his cautious

approach to the way he presented his phony productions depending on the party with whom he was dealing.[26] Ken Perenyi's memoir makes the same point. He speaks of approaching Phillips Auction House in London with a Martin Johnson Heade fake (eventually sold for $94,000) that he "found in a boot sale" and that looked like something he once saw in a magazine ad.[27] Later, he says, when the FBI was closing in, his lawyers sent a letter claiming their client "has been creating high quality reproductions for years and never misrepresents them."[28] Perenyi avoided arrest, probably from a combination of the art market's not wanting the public relations debacle that would ensue and his willingness to play dumb about the authenticity of what he offered for sale. Here are two bold but shrewd operators who managed to be thought of as too big and too complicated to be prosecuted, whereas other prominent forgers were unable to escape the legal system.

While Perenyi, Hebborn, and Tetro worked in the late twentieth century as they strategized over how to evade the law, a century earlier Giovanni Bastianini presented himself willingly to the public as the artist behind a major fraud. Described sometimes as the nineteenth century's most prominent forger, he was never subject to legal action since he died at the age of thirty-seven while trying to prove his claim to have created a sculpture depicting the Renaissance poet Girolamo Benivieni that was on display in the Louvre as a Renaissance original (see Figure 2.1). The artist wanted the world to know of his talent, and declared he did not intend his works to be received as genuine products of the Renaissance. Public opinion about his honesty wavered, and with time, especially as more of his sculptures thought to be Renaissance-period originals were discovered, the label of forger won out, although it was not universally endorsed.[29] In recent years, a reassessment has been underway that questions Bastianini's culpability. He did not claim that any of his sculptures were the products of other artists, or sign with false names: some works were undesignated, and others were put forward under his own name. A series of Renaissance figures, including the disputed Benivieni piece, are among the items that provoke controversy,[30] although there seems to have been no attempt by the artist to misrepresent them. Also key are that he did not apply artificial aging and offered no false provenance. He was typically paid between 200 and 500 lire for the works in question, while they were then sold for 9,000 to 10,000 lire, and the amount of 13,600 francs for the Louvre's acquisition.[31]

The evidence against Bastianini is largely circumstantial and based on his association with art dealer Giovanni Freppa, who determined how much he was paid, although there is a letter by a third party describing a transaction between the artist and a buyer of one of his works for 1,000 francs along with the artist's agreement to remain quiet about the deal. What is unclear is

Figure 2.1. Bust of Girolamo Benivieni by Giovanni Bastianini, terracotta, 54 × 54 × 33 cm. Purchased by the Louvre as an unattributed Renaissance masterpiece. Art Resource/ Courtesy of the Louvre

whether Bastianini was agreeing to sell an intentional fake for that amount or he wanted the amount to be secret for another reason.[32] What is certain is that the artist perfected his talent for sculpting in the Renaissance manner, and that in designating some of the works he produced to be his own emulations of that period, he worked as a legitimate copyist. This status does not preclude his also being a forger, and because a number of his works have turned up in the guise of originals, it is not difficult to believe that sometimes he acted with the intention to deceive.

In the legal realm as well as in common understanding, determining an artwork to be a fake rather than authentic, or an artist to be fraudulent rather than a legitimate imitator, lies in finding an intention to deceive. However, in the realm of aesthetics, a variety of views can be found that range from endorsing the importance of intention to downplaying and even denying it. From the latter perspective, the difference between forgery and authenticity in art becomes clouded. And as the gap between forgery and authenticity closes, forgery gains in its perceived aesthetic value and finds proponents to speak for its worth.

Among philosophers, the conventional view is that a forgery—taken to be the antithesis of "authentic"—is what dictionary definitions say but with a more precise or deeper explanation. Denis Dutton states, "A forgery is normally defined as a work of art presented to a buyer or audience with the intention to deceive. Fraudulent intention is necessary for a work to be a forgery; this distinguishes forgeries from honest copies and merely mistaken attributions."[33] Taking a different tack, Sándor Radnóti, borrowing from and amending a definition by Nelson Goodman, asserts that "a forgery of a work of art is an object falsely purporting to have both the history of production as well as the entire subsequent general historical fate requisite for the original work."[34] A forgery, then, is designed to look its age, beyond demonstrating the handiwork typical of the artist being copied. And still another formulation, from Michael Wreen, stipulates that

> A forgery is to be understood as a forged XY. . . . a forged XY is not a genuine XY, but is represented as a genuine XY, and is so represented with the intention to deceive. . . . A forged Picasso painting is not a genuine Picasso painting, but is represented as a genuine Picasso painting, and is so represented with the intention to deceive.[35]

The Picasso painting is an XY, with the class X being the "source of issue" and class Y the type of object being forged. Wreen says he prefers his definition because it applies successfully when dealing with several complications beyond simply stating the nature of an art forgery, such as allowing for the possibility of a forgery of a forgery, a forgery with a genuine signature, self-forgery, and the work of a nonexistent artist to be classified as a forgery.

Willful deception is front and center in all of these definitions. Its presence is a given and is necessary for forgery to occur. This point can be highlighted by asking whether an example can be cited in which forgery oc-curred without the intention to deceive. An attempt might be some version of the following: a copyist makes a copy of an artwork and sells it as a copy to a purchaser who displays it as a copy. After the copy leaves the purchaser's possession still designated as a copy (as a gift or through an auction or other

sale), it passes through a succession of owners and eventually is displayed innocently as an original, although it is not known at what point it acquired that designation. In its latest resting place, the artwork is assessed by an expert and labeled as a forgery. The artwork is not an original, and no one is known to have intentionally misrepresented it. Is this a case of forgery without the intent to deceive? The answer is no. Two mistakes have occurred, the first of which was to assess the artwork to be an original, and this was done without a wrongful intention. The other mistake was to apply the label of forgery. The misrepresented artwork can be called just that, a misrepresentation, or, to use another term common in the practice of authenticating art that is suggested in the quote from Dutton, it is a "misattribution." The lack of willful deception is the telling factor. There was or was not an intention to deceive; this factor is binary—either-or. When situations arise, as with Tetro, in which it is difficult to determine if intention implies forgery, the problem lies with gaining the necessary evidence to determine the contents of the suspected forger's mind. There is not a problem concerning the nature of forgery itself: there is no question that the intention to deceive is present with a forgery and not with an authentic work.

The idea that the separation between forgery and authentic art lies with intention as described so far has been challenged by postmodern theorists. From the perspective of "anti-intentionalism," it is futile to look to the mind of the creator of a work of art to find its meaning. This view has been a staple in aesthetic theory for literature and the visual arts during the last half of the twentieth century to the present, and although endorsed in one version or another by many scholars, it has its detractors as well.[36] In its moderate version, the assertion is that readers or viewers are incapable of determining with certainty what, for instance, a novelist's or a painter's intention was in creating a particular work: while meaning does exist, access to it is mediated rather than direct, and various interpretations will result. The aim of criticism is to proceed from the various interpretations to come to the best possible understanding of a work. A strong version of anti-intentionalism rejects the notion of searching for an overall meaning and holds that all that is available are multiple interpreters with their own interpretations. Figuring out the contents of an artist's mind, then, cannot be done even collaboratively. An essay by Rosalind Krauss explains this view particularly in light of what the creators of modern art have done in conjunction with the thinking of twentieth-century philosophers such as Ludwig Wittgenstein and Maurice Merleau-Ponty, who have displaced a Cartesian notion of mental events—intentions—that exist in an artist's mind and then become externalized in objects outside of the mind to be discovered. Regarding Wittgenstein, "his work became an attempt to confound our picture of the necessity that there be a private mental space (a

space only available to the single self) in which meanings and intentions have to exist before they could issue into the space of the world."[37] As an example of specific artworks Krauss cites paintings by Frank Stella, saying that "the real achievement of these paintings is to have fully immersed themselves in meaning, but to have made meaning itself a function of surface—of the external, the public, or a space that is in no way a signifier of the apriori, or the privacy of intention."[38] Meaning, then, is established outside of what may be in an artist's mind. It is born only when an artwork comes into contact with viewers who offer their particular perspectives on it.

With the meaning in artworks cut off from the minds of their creators, and established only when outside parties have conferred their own thoughts about the works themselves, artists become expendable in the process of coming to understand those works. A continuation of anti-intentionalism declares that the creator of a work is effectively a nonentity for the purpose of establishing meaning. This is the message from Roland Barthes in his famous pronouncement of "the death of the author,"[39] and from Michel Foucault in his preference for referring to an "author-function" rather than a person.

> We can easily imagine a culture where discourse would circulate without any need for an author. Discourses where whatever their status, form, or value, and regardless of our manner of handling them, would unfold in a pervasive anonymity. No longer the tiresome repetitions:
> "Who is the real author?"
> "Have we proof of his authenticity and originality?"
> "What has he revealed of his most profound self in language?"[40]

How the relationship between strong anti-intentionalism and forgery works requires further explanation. Krauss and Foucault are not denying that artists have intentions, but saying that their intentions do not count beyond their own minds. What do count are the various meanings found in viewing the surface of an artwork that each person sees differently. Questions about the status of a particular painting as an original or a legitimate copy or a forgery lose out to an all-consuming focus on interpreting the intellectual and emotional impact that comes from viewing it. How the artwork speaks to the viewer is the key, and not what the artist who made it was thinking. Herein lies a problem. Focusing merely on the form an art object presents— "formalism" in aesthetic terms—hits a philosophical snag that will be discussed in part III with the topic of the "perfect fake." In short, it is that leaving out the contents of artists' minds oversimplifies the process of criticism by leaving out key factors that many viewers find important.

Anti-intentionalism faces another philosophical roadblock over the demand that multiple and competing interpretations of artworks be recog-

nized. Its moderate version melds with moderate intentionalism, which also recognizes multiple interpretations, to form a continuum that accommodates various theoretical perspectives between the poles of strong intentionalism and strong anti-intentionalism.[41] It is anti-intentionalism in its strong sense of discarding authorial intent and nullifying concerns about authenticity that becomes problematic. With no author, and confronted with a multiplicity of meanings, interpretation becomes unsupportable. If meaning—what is in an artist's (author's) mind—is only a construction by interpreters and unavailable to be discovered, the meanings the interpreters come up with are also created in a way that makes them unavailable to be discovered and not able to be understood for their intention. Interpretation is trapped in subjectivism. As explained by philosopher Paisley Livingston,

> If the minds of readers are the constructed products of a theoretician's interpretative operation, who constructs what may be called the theoretician-function? Either there are "spontaneous" cognitive processes—perhaps even genuinely rational ones—that are not the product of someone else's projection, or there is an endless regress of projections.[42]

The upshot is that interpretation needs to recognize genuine contents in genuine minds. The psychological makeup of both interpreters and the artists whose works they interpret must be recognized after all. And this allows back into the equation an interest in what Foucault has said is irrelevant: a concern about authenticity when engaging in the analysis of artworks. Rather than being put aside, the question of whether an artist intends to make an illegitimate work belongs within the range of art criticism.

The strain between intentionalism and anti-intentionalism in interpreting art extends beyond art criticism per se and into an important consideration in law. The significance of interpreting the meaning in an artist's mind when creating an artwork versus the meaning decided by viewers of that work has relevance in copyright law in regard to appropriation art. This topic will be discussed later in part II in the section on appropriation.

RESTORATION

In his memoir, Eric Hebborn tells a story from his early years working for a painting restorer as he underwent his initiation into the underworld of art. A dealer with a gentlemanly manner approached him and his employer with a canvas to be worked on. The man announced, "I've made an exciting discovery, what do you think of this Vandevelde? [*sic*]" Not knowing what to say,

Hebborn simply seconded his employer's reply that he found it very interesting. The dealer then admitted that the painting would need extensive restoration, and mentioned his hope that after it was cleaned the signature would be visible. And he provided photographs of Van de Velde's works he thought would be helpful in understanding the present painting. The whole conversation went on with an air of deadpan innocence as if in an on-stage comedy where the audience, looking from behind Hebborn, would see just what he saw—an entirely blank canvas, and an ideal one for the project at hand in that it dated to the seventeenth century and had been carefully scraped down to the base layer of gesso. It was an Old Master waiting for the restorer's full treatment.[43] Obviously, the painting Hebborn made light of (it was proclaimed to be an "original" Van de Velde) was a fake. What, though, if the restoration was to a painting made by Van de Velde himself, but where much of the paint was missing and the blank areas needed to be filled in? What status would this work hold?

When an artwork that has deteriorated or been damaged undergoes restoration, an alteration occurs in what remains of the original work. A question looms as to how much alteration is acceptable. Is there a limit not to be surpassed, a point after which authenticity has been unacceptably compromised? The issue here is a variation on a metaphysical puzzler about change and permanence, which is sometimes exemplified in terms of replacing the parts of an automobile. If it has been repaired, perhaps on several occasions, so that most of the original parts have been replaced, is it the same automobile as before? Art forgers capitalize on the gray area involved in answering this sort of question. A strategy they sometimes employ is to find a damaged piece by a recognized artist that can be bought cheaply and then "restore" it by repainting key portions. In the process, the image may be changed to make it more interesting—an old woman becomes young and attractive, a house appears in a landscape, or a cat in an interior scene. With skilled brushwork, an old reject becomes vitalized and is given a much higher price tag. Other times, the intention in restoration is not to create a deceptively false image but to legitimately renew what has gone missing so viewers see the image as it originally looked. In this case, the artwork has been altered without attempted fraud, yet with extensive restoration its authenticity comes into question.

Part I discussed changing views over time about the amount and type of restoration considered acceptable by professional restorers as well as by art critics. And it was noted that although today standard treatment consists of less intervention than it did historically, that perspective is often disregarded in favor of significant alteration for improved visual effect. How, then, can it be determined whether an artwork has retained its original status after restoration or has been altered in such a way as to be classified either as a fake or as

unintentionally rendered inauthentic? While it may seem that there should be a point of differentiation, how can it be established? Experts of different types can be consulted who give answers in various forms.

In the legal realm, statutes are silent on this issue, although on rare occasions case law has spoken to it. In 1981, the US Tax Court decided the case of *Monaghan v. Commissioner* over the tax write-off claimed for donating a seventeenth-century Spanish portrait to a museum. Two expert witnesses determined the painting to be inauthentic on connoisseurial grounds, but one of them, after examining the restoration the work had undergone, also found it problematic that only 40 percent of the original paint remained on the canvas.[44] In 1989, the Tax Court heard the case of *Ferrari v. Commissioner* in which the value for charitable contribution of twenty-one Pre-Columbian art objects was challenged. Many of the works had extensive restoration. Here, an expert witness stated her opinion that a work with more than 50 percent restoration was of doubtful authenticity, while the court declared,

> At some point, excessive restoration takes a piece of this art out of the category of an original. . . . it would be misleading to sell as pre-Columbian an art object which consists of less than 25 percent original material. That dividing line may in fact be too low without full disclosure to the customer.[45]

On the other hand is the case of *De Balkany v. Christie's* (1997), decided by the High Court in England, in which Christie's was found liable when a client claimed to have been sold an inauthentic painting by Egon Schiele. The entirety of the painting's surface except for 6 percent was overpainted, including the artist's initials E and S in the lower right and left corners (his typical signature). With the signature misrepresented by the seller as having been applied by Schiele, the work was declared a forgery. The 94 percent overpainted surface was not a disqualifying factor as long as it adhered faithfully to what appeared on the canvas originally and the original brushwork was in fact done by Schiele. In the words of the court, which accepted the defense's argument,

> if the original picture had been by Schiele then nothing that was done by another hand could be said to make it a forgery . . . even if the painting had been 100% overpainted by someone other than Schiele . . . it would have been proper for Christie's to attribute the work to Schiele if he had designed the picture and the overpainter had reproduced Schiele's colours.[46]

In this situation the judgment was liberal to the point of being unconcerned with the amount of surface area that was restored, while strict about changes to what the surface originally looked like. What was not established was how

much deviation from the original look, even if unintentional, this strictness allows.

With legal opinions varying considerably as to how much restoration it takes to nullify authenticity, what does philosophy have to say? Here the discussion moves away from percentages to an even greater disparity of viewpoints. At one pole is the position proclaimed in the nineteenth century by John Ruskin that no restoration is acceptable because the original object will never exist again. Earlier in the century, artist Francisco de Goya announced a similar stance:

> Whenever one touches a painting under the pretext of conservation, one always destroys it; and even the authors themselves, coming back to life, would not be able to retouch them perfectly because of the yellowish tone which they acquire with Time, who, as the sages have observed, is also a painter, because it is not easy to retain the fleeting and momentary impulse of the imagination and concert which are found in the initial creation.[47]

Not even the original artist, we are told, can mitigate the natural aging process. Even if no human cause degrades an artwork, nature does so over time. A created work carries its history, which is bound at its origin and cannot be reembodied.

Philosopher Mark Sagoff presents a more recent and detailed explanation of the importance of an object's history for its authenticity. Art restoration, he notes, is like medical prosthetics in that it saves the appearance of an original but changes the substance. Referring to the analogy of an automobile, Sagoff notes that replacing its parts is different than renovating an artwork because the artwork was created by a particular artist at a particular time as unique. The features of the artwork are historical and cannot be identical to anything else, even something that has the same appearance. Appreciation of the artwork invests in this special quality, which is why originals are valued much more highly than copies made of them and damaged works are restored rather than simply replaced. The authenticity we prize in an artwork is tied to its unique history in such a way that to alter it through restoration, even while offering a pleasing appearance, corrupts its historical being.[48]

At the opposite pole from what Sagoff describes is a view that also keys on the history of an artwork but sees the moment of its creation as a mechanism for change rather than a completed event. Martin Heidegger is sometimes cited as a primary adherent.[49] "Being" is regarded as always in flux, which applies not only to living beings but also to nonliving objects, including artworks. The history of an artwork is dynamic in that its state at creation undergoes development as its life extends into the future, and it is expected

to be different over time. Change is not seen as a loss of originality, although new characteristics will be introduced that were not present at creation. An artwork's authenticity, then, evolves rather than remaining static. Reaction to viewing an artwork should respect this factor, along with decisions about what physical treatment is warranted. Here is an invitation for liberal restoration, and a possible justification for the claim in the *De Balkany* case that an unlimited amount of overpainting is acceptable.

Both of these poles are untenable. Adhering to either one points toward the loss of art objects in order to respect the nature of their authenticity. Without intervention, an object in physical decline may collapse into rubble or remain in existence but be unrecognizable. With intervention, we are told by one view, authenticity is destroyed. By the other view, the expectation of change for any artwork suggests that intervention is not a liability but to be welcomed. If a sculpture is badly damaged, it can live on by having missing parts replaced, and its history has not been compromised but has been assisted. But when all of the parts have been replaced, what remains is merely a reproduction that was constructed gradually. The alternatives are having no object at all or having an object void of any original material and workmanship. When put in these practical terms, neither pole has many adherents, with most parties accepting some sort of middle ground. And over this broad terrain, there are various and conflicting answers for determining how much restoration is acceptable.

One approach to narrowing the middle ground is to apply the principle of parsimony and allow for intervention in a minimal way. Rafael De Clercq contends that "restoration is to make as few alterations as possible while aiming to return those properties that the artist intended the work to have, and which at some point after completion it actually had."[50] Still, a judgment is called for not only about the purpose of the artist, which with many works is something that will never be known, but most importantly, based on a chosen metaphysics of change applied to the historical quality of artworks. Sagoff describes two fundamentally different types of restoration. The more conservative type, "purism," aligns with his own metaphysical preference and includes cleaning along with reattaching remnants from a work's original creation, such as an arm that had broken off from a sculpture. To go further is considered deceptive to viewers and to destroy authenticity. "Integral" restoration is less concerned about changing a work's basic nature, and goes further than purism by replacing what was lost from the original with new materials and workmanship, such as creating a new arm for a statue and applying paint to a canvas where paint is missing or weakened.[51]

In practice, restoration commonly involves both purist and integral principles. An often-cited example by philosophers is the work done on

Michelangelo's *Pietà* after it was damaged in 1972 by a crazed viewer wielding a hammer. Numerous pieces were found that had broken away from Mary's arm and face. They were reassembled with adhesive, and areas where pieces were missing were filled with replacement material fashioned from marble dust. The materials and process respected the call for detectable and reversible repairs that has been voiced by professional associations in recent decades, so the added materials were not permanent and were visible under ultraviolet light.[52] The sculpture also was cleaned using soap and water, resulting in a lighter patina and removal of shadowing around the face from an accumulation of dirt that was thought to add depth to the eyes. Critics argued over whether cleaning resulted in an improvement of the work by revealing its original state or detracted from an improved state it had reached due to aging and that Michelangelo may or may not have anticipated.[53]

The restoration process for the *Pietà* used Michelangelo's own materials as well as integrated substitutions. Another case that followed suit, although in a different fashion, is the treatment of Rembrandt's painting *Danaë* (see Figures 2.2a and 2.2b) in the Hermitage Museum, which was badly damaged in 1985 when a vandal slashed the canvas with a knife and splashed acid on its surface. Restoration took twelve years of painstaking work, with authenticity paramount on the minds of the restorers. Despite pressure from government officials to overpaint and put a prize exhibit back on view quickly, they settled on inpainting blank areas around patches of existing original paint in the fashion of a mosaic. As a museum staff member explained,

> We were very careful with original pigments. Any repainting means dissonance. . . . Some parts are 100 percent Rembrandt, some are 50 percent Rembrandt, and some had to be redone. . . . What the visitor sees is not "the original," and we would never put it forward as such. But the spirit of Rembrandt is intact.[54]

The goal was achieved of presenting the painting in a way that viewers can recognize the workmanship of the artist but also realize that it is now a weaker version of its former self. When seen from a distance of ten or fifteen feet, evidence of the repair fades, while in a close-up observation problematic areas can be distinguished.

The question of how much restoration is too much—so that authenticity has been compromised—is subject to differing views among museum officials when restoring works of art and to various positions among philosophers, as well as the absence of a definitive answer in the courts. What constitutes inauthenticity as a result of restoration has variable interpretations. Even without intentional deception on the part of the restorer à la Hebborn, Jef Van der Veken, Lothar Malskat, and other figures in the history of art forgery, unintended

Figure 2.2a. *Danaë* by Rembrandt, 1636, oil on canvas, 185 × 203 cm, after the canvas was damaged in 1985 and prior to restoration. Reuters/Alamy Stock Photo

Figure 2.2b. *Danaë* by Rembrandt, after restoration. Alamy Stock Photo

deception may occur. But there is not a zero-sum formula or line to be crossed that determines when that happens. Still, without clear-cut guidelines to follow, commercial interests in the evaluation of art objects make financial determinations of their worth that take into account changes made by restoration. Two of the court cases cited previously provide examples.

In the *Monaghan* case, the value claimed for the donated painting was $80,000, supported by documentation from an appraiser who stated that it was in good condition. Although its status as inauthentic was determined later on connoisseurial grounds rather than overrestoration, the discovery that only 40 percent of the original paint remained on the canvas devalued the work monetarily. The experts who declared the painting was inauthentic estimated its fair market value to be $3,000 at the time it was listed as a charitable deduction. One of the experts said this was the proper value even if the painting were an original, given the extensive restoration that had occurred. Similarly in the *Ferrari* case, when during the trial the works in question were said to have undergone restoration not recognized at the time they were declared as a charitable deduction, their monetary worth dropped. The most notable change was for a Jaina figurine originally appraised at $18,000, which the professional who had done the appraisal now estimated at $500 after recognizing its considerable restoration. With other objects, he revised his estimates to a lesser extent, including a Mayan cylinder base originally listed at $30,000 lowered to between $15,000 and $20,000. Restoration, then, clearly can reduce the commercial value of artworks, whether or not their authenticity is in question. This downward revaluation suggests a perspective in which authenticity is seen as lost in degrees, with the extent of the loss being an individual matter for each object in question that is determined by expert opinions.

COLLABORATION

In the restoration process, someone other than the creator of an artwork becomes involved after the work has been completed, sometimes leading to questions about authenticity. In other situations, multiple artists are involved while the work is being created, making it a collaborative effort, although typically the resulting product carries only one name. As with restoration, a concern sometimes arises as to whether adding the participation of another person challenges the claim that a work is an original by a single named artist. Does coproduction undermine authenticity? Is there an amount of participation or type of participation by someone other than the named artist that, without formal recognition, renders a work inauthentic? History provides various examples from the Renaissance to the present where collaboration has

been an accepted practice, yet at times the matter becomes thorny in philo-sophical and legal terms as well as public opinion.

In some instances of collaboration, multiple names are given as the artist of record. The coproduced paintings of Rubens and Jan Brueghel (the Elder) in the seventeenth century are a classic example. Over a period of nearly three decades, they jointly completed two dozen paintings of various religious and mythological themes, with Rubens rendering the figures and Brueghel the landscape background and various details. Each artist contributed his own specialty while adhering to his own style to complete a product that offered the best of both. As the two most renowned southern Netherlandish artists of their day, they held equal prestige among the public and respect between themselves as well as being close personal friends. Often without signatures to name the artists, these paintings were still prized, and because of the joint attribution by two masters rather than one, they carried an inflated value. The combination of major talents was perceived as an all-star team. In other instances, each artist collaborated with other artists who were respected profes-sionally but of lesser renown (Brueghel with Hendrick de Clerck, for instance, and Rubens with Frans Snyders).[55]

While Rubens's collaboration with recognized names occurred on an occasional basis, he worked daily in a combined effort with underlings in his studio. The system he developed for joint production is sometimes cited for efficiency and business acumen among artists of his day. His output was prodigious, including many works of monumental size. Some paintings were fully autograph works, but for many others, various assistants were employed to produce part or most of the painting, often with a division of labor in which specialists concentrated on animals, backgrounds, or other features. The master first made a drawing, then a small oil painting on panel as a model, and perhaps a chalk sketch on the main panel or canvas. Later, he put on final touches and oversaw quality control. For engravings, assistants typically made sketches copied from his paintings and also executed the printing process.[56] All of these works carried Rubens's name alone, although on some occasions buy-ers were informed about the contributions of assistants, and it was understood that products exclusively of the master's hand carried greater value. Important clients were treated with care, as with English nobleman Dudley Carleton, who inquired about purchasing a dozen paintings from Rubens's inventory. The artist provided a list that noted some as retouched, one as a collaboration with Snyders, and another as worked on by his best student, with only five works as fully original. When Carleton balked, Rubens submitted another list specifying paintings that were exclusively his along with others worked on by assistants that he guaranteed to be of top quality and offered at bargain prices.[57]

In the late nineteenth and early twentieth centuries, Rodin developed a notable studio system of production that followed that of his Renaissance predecessors. The first stage, after preparing a set of drawings from various angles, was to fashion a model figure from clay or wax that was then cast in plaster, often with several copies made. With this much accomplished by the named sculptor, the remaining work was done by assistants who carved from stone or made casts in metal. Carving was carried out with a pointing machine, which ensured faithfulness to the model being followed and allowed for scaling up or down in size. In sum, Rodin himself made the models for his works, and his studio artists completed the process of transferring them to other mediums. His plaster casts were prized, and the artist often gave them as gifts to friends, and toward the end of his career, he experimented with assemblages of plaster and bronze.[58]

In the twentieth and twenty-first centuries, collaboration between artists moved beyond previous practices. Not only have coequal relationships occurred occasionally, but in some cases the artists have engaged in them for all of their works or at least frequently. The results are promoted as joint productions. The posters of the Stenberg brothers, from early in the twentieth century, are signed "2 Stenberg 2"; Gilbert & George have collaborated since the 1970s, working in various mediums and signing together; Komar and Melamid signed jointly for several decades. Other examples include the Starn brothers (Doug and Mike), Jane and Louise Wilson, the Zhou brothers (ShanZuo and DaHuang), and the Boyle family.[59] Collaboration among equals has led to the building of team reputations in which multiple artists are recognized as single entities. In an extension of this principle, the logo for "The Art Guys" (Michael Galbreth and Jack Massing) features their professional moniker more prominently than their surnames.[60]

Studio collaboration of artists with unequals also has reached a new level in recent decades. Andy Warhol's naming of his studio as the "Factory" demonstrated not only his employment of a large number of assistants but also an attitude about the contribution needed by an artist to designate the products sold under a single name as originals. In the 1960s, he assigned the entirety of the painting process for some of his canvases to an assistant and, by the 1970s, left craftsmanship to others for many works in what had become mass production. One assistant said that he and Warhol communicated by phone rather than working together in person, and that even the security guard became a painter on busy days.[61] Another assistant attested that his employer's primary role in making numerous works was to sign them when a sale was made.[62] Other artists followed Warhol's approach with even more boldness. Jeff Koons, Damien Hirst, and Dale Chihuly, in particular, are known for large

outputs of artworks carrying their name that involved little or none of their workmanship. In some cases, the images as well as the workmanship have been challenged as not being theirs. Discussion of that factor and how it relates to authenticity will come in the section of part II on appropriation.

Koons is on record in an interview as saying, "I'm basically the idea person. I'm not physically involved in the production. I don't have the necessary abilities."[63] Hirst, too, has noted his incapability to produce works put out under his name. Regarding the spot paintings that gained him fame, he stated, "I only painted the first five. I was like 'f--- this, I hate it.' As soon as I sold one, I used the money to pay people to make them. They were better at it than me."[64] On another occasion, referring to Rachel Howard, a recognized artist in her own right, he remarked that "the spots I painted are shite. The best person who ever painted spots for me was Rachel. She's brilliant. The best spot painting you can have by me is one painted by Rachel."[65] Chihuly, known especially for his sculptures in glass, has not blown glass since 1979 due to a physical disability incurred in a surfing accident. His studio continues to produce glass creations in his name as well as works in other mediums where he employs assistants.

What differentiates these present-day artists from Rubens, Rodin, and other predecessors who made regular use of studio workers while promoting their finished products under a single name? A key is their admission that none of the workmanship, rather than at least some of it, is theirs. They make no allowance, as Rubens did, for differences in price—a proxy for difference in authenticity—according to how much their own participation was involved. The value lies simply in the name attached to their work, and not in how much or what sort of workmanship was accomplished by whom. But in what sense, then, are these artists masters? Rubens was a gifted painter whose autograph works demonstrate his ability with a brush. Rodin's remarkable talent was in sculpting with pliant material to create completed images that were later reproduced in other mediums. Koons and Hirst have acknowledged their own lack of capability, and Chihuly was at one time an accomplished glassblower but long ago lost his dexterity. Not only do these contemporary famous figures not perform workmanship but they do not possess the capability for it, a factor many art aficionados would say is crucial in assessing an artist's stature.

The practice of artists declaring works as their own when they have contributed nothing to the workmanship has been successful for certain ones who have achieved fame, high prices, and inclusion in museum collections. But the practice is controversial. There is public skepticism, and gallerists are sensitive about it. In Australia, noted Aboriginal painters have drawn attention for pro-

ducing works that relied on the labor of other artists. Turkey Tolson Tjupurrula declared that he had signed paintings done by his relatives, Kathleen Petyarre's husband was a collaborator on her paintings, and Clifford Possum Tjapaltjarri was investigated for fraud for signing paintings he did not create.[66] At the White Cube Gallery in London, when an art writer approached sales assistants to ask if Hirst had any physical input in making the works on display there carrying his name, the responses were cagey, with one changing the subject, and another saying, "the gallery told us that if asked, we should say: Yes, but how much we're not sure."[67] Art experts, too, may be critical, as with the Andy Warhol Foundation, which was sued in 2007 after its authentication board decided that a *Red Self-Portrait* silkscreen, one in a series of the artist's best-known works, was inauthentic because Warhol was not present when it was printed. The plaintiff accused the Warhol organization of manipulating the art market to benefit the value of its considerable holdings of the artist's works.[68]

Given that the practice of collaboration is subject to dispute, where does it stand legally? The matter of who among collaborators gets credit for an artwork is intertwined with economic rights as supported by copyright law, and is tied to the statutes of individual countries. In some countries, the tradition of "moral rights" speaks to legal claims of authorship, but even so, precedence often is given to physical ownership and property rights.[69] Under Title 17 of the US Code, copyright goes to a person who creates a work. However, with "works made for hire," "the employer or other person for whom the work was prepared is considered the author . . . and unless the parties have expressly agreed otherwise in a written statement signed by them, owns all of the rights addressed in the copyright."[70] When the United States passed the Visual Artists Rights Act of 1990, which provides protections for the makers of paintings, drawings, prints, sculptures, and still photographs, it retained the "works made for hire" clause. In a US Supreme Court decision (*Community for Non-Violence v. Reid*, 1989), a test involving several factors was established to determine who qualifies as an employee for hire, as distinguished from an independent contractor who might claim to be a coauthor rather than a hired worker. The factors include, among others, the right to control the manner and means of production, the skill required, whether the hiring party has the right to assign additional projects to the hired, and whether employee benefits are provided.[71] Not all of the factors may be relevant in any given case, and which ones and how much they are weighted vary on a case-by-case basis.

Because of the dominance of copyright law, artists in the United States who are hired to make artworks for other artists face a high bar to clear if they wish to claim a legal right of coauthorship. On the other hand, because

the list of factors defining "for hire" that may be considered in any given case is variable and complex, establishing coauthorship is not ruled out. Taking legal action may be beyond the means of most studio workers involved in creating pieces for established artists, but it occurs occasionally. Chihuly has been involved in two key cases of this sort, the first of which, *Chihuly v. Kaindl* in 2005, drew countercharges from the defendants. Chihuly alleged that former employee Bryan Rubino was producing glassworks based on his images, which were being sold by Robert Kaindl, whose name was put on them.[72] Chihuly declared that his glassblowing technique was unique and that the copied works were in categories he was well known for such as baskets, chandeliers, sea forms, and cylinders. The defendants responded that their glassblowing methods were centuries old and that design categories taken from the surrounding world are in the public domain and not protected. They countered Chihuly's claim to be the creator of works sold under his name by attesting that his employees not only produced them but in some instances conceived and signed them for the artist as well. Evidence included a fax from Chihuly to Rubino saying, "Here's a little sketch but make whatever you want."[73] At issue were both the source of the images Chihuly held to be his own and the workmanship involved in executing the images. The suit was settled out of court, which left no precedent to influence further legal actions, but it drew considerable attention to the contributions of assistants in making items sold as Chihuly originals. One focus was on Chihuly's prints, which, it was said, the public and gallery owners had been misled to think Chihuly had enhanced with hand painting when in fact the painting was done by someone else.[74]

Another suit challenging Chihuly's claim of sole authorship was filed in 2017 and decided in 2019. Michael Moi alleged that for fifteen years he worked with Chihuly in conceiving and executing paintings and drawings, and he asked for redress under the Copyright Act and the Visual Artists Rights Act, which includes recognition of coauthorship and sharing in the proceeds for the artworks in question consistent with that status.[75] Chihuly countered that Moi was trying to take advantage of his mental illness by demanding payment in exchange for silence about his condition.[76] Moi's claim included numerous instances over fifteen years of working in a group with Chihuly and several other artists in clandestine painting sessions, while sometimes conceiving of designs for Chihuly's paintings and sometimes signing Chihuly's name on finished works. Moi asserted that he was told the process involving him must be kept secret or the value of Chihuly's works would suffer, and that he never signed documents of employment, was never paid, and was promised on several occasions that records of his participation were being kept and he

would be paid eventually. As with the previous case, in this one both the design of Chihuly's works and their execution were at issue, with various details pointing to Moi's frequent and extensive contribution. Also significant is that the party claiming coauthorship, and compensation at that level, did not enter into a written employee agreement. The case was settled in a summary judgment for Chihuly in which the judge determined that the plaintiff's contribution to the paintings in question merely mimicked Chihuly's style, and he failed to provide evidence of mutual intent to be coauthors as well as of the market appeal of his contribution to the paintings (said to come mainly from Chihuly's name and iconic style).[77]

Artists who hire out the process of making their autograph works have copyright law behind them. Additionally, they can look to philosophical support, particularly from postmodern thought. When Koons, Hirst, and Chihuly assert that they come up with ideas that others embody physically, and that their ideas alone are the key to their being artists, they are appealing to the doctrine of "conceptualism." The main point of the conceptualist approach is that art identifies more closely with the concept from which an object is born than with the physical manifestation of that concept. The true work of art is not the material piece viewers see but the mental activity that precedes its embodiment. When art is thought of in this way, questions about its authenticity focus on concepts rather than objects. The matter of who made an artwork is of little concern, and its ideational model becomes paramount.

Artist Sol LeWitt is often cited as an early proponent of the doctrine of conceptualism. As stated in a 1967 essay,

> In conceptual art the idea or concept is the most important aspect of the work. When an artist uses a conceptual form of art, it means that all of the planning and decisions are made beforehand and execution is a perfunctory affair. The idea becomes a machine that makes the art.[78]

LeWitt reinforces this idea through dictums that depreciate the worth of workmanship in the process of making art, saying, "banal ideas cannot be rescued by beautiful execution" and "when an artist learns his craft too well he makes slick art."[79] What is most worthwhile, then—what counts—in art are mental constructs without their physical expression, a view that has been taken to uphold the hiring of assistants to perform whatever workmanship is required as not only acceptable but even desirable. LeWitt did not claim that conceptualism should apply to all artworks and all types of art, but other theorists have expanded the idea in that direction.

A more recent statement comes from philosopher Alva Noë. He suggests that when we think about paintings, it should be not on the autographic

model (valuable for the signature) but on what he calls an "architectural" model:

> Le Corbusier doesn't have to have built the structure first for it to be an expression of his artistic accomplishment. And so with painters. It isn't the dubious magic of the artist's touch that is significant. What matters, rather, is the distinct achievement of the artist's conception, a conception that can be realized in different ways.[80]

Noë goes on to mention Titian, Rembrandt, Rubens, and Koons as artists known for delegating the workmanship on their originals to surrogates, and then raises the prospect of Vermeer's daughter having made a number of his paintings. Such works, he says, if considered according to an architectural model, "quite possibly (not necessarily)" could be authentic Vermeers, asserting that "maybe Vermeer found a new way to make paintings, a new method? He used his daughter!"[81] This notion corresponds with statements like Hirst's that "I don't think the hand of the artist is important on any level, because you're trying to communicate an idea."[82]

Paisley Livingston adds another philosopher's insight that supports conceptualism and aligns it with determining what persons and types of action should be given credit for the creation of an original artwork. An artwork is attributed to the person or persons holding creative control. This control can be exercised without participating in the physical activity of making an object, in which case it can be likened to a film director's role of supervising the actors who appear on screen.[83] Livingston provides examples for clarification. One (hypothetical) cites a series of silkscreen prints designed by Andy, who gives detailed instructions to artists he hires to produce the images.

> At no point does Andy draw anything or lay a finger on any of the materials, and at no point do his apprentices introduce any artistically significant innovations or changes. Andy is the sole "author" here, as control and credit are his throughout.[84]

In another example (real life), Vanessa assembles a group of women in a gallery space for a performance. Their appearance is dictated (naked except for black high-heeled boots), while their movements are of their own choosing although they must not move abruptly, speak, or contact the audience. Vanessa is designated as the "primary artist" here even though she has ceded control of substantial artistic affect to the performers, and credit for the result as a whole is hers.[85]

Livingston allows for coauthorship of a work, requiring that there be "meshing sub-plans," meaning individual conceptions of what the finished

product is to be. The plans must involve "shared control and decision-making authority over the results."[86] What counts, then, as authorship in making art has to do with planning. Execution, if it figures in, is a minor partner, which is why Vanessa still gets credit for the performance she stages even though she engages people for essential tasks, and Andy's assistants are thought of as little more than programmed devices. This position that disregards or debases workmanship in artistic production runs into difficulty, as counterexamples demonstrate. Just who is Andy, said to be the sole author of what he has conceived but not executed? Is he an artist? What if he is not, but instead is a collector? Suppose the collector commissions Jeanette, a professional artist, to make a portrait of his father that is to be copied directly from a photograph he provides. The portrait is intended to look as much like the photo as possible. When Jeanette completes the painting, whose signature should go on it? Is it the work of the person who made it according to specifications or of the person who hired her to do that? Or perhaps the photographer? To move from the hypothetical to the real, consider John Myatt's career before he became an infamous forger. To earn money as an artist, he ran a magazine ad seeking commissions to make "genuine fakes," and had requests for a wide variety of paintings. Among them were copies of known works such as a landscape by Monet, along with idiosyncratic visions, including a client's uncle dodging bombs amid an aerial attack on London in World War II, a puppy chewing on a bone during the Battle of Agincourt, and a skeleton having intercourse with a nun in the ruins of a Gothic abbey.[87] The concepts for these paintings clearly did not come from Myatt, but who would question that he should be the named artist?

Next, consider a modified version of Jeanette's commission. A gallery owner has been in discussion with a client who has described an image but does not want to commission it as a painting for fear of being disappointed with the result. The gallery decides to take a chance, and the owner presents his understanding of what is to be done to a sales representative, who engages Jeanette to be the painter and gives her his interpretation. Who should be the designated artist for the work Jeanette paints? Jeanette? The gallery owner? The sales representative? The client it was made for? Is it a collaborative work with multiple authors deserving recognition? Relying on the principle of creative control in determining who is and who is not a legitimate author of an artwork so that it carries authenticity under that person's name, leads to confusion. Without allowing workmanship into the equation, the resulting answer confronts common sense and ordinary language.

These counterexamples expose the liability of conceptualism to being applied equally across art forms. The theory fits some forms better than others. The completion of a monumental sculpture requires more people than the

one who conceived it. The same goes for a building made from an architect's plan. Performance art often needs multiple participants, along with other innovations involving unconventional materials and procedures. A LeWitt wall drawing, for instance, was made to be re-created with new materials each time it was exhibited (with instructions by the artist that remained constant).[88] A Koons sculpture, *Puppy*, stood several stories high and was made of stainless steel, soil, geotextile fabric, live flowering plants, and an internal irrigation system. Works like these, along with buildings and traditional large sculptures, are explained comfortably from a conceptualist perspective. Their designs cannot be executed without surrogates such as actors in a performance or workers to assemble a large structure. Here, Noë's reference to architecture is appropriate, along with Livingston's comparison of an artist with a film director. Limitations on artistic production require employing other people. This necessity is understood and respected.

The same point does not hold when Koons and Hirst hire out the workmanship on paintings. Their reasons for engaging assistants are different, which, by their own admission, are impatience and a lack of skill. With performance art and large structural creations, workmanship by the originator of the idea for a particular work lies in orchestrating others to do what it is not humanly possible for the originator to do individually. With a painting, the exercise of workmanship can go further without appealing for help: not only is it humanly possible to go further, but there is a popular expectation for an artist to execute a work to the extent that artists typically are capable of with that art form. If they do not and involve surrogates, authenticity comes into question. This is why, compared with an autograph painting by Rubens, a painting bearing Rubens's name but known to be done in collaboration with his assistants carried a lower value, both culturally and monetarily, in his own day as well as today. Conceptualism applied to the making of paintings is an uncomfortable fit. The idea of privileging this type of artwork, with execution not only diminished but excluded from significance, sets up a division that is both false and incomplete. Even if LeWitt and others are right in pairing conception against execution such that conception is a higher process, that point fails to recognize that the combination of conception plus execution is higher yet.

APPROPRIATION

Related to collaboration is the practice of appropriation, which also is controversial and has faced legal challenges. Whereas in collaboration the contested issue involves an artist acquiring the workmanship of someone else, in appro-

priation what is debated is the acquisition of ideas embodied in the images of artworks produced by others. Critics have sometimes equated appropriation with forgery, but that characterization is misleading. Forgery is the presentation of one's own work as that of another artist, whereas appropriation uses another artist's work as one's own. To put it another way, each practice is a form of exploitation, in one case of a name and in the other case of an image. When appropriation goes wrong, it turns into plagiarism rather than forgery. The legitimacy of appropriation art—what both philosophically and legally is argued to make it other than plagiarism—is determined by how it is distinguished from conventional copying. Although appropriation is not a variety of forgery, it can be thought of as a close cousin, and it is open to challenges concerning the authenticity of the works it generates.

Appropriation art as it is known today is traced by historians to the early twentieth century. It was prompted by artists such as Picasso and Braque in their use of ready-made materials in assembling collages, and especially Marcel Duchamps's taking over whole objects and presenting them as artworks in themselves. Recognition for this approach grew, and by the 1980s and beyond, the term "appropriation" was standard vocabulary, identified with artists such as Andy Warhol, Sherrie Levine, Elaine Sturtevant, Robert Rauschenberg, Jeff Koons, Damien Hirst, and Richard Prince. Beyond using existing objects, they simply confiscated images. Appropriation is differentiated from conventional copying through postmodern thinking, as a challenge to the artistic conventions of originality and creativity and as mocking commercialism or making social commentary of other sorts. The thrust is to do something new with what has already been done, including the use of existing images in full with no alteration or slight alteration that are then put into different settings to introduce new meanings.

An argument commonly offered in support of the practice of appropriation notes that artists have always been copyists. Often added is the assertion that historically this was not a cause for conflict.[89] And it is said that conditions could not be otherwise: all art is derivative because any artist necessarily draws on prior ideas and works. This line of thought is far from new and has been promoted by philosophers and in legal scholarship as well as in the popular press and by artists themselves. Artist Robert Motherwell exemplifies the view that all artists borrow from others: "Every intelligent painter carries the whole culture of modern painting in his head. It is his real subject, of which everything he paints is both an homage and a critique."[90] Philosopher R. G. Collingwood, in his well-known book, *The Principles of Art*, speaks strongly for artists who copy others, citing historical precedent:

> I refer especially to that kind of collaboration in which one artist grafts his own work upon that of another, or (if you wish to be abusive) plagiarizes

another's for incorporation in his own. A new code of artistic morality grew up in the 19th century according to which plagiarism was a crime.[91]

The argument goes: because artists have always been copyists and cannot help themselves, and borrowing from others was not a problem until late in history, then appropriation should not be a cause for complaint. Whether called "borrowing," "copying," "appropriating," or by other words, artists are following the normal order of things. To quote Collingwood again, "I will only say that this fooling about personal property must cease. Let painters and writers and musicians steal with both hands whatever they can use, wherever they can find it."[92]

The perspective that copying is normal and not wrong offers a convenient defense for appropriation art, but it suffers from overgeneralization. Although many artists in history borrowed from other artists, and some appropriated whole images, this does not mean that those who were borrowed from, or the public of their time, approved. Historical events described in part I involving Albrecht Dürer in the sixteenth century and Paul Revere and William Hogarth in the eighteenth century demonstrate the pushback that occurred against artistic appropriation. The movement toward comprehensive copyright laws in the United States and Europe began in the eighteenth century, grew in the nineteenth century, and developed further in the twentieth century, but the fact that legal control over copying is not universal over time does not diminish its importance today. Further, current law makes provisions for artistic appropriation in some circumstances but clearly does not give blanket protection for it. To suggest that appropriation has historical sanction, and opposition to it is a recent aberration that should be surpassed, is misleading at best.

Also misleading is the position that since all art is derivative, appropriation must be acceptable. Artists do not create ex nihilo; they borrow from what they are familiar with when they create. But this does not mean that all artistic borrowing is acceptable any more than that it is acceptable outside the realm of art for people to borrow things from their surroundings when they find they can make use of them. Appropriationists emphasize what they can do with what they borrow, to the neglect of other conditions. But the well-being of those who are appropriated from also comes into play, and when the appropriated item is a work of art, the act of appropriating answers to copyright law. Collingwood's pitch notwithstanding, taking whatever one wants wherever one finds it runs into trouble in the art world just as it does elsewhere.

Despite the explanation that the works they create offer new meanings, appropriation artists have often been denounced by the artists whose works they targeted and have faced legal claims based on copyright infringement. In the United States, in particular, there have been numerous claims, some of

which have been settled out of court. In the 1960s, Warhol fended off three complaints from photographers by giving them (and their agents or attorneys) works of art. One was offered royalties on the future use of the image in question. According to a Warhol associate, "he learned a lesson from the lawsuits" and began securing permissions for his appropriations.[93] Another associate said, "Andy realized that he had to be very careful about appropriating for the fear of being sued again. He opted to start taking his own photographs."[94] In the 1970s, Robert Rauschenberg moved away from using appropriated photos after settling legal problems out of court, and Sherrie Levine, who purposely cultivated a reputation for reusing other artists' images, agreed to a settlement after which she copied works available in the public domain.[95] In 2011, artist Shepard Fairey settled with the Associated Press (AP) over a photograph he appropriated to create a poster for Barack Obama's presidential campaign, agreeing to share rights to the image as well as the merchandising of it, along with a promise to obtain a license for future use of AP photos.[96] On other occasions, accused appropriation artists have decided to go to court, resulting in various decisions that reflect an array of legal thinking about copyright and art.

US copyright law has its foundation in the Constitution, which states that Congress has the power "to promote the Progress of Science and the useful arts, by securing for limited Times to Authors and Inventors the exclusive Right to their respective Writings and Discoveries."[97] The intent is to encourage creators to continue creating, to the benefit of society, rather than give up for fear that whatever they develop will be immediately copied and produced by someone else. Over time, "writings" has been broadly interpreted to include artistic creations and "authors" to include artists, while "useful arts" include fine arts.[98] Successive copyright laws have been passed, and various court cases have set precedents that provide protection for artists against infringement. However, there is an important exception to this protection. Under the Copyright Act of 1976 (with prior legal precedent), it is legal for the works of an artist to be used by another party according to the doctrine of "fair use" (analogous to "fair dealing" used by many other countries, although with structural differences between the two approaches[99]). The objective of fair use is to further freedom of expression and the public good by allowing existing material to be put to new uses and not repressed under exclusive control. A set of four factors is stipulated for determining when fair use is present.

1. the purpose and character of the use, including whether such use is of a commercial nature or is for nonprofit educational purposes;
2. the nature of the copyrighted work;
3. the amount and substantiality of the portion used in relation to the copyrighted work as a whole;

4. the effect of the use upon the potential market for or value of the copyrighted work.[100]

There is no instruction as to how these factors are to be considered holistically or how any one of them is to be evaluated. Courts must determine that one outweighs another when they do not all point in the same direction.

Jeff Koons's several experiences of being sued for infringement highlight the evolving interpretation of the fair use doctrine. An action was brought against him in 1989 (*Rogers v. Koons*) for copying an image of puppies he found on a postcard and made into a sculpture he titled *String of Puppies*. The photographer who took the photo for the card claimed infringement. Koons's defense was that he was parodying the image and in that way changing its meaning, which was aimed at satisfying the first factor of fair use. The court rejected this explanation by noting that the sculpture failed to ridicule the material it drew from and that the commercial purpose by which Koons gained from his appropriation was evident.[101] Another lawsuit (*United Feature Syndicate v. Koons*) followed in 1993 over his sculpture *Wild Boy and Puppy*, which copied the *Garfield* comic strip character "Odie," with a similar defense and similar result.[102] The artist then began licensing copyrighted images he appropriated, although he was sued for infringement on later occasions. During the intervening period an important Supreme Court decision established a precedent favorable to appropriation art. In *Campbell v. Acuff-Rose*, a musical group's combination of new lyrics with the score from a famous song was found acceptable because the resulting work was "transformative" by making a general comment on culture without parodying the appropriated content. Furthermore, the newly named characteristic of transformativeness was held to be important enough that as it increases in degree, the four factors considered in fair use are diminished.[103]

Koons was sued in 2003 (*Blanch v. Koons*) for the unauthorized use of a photograph in his collage painting *Niagara*. This time he relied on transformativeness and won the case, which in 2006 was affirmed when the plaintiff appealed to the circuit court level. Although all four fair use factors were considered, transformativeness was key, with the defendant stating that the copyrighted work he appropriated was used for the purpose of the "creation of new information, new aesthetics, new insights and understandings."[104] With transformativeness established in case law, it became the basis for Richard Prince's defense in *Cariou v. Prince* in 2013 for tearing a set of thirty-five photographs from a book and pasting them on a board as a collage, trimming and overpainting some in the process. Thirty more works comprising the *Canal Zone* series were made using photos removed from other copies of the same book. The district court's ruling was against fair use because the defendant

demonstrated no parody on an individual level or a satirical commentary on culture more broadly. However, Prince won on appeal for all but five of the thirty works in question when the Second Circuit Court determined that transformativeness does not require commentary of any sort invested in a work by its author but rests on how the work is perceived by viewers. Whether transformativeness is present depends on what the work is seen to be rather than on an intended message by the artist. The court found *Canal Zone* to "reasonably be perceived" as of a different nature than the appropriated photos that appeared in it. Further, when the court evaluated the market effect of the appropriation in the fourth factor of fair use, it focused on the economic damage the plaintiff might experience in the particular market where the original was sold compared to damage in the market for the new work, declaring that the more transformative the work is, the less likelihood there is that the markets will overlap. Cariou's book from which the photos in question were taken earned $8,000 in royalties, whereas Prince's work that used the photos netted millions, selling to a different audience. Thus, Prince had not interfered with the marketability of Cariou's work.[105]

The trend in US copyright cases toward easier acceptance of appropriation art has drawn much commentary and controversy. The practitioners of appropriation appreciate that their method has acquired the cachet of legal recognition. Postmodern thinkers on art favor the message transformativeness sends about rejecting tradition and establishing new meanings. And supporters of freedom of expression find an ally in a policy of noninterference. On the other hand are legal thinkers and philosophers who oppose the courts being placed in a position of having to make judgments about aesthetics. And they specify that a particular brand of aesthetics has been privileged, along with a particular view in economics.

Legal scholars have pointed out that the variety of opinions on the nature of fair use in appropriation art is grounded in differing approaches to aesthetics.[106] Judges are forced to make determinations based on philosophical considerations that are out of their purview and that have a reputation for being subjective in contrast with the objectivity sought in matters of law. Concern about mixing the law with the ambiguity of art was spoken to famously by Justice Oliver Wendell Holmes more than a century ago, saying, "It would be a dangerous undertaking for persons trained only to law to constitute themselves final judges of the worth of pictorial illustrations, outside of the narrowest and most obvious limits."[107] This warning is born out in the copyright decisions described here. In the cases of *Rogers*, *United Feature Syndicate*, and *Campbell*, the crux of the reasoning rested on whether the artist fulfilled the intention of changing the meaning of appropriated material. Embedded in the decisions was the basic aesthetic theory of intentionalism. Its premise, which has already

been discussed, is that aesthetic judgments should focus on the intention of the artist producing a work. In *Cariou v. Prince*, on the other hand, the intention of the artist was noted, but what counted instead was the response to the work by viewers. Here, what is often referred to as "reader-response theory" controlled the outcome. A third alternative is formalism (mentioned earlier and to be discussed further in part III), which focuses on the visible features of objects such as line, shape, color, texture, and composition, to the exclusion of artists' intended meanings as well as the meanings viewers may interpret through the context of the times and their own personal preconceptions. Although it is possible to consider more than one theory in any situation, doing so requires assigning relative weights and often simply choosing one over the others. Judges cannot avoid these basic theories when assessing objects of art. Their views come from one direction or another whether or not they are aware of the full range of possibilities open to them.

How should jurists deal with the embeddedness of aesthetic theories? One suggestion is for them to become educated in the field, although the extent of their effort that can be expected is questionable given the limited number of cases where they could apply their new knowledge. Another proposal has been to develop a procedural mechanism that would employ groups of experts from the art world to determine what "community of practice" a work under consideration falls within, after which jurists would follow that lead in selecting the theory most applicable to the nature of the work.[108] Both of these ideas face the problem that in the end judicial decisions will be determined by one theory of aesthetics or another. A heightened level of expertise does not remove this reality. Still a third possibility for dealing with conflicting aesthetic theories in fair use is to eliminate or minimize the first factor of fair use. This approach, although removing the confusing dimension of transformativeness, would deny the legal recognition for appropriation that its proponents say is deserved. And it would leave more weight placed on economic matters via the fourth factor, which has liabilities disliked by opponents of appropriation.

Support for deflecting the influence of the transformativeness doctrine is more than speculative. In the 2004 case of *Kienitz v. Sconnie Nation*, the Seventh Circuit Court affirmed fair use for an appropriated photograph based on its market effect but rejected "transformative use" as a rationale. The court stated that it is not one of the four statutory factors that should be considered, and suggested the Second Circuit Court went too far with it in the *Cariou* case: "We think it best to stick with the statutory list, of which the most important usually is the fourth (market effect)." Otherwise, transformativeness could replace or override the list to the extent that any appropriated work could be justified by claiming fair use.[109] Further, in 2015 Prince was in court again (*Graham v. Prince et al.*) facing a complaint for rephotographing a photo

and adding a caption. In 2017, the district court denied his request for dismissal or summary judgment because the contested work "does not make any substantial alterations to the original," and Prince and the plaintiff were targeting the same market.[110] These cases serve as indicators of the unsettled and changing status of fair use in legal thinking about appropriating images.

Outside the legal system, too, there is skepticism about appropriation. Observers ask why artists lack protection for the works they create such that other artists are allowed to take from them. The issue is generally seen as a matter of basic rights rather than theories about art. The rights envisioned draw from assumptions that are not present in the US copyright law that governs fair use. Matters of copyright derive from a statement in the Constitution about promoting progress in the arts, making it an instrumental right, something given to people by the government in the best interest of society. But the basic rights envisioned by opponents of appropriation are often conceived of as natural, and thus more fundamental than instrumentalities. One view traces to the reward expected for the fruits of one's labor, which holds that someone who creates property has earned the right to control it. This idea is prominent in American thinking, although subordinated in copyright law.[111] A related view, which holds more sway in Europe and has philosophical roots in Germany and France, emphasizes a moral right deriving from the personality of an artist that is invested in an artwork.[112] Both views trace to something an artist infuses into an artwork, whether it is explained as personality or labor. The work itself, then, bears personification. Either approach to natural rights places greater value on the right of an individual than on a government's claim to further the common good. Taken from the abstract to the concrete, this means giving priority to artists for what is naturally theirs—their original works—over other artists who appropriate those works and use them for their own purposes.

How this perspective plays out in court is represented by a 2017 case in France, where Koons was sued for copyright infringement over another sculpture from his 1988 *Banality* series, which also included *String of Puppies* and *Wild Boy and Puppy*. The image for *Naked*, depicting a boy and a girl, was appropriated from French photographer Jean-François Bauret's work *Deux enfants* and features essentially the same pose but adds flowers in a bouquet and strewn around the base (see Figures 2.3a and 2.3b). When the Pompidou Center publicized an exhibition in 2014 that would include the work, Bauret's widow filed a claim against Koons and the museum. The charge was against an image of the sculpture in an exhibition brochure and on Koons's website, but not against the sculpture itself because it was held back from display. The French court deciding the case considered transformativeness as well as freedom of expression, with these principles weighed against intellectual prop-

Figure 2.3a. *Deux enfants* by Jean-François Bauret, 1970. Estate of Jean-François Bauret/ Courtesy Baudoin Lebon

Figure 2.3b. *Naked* by Jeff Koons, 1988, porcelain, 115.6 × 68.6 × 68.6 cm. Prisma by Dukas Presseagentur GmbH/Alamy Stock Photo

erty rights. The ruling was against Koons, noting that it was unclear why he needed the particular photograph in question to make his point and that the image was not well known to the public and, therefore, would not be subject to parody, as well as suggesting the artist's motivation for appropriation was to save on creative effort.[113] The artist was assessed a payment of $29,000 and the Pompidou Center $24,000. A much higher amount would have been possible if the sculpture itself had been exhibited or sold.[114] In another case against Koons in France, decided in 2018, his *Banality* series continued to draw copyright infringement charges, this time for the sculpture *Fait d'hiver*, in which a pig stands beside a woman lying in the snow. In 2014, photographer Franck Davidovici noticed an image of the work in a catalog promoting a Koons retrospective at the Pompidou Center, noting its similarity to his photo used in a 1985 clothing advertisement. In deciding the lawsuit he brought, the court considered both the parody defense and an appeal to freedom of expression, finding Koons and his codefendants (his own company and the Pompidou Center, the organizer of the exhibition and the publisher of the catalog) guilty and issued fines totaling $170,000.[115]

Taken collectively, recent legal decisions regarding what constitutes fair use in appropriation art demarcate a domain that includes conflicts and contradictions, especially over permissiveness as determined by the principle of transformativeness. On one hand, permissiveness can be seen as proper growth in the law in keeping with revised views about art that are part of evolving culture. On the other hand is the view that fair use has been opened too wide so that fairness to artists who are appropriated from has been compromised. A critical perspective also sees permissiveness as moving toward monopolism by favoring an art elite at the expense of artists generally, and nullifying rather than supporting the purpose of fair use to promote creativity.

When an artist makes a work by appropriating, something new develops out of what already exists. Progress in the arts, as envisioned in the Constitution and its extension in fair use, has been achieved. What happens when a work made through appropriation is itself subjected to appropriation? Presumably still another work is generated that adds again to the community store of ideas and so on through further versions. But what is presumed in theory has broken down in the practical realm where artists sell their products, when some of the most prominent names in contemporary art who practice appropriation have taken legal action, or threatened it, to prevent other artists from appropriating their productions. Chihuly's case against a former employee accused the defendant of copying from categories of design he is known for, such as baskets and cylinders, rather than from individual works, as if those categories were his to be protected. In 2010, Koons claimed he was victimized by a business selling bookends shaped like his well-known

sculpture *Balloon Dog*. His attorneys sent cease-and-desist letters to Park Life, a San Francisco store and gallery selling the bookends, and Imm-Living, the Canadian company that produced them. The prospective defendants resisted, noting that the items in question were not competing with Koons's sales because they were sold for $30 each, whereas Koons's large sculptures commanded millions of dollars and ten-inch versions were in the $10,000 range.[116] The gallery's attorney lined up expert witnesses, including one with a how-to book on making balloon animals,[117] and filed a legal document that stated, "no one owns the idea of making a balloon dog, and the shape created by twisting a balloon into a dog-like form is part of the public domain."[118] News coverage intensified, and attorneys weighed in over the unlikelihood that Koons would win in court. He ceased legal action, and the gallery reported that sales of the bookends jumped from three before the legal affair to 150 due to the public attention that was created.[119]

Hirst, too, has threatened lawsuits against works resembling his own. In 1990, he claimed that advertising for Go Fly (a subsidiary of British Airways) included spots similar to those in his popular spot paintings. The company rebuffed him, saying, "Circles have been used in transport for years—wheels are round."[120] Ten years later when teenage graffiti artist Cartrain was selling collage prints that incorporated an image of Hirst's famous glittering skull sculpture, *For the Love of God*, Hirst demanded that the prints be turned over to him along with payment of $3,000. The artist complied.[121] Several well-known artists protested that they would create similar works and disregard complaints Hirst might make.[122] Cartrain retaliated by stealing a box of pencils from a Hirst installation exhibition and threatening to sharpen them if his forfeited money was not returned. He was arrested for theft estimated at $850,000 for the destruction of a highly valued property, but the police dropped the charges against him, and he used the pencils to sign his artworks.[123]

Stories like these are colored by elements of humor and theatrics, and curiosity about how the plaintiffs would be received in court. But regardless of legal standing, the intimidation tactics they describe can put a chill on the new use of existing images other artists might envision. To think that balloon dogs and spots are problematic choices for them, as well as other imagery that wealthy and famous artists might claim as their own, limits creativity. Other artists are warned off unless they can afford to battle against the high-priced legal representation their accusers can afford as a business expense even if they lose. When the leaders of appropriationism act to appropriate that art form in itself by denying it to others, the spirit of freedom represented in the act of appropriating has been lost. Put in terms of practical economics, elite names can exercise their wealth and power at the expense of artists in general.

The dominance of an appropriation elite can extend to application of the doctrine of fair use when deciding copyright complaints. The decision in the *Cariou* case emphasized that not only did the plaintiff make little money from his work while Prince made millions of dollars from his appropriated version of it, but Prince also had a guest list for the opening of his exhibition that included Beyoncé, Hirst, Koons, Tom Brady, Angelina Jolie, Brad Pitt, and various other well-known names.[124] A law review article titled "Fair Use for the Rich and Fabulous?" suggests that an appropriator's celebrity status, or lack thereof, infiltrates judgments in determinations about transformativeness. The authors note that Cariou's claim against fair use was denied, while a claim made on similar grounds by acclaimed author J. D. Salinger (*Salinger v. Colting*) about appropriation from his book *The Catcher in the Rye* was accepted. The explanation offered is that "the problem largely appears to be one of framing. We unconsciously categorize the things to which we relate and accord respect to those things that fit within the categories we deem respectable."[125]

POSTHUMOUS PRODUCTION

The processes of restoration, collaboration, and appropriation all involve more than one person in the creation of an artwork. Still another variation on cocreation is the posthumous production of works whose nature is to be made in stages. Prints and sculptural casts are begun by artists who turn over their works to other parties for the final stage of production. What happens when that final stage extends beyond the named artist's lifetime? Posthumous casting and printing are generally regarded as acceptable provided that certain conditions are met, although just what those conditions are has been debated, and some critics hold firmly against any works bearing an artist's name being claimed as original if they were made after the artist's death. Questions arise over authenticity versus inauthenticity and degrees of authenticity, based on factors including when production occurred, the legal and moral right to produce from original materials, details of the production process, and whether a new execution of an artwork is identical to the first one or bears changes (in what ways and to what degree).

One of the most celebrated controversies over authenticity in posthumous production lies with the bronze sculptures of Edgar Degas. Best known in his day for his paintings, Degas also made sculptures of wax, clay, and plastiline, with wire armatures and filler materials that included pieces of wood, cotton batting, paintbrush handles, ropes, and cork. These works were makeshift and functioned as studies or thumbnail sketches helpful for the artist in conceiving forms, rather than as finished products. They were unsigned,

and the only one shown publicly during the artist's lifetime was *Little Dancer, Aged Fourteen*. No bronzes were made, but evidence shows that the artist did work occasionally in plaster, both modeled and cast, and there are reports that several of his plaster statuettes were placed in a display case in his home.[126] After the artist's death in 1917, 150 sculptures, many of them in disrepair, were found in his studio, and his heirs contracted with the Hébrard Foundry to cast seventy-three of them in bronze. Twenty-two sets were made between 1919 and 1936, and the bronzes were sold to collectors and institutions. The wax figures, reported to have been destroyed, were uncovered in 1955, and then sold to Paul Mellon, who donated most of them to the National Gallery in Washington, D.C. A set of master models (in bronze) made for use in casting was purchased by Norton Simon for his collection, which eventually became the Norton Simon Museum.[127]

Today, the Degas bronzes are among the best-known sculptures in the world, with a number of them selling at auction over the last two decades for prices ranging into the hundreds of thousands and millions of dollars.[128] The ballerinas, horses, and other figures are key holdings in major museums and have been featured in traveling exhibitions in many countries. And they have inspired reproductions sold in gift shops. But are they truly originals? Various scholars have weighed in against that status, while curators often avoid the issue of authenticity even when providing historical information about the production of the bronzes. One concern is over authorization for casting. Degas's heirs were legal owners of the figures from which the bronzes were made and in a position to control their disposition. However, the process occurred against the artist's intent. He was opposed to transferring his works to bronze, believing that it was "too great a responsibility" in a medium that "is so very indestructible" and "for eternity."[129] Instead, his purpose in sculpting was to work with a material having the plasticity to make continual changes, which he did easily in wax. In a letter to a critic he is quoted as saying,

> My sculptures will never give that impression of completion that is the ultimate goal of the statue-makers trade and since, after all, no one will ever see these efforts, no one should think of speaking about them, not even you. After my death all that will fall apart by itself, and that will be better for my reputation.[130]

Critics have asserted that Degas's expectation was violated.[131] At issue is the moral right (different than property rights, which are covered under copyright law) of artists to a claim on their creations postmortem. In current legal terms, the answer varies by location. The Berne Convention for the Protection of Literary and Artistic Works (177 signatory countries)[132] sets international standards stipulating that authors are protected against the creation

of works prejudicial to their honor or reputation, but extension of that right after death is unclear. Under the US Visual Artists Rights Act, the right exists for the duration of an artist's lifetime, while in Germany it extends simultaneously with copyright (seventy years after an artist's death), and in France the right is perpetual.[133] These stipulations are from late in the twentieth century, long after the Hébrard casting of the Degas bronzes, their sale, and their enshrinement in art history.

The historical inertia has carried the Degas sculptures to iconic status worldwide. This circumstance lends support to the argument that countering the moral right of the artist is justified by the benefit provided to the common good. Millions of viewers have been privy to key artworks that would have been denied to them otherwise, and art history is enriched. What the public desires and finds beneficial may outweigh the aesthetic perspective of a given artist toward posterity, particularly when the destruction of many works lies in the balance. This argument for cultural benefit, however, although pertinent to the preservation of the original wax figures and to the production of bronzes based on the waxes, does not pertain to labeling the bronzes as originals. It is the labeling that critics want changed. Recognizing that the genie has long been out of the bottle and provides an asset to history, they ask for an honest explanation of the nature of the bronzes derived from Degas.

Classifying the sculptures begins with recognizing that the wax figures Hébrard received to prepare for casting were in disrepair, with the process of deterioration Degas envisioned having already begun. They required refurbishing to be ready for conversion to bronze. What the foundry produced, then, were sculptures altered from their original images. With the waxes ready for use, a set of molds was made from them to cast duplicates in wax, allowing the original waxes to be retained while the new set was used in the lost wax process for another set of molds that was poured with bronze. The resulting sculptures were then treated as models from which molds were made and poured with bronze for the final product. With each successive cast, clarity of details was jeopardized, as explained by Degas scholar Gary Tinterow: "The virtue of saving the original sculptures extracted a cost on the manufacture of the final edition of bronzes . . . Incidental details . . . appear indistinct or blurred. Even the models lack much of the liveliness evident today in the original waxes."[134] And each time the bronzes cooled, they were subject to standard 2 percent shrinkage. The final product, then, was a copy of a copy of a copy with alterations to the image. In effect, the renowned bronzes are aftercasts (*surmoulages*), with this status in itself being enough in the eyes of many to rule against a claim of authenticity. As stated by the College Art Association in the United States, "In our opinion, a bronze made from a finished bronze,

unless under the direct supervision of the artist, even when not prohibited by law and authorized by the artist's heirs or executors, is inauthentic."[135] And making a potential judgment of authenticity even more difficult is that there was an unauthorized rendering of a sculpture from one material to another. Again, the College Art Association takes a forceful position that

> When the artist's heirs or executors cast the work in a new medium other than that clearly intended by the artist as the final version of the work . . . in the absence of authorization from the artist, this form of *moulage* should also be considered unethical. . . . those responsible for this new form of reproduction have the serious responsibility of proving without doubt that they are carrying out the explicit intentions of the artist at the time of his or her death.[136]

The authenticity of the Degas bronzes is problematic in several ways: they were produced against the artist's wishes and with alterations due to repairs, casting involved multiple repetitions of models, and there was a change of medium. The iconic works have been given a pass by forces in the art establishment wanting to preserve the cachet of the famous sculptures, although there are critics who question their authenticity. The bronzes are not, however, the only Degas sculptures to draw attention over the claim to be authentic. Coming onto the scene nearly a century later was a different set of bronzes that rivals those from Hébrard and claims a status as being more original. In the 1990s Leonardo Benatov, owner of the Valsuani foundry in Paris, began producing selected Degas bronzes from a set of seventy-four plaster casts corresponding to the Hébrard casts, which he said were in the foundry's inventory when he purchased it in 1980. In 2005, he engaged New York dealer Walter Maibaum to sell full sets of the bronzes, while art historian and dealer Gregory Hedberg provided his expertise in attesting that the plaster casts were made during Degas's lifetime from the artist's wax figures.[137] Full sets of the Valsuani sculptures sold for prices said to be around $7 million,[138] far less than the value of the Hébrard bronzes but far more than mere reproductions.

If the plasters are truly of lifetime vintage, they are the most original of all casts of Degas's wax figures, and bronzes made from them are more original than the Hébrard bronzes, which derive from posthumously made bronze models. However, they have provoked much controversy. Generally, Degas scholars have declined to pronounce the Valsuani sculptures as authentic, while the dealers representing them have built a case in their favor and museums in several countries have featured them in exhibitions. Although there has been little movement from either side, one expert who had opposed authenticity announced a change of mind in 2016. Most opponents have been quiet out of concern they might be sued for damaging the sculptures' marketability.[139]

The case for the authenticity of the Valsuani plasters notes that some of them are a better match than the corresponding Hébrard bronzes to photos taken of Degas's waxes just after his death, which places the plasters in closest proximity to what the waxes looked like before they underwent restoration treatment in preparation for the Hébrard bronzes. Various measurements show the plasters to be slightly larger than the Hébrard works, demonstrating that they could not have been made from them because if they were there would have been shrinkage. Further, scientific tests done to determine the age of the plasters point to an early (closer to Degas's lifetime) rather than later date. When fibers embedded in one of them were analyzed, they were determined to be pre-1955. And the components in the plaster material of one of the sculptures was determined to be similar to that of a Rodin plaster from the artist's lifetime (both he and Degas died in 1917) and different than a modern sculpture (1990s) when they were compared. Using these factors as support for dating the plasters to Degas's lifetime, proponents of their authenticity suggest that they were made from the Degas waxes by his friend and colleague Albert Bartholomé at a time when the artist was still making changes in them and before they took on the final form found after his death.[140]

Opponents of the claim that the plasters were made from early versions of Degas's waxes find the scientific testing to show only roughly that they were made before 1955, and not that they were made during the artist's lifetime. Provenance is lacking, so the explanation by proponents of who made the plasters is merely conjecture. And measurements showing that they are not made from the Hébrard bronzes do not determine their origin. Further, since the seventy-four Valsuani figures correspond to the same seventy-four wax figures that were preserved and cast by Hébrard, and many more figures would have been available to choose from in Degas's lifetime, it follows logically that the Valsuani works derived from the Hébrard list. Proponents, however, contend that Bartholomé, having made the plasters, would have advised Degas's heirs about which waxes to preserve and would have followed the same list for selecting the plasters. Regarding the visual differences between various Valsuani plasters and the Hébrard bronzes to which they correspond, opponents do not accept that this circumstance occurred through changes Degas made in the waxes over time. *Little Dancer* is cited as an example, noting that drawings Degas made (c. 1880) of the girl who modeled for the sculpture show her to be of the same build as the girl in the iconic bronzes and unlike the one in the Valsuani plasters, and that difficult and dramatic changes would have to have been made to result in the body and pose of the Valsuani figure.[141]

Dispute over the plasters is ongoing. Perhaps in the future science will be able to provide accurate dating for them. With or without that evidence, where will the weight of opinion by Degas experts lie? Will it shift to accumu-

late support for authenticity? Another factor involves the decisions museums make that collectively produce inertia in determinations of authenticity. Various museums have exhibited the Valsuani Degas sculptures, but it would be a significant step for them to spend large sums (which original Degas artworks command) to purchase the works for their collections. On the other hand, will they spend smaller sums for works with disputed authenticity or accept them as donations, and if so, how will those works be designated when put on display?

For the Valsuani bronzes, the matter at issue is a clear-cut one of authenticity versus inauthenticity: the sculptures derive from the hand of Degas or else from another source. The Hébrard bronzes, on the other hand, unequivocally trace to the named artist. Still, their authenticity has been assessed more liberally than has been the case with bronzes bearing the names of comparably great artists. Regarding Frederic Remington's works, numerous lifetime casts were produced, and after his death, his widow, Eva Caten Remington, continued his legacy with estate casts until she died in 1918, at which point the molds were destroyed. Those originals stand in contrast to the thousands of aftercasts made from the 1960s onward after the copyright for the artist's works, held by the Frederic Remington Art Museum, expired. The reproductions have sometimes been sold as originals, including some bearing the marking "Copyright by Frederic Remington," but that occurrence unequivocally constitutes forgery.[142]

Classification of Rodin's sculptures, too, has been carefully monitored. Before his death in 1917, he donated all of his works and artistic rights attached to them to the nation of France, which created the Musée Rodin to exhibit and oversee originals as well as to produce more. Sculptures coming from other producers are considered to be reproductions. Questions have arisen about the degree of control the museum has exercised. Late in the twentieth century Gruppo Mondiale, a company incorporated in Lichtenstein and headed by American businessman and art dealer Gary Snell, was challenged for the Rodin bronzes it had sold. The company claimed ownership of a number of original plaster casts that did not go to the Musée Rodin on the artist's death but instead passed through other hands to itself. Over time, many bronzes were cast from the plasters. Six hundred sold at prices averaging $45,000, according to Snell; more than seventeen hundred works totaling $76 million according to French legal sources. In 2001, the Musée Rodin took legal action charging forgery, noting the sculptures sold were not labeled as reproductions. Complicated proceedings lasted until 2014, when a Paris criminal court issued a decision that no French law had been violated because Gruppo Mondiale did not produce, exhibit, or sell its works in France. However, on appeal to a higher court and with the company having been liquidated, in

2019 Snell was found guilty, along with his associate, French art dealer Robert Crouzet. The prosecution asserted that the sculptures were accessible for sale in France via the Internet, other plasters and molds connected to Snell's operation were found in a studio in France, and some of the reproductions were so poorly made that they betrayed Rodin's moral right to his reputation.[143]

As was noted regarding Degas, confusion may arise over the perspective of French law and customs as it compares with the perspectives of other countries. Coming from the French Intellectual Property Code along with decrees issued in 1981 and 1993,[144] several provisions are in place that affect Rodin bronzes. Artists control the copyright for their own works during their own lifetime and seventy years after their death. And by virtue of moral rights, the rights to their works may be passed along to their heirs, or other designees, perpetually. First editions of Rodin bronzes must come from plasters and molds held by the Musée Rodin, and no more than twelve may be produced of each sculpture. Reproductions may be made legitimately, but they must be designated as such. Critics ask whether and for how long French law should apply in other countries. The seventy-year period of protection after an artist's death is standard in the copyright laws of many countries, but extending beyond that time by virtue of moral rights is not a legal stipulation in such places as the United States and the United Kingdom. In the view of those who see Rodin's works to have been in the public domain since 1987, the plasters in question (presuming they are in fact originals) are fair game to be used in producing bronzes equal in authenticity to those produced by the Musée Rodin during that time. Both are reproductions, or if the Musée Rodin's are originals, so, too, are sculptures cast from original plasters held by other parties. A writer for Toronto's *Globe and Mail* pondered a collection of original plasters held by a Canadian museum:

> But who knows, maybe the MacLaren Arts Centre . . . will someday make its own reproduction casts . . . there's pretty much nothing to stop the MacLaren from doing so. Since Rodin died in 1917, there are no copyright concerns and, despite all the bleatings of the Musée Rodin, no impediments in terms of legal or moral rights. Rodins, rain down.[145]

Philosopher Darren Hick, an expert on the philosophical aspects of copyright, explains as follows:

> It also seems a generally accepted matter that the copies produced by Gruppo Mondiale are inauthentic copies: reproductions. But what, we might ask, about post-1987 copies produced by the Musée Rodin itself? . . . With the copyright since expired, what claim does the Musée Rodin have to any exclusive power to produce authentic Rodin copies? . . . with

copyright removed as setting the authority in the matter, authenticity becomes an open question left to the art world to sort out.[146]

Both Remington and Rodin cast in bronze during their lifetime and left no provision against continued casting postmortem, whereas Degas chose not to work in bronze and expected there would be no postmortem activity in his name. By the standards of authenticity applied for Remington and Rodin, the Degas sculptures would not be acceptable as originals. Yet their status today as iconic remains. As explained by Judd Tully, an art writer and former editor for *Art and Auction* magazine, "Most scholars and aficionados don't quibble about their existence since the 'scandal' has been sanitized over time and people and institutions are keen on maintaining their investments."[147] Tully also quotes Kirk Varnedoe, who was Chief Curator of Painting and Sculpture at New York's Museum of Modern Art, for his opinion on posthumous bronze casting as "the messiest subject alive. . . . If you decide once the heart (of an artist) beats for the last time, that's it, nothing ever produced after that is authentic, it makes your life much simpler."[148]

If determining the authenticity of posthumous casts is confusing, posthumous prints can be at least as problematic. Determinations are often couched in degrees of authenticity depending on how close or removed a print is from the hand of the artist. Factors such as overriding a deceased artist's wishes and alteration of a model could be troubling but not necessarily disqualifying, although a change of medium would not be acceptable. Consider a hypothetical case similar to that of the Degas bronzes but in the medium of lithography. The will of an artist who made engraved prints designates that none of the plates should ever be printed from again. The artist's heirs have some recutting done on the plates and print a new edition, after which they have the images from the worn-down plates transferred to lithographic plates from which lithographs are made. The lithographs would not be recognized as "authentic" or "original" works by the artist. The greatest difficulty lies in the change of medium that involves the creation of new plates. The acceptability of using the old plates against the artist's instructions could be debated, yet if prints were made directly from them, those works clearly derived from the hand of the artist. Recutting the plates would not render them inauthentic per se, although it could be perceived that because of the degree of alteration, authenticity was partially lost. With these factors in mind, consider the prints made from Rembrandt's original plates during his lifetime and then periodically into the twenty-first century.

In his own era, Rembrandt's prints were more widely known than the oil paintings that eventually secured his fame in art history. The multiplicity of the medium made prints available to many people, and the artist followed his business sense as well as his creative impulse in producing nearly three

hundred images of landscapes, biblical scenes, self-portraits, genre scenes, and a few nudes and erotica. Many of these works carried affordable prices, although a few sold for more than his oils, including the "100 Guilder Print" of Christ healing the sick, with that amount being about one-tenth of the price of a large house in Amsterdam.[149] Some prints were given small modifications to create a new state that was reissued in a way that attracted collectors who wanted to have not only the first version of an image but also the latest. In some cases, a single image appeared in several states. Generally the prints are classified as etchings, although Rembrandt often added the engraving technique of drypoint for enhancement. The resulting detailed patterns of lines produced finely wrought shapes and sophisticated tonalities of light to dark that could become muddied in later editions as plates deteriorated from the printing process.

After Rembrandt's death in 1669, about 150 of his plates were in circulation, some of which were said to have been sold during his lifetime when he needed money.[150] Clement de Jonghe, a print dealer and friend of the artist, held a large collection of the plates in the late seventeenth century, followed by a number of others who owned it in succession (perhaps adding or subtracting certain pieces) until the existing assemblage of seventy-eight plates was auctioned piecemeal in London in 1993. Over the centuries, at least some of the plates were printed from several times, with well-known editions by Watelet, Basan, Bernard, and Beaumont.[151] The most recent printings were done from a set of eight plates in the late 1990s and 2000s. They were owned by Howard Berger, who used them to issue the "Millennium Impressions" and then sold them to the Park West Gallery (Michigan), which used them for further Millennium prints that were sold through cruise ships, among other outlets.

What can be said about the authenticity of the prints produced from Rembrandt's plates at different times over several hundred years? To use another term, are they true "originals"? Simply put, although all of them possess the originality of the master, some are stronger examples than others. Impressions made by the artist during his lifetime are originals in the fullest sense, and subsequent printings (restrikes) decline in status. By this distinction, which is made regularly by dealers, collectors, and curators, posthumous production automatically diminishes the authenticity of works produced from existing models but without sacrificing it entirely. In theory, a second lifetime impression from a plate is next in status to an initial impression, a third is a lesser creation yet, and so on, with posthumous production even further removed. While the quality of a set of prints at the hands of a poorly skilled technician occasionally determines otherwise, market prices generally reflect this profile, which is supported by a detailed study of the value of Rembrandt's lifetime

versus posthumous prints. Controlling for rarity and condition, the finding was that first impressions are the most desirable—defined as most "original"—when compared with subsequent impressions and in particular with posthumous impressions.[152]

Part of the explanation for a decrease in value as a print undergoes successive impressions lies with the perception that newness is overshadowed by the cachet bestowed by history. But another important factor is that the markings artists apply to their plates wear down from use and become less distinct. The visual quality of the prints suffers. This happened with Rembrandt's plates as a series of owners made restrikes from them. Prints made by Pierre François Basan in the latter eighteenth century are of high quality, whereas late restrikes by his son Henri Louis Basan compare poorly. Early examples of *Faust* indicate the plate was in good condition, while later examples drawn from a reworked plate show noticeable change to the image. The plate for *The Death of the Virgin* was worn to the extent that its page in an album of Rembrandt prints (popular with collectors of the day) was given over to a reproduction.[153] In the nineteenth century, the advent of photography allowed for the creation of new plates that produced facsimile prints simulating first impressions, which encouraged some Rembrandt followers to consider his well-worn plates as relics. Continuing into the early twentieth century, this attitude was expressed by expert E. W. Moes when he was consulted about the prospect of Rembrandt's plates being printed from once again: "I prefer a photogravure of a good impression of an early state to an impression, however carefully done, from such a ruined original copper."[154]

Both enthusiasm for facsimile first impressions and the trend of devaluing original prints over successive impressions have been challenged in recent decades by the Millennium editions. The Millennium Impressions, issued as twenty-five hundred each of eight titles, sold for less than Millennium etchings that were printed later without a number designating how many were made. The Millennium works in general have sold for several thousand dollars apiece (sometimes more),[155] while critics have expressed concern about their long-term value, especially when compared with impressions from previous centuries. Some Millennium works have shown up for resale at auctions for prices in the hundreds of dollars compared with the thousands that were paid for them initially.[156]

On the other hand, dealers selling Millennium prints point out that they are satisfying the public by making the works of a great artist available to them. More people than who could do so otherwise can enjoy the pleasure and pride of "owning a Rembrandt." Those people seem to prefer collecting works that possess originality over more aesthetically pleasing photomechanical reproductions. And they may not have the time or inclination to study the complicated

market in Rembrandt prints to find works from earlier editions that rival Millennium prices. The degree to which Millennium prints will continue to hold their appeal in a mass market, and how their prices fare relative to those for prior editions, remains to be seen.

CULTURAL APPROPRIATION

In 1994, Australian Aboriginal artist Eddie Burrup began putting his paintings on public display. They were entered in exhibitions and received favorable reviews by people knowledgeable about Indigenous art, and the paintings began to sell. The images, which would be described in the terminology of Western art as "abstract," were in the fashion of the "Dreaming" patterns (representing cultural values and beliefs) of other Aboriginal works (see Figure 2.4). The artist provided a biography that told of his life and artistic endeavors. As Burrup's professional trajectory carried to the point where more sales were imminent and he would be in demand for interviews, he revealed in 1997 that his identity was not as advertised. He was actually Elizabeth Durack, an elderly white woman from a prominent family in Western Australia who was an artist with a long career of accomplishment and reputation. When the story circulated as a major news item throughout the country and drew attention internationally, the artist faced condemnation from many parties, although less from those who knew her, and she was supported by others. She never renounced her deception, but explained it (through print media, several videotaped interviews, and her website), and continued to paint as Eddie Burrup until the end of her life in 2000 at age eighty-five.

Durack's case is a provocative example of what is often described as "cultural appropriation." In its broad sense, the term refers to the transfer of anything of cultural significance from the culture where it originated to another culture. In art, examples include tangible objects such as the Elgin Marbles and American Indian headdresses purchased for European collections. Depending on the circumstances in which they occur, acquisitions of this sort may cause controversy, but of a different sort than in the present discussion. In a more restricted sense, which is the way the term is used here, "cultural appropriation" refers to the intangible factor of a style, icon, or theme. Ideas are acquired from another culture by outsiders and replicated in making new artworks. The production of those works often brings accusations of theft and questions about authenticity.

Similar to the appropriation practiced by Koons and others, in cultural appropriation what already exists is taken for use in a new artwork. However, appropriation art involves taking from an individual artist, whereas the cul-

Figure 2.4. *Crested Ibis Landed at Low Tide on Karacumbi Bar. The Mission Boat Picked Him Up.* From *The Art of Eddie Burrup* by Elizabeth Durack, mixed media on linen, 133 × 92 cm. Courtesy of Perpetua A. Clancy and Michael F. Clancy

tural version involves a group. The appropriation may target a particular artist within the group, but the concern is about the artist's group identity. Offense occurs when a dominant group takes from a minority group, as with white artists fashioning works that appear like those of Indigenous artists. The basis for controversy is that the minority group's culture is being exploited, and as a result, their identity is usurped and a source of their income threatened.

Instances of cultural appropriation have drawn condemnation from members of the targeted groups. One of Durack's critics declared of Aboriginal art, "It's the last thing you could possibly take away other than the rest of our lives or just shoot us all."[157] Other artists, too, have been mistakenly thought to be cultural insiders only to be eventually unmasked. Farley French, originally from Calcutta, took the name Sakshi Anmatyerre and for six years in the 1990s painted Australian Aboriginal works.[158] In the United States, Jimmie Durham's long and distinguished career as a Cherokee artist and political activist has transpired amid confusion over claims that he is not of American Indian heritage. The artist has admitted this to be true while asserting that he learned the Cherokee language at home as a boy.[159] On the other hand are cultural outsiders who work in the fashion of insiders but with no misunderstanding over their identity. In Canada, for instance, Amanda PL found her 2017 exhibition of Indigenous-inspired paintings (styled much like the works of noted Canadian artist Norval Morrisseau) to be offensive to Indigenous artists,[160] and in New Zealand the following year, Sally Anderson, married to a man of Māori descent, was denounced for inappropriately wearing a facial tattoo of a Māori symbol.[161] Further, beyond styles adopted from minority groups, the offense of cultural appropriation has extended to themes that characterize those groups. In 2017, Dana Schutz's painting *Open Casket* (a semiabstract depiction of an African American teenager who was murdered) at the Whitney Museum of American Art evoked artist Hannah Black's response that

> The painting should not be acceptable to anyone who cares or pretends to care about Black people because it is not acceptable for a white person to transmute Black suffering into profit and fun. . . . The subject matter is not Schutz's; white free speech and white creative freedom have been founded on the constraint of others, and are not natural rights.[162]

In the same year, Sam Durant's monumental sculpture *Scaffold* (depicting several historical gallows in the United States) drew condemnation from the Dakota tribe when it was displayed in Minneapolis. The work was designed to protest unfair executions, including the mass hanging of American Indians in 1862. Durant was told the portrayal could not be carried out appropriately by a non-native artist.[163]

In some instances, cultural appropriation is prosecutable under the law. Indigenous groups have applied fraud statutes against deceptive practices when items were sold by falsely claiming them to be Indigenous products. In Australia, the Trade Protection Act (1974) is applicable in civil cases and was the basis for the key case of *Australian Competition and Consumer Commission v. Australian Dreamtime Creations* in 2009. The defendant was found guilty of misleading consumers about the nature of many items sold as Indigenous products, including paintings, prints, carvings, and decorated objects such as boomerangs and didgeridoos. The artwork was said to have been made by Aboriginal hands, in particular by a fictitious artist named Ubanoo Brown. Two factors are highlighted in the case. The penalty meted out required the defendant to pay the prosecutor's court costs, and for a period of three years to refrain from selling artworks designated as Aboriginal without first making inquiries as to their authenticity. The second factor is a stipulation that the term "Aboriginal art" refers to the person producing a work and not to the style in which it is made. What counts when determining fraud versus authenticity is whether the artist comes from an Aboriginal bloodline.[164]

Legal redress in the United States against falsely designated American Indian artworks also lies with the identity of the artist rather than with the visual features of the works themselves. Determining the status of a work to be genuine requires that the maker be a member of an American Indian tribe or certified by an American Indian tribe as an American Indian artisan.[165] By this definition, only American Indians can produce American Indian works. Claims that works have been faked can be dealt with as fraud generally or through the Indian Arts and Crafts Act (IACA) of 1990, which is applicable in both criminal and civil litigation. The first version of the act in 1935 carried a maximum penalty of six months imprisonment and $2,000 fine, while in the present version a first-time offender faces prison time of five years maximum with a fine of up to $250,000 and a repeat offender up to fifteen years imprisonment and $5 million.[166] The IACA was the law applied in a notable case that concluded in 2018 over the sale of inauthentic American Indian jewelry,[167] the market for which by some estimates is 80 percent fraudulent.[168] While the overall fraud under investigation was high-volume and widespread, the principal defendant pled guilty to two felony charges and was sentenced to six months imprisonment, with $9,000 to be paid in restitution.[169] A related case involving jewelry was brought in 2017 and will take time to proceed through the legal system.[170] Critics have denounced lax enforcement against fake American Indian-made artworks including, besides jewelry, such forms as blankets, baskets, and bone carvings, noting that from 1996 to 2017 more than seventeen hundred complaints of alleged fraud in five states (New Mexico, Alaska, Utah, South Dakota, and Missouri) resulted in only twenty-two

prosecutions.[171] In Canada and Australia, too, prosecutions have been few and lawmakers have been lobbied to create new legislation with strong penalties targeted specifically at scams on Indigenous art.[172]

Cultural appropriation is prosecutable when there has been a false claim of Indigenous identity. But the law does not apply when a non-Indigenous artist makes no such claim and creates a work that is seen as culturally Indigenous, or when what is appropriated is from a minority group that is not Indigenous, such as African Americans. In such instances, other actions have been taken. Shaming and physical protests have sometimes been effective reprimands. Amanda PL's exhibition of Norval Morrisseau look-alikes was canceled by the sponsoring gallery due to negative publicity,[173] and Durant's *Scaffold* was removed from exhibition after protesters appeared and an activist curator called for a peaceful occupation of the park where it stood. The artist issued an apologetic statement.[174] On the other hand is Durham, who, despite confusion about his heritage, was honored with a major retrospective in 2017–18.[175] He is still often identified as an American Indian artist, with his works discussed in that context.[176] And the display of Schutz's *Open Casket*, although subjected to protesters blocking its view from spectators, was defended by the Whitney Museum and by Schutz as legitimately addressing an emotional topic in a controversial way supported by the spirit of artistic freedom and interpretation.[177]

Although cultural appropriation has drawn much public attention as well as increased prosecution under the law, philosophers and legal scholars have often found objections against it to be problematic. With a version of "essentialism" as its basis, it assumes each group due for protection has its own cultural essence that establishes separation from other groups. Distinguishing insiders from outsiders is a key aspect of this essentialism. As explained by Bruce Ziff and Pratima Rao in *Borrowed Culture*,

> The need to describe a community of insiders and outsiders is implicit in most of what has been said about the practice of appropriation . . . certain divisions among cultural groups will be amorphous. Nevertheless, some test of group belonging seems required in discussions about cultural appropriation.[178]

Intruders are seen to fail the cultural test in aesthetic terms and moral terms. Aesthetically, they lack an insider's understanding of unique beliefs, customs, and artistic techniques, and therefore create works that are inferior substitutes. Morally, they violate the rights of insiders by taking what is not rightfully theirs, which links appropriation to theft and conceives of the cultural material taken as property. The appropriation is objectionable whether or not it is found to be illegal.[179]

In legal terms, however, an understanding of the nature of the victimized group—its essence—is necessary. Legal scholar Naomi Mezey explains, "The problem with certifying authentic Indian stuff is that it requires certifying authentic Indians." Again, "The broader presumptions of the law . . . assumes that we always know what Indian stuff is and who Indians are."[180] This difficulty is faced in Australia, Canada, and other countries where Indigenous people are recognized for their art. Considerable confusion arises over who fits within a particular group and who does not. In some situations, as with the IACA in the United States, tribal membership is the key: an insider—someone legally empowered to make American Indian art—is a certified member of a tribe. Membership is based on "blood quantum" requirements and other determining factors. A minimum of proven native blood is stipulated, which leaves out many people who unofficially claim to have Indigenous heritage. Even if there is a traceable bloodline, the matter of what it takes to be legitimized as American Indian varies considerably from one tribe to another. The Shawnee Tribe requires one-thirtieth blood heritage for membership, whereas for the Fort Sill Apache Tribe it is one-sixteenth, with one-eighth for the Comanche Nation of Oklahoma, one-quarter for the Hopi of Arizona, and one-half for the Miccosukee of Florida.[181] In other countries, too, the same issue applies, as Indigenous status generally is determined by a requirement of blood heritage that may vary from one Indigenous community to another and among political entities (i.e., state, province).[182] While eliminating pretenders, legal definitions of what constitutes Indigenous status are highly inconsistent.

Beyond the matter of membership in Indigenous groups are questions about the capability of members and nonmembers to produce artworks in the manner of those groups. Are members producing works that are authentic by tradition, or are they creating products of a new sort? Are outsiders producing works that appear to be as traditionally authentic as those of insiders? As with the mixing of bloodlines, cultural ideas, values, and practices, too, have become mixed through assimilation. While Indigenous groups have been appropriated from, they also have adopted the ways of the dominant culture. To what extent do they or can they step back from their assimilated lives and create art that is different or better than that of outsiders who learn about the minority culture and then adopt its ways? Much of the Indigenous art in Australia that attracts imitations is a hybrid form developed in the 1970s using acrylic paint (a mid-twentieth-century Western invention) on canvas, whereas earlier works were made with traditional materials. Even the idea of producing "fine art" has been adopted from the dominant culture. Prior to incorporating Western ways, the purpose of Aboriginal art was decorative, and it fulfilled the practical objectives of enhancing ceremonies and adorning functional objects. It can be argued that the Dreaming themes (often pointed to as distinctly

Aboriginal) remain traditional, but they are filtered through minds conditioned by recent times and cultural assimilation.[183] This is not to say that assimilation has entirely erased connections with the past and traditional Aboriginal ways, but that it has had an inevitable effect. There are artists such as John Mawurndjul, who uses traditional materials (working on bark and grinding his own pigments), has spent much time at remote outstations and is attuned to his Indigenous history. Still, he embraces the present, with a promotional statement for a 2018 exhibition saying, "The old ways of doing things have changed into the new ways. The new generation does things differently. But me, I have two ways. I am the old and the new."[184]

Elizabeth Durack, too, regarded her artwork as resisting a singular classification. She spent most of her life in Western Australia, where, as a child, she often played with Aboriginal children and as an adult went on journeys of sometimes two weeks' duration where she was included in the men's ceremonies. (She said the men seemed to think of her as sexless because she was white, whereas Aboriginal women were excluded from the ceremonies.) From the 1950s onward, her art featured Aboriginal subjects, and sometimes alluded to the Dreaming. She studied with a respected Aboriginal painter, and herself mentored an Aboriginal boy, her "classificatory son," who remained close in adulthood. She knew the Kriol language (a version of pidgin English) and wrote a promotional piece in it attributed to Eddie Burrup. The Burrup paintings, Durack felt, were part and parcel of her life. She saw herself as participating in an arena where she belonged rather than appropriating from it. She explained her alter ego as a natural extension of her career, a next phase that had been inside of her for many years and finally reached self-expression. Whereas her earlier paintings depicted mainly graphic images of Aboriginal life over time, her work evolved into a "morphological" stage where shadowy forms and shapes reflected an expression of the Dreaming.

Durack saw her career against the backdrop of her own personal history and the history of Aboriginal art in Australia. In the artist's words, she believed in

> the right to gain a legitimate place for Eddie Burrup in the extremely complex and inter-wed world of contemporary "Aboriginal Art.". . . Eddie Burrup asserts his right to his place in the scheme of things via an intellectual and psychic connection with this country's ancient culture and via knowledge which has been donated first-hand and accumulated over a life-time of learning.[185]

This perspective invokes questions about the essentialism that supports Indigenous art. Are Durack's paintings less Aboriginal than those of an artist who was born of Aboriginal parents, grew up in Sydney, and pursued Western art

as well as Aboriginal art along the way to creating a series of Dreaming paintings? Or change the artist's background to having grown up in rural Australia but late in the twentieth century so as not to see the sort of rural life Durack was privy to several decades earlier and that now had died out. These hypothetical artists are Aboriginal by bloodline, but how culturally Aboriginal are the works they produce? This point holds for any minority group: the creative productions of insiders may be rivaled in cultural authenticity by serious outsiders who study, live in or around the group, and follow its practices.

A further question, however, is whether what outsiders produce is qualitatively good enough to be worthy of recognition. Is there something that at least many insiders have to a greater degree and that accounts for quality if not outright authenticity in artistic practice? Philosopher James Young speaks of the "aesthetic handicap" thesis, which claims such an advantage for insiders over outsiders. He concludes against it, asserting that artists who engage in cultural appropriation can produce works that are "in any aesthetically important sense of the word, authentic. Outsiders who appropriate artistic content from other cultures may very well produce masterpieces."[186] Young holds this view for the arts in general, including music where he cites, among others, Charlie Musselwhite, Stevie Ray Vaughan, and particularly Eric Clapton as having successful careers performing the blues although they are not African American, the culture from which that form of music derives. In the visual arts Young notes collaborative efforts of Australian Aboriginal artists such as those already mentioned. Clifford Possum has on various occasions employed non-Aboriginal assistants in making his highly regarded paintings. Kathleen Petyarre's white husband, Ray Beamish, is reported to have done significant work on her *Storm in Atnangkere County II*, a painting that won the prestigious Telstra Award for Aboriginal art. And one of Durack's Burrup paintings was nominated for the same award.[187] If there is an aesthetic handicap for outsiders making artworks that are thought of as the province of a minority cultural group, it seems not to apply to certain artists whose works have been recognized for their excellence.

Beyond questions about what constitutes cultural essentialism, with its emphasis on insider status, the concept faces a liability in the political arena. The danger is in reinforcing the detrimental side of identity politics. In a positive sense, identity politics emphasizes the worth of minority groups that is often glossed over when their accomplishments are appropriated. When those groups defend certain cultural productions as their own creations—Indigenous painters and their designs, African Americans and blues music, and so on—they draw attention and respect that is deserved. But the downside is that the groups may become separated from the dominant culture while striving for fair treatment from it. Prominent minority intellectuals have raised this point,

cautioning that cultural identity is important but should not be emphasized to the extent of estrangement from the larger whole within which it exists. Social activist bell hooks warns that subordinated peoples should "eschew essentialist notions of identity and fashion selves that emerge from diverse epistemologies, habits of being, concrete class locations, and radical political commitments."[188] Philosopher Kwame Anthony Appiah sees cultural mixing as both natural and advantageous.[189] He describes the fruitlessness of trying to preserve traditional cultures against the inertia of assimilation, and notes that the Western notion of "culture," along with the word itself, is a Western invention exported to other societies and used to support colonialism. The fundamental unit of society, he stresses, is the individual, who fashions a way of life amid changing beliefs and practices.[190] And one of the foremost critics of postcolonialism, Edward Said, cautions about groups being boxed in when they are defined through stereotyped images. Rather, he says, it is important to

> acknowledge the massively knotted and complex histories of special but nevertheless overlapping and interconnected experiences—of women, of Westerners, of Blacks, of national states and cultures—there is no particular intellectual reason for granting each and all of them an ideal and essentially separate status.[191]

For all of the pride an essentialist approach to culture offers, it necessarily resists assimilation and carries harmful ramifications in the process.

The harm is that the effect of essentialist claims hinders more than advances the cause of minority groups. It reifies notions of what groups are like, and thus pushes them toward marginalization. They become known for their insider identities, holding them back from recognition beyond that limited scope. Culture as a whole is seen as divided among bastions here and there, with Indigenous groups often cast as backward and simplistic. As art critic Benjamin Genocchio describes this circumstance at its worst,

> Whether we like it or not, much of the desire for Aboriginal art crystallizes around . . . a cocktail of exoticism, primitivism, redemption and innocence, which in turn perpetuates derogatory ideas of Aboriginal art as a racial curio fetishised as the production of an authentic spirit.[192]

Authenticity for Indigenous art, then, comes at the price of preserving a condescending attitude toward the groups from which it originates.

In spite of the negative stereotyping that accompanies the popularity of Indigenous art, the works produced provide an important source of income for the artists. This is especially so in Australia, where it has been estimated that as many as half of all Aboriginal Australians are employed in the visual arts

and crafts sector (while for the non-Indigenous population the figure is less than 10 percent)[193] and that the value of the country's Aboriginal art market annually is several hundred million dollars.[194] Individual Aboriginal works have sold for more than $2 million, although most artists struggle to make a living.[195] For many of them, the aura of primitivism is accepted as a condition of doing business, but some living in urban areas have challenged the notion that for art to be considered authentically Aboriginal it must be traditional in style and be made in rural locations that reflect a past environment in the bush. Urban Aboriginal art developed in the latter twentieth century through diverse styles that combined traditional Aboriginal art and Western forms such as Expressionism and Pop Art with themes that critique changes in traditional culture brought on by colonialism.[196] The thrust is to protest social abuse and reclaim Aboriginal identity.

One of the key figures in Urban Aboriginal art is Richard Bell, who was selected in 2004 for the Telstra Award for his painting *Scientia e Metaphysica* (see Figure 2.5). The image consists of blocks of color with stripes, overlain by Pollock-like swirls along with the printed message in large capital letters, "Aboriginal Art It's a White Thing." [197] Accompanying the painting was an essay titled "Bell's Theorem," a manifesto decrying mistreatment of Aboriginal artists and misunderstanding of their works. Bell emphasizes the fetishizing of

Figure 2.5. *Scientia e Metaphysica (Bell's Theorem)* **by Richard Bell, acrylic on canvas, 240 × 540 cm. Courtesy of Richard Bell and Milani Gallery, Brisbane**

Aboriginal art, calling it "a product of the time. A commodity. The result of a concerted and sustained marketing strategy."[198] And he protests the effects of assimilation on contemporary life. But he holds also that there is still something unique for Aboriginal artists to express in the context of the present.

> Consider the classification of "Urban Aboriginal Art." This is the work of people descended from the original owners of the heavily populated areas of the continent. Through a brutal colonization process much of the culture has disappeared. However, what has survived is important. The "Dreamtime" is the past, the present and the future. The Urban Artists are still telling their "Dreamtime" stories, albeit contemporary ones.[199]

Bell has continued his political message in other works, including a series of paintings bearing statements such as "Australian Art Does Not Exist," "Western Art Does Not Exist," "I See You As My Equal," and "We Were Here First." Other Aboriginal artists, particularly ones associated with the proppaNOW collective,[200] have proclaimed similar themes and spoken about oppression as experienced by Indigenous Australians. Underlying their efforts is the conception that what they portray is something Aboriginal artists have experienced personally and non-Aboriginal artists have not. Despite the effects of assimilation, there is still this distinctly Aboriginal cultural factor. Here is a revision of essentialism located within the climate of contemporary times. What will its place be as Aboriginal art continues to evolve? If the political edge that has been introduced into Australian Aboriginal art is recognized as drawing on the essence of Aboriginal culture today, will its message be popular among collectors? That is, if the consciousness-raising Bell and others are attempting is successful, will art aficionados come to see traditional Aboriginal art as less desirable than before, that is, will recognition of its fetishized status make a difference? Could it be seen as old-fashioned? On the other hand, will it be respected as historically iconic and still valuable both aesthetically and commercially? Will Urban Aboriginal identity be subject to controversy when outsiders produce works like that of insiders, as with Durack in traditional Aboriginal art and Durham following American Indian culture? Is the message of Urban Aboriginal art exclusive enough that it cannot be expressed well and genuinely by an outsider, at least one closely familiar with it?

The Urban Aboriginal movement presents a counterpoint to the stereotypical style and content of Aboriginal art, while continuing the understanding that Aboriginal works are made by Aboriginal people. In contrast stands Durack, who supported the traditional perception of what Aboriginal paintings should look like while threatening the exclusive right of artists of Aboriginal bloodlines to produce it. The difference between them exemplifies the challenges, not only in Australia but also in other countries, that Indigenous artists

and their works face over authenticity as considered in terms of aesthetic and social theory. Both the what and the who of productions designated as exclusively Indigenous are in question: which artworks, and which artists, do and do not fit the category so as to be genuine? The essentialism that underlies attempts to make those judgments is an indeterminate concept, and it bears the additional liability of conceiving of certain peoples and cultures in a limited and condescending way. On the other hand, many producers of Indigenous art accept this liability and welcome strict limits that designate them as insiders and their works as carrying a uniqueness. They are backed up by laws defining what Indigenous art consists of, which are supported by a sense of social justice for minority groups. The thrust begins with group pride but is steeped largely in the economics of providing a livelihood for those groups that would otherwise be threatened. Here, concern arises over a lack of legal enforcement, and an underemphasis in respecting Indigenous art, whereas critics working from a different perspective have found an overemphasis. All of this—the web of incompatible forces in art, philosophy, social thought, and politics—leaves Indigenous art with an ambiguous standing.

A Face-Off of Values

When I woke up the next morning there on my easel was a self-portrait of Degas. I know I must have done itwhen the spirit of a long-dead artist comes into my hands the images flow out onto the canvas without the slightest effort on my part.

—Tom Keating, master forger, 1977

I had lots of offers from dealers. . . . Some offered up to a million dollars to buy these prints so they could sell them as the "famous fakes."

—Jack Ellis, lead US Postal Inspector for Operation Bogart, which resulted in the 1991 seizure of eighty thousand fake prints

The most tantalizing question of all: If a fake is so expert that even after the most thorough and trustworthy examination its authenticity is still open to doubt, is it or is it not as satisfactory a work of art as if it were unequivocally genuine?

—Aline Saarinen, art critic, 1961

*T*he conventional attitude toward art forgery is that it conflicts with moral and aesthetic values, and is deserving of censure both philosophically and in the practical realm of the law. That is, by its nature, forgery inhabits the dark side. However, there are other perspectives that consider forgery outside of this context. Shades of gray are evident not only when asking, as part II does, what distinguishes forgery from legitimate art, but also in making judgments about the wrongness of fake art and its practitioners as well as about the significance of an excellently rendered fake. Not surprisingly, forgers and their accomplices, who have an obvious reason for wanting to justify what others

see as fraudulent behavior, hold views beyond the mainstream. But besides these insiders are other parties whose vantage point lies on the outside. Critics of the high-minded and well-heeled may see art forgery as a leveling agent. Considered in terms of psychology, forgers are human subjects exhibiting certain emotional and mental traits, while an economic analysis may think in terms of cost versus benefit in asking whose lives are harmed by fake art and by how much, as well as whose lives are enriched. And in philosophy, when aesthetics addresses false art, a question emerges as to whether an outstanding forgery bears a level of authenticity and legitimacy that is worthy of respect.

An analysis of psychological profiles reveals a combination of motives and attitudes among forgers along with a penchant for rationalization. Troubled psyches are prevalent and recidivism not uncommon. Although society punishes art forgery through legal action, prosecution can be difficult due to the nature of the crime, and prison sentences are sometimes brief. A few forgers whose stories have made them public figures have managed to parlay their notoriety into book deals, television contracts, and gallery exhibitions. Beyond seeing forgers through their mentalities and their post-forgery lives, the nature of what they do is such that it is often considered less reprehensible than other criminal activities. It has been portrayed as a victimless crime in which wealthy collectors can afford to lose money on a bad purchase. The artists who make forgeries have appeared as likable rogues who have battled and exposed corrupt forces in the art establishment: their culpability has been mitigated as they demonstrate attributes popular with the public. Then, surpassing apologetics that soften the harm done by forgery, a case has been made for the collective enterprise as constituting a beneficial market force. When forgeries are intermingled with genuine art, more people than otherwise can take delight in owning or viewing works respected as originals by notable masters, while business flourishes. And aesthetics, too, confronts a face-off of competing perspectives on forgery. Much has been made by philosophers about the notion of a "perfect fake." One concern questions the possibility of such a thing on the grounds that differences will always exist between originals and fakes, and that even if those differences are imperceptible in the present, they are subject to discovery in the future. Practically speaking, however, unidentified fakes may become accepted as part of an artist's output and then enter public and private collections, while their defining features are included in an understanding of what constitutes an authentic work. Finally, assuming there are fakes that are perfect in the sense that they are as good technically in their composition as originals, what aesthetic value should they be accorded when exposed? Although fakes are denounced as a threat to our understanding of art history, some theorists see excellent ones as exceptions.

THE MIND OF THE FORGER

The impulse toward art forgery derives from an assortment of motivations. Determining which ones pertain for any individual forger is complicated by their tendency toward misleading self-reporting that is due to self-deception and conscious lying. What forgers say about themselves is important in understanding their mindset, but it has to be recognized as coming from perpetrators of fraud. Claims they make about their motivations may mask an agenda that is not acceptable to society, especially in a court of law. In particular, they may minimize the goal of earning money illicitly, even if that is their primary purpose.

Psychologists explain that regardless of the type of fraud, perpetrators create justifications for their actions that avoid the perception of wrongdoing.[1] When Han van Meegeren admitted to painting a series of false Vermeers that sold for enormous sums, the defense presented at his trial was that he wanted revenge on the art world for not respecting his talent. His own testimony laid this claim (see Figure 3.1). When asked by the judge why he persisted in a life of forgery, he answered that his motivation was not financial gain, and when asked pointedly if it had at least some influence, he doubled down by saying

Figure 3.1. Han van Meegeren's trial in Amsterdam, 1947. Van Meegeren is standing in the box on the left. Behind the panel of jurists are two of his Vermeer forgeries: *The Last Supper* (left) and *The Supper at Emmaus* (right). Licensed under Creative Commons

he did not do it for the money but only to carry on as a painter using the technique he had developed.[2] The forger's attorney provided further support for deflecting suspicion of a financial motive by reading from a court-ordered psychiatric report that found the subject to have a "special vulnerability" to criticism and "an abnormal need to avenge himself."[3] Hidden was that Van Meegeren's turn toward fraud came at the age of twenty-four when he was short on finances but well respected for his talent and confident that he was on a path to success. He had won a gold medal for his intricate rendering of a church interior and then made a duplicate that he arranged to sell to a collector who thought it was the singular original. After his wife argued with him and talked him into telling the truth, the buyer offered a small fraction of the initial price.[4] Van Meegeren's start as a professional artist included the offer of a professorship at the Hague Academy (which he declined as a waste of his talent), a first exhibition that drew sales and critical acclaim, and a sketch of a deer that became the most reproduced image in the Netherlands.[5] It was only when his second exhibition failed and was labeled as lacking originality that he became embittered. The inclination within him that led to forgery was present early and connected directly to a desire to earn money. His hostility toward the art establishment was real, but was not his only or initial motivation toward a life of fraud.

Van Meegeren was advised by gallery owners that to be successful he should embrace current trends that were selling well such as Impressionism, Pointillism, and Fauvism.[6] Instead, he defended traditionalism and took the route of forgery. Tom Keating was another devotee of Old Masters, although he faked new masters as well. Never having developed his own distinctive style, he claimed in his memoir that he was not motivated by money.[7] He said he turned to forgery out of disgust for the poor treatment the French Impressionists received at the hands of their art dealers: "I was determined to do what I could to avenge my brothers and it was to this end that I decided to turn my hand to Sexton Blaking" (his Cockney term for "faking").[8] In fact, Keating held a strong disdain for dealers, but as a full reading of his book makes clear, it derived from his own business transactions with them rather than sympathy for figures from art history.

Perhaps no forger is known to speak ill of the art establishment more than Eric Hebborn, although he made his living as an art dealer for many years. His life of fraud was not a reaction against rejection of his own works. He had exhibitions of them on occasion, and in one exhibition displayed a unique and provocative idea of multiple images of the same subjects in single sculptures.[9] Rather than lacking a knack for originality, he was inspired by historical tendencies in art and chose to follow them while characterizing twentieth-century art as "neurotic, desperately extrovert and egocentric."[10]

Hebborn's motivation as a forger was not revenge so much as competition. He believed dealers (nearly all of them) to be "deep into the ungentlemanly muck and mire"[11] and considered experts to be his opponents. He engaged in forgery to joust with art experts and earn a better living than he would have anticipated from works done under his own name. He learned forgery as a young man while working for a crooked restorer and decided to remain in his illicit career even after doing graduate study in a prestigious program in Rome and securing high-level connections. Hebborn was confident of his great talent, and considered himself "not a dropout, I'm a stand aside."[12] He drew inspiration from his accomplishment at duping many experts.

Hebborn was proud of his career of deception. Other forgers have expressed this emotion as well: a feeling of gratification that comes from a performance so skillful that it mimics what respected artists do, demonstrated when their false creations are marveled at and purchased by collectors and institutions. When he was exposed and felt dismayed at facing prosecution, Tony Tetro found his spirit buoyed by a newfound respect for his talent:

> For well over 10 years, every cop in the valley and many people who didn't know me personally, were certain I was a drug dealer. . . . So there was some satisfaction . . . even some pride when I was arrested . . . that finally these idiots knew that I was an artist.[13]

The pride that recognition brings, however, comes at a steep price when it is connected to public exposure of a forger's identity because that means legal trouble and the end of the career that is worthy of the recognition. But there is also pride of a quieter sort that is consistent with being anonymous. It lies with knowing the artworks that have been created are drawing respect even if their creator is not. Geert Jan Jansen has said about his output of counterfeits,

> I think maybe one percent has been discovered as work by myself, but the rest is all circulating in the art market. . . . there are a few paintings in museums and yes, I like that very much. They are hanging there in a nice place . . . and the more time they spend in a museum the more real they become.
>
> If a painting comes up in an auction, the catalog is sent all over the world and examined by all the experts and collectors. On the viewing day they come together and discuss the work and everybody says it's an original . . . it's fantastic. Yes, I enjoyed it very much.[14]

The pride forgers feel comes in variations, such as Mark Landis's drive to be philanthropic. As a shy twelve-year-old seeking friends and a stronger self-image, he forged cancellations on stamps that increased their value for

collectors and then gave them to other boys. Later, as an artist who did poorly selling his own art, he was uplifted by the donations he made of his forgeries to museums, sensing what it would be like to be wealthy and powerful. And he believed he was making his mother (who did not know his donations were forgeries) proud.[15] In contrast is the hubris of Ken Perenyi, who like Hebborn enjoyed jousting with experts, sometimes acting as his own front man: "I miss the addictive thrill of fooling the experts. It was great sport for me."[16] His pride shows through in supreme confidence: "I'm convinced that if these artists were alive today, they would thank me. . . . I'm sure Herring himself would be proud to put his name on this painting."[17]

Although revenge and pride are significant motivational factors that may influence the minds of art forgers, neither is likely to be the primary one. Foremost in drawing artists to forgery, and holding them there, is the desire to make money. Regardless of other inducements, this is what keeps them going in the face of being caught in a criminal activity. If they were directed by animosity toward the art establishment or a desire to gain approval, they would at some point announce their exploits to the world and enjoy the embarrassment caused to the experts they fooled and the financial havoc wrought in the art market, and bask in the esteem of being recognized as an equal talent to the artists they imitated. Most forgers do not do this, with the historical exceptions of Giovanni Bastianini, Alceo Dossena, and Lothar Malskat. Rather, the common practice is to maintain secrecy about their production of fakes until they are caught. The drive to make money is not necessarily for large sums and may be constrained by limited artistic skills or sales connections, and a desire simply to live the life of an artist. This observation about the pursuit of financial gain, of course, is based only on those forgers who have been exposed. How many there may be who pursued forgery silently and gave it up without being found out is an open question, but however extensive this phenomenon is, it lends credence to the supposition that their motivation was not egoistic but monetary.

Some forgers have used their earnings to finance a luxurious lifestyle. Van Meegeren lived in an elegant villa where he hosted lavish parties, had an expensive addiction to morphine, and owned numerous nightclubs, hotels, and country homes (with secret cash boxes hidden on many of the properties to avoid banks and not declare income).[18] Tetro, although not as wealthy as Van Meegeren, decorated his home with custom wallpaper of lizard skin and suede, owned a Rolls Royce, two Ferraris, and a Lamborghini, spent time in Paris and Rome, and liked to gamble in Monte Carlo.[19] Guy Ribes, too, was a lavish spender, proclaiming the millions of dollars he paid to live glamorously.[20] Wolfgang and Helene Beltracchi purchased magnificent homes where they held extravagant social affairs through which they advertised their cover

as owners of a major collection of artworks by twentieth-century masters (all forgeries).[21] John Re, who earned nearly $2 million from his fake Jackson Pollock paintings, spent $700,000 of it to indulge his fantasy of owning a submarine that he fitted with luxury accommodations and used for day trips.[22] Elmyr de Hory was another forger with expensive taste that he satisfied to the extent he was able, but he was constrained by the financial arrangement contrived by his front men, Fernand Legros and Réal Lessard, in which they kept most of the profits from selling his fakes and lived a jet-setting lifestyle as successful art dealers.[23]

On the other hand are notorious forgers who did not make large sums of money or live conspicuously. In his memoir, Keating claims to have given away many fakes and to have sold many more for small sums.[24] With documents to prove it, William Blundell testified in court that he routinely received $100 to $200 each for hundreds of fake paintings that the art dealer who purchased them sold at prices in the thousands.[25] Pei-Shen Qian insisted that he received no more than a few thousand dollars each for the paintings he made that sold for many millions, and was backed up by an unassuming lifestyle in what has been called a "shabby house" in New York.[26] John Myatt's ten years of illicit labors netted him less than $200,000, much of it spent on schooling for his children and donations to his church and the Salvation Army.[27] Shaun Greenhalgh and his family had ample money from his career of making fakes, but continued the lifestyle they were accustomed to as welfare recipients even after the Amarna Princess sold for the better part of a million dollars. When questioned by police about why he did not spend from his large bank accounts, Greenhalgh replied, "I have five brand new pairs of socks in my dresser. What more could I want?"[28]

Greenhalgh, perhaps more than any other forger, represents the desire to pursue a career doing what he was good at and enjoyed: he was a copyist from an early age and began selling his forgeries while still a teenager. His motivation involved a desire to make a living while engaging in his chosen profession. Although police investigators labeled him as resentful and bent on retaliating against an art elite, he opens his memoir with a repudiation of this notion:

> I've been described as some kind of class warrior . . . the little man against the Establishment. Others have me down as a disgruntled artist out for revenge. But having never been to art school or ever been interested in an artistic career, revenge against whom?[29]

With many other forgers, it may be suspected that the inducement leading them to fraud is similar to Greenhalgh's, even if they are not as prolific or successful as he was. For artists who want to earn money from their creative

activity, making fakes may be their best chance, and some of them turn in that direction. Vocationalism adds to revenge, pride, and money as a motivational force behind forgery.

Different from motivation but related to it is the mental state that psychology terms "neutralization," meaning the overcoming of moral concerns about what is generally understood to be socially unacceptable behavior.[30] Beyond the impetus to commit a criminal act lies the attitude forgers hold that allows them to justify that act. Rather than feeling remorse for their behavior, they develop various pretexts for vindication that smooth the way for continuing with fraud. An expression of remorse, if it occurs at all, is likely to be at their trial to avoid a guilty verdict or to angle for a light sentence, and its sincerity is suspect. Myatt expressed remorse at his trial and was believed, but he felt differently when he began his illegal career. In a 2017 conference presentation, he said, "It didn't occur to me at the time that it was a bad thing. . . . I really believed there were no victims. Not true, of course, but people do like to delude themselves that this is a victimless crime. Well, it isn't, but you think it is!"[31] Tetro, too, experienced a change of heart. As he explained in a 2014 interview, long after his court-ordered sentence was completed,

> I went through life thinking I did a victimless crime . . . until about five years ago. There's a program on American television called *American Greed* and it showed it from the victim's point of view.
>
> My point is, eventually someday, somebody's gonna be hurt. They're gonna think they have a multi-million dollar painting then find out that it's not. And I only came to this conclusion about five years ago.[32]

Without focusing on a victim, a forger's conscience can believe no crime is being committed. Other perspectives recognize the nature of the criminal act but mitigate its consequence for victims or transfer blame to them, effectively saying they can afford it or they deserve it. Perenyi expressed the attitude that his victims could afford a loss: "Do I feel guilty about taking money from auction houses? The idea is laughable. . . . These were not poor people. This was a world of glamour and money, and plenty of it."[33] Robert Driessen's disdain was more pointed and harsher about the people fooled by his fake sculptures: "Anyone who believes he can buy a real Giacometti for 20,000 euros deserves to be duped. The art world is rotten."[34]

Hebborn's method of neutralization was more complicated and high-minded, expressed in a code of ethics. In his books he professed three principles for art forgers to follow so their activity would avoid wrongdoing. His thinking can be summarized as follows.

1. Do not sell to novices or collectors, but only to dealers. Professionals are a fair target and ought to be responsible enough to take care of themselves; if not, they are in the wrong business.
2. Let the client be the one to establish whether what you are selling is genuine, rather than making an assertion about it yourself. You have not misled anyone if you simply offer a professional an opportunity to make a judgment.
3. Sell your fakes for the same price you would ask for works signed with your own name. That way you are not taking advantage of anyone.[35]

Hebborn's reasoning may appeal to people inclined toward fraud, but others will see his instructions as misguided. He assumes the world of dealers is not worthy of the respect offered to other members of society and ignores the damage done to the victims of dealers who sell his forgeries either knowingly or unknowingly. And his advice about pricing assumes that someone who buys a fake of a recognized artist unknowingly at a low price would want to buy a genuine work by an artist of little or no standing at that same price. Moreover, it is unlikely that Hebborn followed his own advice. As a gallery owner, he mixed his fakes with legitimate works, and it is difficult to imagine that he disallowed collectors from purchasing fakes when they visited his gallery. Still, he found a way not only to harness his own conscience but also to try to convince his readers of his vindication and, by extension, their potential for the same if they chose a path of forgery and followed his directions.

The psyche of a forger engages in neutralization to soothe pangs of conscience from telling lies about the authenticity of false artworks. In this sense forgers are habitual liars. In extreme cases, their lies have gone beyond misrepresenting art and encompass their personal identity and accomplishments, an indication of severe personality disorder. John Drewe's persona was an elaborate fabrication, reaching proportions that clinicians might describe as *pseudologia fantastica*. Fact and fiction are blurred and woven together, and when untruths are spotted by other people, the story is amended or a new one is created.[36] After John Cockett (Drewe's real name), an unusually bright teenager with a passion for physics, dropped out of high school and worked as a clerk for the Atomic Energy Authority, he disappeared for fifteen years before turning up to identify himself as a PhD physicist who flew helicopters, had connections to Russian, South American, and Chinese officials, and was a military weapons expert who had served in the British special forces, all in addition to being an art collector. He lived for a decade with a physician who believed he was an advisor to the Atomic Energy Authority and on the boards of several companies, gained control of her finances, and eventually left her while taking their two children with him. Later, when a New York art

dealer questioned the authenticity of a Giacometti painting (a fake painted by Drewe's partner, Myatt) and tracked it to one of Drewe's associates, Drewe managed to have him steered to a consulting firm he had created and met the man in London at the archives of the Victoria and Albert Museum. There, he showed the dealer "irrefutable" evidence in the form of exhibition catalogs (fakes planted by Drewe during his extensive seeding of the archives with false documents) picturing the painting, after which he presented the man a bill for his expert services.[37] At his trial, although his partner admitted to the forgery scheme, Drewe spun an extraordinary tale about being a pawn in an international art fraud conspiracy involving MI6 and the CIA.[38] All that is known of Drewe's adult life are a series of elaborate and sometimes interwoven confidence games. Having served his sentence for art fraud, he later swindled an elderly widow for more than a million dollars. Following the death of her husband, whom Drewe had befriended, he gained control of her finances, sold her properties, and after spending the money, took several thousand dollars more that he convinced her to borrow from a friend. The judge who sentenced him to eight years for that offense stated, "In my view, you are about the most dishonest and devious person I have ever dealt with, even through the trial you were fabricating documents."[39]

De Hory, too, lived his life as an extended lie, although a consistent one. The story he told when selling his fakes to dealers for fifteen years (later he worked with front men) was of a Hungarian aristocrat with Jewish heritage who narrowly escaped the Nazis during World War II. He managed to save the family's art collection, but his family perished: his brother in a racing accident driving a Bugatti, his diplomat father in Auschwitz, and his mother shot by a Russian soldier for her fur coat. He added embellishments of studying as a young man at a respected art school in Hungary and with Fernand Léger in Paris and personally knowing various celebrities. De Hory's accent, along with a suave manner including wearing a stylish suit and a monocle, enhanced the dignified air he presented. While he used a variety of aliases in different locations, his modus operandi remained the same. It differed from the temporary persona a con artist would typically assume in that De Hory continued the story with his friends and con artist associates and did so throughout his lifetime.

Little of De Hory's self-styled biography is true, with the exception of his art training and possibly some of the Paris connections, although later in life he did know several Hollywood stars. Facts about his family history were discovered in 2011. He was born Elemér Hoffmann to a middle-class family, and his mother and brother survived the war. His most prized claim to aristocracy, a portrait of himself and his brother as children supposedly painted by a famous artist, was painted by someone else (perhaps himself). The elaborate

charade answered a desperate need for respect encapsulated a favorite aphorism of his that "Image is everything." In his later years, after being exposed as a forger and achieving folk hero status, the lie became even more important to maintain, and De Hory took with him to his grave many hidden truths he retained after decades of deceit and rationalization.[40]

Habitual lying is often associated with "antisocial personality disorder," a common condition among criminals. For researchers and clinicians, this term has replaced the traditional terms of "psychopath" and "sociopath," although those labels still appear in ordinary language. The extent of deceit involved may not be at the level of Drewe and De Hory but still may be significant. It relates to other factors including a lack of remorse and an emphasis on self-gratification. Other people are held at an emotional distance, although there may be an outward display of friendliness and sympathetic behavior, and occasionally strong attachments can be formed although they may not last.[41]

Comments made by some of the most notorious forgers indicate an antisocial makeup. In his documentary, Ribes shows a hard edge as he describes taking up forgery as a game and then using it to fund his extravagant spending habits. About art dealers he disliked doing business with, he says, "If a guy complained, I said it's my job dickhead. It's a choice." When asked questions about his personal relationships, he reveals a striking misogyny.

> I've never been in love. Lila, like all the others, some great times, but no. They're not on the street but they're still whores. When you hang out with pimps and whores—But I loved my cat, my dogs. I remember my dogs better than my women.[42]

Ribes's jaded attitude reflects his early life when he spent several years of his boyhood living in a brothel owned by his father.

Perenyi's disregard for society is announced in the title of a series of videotapes he made (available on YouTube): *How to Fool the Experts and Laugh Your Way to the Bank.*[43] When asked in an interview if people are harmed by the presence of his fakes in the art world, he responded, "I don't think so. I think that I've made a contribution to the art world." As for his success in fooling experts: "I wouldn't characterize it as gloating. I'm just being honest."[44] This mentality of glossing over the detriment he caused to the world around him dovetails with a brash confidence in his ability that surpasses what forgers typically have expressed. Beltracchi, however, professes supreme self-assurance. During his trial, he put on a theatrical air with a rambling confession that described his youthful passion for "drugs and rock 'n' roll," an admission that his art fraud had been "great fun," and boastfulness about spending only a few hours each in creating his multimillion-dollar forgeries. A journalist who covered the case for two years stated, "It was an incredibly vain performance.

The guy is a total egomaniac."[45] In an interview with *Der Spiegel*, he was described as having "the self-confidence and hubris of a man who believes he is a genius."[46] And in the documentary made about him, Beltracchi's exchange with his interviewer claims, "There's nothing I couldn't paint. I think I could paint anything." When challenged on this declaration he responded,

But I can. Anything.
(interviewer) Vermeer?
Him too.
Rembrandt?
Any of his.
Leonardo?
Of course. I don't find him difficult. Not at all. Sure, I could paint a new Leonardo.[47]

Beltracchi's tendency for showmanship traces to his youth, when he delighted in dressing in Italian robes and a full-length fur coat and sported waist-length hair as he posed for photographs by tourists.[48] His personality pattern might fit a clinical classification as narcissism, although other medically relevant factors

Figure 3.2. Wolfgang Beltracchi and Helene Beltracchi with director Arne Birkenstock at the screening of the documentary film *Beltracchi: Die Kunst des Fälschung*. dpa pictures/Alamy Stock Photo

may be at work as well. He says proudly about a pathology professor who knows him well, "He would like to examine my brain. He believes he would find something completely different there."[49]

Separate from factors of personality and pathology among forgers is another sort of question regarding their mindset: what goes on in their minds as they prepare for and produce works in the manner of other artists? Although the process may be like legitimate copying, forgers have a particularly strong incentive to be as convincing as possible. At a minimum, it is necessary to study the works of target artists, after which comes practice and likely many false starts. But beyond careful and conscious emulation, there are cases where it has been suggested that more is involved: that a forger has formed a special bond or made an unusual connection with the artist being copied.

In *The Art of the Faker*, Frank Arnau discusses the process by which Alceo Dossena worked in fashioning sculptures like those from the ancient world to the Renaissance that fooled many experts. Arnau's explanation hints that the sculptor engaged the past through a paranormal means: "Is it so improbable to suggest that Dossena, activated by forces of a metaphysical nature, worked from inner compulsion in a manner which was at once his own and that of others?"[50] Hans Cürlis, director of the Institute of Cultural Research in Berlin and maker of a film on Dossena, spent much time watching the sculptor in his studio and marveled at the way in which he worked quickly and easily. His actions seemed so natural that

> It only later occurred to us that we had witnessed the reincarnation of a Renaissance master and Attic sculptor. . . . One of the fundamental laws governing our attitude seems to have lost its meaning. . . . it is as though causality has been suspended and its dogmas cut adrift from the safe anchorage of experience. . . . Nor is the matter sufficiently explained by the fashionable "state of trance" theory.[51]

There was nothing about the way Dossena worked in front of viewers that suggested a trance, but a similar way of explaining how a temporal gap that covers more than a millennium can be bridged was offered in an interview by a twentieth-century Egyptian copyist and antiquities forger. He disclosed that when producing important items, he shut himself away in a tomb for a period of days and induced a hashish haze that continued until he was finished.[52]

Tom Keating makes bold and repeated claims in his memoir that some of his forgeries were done by the guiding hand of the artist he was simulating. He differentiates those works from his typical fakes that he calls "Sexton Blakes" and says they were always done at night. Vowing no other bond with spiritualism than his artwork, and asserting that people he told about his psychic connections did not believe him, he describes having a fitful sleep after which

When I woke up the next morning there on my easel was a self-portrait of Degas. I know I must have done it, but I had no memory of it. The only van Gogh that I ever painted happened in a similar way. I couldn't paint a Goya, Rembrandt or even a Samuel Palmer for a million pounds or to save my life. But when the spirit of a long-dead artist comes into my hands the images flow out onto the canvas without the slightest effort on my part.[53]

He also tells of a spiritually inspired self-portrait of Goya that he worked on long into the night, of a particular Samuel Palmer landscape, and mentions Gainsborough, Turner, Constable, Munch, Nolde, and Pechstein as others he channeled, although he faked many more artists without that special connection.[54] While Keating's recounting sounds sincere, he was known for his colorful personality and flair as an anecdotalist. And he admits in his book to periodic spells of heavy drinking, although without relating this factor to his transcendental encounters with dead artists.

A milder hint of a special bond between a forger and the artists he faked is found with David Stein. While out on bail after his arrest, he stated in an interview,

You go into the soul and mind of the artist. It's like a Dr. Jekyll and Mr. Hyde thing. You become someone else. When I painted a Matisse, I became Matisse. When I painted a Chagall I became Chagall, I was Chagall. When I painted a Picasso, I was Picasso.[55]

His wife, Anne-Marie Stein, described this state as a "mood," saying that he would put himself in the frame of mind to work like a particular artist and then often do several pieces, during which time he was unable to imitate any other artist. He could acquire moods quickly, however, and then worked in rapid fashion.[56] De Hory seized on Stein's depiction of "soul and mind," saying he had read about it, and he ridiculed the notion: "I personally think that's all the worst sort of nonsense. . . . it's a terribly vulgar and romantic explanation . . . though I'm sure the public eats it up. What I did was study—very carefully—the man's work. That's all there is to it."[57] De Hory was quick to criticize his competitor, but Stein's language could be understood metaphorically rather than literally, as describing a physical rather than metaphysical occurrence. In that sense, he would be relating an unusual closeness that a copyist who has studied and practiced extensively feels toward the subject artist. With this background, the experience of working like the subject seems natural, as with an actor preparing long and hard to play a part and then acting it out. Other forgers have described an experience of this sort through metaphorical language, including De Hory himself. In one of the notebooks he kept and considered publishing, he declared, "I am continuing their work. Modigliani

is dead. Matisse is dead. I sometimes feel their souls were transplanted in me. I have a mission to fulfill."[58]

Comparing a forger with an actor is a rhetorical strategy used by Hebborn to explain how he could establish an unusual link to long-dead artists without introducing the paranormal. He notes that only after learning someone's speech and their movements is it possible to give a convincing portrayal. But Hebborn goes further with his analogy to language by asserting the theoretical position that art is subject to an ahistorical foundation, so "the art of drawing is seen as an ancient and alas almost dead language, the grammar of which had remained largely unchanged since man's appearance on earth."[59] The idea is that in all eras what is most fundamental in art is the same: styles are variations on a never-changing foundation. All artists, then, are related in a way that makes it possible to hearken back to their particular approaches—to how they employed the universal grammar of art—and come to a clear understanding of what they were doing. With this understanding it is possible to create just as they did without guesswork. The key is to break into their movements as a linguist would into a language, and then translate.[60]

> If one truly understands the marks of a drawing and more particularly the meaningful relationships between those marks, one is in mental contact with their author, no matter how remote in time and space. This requires great knowledge and sensibility, not clairvoyance. It is no more than can be reasonably expected of a connoisseur.[61]

In empowering connoisseurs, Hebborn is giving broad range to the capability of understanding the processes employed by artists from the past, which is in keeping with his encouragement for artists to become forgers. He was not an egalitarian, however, but confident of his own elevated status from which he instigated others to act against the art establishment.

The various ways in which forgers have explained having a special connection with their target artists provide a common takeaway. They differentiate themselves from copyists in general and even from other forgers. They set themselves up in a manner in which it appears they hold a privileged status that might mitigate negative judgments about their actions and potentially challenge an attitude of hostility toward forgery in general. Whether the appeal is to a paranormal force, a theory of foundationalism, or the lesser implication of metaphorical description, the forgers mentioned here claim an access that is not generally recognized. This access allows them to "be" another artist in a sense, to delve inside the other artist's works and way of fashioning them rather than merely observe from the outside. To the extent they become one with the other artist, they blur the line between legitimacy and illegitimacy in artistic production. They lessen the tension between fake and real in a way

that enables the psychological process of neutralization, and that through their published words presents a justification for their actions.

CRIMINALITY

What happens to forgers when their fraudulent activity is discovered? As can be recognized from the biographical sketches in part I of forgers over the last century, time spent in prison is often less than two years. This is a trend that holds in Europe and the United States. Some of the most notorious forgers of recent times never served prison sentences. Hebborn, Perenyi, Landis, Qian, and Blundell avoided arrest. Ken Walton dodged prison in exchange for cooperating in the conviction of his partner. Others received suspended sentences, including Edgar Mrugalla, William Toye, and Christian Parisot (whose second offense earned him four years' house arrest). Van Meegeren died before serving his sentence, and Keating's charges were dropped due to his ill health (after which he lived five more years). De Hory served two months in a local jail on the island of Ibiza for charges unrelated to forgery (and later committed suicide on learning he would be extradited to France for trial there).

For those forgers who do serve time sentences vary, beginning with a year or two and often involve early release. Tetro shortened what would have been a twelve-month sentence to nine months in a work-release program. Myatt served four months of his one-year sentence, and Ribes served one year of his three-year sentence. Stein served eighteen months of a three-year term in the United States and then another two years in France. One of the longer sentences—six years—was meted out to Beltracchi, but it was in work-release or "open prison" in which he left during the day to go to a job, and he was released after three years. Greenhalgh was given four years and eight months and released after serving two years. Kristine Eubanks received a seven-year sentence but factored in was that she was already on probation for credit card fraud. Guy Hain's first offense drew four years, of which he served eighteen months, and then for his second offense he was given four more years. Other sentences at the long end include John Re (five years and then twenty-seven to eighty-four months for a second offense), Ken Fetterman (forty-six months), and the Amiel family (Kathryn, six years and six months; Joanne, three years and ten months; and Sarina, two years and nine months). While this list does not include many less notable forgers, it serves as a rough indication of the prison time art forgery draws for those caught at it.

The creators of fake art are only part of the network responsible for its widespread presence in the art world, although they are the main focus of this book. Distribution of fakes involves many more people, some who work

closely with forgers as their accomplices and others who may be at arm's length in a sales network. It is these sellers who are in greatest jeopardy of being discovered and facing prosecution since they are on the front line of a fraud operation. When convicted, their prison time can be similar to that of forgers themselves or of greater duration. Gerald Sullivan and James Mobley, who conspired with Eubanks, received sentences of forty-eight and sixty months, respectively. Helene Beltracchi was sentenced to four years and associate Otto Schulte-Kellinghaus to five years. Robert Driessen's sales associate Lothar Senke received nine years, with seven years and four months for Herbert Schulte. Eli Sakhai's sentence was forty-one months. Among other dealers, of whom there are many, examples include Donald Austin, who received eight years and six months for selling counterfeit prints in his galleries in Chicago, Detroit, and San Francisco,[62] and fifty-seven months for David Crespo for fake prints (the amount totaling $400,000).[63] Lighter sentences include three months for Glafira Rosales (time already served), who fronted for Qian's fakes; six months for Florida pastor Kevin Sutherland for Damien Hirst forgeries he acquired on eBay unwittingly and then tried to sell as originals after finding out their true status;[64] and (in Australia) three years' "good behavior" to John O'Loughlin for selling Clifford Possum dot paintings he completed and signed after buying unfinished works from the artist when he was drunk.[65]

There are various reasons for these differences in sentencing. Each case is unique. One factor, however, that often limits prosecution is that fraudulent works that can be traced to a forger have passed the statute of limitations for the crime(s) being charged. Sometimes, cases are narrow in scope, or not brought at all, for this reason. In most countries limitations run from three to ten years under either criminal or civil law for the types of crimes art forgers are accused of, such as fraud and money laundering. In the United States, the time period varies somewhat from state laws to federal law, but a uniform principle is that the clock for limitations begins when a fraudulent act occurs rather than at the time it is discovered. Thus, an artwork exposed as a fake when it was put on the market long after it was purchased could not be cited for prosecution, although there is an exception under unusual circumstances in which the limitation period may be extended through a "toll." An example is a case in Hawaii (*Balog v. Center Art Gallery-Hawaii*) in which a gallery sold fraudulent works of Dalí and periodically issued updated certificates of authenticity along with appraisals of increasing value. Based on this information, the buyers held the works for ten years until learning that the gallery had been involved in questionable dealings, then sent the works for independent appraisal and found they were counterfeit.[66] When the buyers took legal action for breach of warranty, the defendants cited the four-year statute of limitations under the US Commercial Code.[67] The court found that the breached

agreement included a promise of future performance of the goods in question, and tolled the limitation period, setting the beginning of it at the time when the performance of the goods in question (their discovery as counterfeit) occurred.

Statutes of limitations exist for the purposes of practicality and fairness to society. Over time, witnesses become unavailable, and evidence is lost or ceases to exist. With crimes in the business world, the expectation is that commerce will go on without the prospect of disruption for occurrences that are long past, as various vendors will have been paid and ownership may have progressed through several parties. It has been argued that artworks are long-lasting, and the stimulus to discover falsity in them may occur only after statutes of limitations have passed, as opposed to such items as computers, kitchen appliances, and motor vehicles, where defects typically would be discovered much sooner. The implication is that an exception for artworks should be written into law that sets the clock for limitation for a longer period than is generally the case.[68] However, if the law were changed in this way, concerns about difficulties in producing witnesses and evidence, and the expeditious flow of commerce, would escalate.

Forgers have used the statute of limitations to their advantage. Perenyi, having never been arrested, waited until it had expired for the fake paintings he chose to admit to and then wrote his memoir detailing a life of forgery that describes those works. He is free from prosecution for his abundant output over many years as a forger. Sakhai was investigated for several years before he was arrested and convicted in criminal court in 2004. When the owner of one of the fake paintings he sold attempted to bring a civil suit in New York for his loss, he was unsuccessful because the statute of limitations had passed.[69] Beltracchi, too, benefited from the statute of limitations for his criminal offense, which in Germany was ten years for his crimes.[70] The remainder of the several hundred false works he is suspected of making and has bragged about will exceed the time limit for prosecution in the early 2020s, although after his criminal trial he did face further legal action from several individuals who purchased his fakes.

Statutes of limitations are likely to prevent prosecution for many works by prolific forgers who have plied their trade for decades before being arrested. Even when there are numerous fakes that fall within the prosecutable time period, however, it is common for only a few to be included in the formal charges against the accused party. Each work cited as false must be proven so individually. A case decided in Germany in 2018 highlights the pitfalls that prosecutors face. After court proceedings lasting three and a half years, art dealers Itzhak Zarug and Moez Ben Hazaz received prison sentences of thirty-two and thirty-six months, respectively, for the fraudulent sale of paintings by

Russian artists El Lissitzky, Kazimir Malevich, and Alexander Rodchenko. Many people following the lawsuit were disappointed that the sentences were not greater, as the case was hailed as one of the most important actions against art crime in Germany in decades. The two defendants were alleged to be the leaders of a cartel operating in several countries to sell fake Russian avant-garde art. More than two dozen properties were raided in Israel, Switzerland, and Germany, and fifteen hundred works were seized. At trial, the charge sheet totaled nineteen works. When the trial concluded, the prosecution had proven the fraudulent sale of only three of those works, based on the presence of an anachronistic pigment. For the rest of the paintings, science did not reveal material falsity, and determinations then rested on connoisseurial opinion. The prosecution's leading expert was rebutted on each count by the defense's expert of equal standing in a face-off between art historians with a long personal history and animus toward one another.[71] Courts are often faced with conflicting expert opinions, with the burden of proof falling on the reputations of the various parties offering them.

The legal case against Geert Jan Jansen, too, was problematic over identification of the works in his possession when he was arrested. Rudy Fuchs, director of the Municipal Museum of Amsterdam, considered many of them to be originals.[72] Further, most of the purchasers of Jansen's fakes declined to cooperate with the prosecution. One collector said he loved his painting even if it was a forgery, and dealers were reluctant to part with items that might earn a profit. In an interview, Jansen noted that there are many fakes on the market, and "art dealers know that, but they're hypocrites—they don't tell the buyers: if a dealer thinks he's bought a forgery, he salts it away for a year or two and then sells it at auction."[73] When Jansen's case reached trial after six years of preparation, most of the charges against him had been dropped, and he was sentenced to one year in prison (with five years suspended). He quotes one of the prosecutors as remarking, "Obviously you only had satisfied customers."[74]

Beyond establishing in court that an artwork is inauthentic lies the question of the intent of the seller. The fact that a nonoriginal work has appeared in the guise of an original is not enough to determine guilt. The seller must be shown to have intended to defraud. Forgers when caught often claim they made their works as copies and informed buyers of that status. Tony Tetro's steadfast defense that he was a legitimate copyist rather than a forger earned him a mistrial (after which he made a plea deal that averted a second trial), and William Blundell's insistence that he sold his works (to a dealer) at the price of legitimate copies may have kept him from being convicted of fraud. Dealers, on the other hand, often say they believed the works they acquired to sell were originals since they were presented to them that way or there was no reason to assume they were problematic. To refute this claim, authorities sometimes

are able to turn co-conspirators against one another, as with Michael Zabrin, a dealer in fake prints who was exposed in the US government's Operation Bogart that unraveled the network of dealers involved in the Amiel operation. In exchange for lenient treatment, he not only informed on associates but also wore a recording device in meetings with them to provide further evidence.[75] The cases of other dealers in false prints (mentioned previously for their sentences) demonstrate more factors that weigh against their claims of innocent ignorance. One giveaway is possessing an unreasonably large number of works. Gallerist Donald Austin, who was indicted based on testimony by Zabrin, held a voluminous inventory of prints, and when 490 items were examined, all were found to be fakes. His employees testified that he never ran out of prints and that when clients asked for a specific edition number they were never told it was unavailable. Austin had acquired some of the fake prints in quantities greater than the total number of originals in the edition.[76] Another telltale sign of fraudulent prints lies with the signature, which in some cases is not applied until they reach the dealer who will sell them. For instance, a search by the FBI of David Crespo's gallery revealed packages of Chagall prints along with practiced renderings of Chagall's signature.[77]

Pleas about innocent intentions made by fraudulent art dealers differ from those of forgers because dealers are in the business of selling what someone else makes, whereas forgers are the makers. This basic distinction of roles carries through in the options that perpetrators of art fraud have available to them after they are exposed. Forgers are in a position to use what they did illegally as the basis for success in a legal way. Some among the high-profile forgers have leveraged their notoriety to show off their artistic skills and gain respect as well as financial reward. Others, however, have lapsed into their former criminal activity. Convicted dealers, too, may become recidivists, but what thrust them into the public eye does not carry the potential to be admired or to open an avenue for transfer to a legitimate enterprise.

Among the more prominent names in the annals of art forgery described in part I, several became repeat offenders. After serving sentences in the United States and France, David Stein painted under his own name but also was reported to have made fakes of Andy Warhol's *Superman*, although he was not arrested. Guy Hain, following his release from prison in 1999 for flooding the market with fake bronzes, soon resumed his illegal manufacturing and attempted to conceal the operation by having each stage in the process (casting, chasing, patination) done at a different foundry. He was arrested again in 2002 and imprisoned. In Italy, Modigliani expert Christian Parisot followed up his 2010 conviction for selling fakes (of works by Modigliani's mistress, Jeanne Hébuterne) with another conviction two years later for placing Modigliani fakes in an exhibition he organized.

Lesser-known recidivists also have accounted for major art fraud. Vilas Likhite, a Boston physician and Harvard Medical School professor, was involved in a 1985 civil case alleging the sale of fake art, but no action was taken. In 1989, he was in court again for selling art forgeries, and sentenced to probation. Having lost his medical license for administering experimental drugs to his patients, he moved to California and continued selling fake art for tens of millions of dollars by working through brokers and avoiding major auction houses and other parties having significant expertise.[78] He was arrested in 2004 for selling a fake Mary Cassatt painting for $800,000 to undercover officers and later sentenced to a one-year prison term. His claim to possess hundreds of artworks led the prosecutor to suggest aggressive action should be taken to prevent him from putting more fakes on the market.[79] Also in California, Vincent Lopreto, who had been imprisoned for five years for selling art forgeries, was arrested in 2013 as a repeat offender. In return for testifying in a case against Kevin Sutherland, who had attempted to sell fake Damien Hirst paintings Lopreto had sold him, Lopreto was given a lenient sentence and released in 2015. Two weeks later he resumed selling fakes of Hirst's work, making prints on a printer found in his possession. He was arrested in New York in 2017 for that scheme, which involved $400,000 in sales to thirty-five clients, and was sentenced to five-and-a-half to eleven years in prison.[80]

These examples are of recidivist acts of art fraud that occurred after the offenders were given light sentences. Whether stronger sentences would have resulted in greater deterrence can be debated. What also must be factored in is the career-criminal pattern that may accompany fraudulent behavior. Culprits may be unable to control their impulses toward socially unacceptable conduct. And for such individuals, dealing in fake art may be only part of a larger picture of criminal activity. Art fraud, then, becomes a convenient alternative on a list of nonviolent crimes of deception.

Ken Perenyi's career as an art forger began in combination with larceny and living on the edge of the law through connections with art-loving thief and swindler Anthony Masaccio and famous and controversial attorney Roy Cohn. Perenyi's memoir offers a lighthearted and remorseless interpretation of stealing a bathtub, twice stealing files from a clinic occupying the building where he lived, furniture and business equipment from his building, and inventory from an auction house.[81] Operating in and around criminal activity became a way of life when he was barely past his teens, with his talent for forgery gradually growing into his main source of income. Other figures whose art fraud appears along with criminal activity of varied types include Kristine Eubanks, who was on probation for credit card fraud at the time of her arrest; John Re, who served a prison sentence for printing counterfeit money before being caught as an art forger; and Michael Zabrin, whose complicated role in

the industry of fake prints included a connection to the Amiel enterprise, and being caught in a sting operation in 1990 at which time he turned informant and wore a wire to collect important evidence. In return, in 1994 he received a sentence of one year and one day that was served in a minimum security facility, and within a year after release returned to selling fake prints, this time acquired from European sources. In the early 2000s he expanded to selling on eBay. In 2006 he was arrested again, once more agreed to be an informant, and while cooperating with the FBI, he was caught defrauding a business partner by selling his partner's share of a joint purchase of Chagall prints that both thought (mistakenly) were genuine. Also during the early 2000s, Zabrin was arrested on state charges as a serial shoplifter and was shielded by federal authorities counting on his collaboration to prosecute art dealers. When the secret recordings he facilitated were completed, and his use as a witness in court had been severely compromised due to his reputation for continual criminal activities, he was sentenced in 2009 to three years' imprisonment for retail theft and in 2011 to nine years for his sales of fake art.[82]

Another convicted criminal who turned to selling fake art is David Henty, after he served a sentence in Britain for passport forgery and another in Spain for selling stolen cars. He developed his skill as a painter while in prison, and afterward worked unsuccessfully under his own name before resorting to faking the works of famous artists and selling them on eBay. He used age-appropriate materials and added old stamps on the back as well as words seemingly written by the artist. He posted promotional descriptions on eBay that insinuated the paintings could be genuine, although prices ranged from the hundreds to the low thousands of pounds. A typical description stated,

> Oil painting on canvas. Initialled w.s.c. Plaque on the front bears his name. Never been out of the frame, offered in original condition. One of two. . . . I have tried to provenance them. . . . there is no record of them. So reluctantly I am selling as after Winston Churchill.[83]

Henty was investigated by reporters from the *Telegraph*, who interviewed him and drew out an admission presented in a 2014 article that he had sold more than one hundred paintings under similar descriptions.[84] He said an attorney-friend had advised him on how to stay just within the realm of legality. Although he was not arrested, eBay closed down the several accounts he had set up, after which he persisted by using a different Internet address. The *Telegraph* exposed him again in 2015 for his continuing activities.[85] The publicity generated by those articles provided Henty with a forum to launch himself as a legitimate copyist. He thanked the newspaper, saying,

Since you did those stories, I have had quite a few new commissions. People read about . . . and send me letters requesting I do copies for them of masterpieces. As a result, I decided to go straight and business is brilliant. I can't thank *The Telegraph* enough.[86]

Henty has sold his legitimate works through several British galleries as well as on his own website, with prices reaching up to ten thousand pounds for his renditions of L. S. Lowry, Picasso, Van Gogh, and other artists.[87]

Henty's success in converting from art forgery to a legitimate enterprise based on his artistic ability represents the opposite end of the spectrum from forgers who continue their illegal activity after being caught. Celebrity forgers in particular are inclined to make the move successfully. Media portrayals of them as skilled artists who fooled many people have built reputations that make them not only recognizable but also sought-after for their talent. Stein capitalized on major news stories featuring his ability as a forger, including a *60 Minutes* television program that generated interest among collectors.[88] He had an exhibition of his works in New York that sold forty paintings in a single day before being shut down by the state attorney general (who feared the works would be resold as originals).[89] De Hory was in demand after he was unmasked as a forger, which earned him several exhibitions in Madrid and London in the 1970s.[90] Twenty years later, well after his death, prices for "Elmyrs" ranged into the tens of thousands of dollars,[91] and fake "Elmyrs" proliferated as it was established that there was market demand for the works of a famous forger. Other former forgers have met with various levels of commercial appeal for their artistic skills. Jansen and Myatt, among others, have sold their works through gallery representation and exhibitions.

The demand in such cases is for the kinds of works that made the forgers well known. Collectors look for works that are representative of a given artist, so typically they want what a forger is remembered for but without a false signature. Works in forgers' own styles, if in fact they make them, are less common and may be difficult to sell. Malskat in the mid-twentieth century tried to capitalize on the publicity brought about from his fake cathedral murals by selling Expressionist paintings, but his effort was ill-fated. Jansen today produces works in his own style, and Myatt has done so at times while also copying famous masters (see Figure 3.3), as Hebborn did on occasion. Landis accepts commissions through his website to create drawings and paintings from photographs clients provide, although he states that he may take a bit of artistic license for interpretation. Perenyi sells through a gallery in St. Petersburg, Florida, where he lives, as well as through his own gallery and his website, where a substantial inventory of paintings is available that imitate the masters he is known for forging. Tetro today paints replicas and stylistic renderings of masters from the Renaissance through the twentieth century.

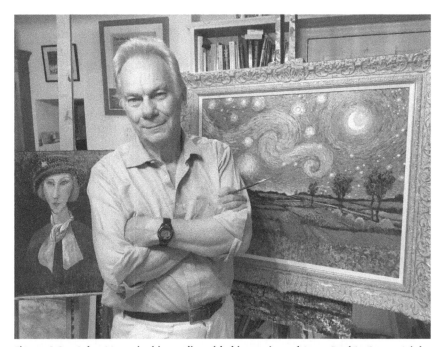

Figure 3.3. John Myatt in his studio with his version of Van Gogh's *Starry Night*. Courtesy of John Myatt

Media representations that account for the fame accrued by certain forgers, and the impetus for their legitimate sales, begin with news stories when they are caught and continue (with the exceptions of those not prosecuted) when they face trial and sentencing. Those stories are often followed up by a television documentary. Celebrity forgers who have been the subject of documentaries include Beltracchi, Ribes, Greenhalgh, De Hory, Hebborn, Tetro, Jansen, and Landis.[92] Interviewers bring out their personalities, and they have the opportunity to be charming and benefit from the humanizing effect as well as to discuss and demonstrate their artistic techniques. Going further on television, Keating made a series of BBC episodes in which he shows how to paint like famous artists (*Tom Keating on Painters*), and Myatt, who as a young man was an art teacher, has hosted two British television series (*The Forger's Masterclass* and *Fame in the Frame*), in which he presents art history, interpretation, and technique.

Beyond broadcast media presentations are books that offer biographical and autobiographical accounts. Memoirs allow the subjects to control the narrative to include or exclude, emphasize or deemphasize, what they please, although personalities still emerge, and biographies range from friendly to

exposés. The memoirs of Hebborn and Perenyi are notable for their hubris and disdain for society's norms. Keating's memoir, cowritten with the journalist who exposed him and her writer-husband, conveys a lively tone and believable exploits while downplaying troubled aspects of the forger's personal life. De Hory, when chronicled by his first biographer (Clifford Irving) through extensive interviews, recounted the same false identity he had lived with for many years. His second biographer (Mark Forgy) also presents De Hory's version of his past but adds a candid explanation debunking his subject's claim to aristocratic heritage and upbringing by citing the revelations of twenty-first-century researchers. A biography of the Myatt-Drewe team (*Provenance: How a Con Man and a Forger Rewrote the History of Modern Art*) presents a sympathetic picture of Myatt, while showing Drewe (who continued to maintain his innocence despite Myatt's admission of their scheme and other overwhelming evidence) to be an emotionally disturbed con man. The most written about of all forgers, Van Meegeren, died prematurely without composing a memoir, so writers telling his story have relied on evidence collected for his trial and on research they conducted. Based on his appearance in court and on journalistic pieces at the time, Van Meegeren was held in high regard by the public for swindling Nazi leader Hermann Göring and fooling important people among the Dutch art intelligentsia. Held back or explained away as malicious gossip was information that the forger's weak health was due to a wildly dissolute lifestyle and that he had Nazi connections that were sympathetic as well as exploitative. Recent biographers have reestablished these factors.[93]

The various figures mentioned here who have been caught and adjudicated—forgers and fraudulent dealers—along with numerous others who have met a similar fate, are responsible for putting an immense volume of fake works into the art world. Sometimes during the process of arrest, a large cache of fakes is seized (hundreds to thousands), although typically only a few are submitted as evidence in a formal indictment. And prosecutors may borrow or subpoena works exposed as fakes that are held by collectors. What happens to the many fraudulent artworks that law enforcement accumulates? As with the vastly differing treatments that befall the makers and sellers of forgeries, the forgeries themselves face divergent outcomes that range from destruction to being put up for sale. Factors influencing the administration of confiscated art include details of the particular cases they are a part of as well as the nature of the legal system in the venues where those cases are tried.

In France and other countries that give strong recognition to the moral rights of artists, the destruction of false art is a more likely outcome than it is in countries like the United States, where property law takes precedence. Knowing this, owners seeking authentication for artworks are sometimes advised not to send them to France for this purpose because an assessment of inauthenticity

by experts there may result in a court order for the works to be destroyed. And beyond the general tendency to destroy false works is an effect of French law that transfers the artist's moral rights to designated heirs, often family members, who then hold the government-endorsed privilege of authenticating items bearing the artist's name and petitioning the court to destroy fakes they discover. Maurice Utrillo's widow is known to have made a bonfire of a large number of fakes bearing her husband's name that had been seized on her authority.[94] Among numerous other examples are two cases in 2013 in which a seized watercolor and drawing done in Miró's name—one submitted for authorization by a collector and the other by an auction house—were declared by the Miró authentication board to be forgeries and assigned for destruction. In each case an appeal to the Court of Appeal was unsuccessful against the winning argument that only destruction would ensure that the artworks would not reach the market again in the guise of originals.[95] In another case (2018), the Chagall Committee, consisting of experts and two of the artist's granddaughters, declared a painting sent to them by a British owner not to be an original Chagall and recommended that it be destroyed. The owner, who had paid $100,000 for the artwork, accepted that there would be no reprieve.[96]

Destruction of fakes is unusual under the US approach to law, although it occurs on occasion, as in various other countries. Tens of thousands of fake prints confiscated from the Amiel family during Operation Bogart were slated for incineration by the US Postal Service, the agency that prosecuted the family for mail fraud.[97] The intent, as with the cases in France, was to remove forgeries that could end up being sold again as originals. In Australia in 2010, the Supreme Court ordered the destruction of fake drawings bearing the names of two of the country's most highly regarded artists, Robert Dickerson and Charles Blackman. The decision was hailed not only as supporting the public's right to be protected from fraud but also as providing a precedent for increased backing for artists who suffer from having forgeries of their works placed on the market.[98]

On the other side of the issue from the advantages of destroying fake art lie key problems. The act of destruction carries an irreversible finality. There is a story in Rembrandt lore about a painting owned by a collector who learned that it was a fake because it was made on a mahogany panel, a type of wood thought not to have been used by artists in Rembrandt's time. The collector burned the painting. Later, it was found that seventeenth-century artists sometimes did paint on mahogany.[99] The art world lost what may have been an important historical artwork due to its mistakenly reduced status. While reversals regarding authenticity are usually demotions, occasionally promotions occur, and confusion caused by disagreements among experts may signal uncertainty. In one instance, two hosts on the BBC television show *Fake or*

Fortune (2014) succeeded in convincing an authentication committee that an Édouard Vuillard painting it had rejected twice was indeed genuine,[100] and in another episode of the show in 2012 three fake J. M. W. Turner paintings, in the collection of the National Museum of Wales and classified as fakes, were reclassified as authentic.[101] In still other situations, such as with Jansen, there is uncertainty about the illegitimacy of works designated for destruction. As a dealer he mixed legitimate pieces with the fakes he made, which confused experts consulted in his court case and resulted in the works confiscated from him not being destroyed.

Working against the act of destroying fake art is the understanding that genuine works that have been misattributed can be lost, including the monetary value they hold. However, the potential loss extends further. Forgeries, too, have worth even after they are exposed. When that happens, their status plummets, but not to zero. They still possess monetary value in some amount. They are property, and on this basis, authorities often prefer not to destroy them but instead to return them to their owners. This occurred with Van Meegeren's forgeries that had been bought for large sums: they were turned back to their legal owners, and the four pieces that were unsold were returned to the Van Meegeren estate for consideration in bankruptcy proceedings.[102] A similar scenario often plays out after other forgers' trials with works that were confiscated, subpoenaed, or borrowed. They are returned to owners who may choose to display or sell them as copies of well-known artists. On some occasions, if the forgers achieved fame, that factor becomes the sales pitch, as with a collection of drawings by Hebborn that were sold individually at an auction in 2014 for a total of $75,000. The auction house that handled the sale said interest was five times what would have been expected were it not for Hebborn's reputation.[103]

When confiscated fakes are remitted to their owners, sometimes they are given a marking that will be noticeable to potential buyers. It might be an indelible stamp on the back or the forger's own signature, as in 1993 with Wolfgang Lämmle, who was allowed to sign the fake paintings and drawing that put him in court and then sell them to pay the fine he was assessed in sentencing.[104] A further move may be to issue a certificate of inauthenticity with each artwork returned to its owner. Here is a compromise action between destroying forgeries and returning them fully intact to be mistaken for originals. This strategy has met with criticism from skeptics who note that ways may be devised to mask indelible markings. And it has not dissuaded dealers who see an opportunity to capitalize on public interest in notable pseudo-originals that carries the possibility of mass marketing. Jack Ellis, the Postal Service inspector who led the investigation in the Amiel case of tens of thousands of fake prints, stated that art dealers had approached him to buy them: "I had lots of offers

from dealers. . . . Some offered up to a million dollars to buy these prints so they could sell them as 'the famous fakes.'"[105] He also spoke against the trial judge's surprise decision that besides incinerating many prints, eleven thousand were to be held back and auctioned off to defray the Postal Service's legal expenses in bringing the case. The sale earned $350,000. Ellis warned that, "cover the back of the print with a mat, lose the certificate that says it's false, and someone is back in business selling counterfeit art."[106]

MITIGATED CULPABILITY AND ALTERNATIVE ECONOMICS

Art forgery is a criminal act. Yet in contrast to other types of crime, it is often perceived less harshly. There are mitigating factors that focus on the degree of harm to victims as well as the place of the forger in the social order and the overall economic effect of forgery. The parties tricked into buying forgeries are often thought of as well-heeled and unscathed. The special skill involved in making art objects that fool experts carries a mystique that draws respect, and artists known for that skill enjoy a degree of public approval, although the art dealers they connect with and who knowingly sell their fake works are treated with scorn. In sociological terms, forgery is sometimes perceived as an economic support for a large group or nation as a whole. And in following a particular brand of economic theory, the presence of fakes in the art world in general can be assessed as being more helpful than it is harmful.

According to some observers, and similar to comments by several forgers already mentioned, art forgery is a victimless crime or close to it. This idea circulates in the blogosphere, with statements like the following:

> Art forgery is a victimless crime. It's not like a rich person who buys a fake Rothko is making an investment for his retirement; he's trying to impress his rich friends, who won't know the difference. And if one day the rich person goes bankrupt, it's the IRS that gets stuck with the fake.[107]

> Art forgery should stay illegal but there shouldn't be harsh punishments like jail time for it. . . . it isn't a victimless crime but the victims are usually anything but.[108]

Well-known publications sometimes back up the perception that common people are unaffected by fake art, whereas the "victims" are financially impervious or deserving of their fate. In reporting the Beltracchi affair, the *Frankfurter Allgemeine* declared that "art forgery is the most moral way to embezzle €16 m," and *Der Spiegel* asserted, "Compared with crooked bankers, Beltracchi and his co-conspirators haven't swindled common people out of their

savings, but rather people who may have wanted to be deceived."[109] Art crime expert Noah Charney holds a more scholarly and nuanced view:

> Those damaged by art forgery tend to be collectors, wealthy individuals or institutions, or scholars without a trickle-down effect—the damage does not normally extend more than a step beyond the victim. . . . As an art scholar, I know there is indeed damage that forgers do, but as a criminologist as well, I recognize that the damage is largely isolated. I'd be happy to go for a beer with just about any of the gentlemen in the art forger's pantheon.[110]

In sum, this view sees art forgery as affecting only people who can afford to be tricked, and not the general population. It is nonviolent and not like other forms of swindling. It is white-collar crime of the least immoral type, so that punishment should be minimal. Its practitioners are not dangerous and would be interesting companions who deserve to be called gentlemen as much as transgressors.

Besides seeing mitigation in the harm of art forgery in terms of the wealth of its victims, looking in another direction finds favorable qualities in the forgers themselves and highlights how their underground activities reveal embarrassing weakness and vice in the art establishment. There is a perspective by which the forger, despite being a swindler, is found to have an endearing side that ranges from roguish trickery to antihero status. This attitude shows up in hoaxes from the Renaissance to modern times, biographical accounts of prominent forgers as they have been promoted through the media, and in imaginative literature. Giorgio Vasari was an early commentator promoting the light side of forgery, with stories of Michelangelo's *Sleeping Cupid* fake of an ancient sculpture and Andrea del Sarto's surreptitious copy of a Raphael portrait. Other stories of this kind continued throughout the centuries, such as of Louis XIV's principal painter, Pierre Mignard, who made and sold a painting of Mary Magdalene as an original by Guido Reni, then revealed himself as the painter and proved it by uncovering an underpainted image he predicted was present, returned the buyer's money, and reveled in the great fun of his trickery and demonstration of his talent. Another tale, from the eighteenth century, involves Giovanni Casanova (artist and younger brother of the famous lover), two of his friends, and art historian Johann Winckelmann as they deceived him with several paintings said to be ancient and to have been removed from Herculaneum. Winckelmann praised the pieces in his writings, only to find out later they were fakes. The upshot was that a pillar of art authority was embarrassed by a scam intended to promote faking.[111]

A notion of the forger as debunker has endured: a figure remembered for exposing the pretensions and missteps of art professionals and institutions,

and especially for making fun of connoisseurial sophistication. An adventurous hoax from the early twentieth century demonstrates the spirit of mocking the authorities of the art world. Paul Jordan-Smith, an American writer and literary critic disenchanted with avant-garde movements in the arts, and having never painted in his life, created a purposely tawdry primitivist image of a wild-eyed native woman holding a banana skin with a skull in the background.[112] He submitted *Exaltation* (see Figure 3.4) for exhibition in 1925 at the Waldorf Astoria Gallery in New York under the pseudonym of Pavel Jerdanowitch, and identified it as representing the Disadumbrationist school (another invented name). When a Paris critic asked for a biography and photograph, he submitted a scruffy, blurred image of himself with a fictitious life story including birth and early years in Russia, study at the Art Institute of Chicago, and life in the South Sea islands to recover from tuberculosis.[113] The critic published a favorable article, and Jordan-Smith proceeded to paint and exhibit six more Disadumbrationist works that received rave reviews

Figure 3.4. *Exaltation* **by Paul Jordan-Smith under the pseudonym of Pavel Jerdanowitch, oil on canvas. Courtesy of Library of Special Collections, Charles E. Young Research Library, UCLA/Paul Jordan-Smith III**

nationally and internationally. One French publication described Jerdanowitch as a "man who not only stands on the heights, but is bold enough to peer into the depths and is among the best artists of the advance guard,"[114] while another said, "a seeker and unique spirit . . . symbolizing things from his own angle which puts him among the best artists of avant-garde by a formula excluding any banality."[115] Jordan-Smith reported being offered "a large sum of money" for two of his works, but refused to sell for fear it would tarnish his hoax.[116] In 1927, he disclosed the whole affair to the *Los Angeles Times*, which published a full-page account.[117] Major stories appeared in various American newspapers and in many cities internationally, with the art establishment ingloriously on display for the inability to distinguish genuine art from crude simulations. The notoriety Jordan-Smith accumulated during his venture into fake art drew hundreds of responses from admirers, including struggling artists expressing their appreciation and asking for advice, while some critics refused to recognize his paintings as the nonsense he intended and insisted that he had manifested latent talent.[118] Satisfied that he had laid bare the hubris of the masters of art connoisseurship, he concentrated on his career as a writer, although his greatest acclaim was always for his brief time as a painter.

Jordan-Smith's plan was to deceive the art world, but the Pavel Jerdanowitch affair is often described as a hoax and set in contrast to forgery in which the intention is to keep the falsity of the artwork secret for as long as possible rather than expose it voluntarily. There is, however, a gray area amid the difference, as spoken for by art historian Henry Keazor, who has coined the term "foax" to describe how a fake and a hoax can blend together. As an example he cites Tom Keating's "time bombs," which were meant to be discovered and embarrass art experts but were so well disguised as to remain undiscovered for many years.[119] The paintings Keating explained as having this purpose failed to do so and ended up as fakes. His claim that he wanted to create a hoax is similar to appeals from Van Meegeren, De Hory, and others to describe their actions, although decades passed before their schemes were exposed. To the degree that forgers are able to promote their personas as hoaxers up against the establishment, they find a mitigating factor that plays well with the public.

In the latter twentieth and twenty-first centuries, the perception of art forgers as debunkers and antiheroes has inspired many books along with documentary films. These biographical and autobiographical accounts often skew the narrative in a way that criminality is overshadowed. Largely missing, however, are feature-length Hollywood biopics, although in 2020 Sony Pictures released *The Last Vermeer* about Van Meegeren.[120] The lives and careers of several other figures would make fascinating stories, such as De Hory, Stein, Ribes, Perenyi, and the Myatt-Drewe partnership. On the other hand, Hollywood has presented an enchanting image of art forgery through fictional

accounts. *How to Steal a Million* and *The Thomas Crown Affair* (original and remake), seen by many millions of viewers, offer lighthearted, romantic portrayals of forgery combined with theft as the heroes outsmart the art world's established order. Novels, too, bring attention to art forgers, and have room to delve more deeply and seriously into the minds and motives of artists who enter the realm of fraud. Bestsellers *The Art Forger*[121] and *The Last Painting of Sara de Vos*[122] explore themes such as the fine line between copying and fraud, the temptation of the struggling artist to turn to fakes, and competing perspectives on the morality of doing so. In these books the forger is not made to appear glorified but conflicted, although the result is still a sympathetic rendering. The overall image is of an artist caught up in life's complications and deserving of a humane response. Rather than gliding along breezily as in the movie scripts, from this perspective the forger's life connects more closely to an everyman's confrontation with discord and angst.

Beyond mitigation conceived as minimal financial harm to victims or as a compassionate treatment of forgers lies a perception of forgery in broader social terms. Rather than being thought of primarily as the acts of individuals affecting other individuals, forgery is sometimes assessed in a sociological sense as an institution functioning within a large group. In certain locales, the making and selling of fake art is an established practice that is accepted by many residents. Historian Carol Helstosky has described the phenomenon of art forgery in eighteenth- and nineteenth-century Italy, not to justify it but to point out that it was perceived by many people of that time and place as reasonable. Deceptive practices in art were considered in the context of consumer demand and national pride.

Tourism in Italy expanded during the eighteenth century with support from the popularity of the Grand Tour, and by the mid-nineteenth century drew even larger numbers of travelers as railway transportation became available. Given the reputation held by various centers of Italian art as pillars of art history, many tourists desired to purchase original historical works as souvenirs. The supply of originals dwindled to the point where some Italian art dealers traveled to other countries to find legitimate Italian works that had been exported and purchase them to replenish their inventories. But this strategy was far outdone by the more common approach of creating and marketing forgeries.[123] As the quote in part I about a nineteenth-century tourist's experience in Italy indicates, the completion of an art purchase often involved various interested parties. Experts, consultants, and connoisseurs assisted in the ritual of negotiation, and still other people might offer friendly voices to help the proceedings along. All of these people were aware that the items sold as originals were usually fakes, and it was common knowledge among buyers that the Italian art market had a reputation for being rife with fraud. Still, buyers

persisted in their quest, while an uneasy intercultural dynamic played out. As described by Helstosky,

> Italian dealers presumed their non-Italian customers understood the less tangible aspects of these transactions and essentially "played along" in the sometimes elaborate scenarios of discovery and purchase. Foreign customers were chagrined and even outraged that the Italians would knowingly deceive others with copies and imitations.[124]

From the vantage point of the Italian dealers, answering an international demand for a domestic product that was in limited supply supported the national reputation and avoided a negative reaction that could harm the tourist trade if the desired items were not available. Further, the claim that selling fakes was wrong was inverted. The reasoning was that tourists who wanted to buy genuine artworks at the cut-rate prices they were pleased with themselves to get through haggling—a small fraction of what a legitimate piece would sell for—were willfully entering into an immoral bargain. An example cited by one Italian commentator asked, if a dealer sold a Donatello to a tourist for 5,000 lire, and the tourist believed it to be genuine with a worth of 500,000 lire, who is being dishonest?[125] Reflecting on the situation as a whole, an Italian art critic found the practice of selling fakes (in this case antiquities, although the point also would hold for other fakes) to foreigners not only not objectionable but also nothing less than noble:

> The antiquarian accomplished a task that is ultimately humanitarian or almost social in that, on the one hand, it encourages the love of art, ennobling even the roughest spirit; and on the other hand it brings much-needed foreign currency into our country.[126]

The outlook described here—that art forgery can be an asset to the economy (suggesting patriotism as well as profit) and humanitarian—seems far-fetched in the grand scheme of moral judgments where fraud is considered reprehensible. But in the contextual perspective of a certain time and place, it may appear sensible to insiders. Beyond the period in Italian history described in which a favorable sentiment for selling fake art was held by a significant number of people (just how widespread it was can only be conjectured), it is possible to think of other situations that might harbor a similar view. The selling of fake antiquities was widespread in nineteenth- and early twentieth-century Egypt. Historian Jean-Jacques Fiechter notes that some of the forgery workshops made no secret of what they did, and that various parties involved in faking antiquities seemed to comprise an organized network.[127] Although without direct evidence, it is not difficult to imagine that the notion of spur-

ring the economy of one's country as well as one's personal fortune would have been attractive to a significant number of people. And in some situations, support for selling forgeries might involve tacit sanction from government officials. A story from Thomas Hoving relates his discussion with a Greek antiques dealer who owned a shop in Athens and who had knowingly purchased some fake ancient Tanagra figurines at a New York auction. The man's explanation was that his government prohibited him from selling genuine Tanagra works but went along with his selling counterfeits of them.[128] The Greek economy benefited as the government collected more taxes and dealers increased their profits, all while authentic antiquities, considered to be national treasures, remained under restricted status.

Cultural context, then, may become a mitigating force in making moral judgments about art forgery, along with the claim that forgery is a victimless crime and the notion of the forger as antihero. How well do these views stand up in light of the conventional notion of forgery as legally and morally wrong? All three views can be seen to bear at least some credence, although they are prone to being overstated and misleading. Regarding the claim that the victims of art forgery are wealthy parties who are not harmed financially, it is true that much of the total value lost in buying forgeries lies with high-value works purchased by wealthy individuals or by museums. However, it is not true that they are alone in purchasing art fakes. People from all walks of life buy art, and forgeries appear throughout the range of prices, from high to low. Buyers at all price points are subject to being taken in. Rank-and-file buyers who purchase randomly, as well as collectors who focus on items selling in the hundreds to a few thousand dollars, constitute a large portion of those who are victimized by forgeries. Popular prints bearing the names of Dalí, Miró, Chagall, and others, which are often fakes, usually fall in this range. The single raid by Operation Bogart of eighty thousand such works (many more were in circulation before and after) signals that estimates of hundreds of thousands of fake prints reaching the market are not an exaggeration. Consider also the number of "original" art objects sold to tourists—Pre-Columbian figures and African masks, to mention only a few examples—along with the many lesser-caliber fakes sold on eBay, and it becomes clear that being swindled through art forgery is far from the exclusive domain of a well-heeled elite.

If the assumption that art forgery scams affect only the wealthy is clearly mistaken, what about the reasoning connected to it that suggests it is less immoral to cheat buyers who can afford the loss than to cheat the rank and file? This sentiment is supported by a conception of fairness based on financial status and as being relative to an individual's economic class, as opposed to fairness transcending economic classes and based on uniformity of respect for individuals per se. It may derive from a sense of social justice or from a per-

sonal jealousy of people who are financially successful. It relates to the image of the forger as an antiheroic figure. In recent years the epithet of "Robin Hood" has been used increasingly, especially in connection with Wolfgang Beltracchi.[129] In the documentary *Beltracchi: The Art of Forgery*, the forger is given this label by a gallerist representing him and by an auctioneer who was interviewed for the occasion.[130] One review of the film begins, "It's not hard to admire Wolfgang Beltracchi, the documentary's titular Robin Hood,"[131] while another states, "He can be seen as the Robin Hood of the art world or someone who has wreaked untold havoc on the industry."[132] Invoking this fictional figure connects with a common human desire to cheer on illegal tactics that are envisioned as supporting forces of good against bastions of privilege. To quote Charney again,

> We also like tales of hard-working everymen who make good, and it brings a measure of satisfaction when the high are laid low, the snooty elite cut down to size, a Robin Hood effect. We like to see magicians at work, to look on with wonder and ask "How did they pull that off?"[133]

The Robin Hood image, however, is deceiving. The fictional figure is famous for taking from the rich and giving to the poor, and half of that profile is fulfilled when wealthy buyers are duped by expensive fakes. But the income is not dispensed to the poor. It is held by forgers and their accomplices, and often much of it goes to dealers who knowingly sell fakes. Instead of redistributing wealth to have-nots, the art forgery industry concentrates its profits among a few culprits, some of whom go on to become part of the financial elite. Figures of renown in the history of art forgery exemplify this point. Those known to have made large amounts of money (such as Beltracchi, Van Meegeren, Ribes) spent it on personal pleasures and not on philanthropic endeavors. With those forgers who earned or spent lesser amounts (with the exception of Landis, who gave away his fakes, and Keating, who claimed to have done so on occasion), there is no evidence of charity in distributing the fruits of their labor. If there were a pattern of giving, it would have appeared in their defense at court proceedings, in the press, or in their memoirs and biographies.

While forgers are not Robin Hoods, they do follow the antihero profile by discrediting the art establishment. Although their claims that this is their purpose have been exaggerated to deflect attention from their motivation to make money, the effect is to expose the inability of experts to make accurate judgments about authenticity. Credit forgers get for debunking false claims and unfounded pretensions acts as a mitigating factor in assessing their offenses and in portraying them as pranksters more than criminals. The performance of a skill that has a recognizable and legitimate counterpart product, as opposed

to such other white-collar crimes as documents forgery and embezzlement, also draws respect. Forgers can be thought of as misunderstood or misjudged artists who were not given their proper due, and when they are caught, it can be easily imagined that they will make a successful transition to lawfully plying their trade. Their skillful manipulation of originality in artworks, combined with the public personas they present through the media, may mask the significance of their criminality. And the items they create, once exposed as fakes, still possess a degree of desirability in their own right and may hold monetary value that counterfeit currency and documents (such as stock certificates and deeds) do not. Still, that value is minimal relative to the prices forgeries command when still disguised as originals. A more apt comparison, rather than to currency and documents, is to a material good such as a Rolex watch that after its discovery as a fake still functions as a timepiece and still has an attractive appearance, but with a drastically reduced commercial worth. Despite the portrayal of forgers as antiheroes and recognition of their brand of fraud as unique, they commit serious fraud nonetheless, and it causes losses to many people.

The sociological claim for mitigating the harm caused by forgery, as with portrayals of forgers as antiheroes, shifts the focus away from the effect of their actions on victims and toward a factor thought to balance against that effect. And similar to the notion that defrauding wealthy collectors bears minimal culpability, a relativist morality is assumed that makes group status the primary concern. But the victimized group, rather than being defined in economic terms, consists of foreigners, many of whom are not wealthy (although some are, and Grand Tourists were). The sociological argument overrides conventional moral thinking by asserting an extreme nationalist economics. Supporting the reputation of one's nation for cultural greatness, and ensuring that it is a continuing economic asset, may be important enough to insiders to justify an industry of counterfeit art, but in the larger world it suggests an untenable system that endorses duplicity as a viable moral principle and invites other groups and nations to respond in kind in their actions. Selling forgeries under the banner of nationalism is difficult to defend in moral terms, although it may be a social and economic likelihood in some localities.

Still another perspective that weighs against the condemnation of forgery goes further than those addressed so far by asserting that the overall effect fake art has on society is more beneficial than it is harmful. This view looks beyond victims' losses to other people who gain from them, beyond financial concerns to include aesthetic enjoyment, and beyond national interest to apply to the presence of forgery throughout the art world. The thrust does more than reduce the seriousness perceived in a wrongful act, and aims to locate the wrong within a larger positive outcome. The idea is not new and traces at

least to the nineteenth century. A strand of social science promotes it in the twenty-first century.

In Wilkie Collins's 1856 novella *A Rogue's Life*, an established art forger recruits the main character to his profession, luring him with an inspiring speech about fooling collectors:

> Give them a picture with a good large ruin, fancy trees, prancing nymphs, and a watery sky; dirty it down dexterously to the right pitch; put it in an old frame; call it a Claude; and the sphere of the Old Master is enlarged, the collector is delighted, the picture-dealer is enriched, and the neglected modern artist claps a joyful hand on a well-filled pocket. . . . Kindness is propagated and money is dispersed. Come along, my boy, and make an Old Master.[134]

Here, readers are invited to consider that the financial outcome of forgery moves beyond the obvious loss involved and includes profit as well, with the craftsmen and sellers of fake products as the beneficiaries. This idea opens discussion of the positive economic potential of forgery. And the quotation notes the advantages resulting from forgery that occur beyond economics. With more fakes in existence, more people have access to seeing works of revered artists without knowing they are only imitations. Although it is not said directly, the hint is that exhibitions, whether mounted by museums or commercial galleries, have more materials to include in their presentations to the public. And it is said clearly that more collectors can be made happy with the acquisition of works to add to their holdings.

The mindset conveyed by Collins finds a more complete expression in the twenty-first century by economist Bruno Frey, a leading proponent of "happiness economics."[135] This approach looks past analyzing income and wealth, which are the sphere of classical and neoclassical economics, to include other factors that make for overall human satisfaction. Through a broadly encompassing schema,[136] Frey considers the effects of forgery on viewers, on artists in general (other than those who turn to forgery), on target artists who are forged, and on art experts. He also examines the harm done to buyers who are deceived by fakes as well as to the art market, arguing that this collective downside is not as great as generally believed and is outweighed in his comprehensive model. At some places in his analysis Frey speaks specifically of works of visual art, while in other places he includes examples of musical works, furniture, and writings as falling within the sphere he describes, but his arguments are all meant to be applicable to the visual arts. And although some of his discussion speaks to legitimate copying, he clearly has in mind forgeries as well.

Under the theme of "propagation effect," Frey argues that copies of artworks, whether made legally or illegally, provide a "utility gain" to consumers. More consumers can be exposed to works by key artists if more copies of their works are available. Artists stand to gain from royalties on legal copying that is spurred on by having their name propagated through fakes, as their profile rises along with the prices their works command. Frey also notes that legitimate and illegitimate copying raises "artistic capital." Artists are better trained when they learn to imitate the ways of other artists, and art experts are challenged to learn about authenticity. The presence of fakes constitutes a teaching device that prompts the connoisseurial mind to be on guard for fraud and to overcome shortsightedness by learning how to differentiate inauthentic works from their authentic counterparts. Further, allowing artists maximum room to create as they like is beneficial for society: "The smaller the barriers against imitating, the greater the scope for future artists to experiment." This point is similar to the principle of fair use in copyright law (discussed in part II in regard to appropriation art), meant to encourage copying so as to promote progress in the arts.

As far as the harm done by forgery, Frey argues that buyers are indeed at risk due to fakes on the market, and they incur "resource costs" (time, effort, money) because of them. But the risk can be mitigated by buying from respected dealers who can be trusted and by securing legal guarantees (presumably a money-back pledge for works found to be inauthentic). The consequence is that "it is therefore wrong to think that buyers are solely the passive victims of forgers: on the contrary, they can react actively to the possibility of fakes."[137] And following up on his assertion that artists need free rein to produce as they like so as to encourage creativity, Frey tackles the counterargument that if artists' financial interests are harmed by fakes on the market, they will have less incentive to be creative. Why should they be innovative if their innovations will be taken up by others who will reap the profits? His answer challenges the extent to which artists are motivated by money, suggesting that earlier in their careers they are driven by an intrinsic incentive, and later, when a monetary incentive is important, "it is often doubtful whether the art produced is really innovative."[138]

One of the notable features of happiness economics is that it looks to psychology for explanations that traditional economic thought does not include. But Frey's claim about early-career artists' lack of monetary motivation makes a leap that is easily subject to challenge. Young artists may fit the "starving artist" profile when they are experimenting in an attempt to find a personal style or niche, but this does not mean they are not motivated by wealth, only that they have not achieved it. What reason is there to think they are not as desirous of making a good income from their chosen profession as people in

other professions are of doing so? At a time when they are in need of money, they could be dissuaded from attempting creativity if they think their innovations will be taken over by others. This factor may contribute to the decision to follow an existing style or trend, perhaps as a copyist, or seek a means of income outside of art.

Frey's perspective also faces other challenges. In his analysis, forgeries are combined with other copies in ways that overstate the case for the worth of forgeries in several ways. Following the methods and styles of successful artists is indeed an important way of learning, but the models used need not be the products of fraud; legitimate copies are just as good for this purpose. Training experts to recognize authenticity and inauthenticity makes good use of forgeries, but there is need for only a limited number. Having an adequate supply available for this function does not go far in offsetting the harm forgery causes. And with the gain artists are claimed to derive when their names are popularized by having works made by forgers expand the market, the presence of legitimate copies will accomplish this objective, although it can be argued that if it is known that forgeries have been made of a particular artist's work, this factor can be a signal of popularity and contribute to a rise in reputation.

If claims about the advantages forgeries provide art professionals as a learning tool and branding device do not carry much weight what about the effect of propagation on the consumers of art? This is a much larger group of people, and it includes the victims of fake art. Frey points out, as Wilkie Collins does, that this group also stands to gain from forgeries: more people enjoy viewing works bearing the names of prominent artists. And more are able to purchase them when the number available for collectors to possess is increased. The argument to be made is that the collective happiness of the whole of consumers—both those who enjoy viewing art and those who also buy it—balances against the unhappiness of the much smaller number who find they have purchased fakes. The idea of balance is also key to the overall perspective that leads happiness economics to a different assessment of art forgery than is found in conventional thinking. The combined factors of good attached to forgery weigh against the combined factors of harm to yield a calculation that forgery is not overall an evil in society, and may be a benefit.

This line of thought, expressed in imaginative literature, the writings of economists, and elsewhere, is a version of the philosophy of utilitarianism, with its base premise of promoting the greatest happiness (sometimes stated as "pleasure" or "good") for the greatest number. Utilitarianism faces certain standard criticisms, in particular the difficulty of quantifying and comparing specific goods, and how to reconcile a sacrifice by some people for the good of the whole. How much positive force is carried by the advantages that have been noted to derive from art forgery, including the income provided to

forgers and art dealers from fakes, the enjoyment had by viewers and owners of fakes (not knowing they are fakes), the educational functions of fakes, and the incentive to be creative that is unfettered when faking is not renounced? If each of these factors could be calculated and they were tallied into a sum, does the total good outweigh the aesthetic disappointment and financial loss to owners when they discover fakes in their midst? How does the calculated collective good weigh against condoning a major form of fraud that threatens basic morality as it is commonly understood? Further, as for the viewers of fakes beyond collectors who purchase them—gallery and museum visitors, and others who see images in various publications—how much do they gain in enjoyment versus the loss they suffer from the inaccurate understanding of art history that is imposed on them? This last question strikes back at the favorable propagation effect claimed for fakes since it applies to a large number of victims beyond those who buy fraudulent art. It constitutes a key denunciation of forgery that will be discussed in the following section on the "perfect fake," but is mentioned here as a counterpoint to the claims of happiness economics to assess forgery in favorable terms.

THE PERFECT FAKE

Chapter 3 of Nelson Goodman's influential book *Languages of Art* begins with a quote from art critic Aline Saarinen:

> The most tantalizing question of all: If a fake is so expert that even after the most thorough and trustworthy examination its authenticity is still open to doubt, is it or is it not as satisfactory a work of art as if it were unequivocally genuine?[139]

This issue has been a challenge for art scholars since the Renaissance, and particularly over the last half-century philosophers have wrestled with it. The shorthand term that has been adopted for the type of artwork Saarinen describes is "perfect fake." Her way of putting it invites discussion of two related yet distinct concerns: whether there can be such a thing as a perfect fake, and if so, what its value is, with that value conceived as a matter of aesthetics rather than economics.

The possibility of a perfect fake has drawn attention in theoretical and practical terms. Are there fakes so excellent that they are impervious to detection? Both yes and no have been confidently asserted. Is it possible for there to be an artwork that mimics another work, or a particular artist's style, in every way? Here, the issue of a work's form versus its context is important, with

answers differing about what factors count in assessing it. Do those factors extend beyond physical features that can be perceived to also include information regarding the artist's intention and observers' knowledge and insights? What is the aesthetic worth of a fake so good that it fools many people, including experts, with its falsity known only to the artist who made it and perhaps the party who sells or displays it? This point pertains not only in the immediate circumstance of viewing the work but also to its function in art history.

In the seventeenth and eighteenth centuries, as connoisseurship became popular and its practitioners developed expertise, speculation arose about the possibility of a perfect copy. Several authors made significant statements about whether such a work existed or could exist, and about what its aesthetic significance would be. Much of the discussion addresses duplicates of existing works, but the points made often could be applied to stylistic copying as well. Giulio Mancini's treatise on painting asserts that each artist has a unique style that is evident especially in features such as hair, beards, and eyes, and he compares the individuality found there to the distinctive movements found in each person's handwriting. Good connoisseurs are able to apply their knowledge of styles to spot copies, although on occasion they may be fooled, and viewers with less expertise are more susceptible. Mancini shows admiration for excellent reproductions done by master painters that go unnoticed while masquerading as originals, and for support he cites the opinion of the Grand Duke Cosimo de' Medici that copyists are doubly skilled:

> And for myself, I certainly wish to be deluded by such eminent men, and of such copies I truly believe what the Grand Duke of Tuscany said about them: that there are two arts in them, the one belonging to the author and the other to the copyist, and that they really are gems among paintings.[140]

Among theorists more skeptical of connoisseurs' capabilities to detect copies is Jean-Baptiste Du Bos, who disputed the comparison of artists' styles to individuals' handwriting. Painters, he noted, can rework their strokes, whereas written words are not adaptable in this way, so painters hold a great advantage in mimicking someone else's stylistic peculiarities. On the other hand, he emphasized that artists often copy their own works without being entirely faithful to the original, a factor pointing to the difficulty of copying imperceptibly.[141] Roger de Piles expressed confidence that connoisseurs are often able to distinguish copies from originals, but specified that skillful copies made in the same time period as an original are puzzling even to the best experts. In his book about the idea of a perfect painter, he recites Vasari's story about Del Sarto copying a Raphael painting that was verified by Giulio Romano. When Romano later learned of the duplicity, he announced that given the excellence of the painting, he valued it as much as if it had been done by

Raphael himself.[142] Here, again, is respect for the quality of a well-executed copy that estimates its aesthetic worth to be on par with an original.

Lengthier discussions of copying are found in the writings of Abraham Bosse and Jonathan Richardson. Bosse's treatise on connoisseurship declares against the possibility of a perfect copy: "As the painter who imitates nature never comes to its same perfection, so the copyist never makes his copy to the perfection of the original."[143] Given the status of a copy as secondary, coming after an original, it is bound to lose out in the process of imitation. A second statement from the same writing hedges just a bit by suggesting that there may be a few copies that escape detection: "I am aware that there are few copies and not at all that may be preferable to their original, to pass through the eyes of connoisseurs for other than what they are."[144] As with Mancini, Bosse likens the analysis of artists' styles to the process scribes use to recognize handwriting styles. When copyists imitate originals, they are unable to overcome limitations that include the way they depict various bodily features such as eyes, ears, hands, and feet. Brushstrokes are different on copies, and there is an overall stiffness and flatness. Other obstacles are the use of materials different than those used by the artist being imitated and colors that age into tones that do not match what is found on originals.[145]

Bosse did not claim that all copies are in fact recognized, and he believed that the necessary expertise to spot copies consistently is held only by a few people who understand the techniques of painting and also are knowledgeable about the works and styles of various painters. However, in his view, experts do hold the capacity to assess any work in question to determine its status as an original or a copy. This is also the position of Jonathan Richardson. His *Essay on the Whole Art of Criticism as It Relates to Painting* and *An Argument in Behalf of the Science of a Connoisseur* offer a detailed examination of copying and the role of connoisseurs in attribution and authentication. He holds that even if there were indistinguishable copies, an existence he does not believe in, they would be so rare as to be insignificant. Skilled connoisseurs hold the upper hand over copyists.

> The best counterfeiter of hands cannot do it so well as to deceive a good *connoisseur*; the handling, the colouring, the drawing of the airs of heads, some, nay, all of these discover the author. . . . Tis impossible for any one to transform himself immediately, and become exactly another man.[146]

Richardson notes that no two people in the world think and act alike since each comes from a unique set of causal circumstances, and regarding physical performance, he says painting styles are like voices (as well as handwriting) in distinguishing one person from another. The constant features in a copyist's style cannot be fully overcome, and "if he attempts to follow his original

servilely, and exactly, that cannot but have a stiffness which will easily distinguish what is so done from what is performed naturally, easily, and without restraint."[147] And going further than Bosse regarding a copy as secondary to nature, he states that "an original is the echo of the voice of nature, a copy is the echo of that echo."[148] This is not only because human hands are incapable of executing perfectly in copies what is in their minds, but also because the model in their minds is a lesser, defective version of nature from which it is taken. Richardson invokes God in the background as the sole source of perfection in suggesting an ontological difference in a copy in contrast with an original, in addition to the less-than-perfect level of skill involved in making it. In other words, a copy is lacking not only in the way it is made but also in the metaphysical category to which it belongs. Finally, in keeping with his thinking about levels of perfection, Richardson introduces two ideas that show respect for copies despite his insistence on their inferiority. A copy done by an artist of talent superior to that of the artist who made the original may be better than the original. So although in theory copies are subordinate to originals, in practical terms it makes sense to recognize some that surpass the quality of what they imitate. And regarding the few cases of superior copies Richardson is willing to say may exist, he contends,

> If 'tis doubtful whether a picture, or a drawing is a copy, or an original, 'tis of little consequence which it is; and more, or less in proportion as 'tis doubtful: if the case be exceeding difficult, or impossible to be determined 'tis no matter whether 'tis determined or no; the picture supposing to be a copy must be in a manner as good as the original.[149]

In accordance with the notion of degrees of perfection, an indiscernible copy achieves aesthetic value equal to that of the work it imitates.

The ideas from art history summarized here regarding the concept of the perfect fake carry through in the writings of more recent theorists where they take on variations and complexity. What was said before about copies, often conceived of as legitimate productions, is now applied to forgeries. In two important points of focus for connoisseurs, we are told that forgers are betrayed by a lack of freedom in their execution as well as by personal mannerisms in their own individual styles, neither of which can be avoided. For these reasons, as well as one added in recent times, fakes are said to always be subject to detection even if some manage to avoid the scrutiny that would reveal them. The principle that is added introduces the factor of time: fakes inalterably bear the aesthetics of the era when they were made, which, if not recognizable during that time, will be a giveaway in the future. All three of these ideas are open to criticism, but they have been spoken for by noted art

historians and other art experts. Likewise with perspectives on the quality and aesthetic value of fakes, as views range from their worthlessness to equivalence or near equivalence to originals.

In the mid-twentieth century, the assertion that time will reveal fakes was supported by noted art historians. Hans Tietze was a proponent of this view: "Seen from a safe distance, all productions of a given period fall in line . . . not only the style of the period, but also the personal style of gifted forgers cannot be suppressed in the long run and history will betray their productions."[150] There is something about the look of any fake from a given era that will reveal it as being from that era, although neither artists nor viewers during the era will recognize what constitutes that look. Recognition comes only later on. Max Friedländer, in *Art and Connoisseurship*, sums up:

> Since every epoch acquires fresh eyes, Donatello in 1930 looks different from what he did in 1870. That which is worthy of imitation appears different to each generation. Hence, whoever in 1879 successfully produced works by Donatello, will find his performance no longer passing muster with the experts in 1930. We laugh at the mistakes of our fathers, as our descendants will laugh at us.[151]

And to capitalize on the public relations value of a catchy metaphor, Friedländer coined an expression that is quoted occasionally in the literature of art forgery: "Forgeries must be served hot, as they come out of the oven."[152]

What Friedländer declares assertively, philosopher Nelson Goodman expresses in a nuanced view. Rather than stating outright that forgeries will be spotted over time, he notes that it cannot be proven that this will not happen. What sort of proof could be given, he asks? Considering hypothetically an original artwork and a forgery (direct copy) of it, "I can never ascertain merely by looking at the picture that even I shall never be able to see any difference between them."[153] Another statement, which would be applicable for stylistic forgeries as well, holds that "distinctions not visible to the expert up to a given time may later become manifest even to the most observant layman."[154] Again, "When van Meegeren sold his pictures as Vermeers, he deceived most of the best-qualified experts. . . . Nowadays even the fairly knowing layman is astonished that any competent judge could have taken a van Meegeren for a Vermeer."[155] With Goodman's formulation of the point, as well as with Friedländer's, the notion of a perfect fake is challenged. Over time, a different way of seeing artworks that comes with a new era overrides the status of indistinguishability. If the temporal factor does not assure that fakes will always be discovered, there is at least the potential for that to happen with any fakes, and the notion of perfection in forgery is nullified.

The confidence that time reveals forgeries—that the fresh perspective of knowledgeable viewers in the future will see what is not seen in the present—faces objections. One is that it fails to account for forgeries done of artists who live in the same era as their forgers. A forger of a twentieth-century artist will be influenced by the same general twentieth-century perspective in artistic understanding as that of the artist. There will not be inappropriate features unconsciously incorporated in the forger's product based on a lack of understanding of the norms of the time in which the artist lived. This point is supported by considerable evidence. There is a large output of fakes by twentieth-century forgers who have simulated artists of the same era. Picasso, Dalí, Chagall, Giacometti, Dufy, and other masters of that time were favorites among some of recent history's most notorious forgers: De Hory, Stein, Tetro, Ribes, Jansen. Whatever tripped them up to reveal their deception, it was not a lack of understanding of the time in which the artists they faked lived and worked. And what holds for twentieth-century forgers holds also for those of earlier times whose target artists were their contemporaries. Seventeenth-century forgers were not out of sync with the artists of their own era, and so on. The march of history continues an accumulation of fakes made by contemporaries of the artists they targeted, which, because they were made in accordance with an understanding of the aesthetics of their day, are not subject to the pitfall of anachronism.

A second problem with the temporal argument is that time not only reveals fakes but also strengthens their deception. When a fake is accepted as an original, it influences the understanding experts have of the target artist's manner. They build what they see in the false work into their conception of what constitutes originality, and with more fakes by the same forger that bear the same characteristics unnatural to the artist, the look of an original by that artist becomes permanently distorted. Future generations of experts will see the faulty reading of what constitutes originality for the artist and accept it. For instance, consider a forger who regularly places atypical fingernails on portraits attributed to a master. If the forgeries are accepted as genuine, in the future that characteristic will be recognized as a legitimate variation for the master. Or perhaps the variation is not a matter of technique but of a color. A shade of green not used by an artist may become accepted once a forger uses it successfully. Subject matter, too, may be affected by forgers. If a fake painting of a yacht is discovered bearing the signature of a famous marine artist known for military vessels and clipper ships but never pleasure craft, and it gets past experts because it is well executed in the style of that artist, the subject will be accepted in the future as within the artist's range. Once that happens, more fakes of yachts by the artist may turn up. A variation on this

sort of strategy was employed by Van Meegeren with his *Supper at Emmaus*, which fooled many experts until he revealed himself as the painter. Had he not confessed, he may have convinced the art world that Vermeer's works not only included a period during which he made religious paintings, but that they were stylistically different than was known for Vermeer. Among other factors, the faces of the figures were unlike any painted by Vermeer and instead bore a pale, ethereal cast. The odd appearance of Van Meegeren's Vermeers that Goodman and others have said is so obvious had already been explained away by the forger's ruse. The oddity was easy to point out, not only later but also when the painting was first viewed, and some observers at the time declared it a fake. But without the forger's confession, inertia from experts who believed the work was genuine may have held the upper hand and carried through time. An obvious anomaly, then, could become accepted as mainstream and be passed along through generations as having the endorsement of past experts, with the likelihood of discovering the truth less probable rather than more probable as time moves on.

Besides the temporal argument, the other main points of confidence about detecting fake artworks are that those works display an awkward and unnatural execution and that their makers cannot escape incorporating some of their own individual mannerisms into what they create. Friedländer tells us about copyists (saying that what holds for them holds for forgers as well, with the added factor of deceit) that they are necessarily different than artists making original works: "The servitude and duty of the copyist's task stamp his performance with the character of subordination and lack of freedom; that his mental attitude . . . is essentially different from that of the creative artist."[156] Restricted by attitude, "the copyist draws warily . . . incapable of achieving the boldly flowing sweep of the archetype,"[157] and "deliberation and consciousness reveal themselves in artistic form as a lack of life or else hesitation."[158] Here is the stiffness in execution referred to by Bosse and Richardson. And their emphasis on the individuality of each artist's style, including copyists, is echoed as well in the twentieth century. According to Otto Kurz, "Even the most adaptable talent, the most perfect imitator, has his own personality, however slight it may be, he has his own distinctive inflection."[159] In his handbook on art forgeries, art and antiques expert George Savage relates the recognition of forgeries through individual artists' styles to fingerprint analysis:

> The manner in which the paint was applied, however, and the handling of small details, is never the same from one individual to another, and these are, in fact, almost as idiosyncratic as a fingerprint. Experts have large collections of photographs and micro-photographs of small details, which help to establish the hand of the artist. These methods can equally well be

applied to the detection of modern forgeries of old paintings and to those of contemporary work.[160]

Although stiffness in execution and the personal idiosyncrasies of forgers may be helpful in spotting fakes, the comprehensiveness of these means is questionable. Eric Hebborn makes this point in his memoir, and includes the temporal argument as well, saying, "An artist working in the style of draughtsmen of the past may *sometimes*, even often, reveal his authorship by personal mannerisms, lack of freedom, poor quality, and the sign of his times, but not *always*, and if he is sufficiently able, *never.*"[161] Hebborn offers himself as an example of a forger who has made works that are wholly indistinguishable from the real thing and cites various fakes he claims to have made that have passed the scrutiny of experts.

> There is, for instance, no mannerism linking the Pierpont Morgan's "Cossa" to the British Museum's "Van Dyck," there is no lack of freedom in the National Gallery of Denmark's "Piranesi," some of my own "Johns" are better than many of the artist's own drawings, and I defy anyone to find anything particularly twentieth-century about the National Gallery of Washington's "Sperandino" or the Metropolitan Museum of New York's "Brueghel."[162]

He also says that after he was exposed for twenty-five fakes of the five hundred he made in his first large initiative, he not only improved his technique and made five hundred better ones, but he also created a series of red herrings meant to be spotted and mislead experts who were trying to identify his mannerisms.[163] Given Hebborn's large-scale activity, along with the successes he points to that have fooled museum experts as well as his deliberate program to throw authenticators off his trail, even when factoring in the expectation that as a con man he exaggerated some of his claims, the likelihood seems strong that there are many Hebborn fakes in the art world that are beyond discovery.

Hebborn is only a single source of forgeries, although an especially talented one. There are others—part I names a number of them. Is it not likely that any of them, or another talented forger, will, when having a good day, produce a fake that is good enough to be taken for an original when examined by experts in the present and in the future? How many times has this happened and how many more times will it happen? And this refers only to the forgers who have been caught. How many are there who completed their careers of deception without being discovered? In *False Impressions*, noted fakebuster Thomas Hoving tells of Frank X. Kelly, a paintings restorer and forger of French Impressionist and Post-Impressionist paintings he stumbled on in 1951 while a college student on a summer job. In exchange for a vow of silence

until after his death, Kelly showed Hoving his secrets. His output was five to ten fakes per month, a few pieces of which came to hang on the walls in "the better museums." Kelly made pastiches and was careful to achieve a flow and tempo with his brush that would seem natural and fairly rapid, a process he practiced to avoid the stiffness said to be a giveaway for forgers. Hoving, while claiming he was able to spot Kelly's fakes and that he encountered some of them on occasion, did not identify the works as false, although he sometimes pointed out odd characteristics in them. To his knowledge, most of Kelly's output went undetected.[164] It is likely that Frank X. Kelly would be unknown today were it not for Hoving's uninvited peek at the bins in the back of his studio where his fakes were hidden.

Reinhold Vasters is another prolific forger whose discovery was by accident. Nearly a century after his illicit career, a look through his archived records revealed more than one thousand designs for Renaissance metalworks and other art objects he had created, including those of noted masters. Some were of works held as originals in museum collections (see Figure 3.5), and

Figure 3.5. Rospigliosi Cup by Reinhold Vasters, gold, enamel, and pearls, 19.7 × 21.6 × 22.9 cm. Attributed to Renaissance master Benvenuto Cellini until the 1980s, when Vasters's nineteenth-century forgery activity came to light. Courtesy of the Metropolitan Museum, New York

an uncomfortable reassessment began that resulted in the exposure of fakes. The passage of time, manner of execution, and idiosyncrasies of the artist had not given them away. Indirectly, Vasters turned himself in by not destroying his files, with a question remaining as to why. Other forgers have confessed directly. Bastianini in the nineteenth century and Dossena and Malskat in the early and mid-twentieth century revealed their illicit activities out of anger for being underpaid and unappreciated. Van Meegeren disclosed his forgeries to avoid capital punishment for the crime of collaboration with Nazi Germany. Perhaps their secret careers would have been discovered without their confessions, but that possibility cannot be assumed. The presence of these figures in art history, all of whom except for unusual circumstances unrelated to scrutiny by art experts may never have been found out as art forgers, suggests that there are others who have not been discovered and will not be. This does not mean their fakes cannot be unmasked one by one without knowing who made them, but as with those forgers who are caught, if only a few fakes by some of them pass for originals each time experts view them, the prospect of the perfect fake looms large.

It is reasonable to accept that there are fakes in the art world that have not been discovered and will not be, and would not be even with careful inspection. This is so especially because the features they bear have or will become identified as those of the artists being faked. These false works, so well done that they continually pass scrutiny by experts, are for all practical purposes "perfect." What, then, is their value in aesthetic terms? Are they, as Richardson said in the eighteenth century, as good as an original? In the twentieth century, Arthur Koestler has spoken for the worth of a well-done nonoriginal with an example that challenges dissenters. Catherine hangs a work on her staircase that she believes to be a reproduction of a Picasso drawing, and then on finding out that it is an original Picasso, moves it to a prominent place in her drawing room. Koestler labels this a case of snobbery.[165] Nothing about the artwork itself changed when it was promoted to the status of an original. It looked exactly the same: the colors, form, and lines remained without alteration. That is, there was no change to the intrinsic makeup of the physical object. All that changed was in Catherine's mind, and what occurs there should not, Koestler says, be confused with aesthetic properties, which are the proper measure for making judgments.

Other examples cited to make this point usually move in the reverse direction, with a supposedly authentic work being demoted to inauthentic. This is what occurred with Van Meegeren's *Supper at Emmaus*. When the painting was declared to be a fake, its aesthetic value plummeted. What hung on a museum wall for seven years and was admired by many viewers as a unique demonstration of Vermeer's genius was suddenly looked on as a poor

substitute for the master's work. Again, nothing about the physical object changed, but its moral status—its known fraudulence—was different. Alfred Lessing argues that this factor should not be thought to alter the aesthetic status of the painting, nor should historical, biographical, legal, or financial factors.[166] This perspective does not deny that extrinsic considerations are significant in assessing an artwork, but excludes them from the category of aesthetic properties.

The label given to the way of thinking Koestler and Lessing represent is "formalism." It emphasizes that the formal properties of an artwork—its physical characteristics—have not changed when its status switches from copy to original, or, in the case of forgery, from original to fake. Given the sameness of the object, why should its designation as a fake trigger a loss of aesthetic value so that it becomes a mere second-rate curiosity? When it comes to direct copies, it has been argued that they can be as valuable aesthetically as an original, at least under certain conditions. In Clive Bell's view, if a work "were an absolutely exact copy, clearly it would be as moving as the original."[167] Even if not absolutely exact, a copy has aesthetic value when an original has been destroyed. Its effect on viewers is significant in reminding them of what the original looked like and giving them enjoyment vicariously. And when a damaged or faded original remains in existence, the aesthetic value of a copy may be greater than the value of the original since the copy presents a more credible rendering of the prototype.[168] These claims about copies are not thoroughgoing endorsements of formalism and are not directed to stylistic forgeries, although it is possible that in the unlikely event of the destruction of all known works by a particular artist, a work in the artist's style done by someone else could be instructive and have aesthetic value pertaining to the artist's production. The main point of formalism, however, does apply to stylistic forgeries. *Supper at Emmaus* is a prime example. It is not a direct copy but a new subject claimed to be by Vermeer, with its formal properties remaining unchanged when it went from its status as an original to being a contemptible fake.

When an art lover has a moving experience in viewing an artwork by a master, impressed by its beauty and technique, and during a later viewing of the same work is told it is a fake, prompting a different response, what accounts for the difference? Is the viewer a snob or a misguided moralist? Has the forgery been given its fair due? The challenge of formalism is that because the formal properties of an artwork remain the same when the status of its authenticity changes, there is no reason for there to be a dramatic reassessment of its aesthetic quality. Opposition thinking sees this view as a misinterpretation of the nature of artworks and of what occurs in the experience of viewing them. The perspective of "contextualism" recognizes the background beyond what formalism takes note of in understanding works and determining their aesthetic value.

Formalism fails to recognize that a viewer's perception and interpretation are inextricably related. An important dimension is left out when they are separated. Goodman, with sarcastic humor and a biting explanation, dubs the formalist perspective the "Tingle-Immersion theory," attributed to Immanuel Tingle and Joseph Immersion,

> which tells us that the proper behavior on encountering a work of art is to strip ourselves of all vestments of knowledge and experience (since they might blunt the immediacy of our enjoyment), then submerge ourselves completely and gauge the aesthetic potency of the work by the intensity and duration of the resulting tingle. The theory is absurd on the face of it . . . but it has become part of the fabric of our common nonsense.[169]

Denis Dutton is equally critical:

> Yet who is it who ever has these curious "aesthetic experiences"? In fact, I would suppose they are never had, except by infants perhaps—surely never by serious lovers of paintings. . . . the encounter with a work of art does not consist in merely hearing a succession of pretty sounds or seeing an assemblage of pleasing shapes and colors.[170]

Something beyond the lines, shapes, and colors of the physical object is essential when experiencing art. Viewers do not simply absorb signals and process them mechanically. Prior knowledge and beliefs are brought to the situation and make a difference in how a work is understood—a difference in aesthetic response. Knowing that an artist used a particular technique, or was in a certain frame of mind, or following (or creating) a trend in style affects how a viewer carrying this background reacts. Likewise with holding a belief that the artist's later works are inferior, or that the artist is an underappreciated genius, or that all works of a certain genre are uninteresting. How one actually sees a piece of art, including the value assessment made about the piece, depends on the mindset from which it is approached. Since this is the case, should not knowledge that the piece is inauthentic be factored in as well? This, too, is a part of context, an especially informative part. Considered in that light, Catherine's accused snobbery over her Picasso, and the dramatic change of heart Vermeer admirers had about the aesthetic worth of *Supper at Emmaus* when it was exposed as a fraud, do not deserve criticism and are reasonable responses.

The symbolism of Tingle-Immersion highlights the weakness of formalism, while the full force of contextualism in addressing the aesthetics of authenticity versus inauthenticity has been worked out in terms that often emphasize history as the frame of reference. Goodman defines a forged artwork as "an object falsely purporting to have a history of production requisite

for the (or an) original of the work,"[171] a factor he sees as key when assessing aesthetic properties. Arthur Danto says the nature of a forgery "has something to do with its history, with the way in which it arrived in the world."[172] Dutton posits that "the concept of art is constituted a priori of certain essential properties. . . . reference to origins and achievement must be included among these properties," and "we cannot understand a work of art without some notion of its origins, who created it, the context in which the creator worked, and so forth."[173] A proper aesthetic assessment of an artwork, then, would not exclude such an essential consideration as its beginning. Dutton connects that beginning with the work's achievement. With a forgery not only is the origin misrepresented but so is what it has accomplished. In the case of *Supper at Emmaus*, the achievement of Van Meegeren was falsely portrayed as the achievement of Vermeer. The former may deserve recognition as an achievement, but not of the same sort and not worthy of the same respect as the latter.[174] M. W. Rowe elaborates on this point through the example of Shaun Greenhalgh's fake sculpture *Faun*, sold at Sotheby's in 1994 as an original by Gauguin and later acquired by the Art Institute of Chicago, where it was displayed prominently for ten years. Noting that Gauguin labored for decades to develop his primitivist style, going through mistakes, dead ends, and personal sacrifices, Rowe states,

> In contrast, Shaun Greenhalgh did not spend years of disappointment and self-sacrifice discovering a personal style; he was not responsible for Western art's turn toward the primitive, and he did not influence Picasso and Matisse. The work he produced represents a faun just as Gauguin's might have done; and it follows the conventions of sculpture in just the way Gauguin might have done. But what Greenhalgh cannot put into his work is the originality, insight, discovery, and innovation Gauguin put into his; and consequently Greenhalgh's achievement cannot approach Gauguin's.[175]

Few artists are innovators like Gauguin, but the point Rowe is making holds for artists in general. Although only a few are known for developing prototypical styles, each one making original works does have a personal style. Even if it is simply one more of numerous renditions of, say, Impressionism, individual touches are added that make for uniqueness. When a forger simulates that style, it means following what someone else has formulated, trying to assume a mindset that belongs to another. If, for instance, the original artist intends to paint trees and unconsciously uses a particular broad (or choppy or wispy) stroke, a forger trying to simulate those trees works from a different intention. Whereas the original artist is painting trees, the forger is painting trees meant to look like those of the originator. The resulting achievement, coming from different intentions, is also different: a better or lesser simulation

of what someone else would have created, contrasted with such a creation in itself. There is a distinction in kind between the process occurring from intention to achievement by an artist producing originals and the process from intention to achievement of a forger.

A forgery, then, is of lesser aesthetic worth than an original, and historical context is instrumental in making this determination. But there is more to be said about forgery and context in the grand scheme of understanding and appreciating art. Not only is context informative regarding forgery, but it is also liable to corruption from being seeded with falsity. Fakes affect the historical record, and this occurs in several ways: misinformation regarding an artist's production stands to alter the artist's reputation for style, quality, and quantity. When Gauguin's achievement is misunderstood because a forger's work is accepted as genuine, he is made to appear to be more prolific than he truly was, or to have sometimes borrowed content or technique from somewhere that was not the case, or to have produced a set of works of lesser caliber than usual. Still, a further damage to history lies beyond the reputations of individuals. Wrong information about an artist that is singly accepted from forgeries as genuine affects not only our view of that artist but also where the artist stands relative to other artists. Art history does not consist merely of autonomous agents pursuing personal agendas, but it is more like a tapestry of interconnected elements where a pull on one of the threads results in a reaction among other threads. And beyond the history of art, history in a broader scope may be affected by falsity in art when we rely on visual images of the past to provide information about how people lived.

Johann Winckelmann in the eighteenth century may have been the first to critique the corruption forgery causes in historical terms when he explained the threat of fake frescoes by Giuseppe Guerra, who claimed they were ancient originals excavated from Herculaneum.

> Guerra painted his hero with an armor of complete iron, which soldiers of the Middle Ages used to wear in tournaments. In another painting . . . the praetor or emperor who presides is seen with his arm resting on the hilt of a drawn sword—just like those used during the Thirty Years War.[176]

Winckelmann's takeaway is not simply that Guerra failed as a forger, although clearly he did when the process he used for artificial aging was discovered, but that "if even one of the pictures had been antique, the entire system of knowledge . . . about Antiquity would have been toppled."[177] Which artist(s) made the frescoes is not in question here. No individual artist's reputation is on the line, nor an artist's style, but the content of the works bears the potential to mislead historians about military customs, designs, and technology in the ancient world.

The problem cited by Winckelmann that false art history causes is sometimes equated with a similar liability in scientific findings.[178] Fake fossil remains identified as those of a formerly unknown human ancestor, "Piltdown Man," found in England in the early twentieth century, contrived a misleading picture of human evolution until it was discovered that they consisted of a human skull combined with the mandible of an ape. Similarly in 1999, the "archaeoraptor" fossil discovered in China that misled many experts about the evolution of dinosaurs turned out to be a pastiche of fossil pieces from different species.[179] In cases like these, as with Guerra's frescoes, we see how anomalies corrupted the historical record, although eventually they were discovered and the record was corrected. Forming another example, particularly ominous because of its scope, are the fake Pre-Columbian sculptures of Brigido Lara, who gave away his scam only when he was jailed for selling what appeared to be genuine artifacts protected by the Mexican government. Over several decades, Lara fashioned tens of thousands of clay figures identified by museum experts as Mayan, Aztec, and in an exceptionally large quantity, Totonac. It has been said that the number of Totonac pieces he created may exceed the number of authentic works in existence. The sheer volume of his fakes bears the potential to mislead examiners into thinking they must be the real thing.

Lara's forgeries present a threat to both archaeology and art history. His special expertise is in materials: in knowing just which of an assortment of native clays to use for each of his various creations and how to administer an appropriate patina. He was not a student of iconography, and his works are adaptations rather than faithful depictions of what would have been made fifteen hundred years ago. Because there is considerably less expert information available for the culture his works simulate than for other long-past cultures such as Greece and Rome, his eccentric imagery has been easily accepted as authentic. The statue he claims to be his of the wind god Ehecatl (see Figure 3.6), on view for years at the Metropolitan Museum of Art in New York, was written about by various experts. On seeing a picture of it, Lara responded, "this one I invented completely. A piece like this never has been excavated, and all those in existence are mine."[180] Two female figures and a male figure prominently displayed in the collection of the Dallas Museum of Art also were identified by Lara as his productions. The Los Angeles Museum of Natural History and the Saint Louis Art Museum, too, among other major institutions, have presented sculptures of Lara's as originals, which have served as models for study. These, along with others of his work, hold the potential to mislead us today and in the future about clothing, headgear, and other features, as well as the religious practices, of the people and period he portrayed. Social and cultural history are burdened with misinformation that has to be sorted out by comparison with additional findings. As for the historical study of art, the problem looms larger.

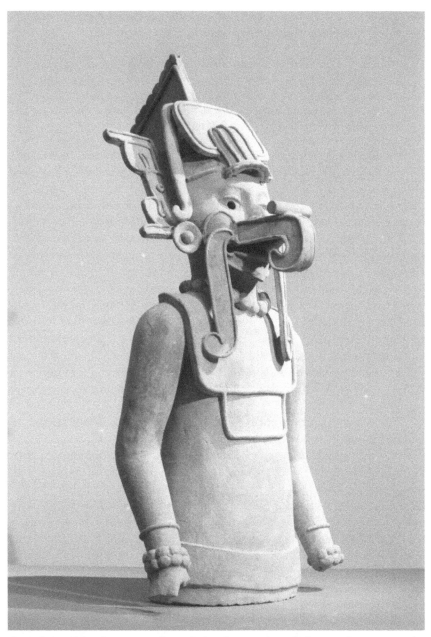

Figure 3.6. Ehecatl (Mesoamerican wind god), seventh to ninth centuries AD, ceramic, 85.7 × 32.2 × 45.1 cm. Claimed by former forger Brigido Lara as his twentieth-century creation in an image devised by himself. Courtesy of the Metropolitan Museum, New York

Mimi Crossley and E. Logan Wagner, museum experts who are knowledgeable about Lara's fakes and have written about them, state that

> Because of the inventiveness with which he executed his figures, it is possible that Lara has singlehandedly skewed our perceptions of a prominent period and style of pre-Columbian art. In other words, this one man has managed to invent much of what up to now scholars have considered to be the Classic Veracruz style.[181]

Consider other examples with potential to muddy the historical record. What if Paul Jordan-Smith had not exposed his Pavel Jerdanowitch hoax, and the paintings he made, perhaps with additional output, became a permanent chapter in the annals of art history? The story of primitivism would be different than it is, and aesthetic judgments based on that account would be altered. With the fictitious school of Disadumbrationism as one of its branches, early twentieth-century primitivist art would be measured against a purposely nonsensical hoax that was thought to be genuine, and the art that followed would be seen in that context. And turning once more to Van Meegeren not only would his forgeries of religious works have caused a distortion in the understanding of the breadth of Vermeer's works but the effect also could have extended to Pieter de Hooch and Frans Hals as well. Van Meegeren also forged these artists, and his stylistic idiosyncrasies would be present in the paintings and affect how these artists stand relative to one another and to Vermeer as well as to others. All of this flawed understanding would come to play in making aesthetic judgments.

Van Meegeren's and Jordan-Smith's deceptive works caused damage to art history that was short-lived because the forgers revealed their creations. In Lara's case, the damage will be long-standing and undone only partially through revelations the forger chooses to make. And it can be reasonably assumed that undiscovered forgeries by the likes of Hebborn, Beltracchi, and Greenhalgh have altered our historical understanding and will do so in the future. The phenomenon extends broadly through the schemes of many forgers who lack celebrity status and whose targets are lesser-known artists working in various mediums and genres. To reiterate an assertion made at the outset of this book, forgery is not everywhere, but it may be anywhere. Misinformation from fakes stands to have a profound effect on art history. The full extent of it cumulatively can only be a matter of conjecture. But more can be said about the role specific forged works play. Those on exhibition in museums, which are seen by many people and infuse the opinions of experts who are fooled by them, are much more influential than the ones held in private collections where they are seldom seen. A counterfeit work ascribed to a famous artist

would, in the latter case, be less of a force against the historical record than one of a minor artist that is displayed publicly.

A more provocative perspective, however, on the relative harm done by fakes addresses their quality. Among the ones that are executed well enough to avoid detection—perfect fakes in a practical sense—we may consider that there will still be degrees of perfection. Some of those works will be closer than others to simulating the style and technique of their target artists. A key ramification is that the more they are like originals, the less damage they do to historical understanding. This point extends Richardson's contention three centuries ago when he said that as difficulty increases in telling a copy apart from an original, concern about making that determination decreases proportionally. A contemporary and more detailed statement comes from philosopher Sherri Irvin:

> A highly competent forgery has great potential to cause harm, yet at the limit its very competence may mitigate the harm's severity. The better a forger is at avoiding detection, the longer the forger's products are likely to remain in place and to subtly corrupt our aesthetic understanding. But if a forgery is successful largely because it has been purged of anachronistic elements and imbued with the style of the forged artist, then for the same reason the magnitude of damage may be relatively slight.[182]

Irvin describes the irony in which a fake's high degree of faithfulness to the manner of an original, as opposed to a fake with lesser excellence, both increases its potential harm to art history and decreases it. Although it is likely to remain undetected longer, there is less in its composition that is misleading.

Despite noting the mitigating factor of excellence, Irvin strongly opposes forgery. She specifies how it acts as a deceptive force not only in regard to a particular artist but also in regard to the connections of that artist with others, and cites Goodman's temporal argument as potentially offsetting the effect of high-quality forgeries. That argument has liabilities, as described previously, but there is another concern that challenges mitigation as a correlate of perfection. A single fake that bears only a small inconsistency in capturing the style of a master can be said to cause relatively little harm to historical understanding, but if more fakes are produced by the same especially talented forger, the size of the master's output is distorted. An artist who made five hundred works may now be thought to have totaled six or seven hundred, perhaps introducing subject matter the master never attempted. So the greater the excellence of the forger's renderings the greater the harm done to art history. Rather than mitigation, perfection leads in this way to escalation.

This argument about volume, while countering the mitigation brought about by excellence, does not pertain to individual forgeries. A single piece

that is truly excellent in copying its target still can be said to do relatively little damage to art history: viewers are subjected to much that tells them accurately what the target artist's work is like and to little that is inaccurate so as to mislead them. How does this circumstance relate to the aesthetic worth of a perfect fake? As a fake reaches proportionally toward equivalence with works by the artist being copied, creating proportionally less mistaken understanding of that artist, does its aesthetic value, then, increase, aspiring to that of an original? In a sense, the mitigation drawn from excellence acts in this way, but at the same time, the achievement of the forger is diminished. The more the forger's work looks like that of the target artist, or in other words, as the performance of a copyist reaches toward absolute perfection, less and less originality is present. Judgment of aesthetic worth, when including the factor of originality and the achievement connected with it, sees even the best forgery as the work of a copyist and lacking in the worth of an original. What makes a fake the best among inauthentic objects isolates it from an authentic work. To put it in terms of formalism and contextualism as they were discussed previously, to the extent that aesthetic judgment moves beyond the formal characteristics of a work to consider contextual factors, the claim for mitigation loses, and a fake that is so excellent that it is virtually harmless to the historical record is still aesthetically inferior to an original.

· IV ·

Reflections on the Big Picture

This book presents a wide-ranging collection of material about historical events, forgers' biographies and mentalities, legal cases, and philosophical views on authenticity. From that expanse there are several main takeaways I hope readers will reach—lines of thought supported by various details and that offer an overall picture of the phenomenon of art forgery as it exists today. Its many faces and shades of gray point in broad terms to key understandings.

Forgery is a prevalent phenomenon in the art world. Fakes have been found in many instances among works offered for sale on the art market and in museums and private collections, which leads to suspicion there are others that have not been discovered. Not surprisingly, this is an unwelcome message, and it is sometimes rejected in the art community. An art scholar who read the manuscript for this book stated, "Missing is recognition that forgeries/fakes are absolute exceptions to the rule; that the overwhelming, crushing majority of artworks in circulation is authentic every way around; that the absolute, vast majority of dealers, restorers, artists, auction houses, etc. is honest." Here is a misguided optimism about the purity of the art world, as well as a confused notion that art professionals in general have been indicted as lacking integrity and are in need of defense. The fact that many fakes have been discovered, and the suggestion that there are more, perhaps many more, still out there, does not translate into an assessment of how many art professionals are honest. A single forger may account for a large number of fakes that fool people who have expertise. The volume of counterfeit artworks in existence does not point to a lack of integrity among artists in general or others in the art industry, although it is reasonable to say that some among them are bad actors (as with examples I have mentioned). It is also reasonable to say that many people have been taken in and that some forgers are quite good at making believable fakes.

What, then, about the volume of forgeries? Are they the "absolute exceptions to the rule" asserted in the quote? Simply noting the output, described in part I, of many thousands of fakes produced by forgers from recent decades says otherwise. And that list is far from a comprehensive accounting. Whatever amount might be suggested, however, offers no point of comparison with authentic works. What would be more helpful is a percentage estimate of how many of the works populating the art world are counterfeit. Occasionally, expert sources have spoken in percentages, such as 40 percent by Thomas Hoving (see the introductory quote to part I), 10 percent by Noah Charney, and more than 50 percent (perhaps as much as 70 to 90 percent) by the Fine Art Experts Institute (FAEI) in Geneva. However, all of these figures carry qualifying conditions and none apply directly to the art world in general. Charney refers to fakes actually hanging on museum walls, repeating a number he says he hears often from others but does not endorse personally. The estimates from Hoving and the FAEI combine misattributions with deliberate fakes, and FAEI experts approach their calculations through their professional experience in dealing with works that are already considered suspicious, so a finding of fraud is likely.[1]

As much as a comprehensive percentage figure is desirable, it could be no more than guesswork. What we do know, however, that speaks to the prevalence of counterfeit works in the art world, besides the output of certain forgers, is that there are pockets where forgery is rife, as with artists such as Corot, Dalí, Rodin, Antoine Blanchard, Mandy Wilkinson, and others who have been faked prolifically. To say that forgeries are prevalent recognizes these pockets of corruption but it is not to claim that they represent the art world as a whole. It is not suggested that the phenomenon of forgery is equally distributed throughout. Neither is it suggested that the art world is otherwise free of forgery. To refer again to the forgers chronicled in part I, they are known to have faked a wide variety of artists working in several mediums, including but not limited to noted Impressionists and Post-Impressionists, Expressionists, sixteenth-century Dutch, nineteenth-century American, twentieth-century Australian, Bombay Progressivists, German Renaissance, and Pre-Columbian.

We know as well that twentieth- and twenty-first-century forgers have built on a long history that precedes them. From ancient Rome to the Renaissance and onward, forgers have plied their trade. This was never a secret, and was notable in the legal action against copyists taken by Dürer in the sixteenth century and Rubens in the seventeenth century, journalist Justus van Effen's disparagement of picture dealers in the eighteenth century, a mocking poem by the British Royal Academy's chaplain about forgeries being common in auctions, and printmaker William Hogarth's artistic satirization of art fraud. And while art forgery has long been a fixture in

Western culture, the conditions that have always encouraged it have grown. The combination of artists with name recognition, collectors who want their works, and a market for buying those works is at a high in the twenty-first century. Especially with the advent of the Internet, more people have the opportunity to view more art. Increased wealth in the world makes for a greater number of art buyers and for more competition to purchase works by popular artists. The global art market has expanded to roughly $50 to $60 billion annually, and art auctions set record high prices in the 2010s. Times are ripe for fakes to supplement the shortage of originals, and forgers continue to react to an increasing demand for them. Common sense about supply and demand adds to the numerical information we have about the output of known forgers and widely forged artists, along with the suspicion of unknown forgers producing further fakes, to conclude that art forgery is indeed a prevalent phenomenon.

Do not expect that most art forgeries will be detected and rooted out. Historically, there have been art experts with confidence that it could be done, from Giulio Mancini, Abraham Bosse, and Jonathan Richardson in the seventeenth and eighteenth centuries to Hans Tietze and Max Friedländer in the twentieth century. Philosopher Nelson Goodman added support with the proposition that we cannot claim we will be unable in the future to spot the falsity in an artwork that seems authentic to us now. However, various factors stand as deterrents to curbing the presence of fakes in the art world and explain why they are prevalent today and can be expected to remain so in the future.

Scientific advancements have brought increasingly sophisticated means for detecting art fakes, and there have been many successes leading to legal action against forgers and fraudulent dealers while removing forgeries from circulation. But key constraints limit the effectiveness of science, particularly its application on a broad scale. The cost of testing, which for many artworks would be more than their full value or at least a significant portion of it, would be passed on to purchasers, and especially if testing were done routinely, it would cause a considerable rise in prices. Spot-checking, on the other hand, would turn up some fakes but miss others. For works of substantial worth testing is not a financial limitation, but at any price point the revelations of the main scientific techniques are limited to falsification rather than extending to verification. These techniques cannot tell us assuredly that an artwork is authentic, but can determine many works to be fakes because they are made of the wrong materials to have been created by the named artist, or involve an uncharacteristic method such as underdrawings or layering of paint. Careful forgers study the forensic impediments they are facing and work around them by using proper materials and methods. They also can submit their fakes for laboratory analysis to find out what works or does not to make them passable.

Artworks that prove acceptable scientifically also need verification by connoisseurship. Experts who express confidence in this process speak of three general principles in spotting fakes. Forgers are said to lack freedom in execution: they display hesitancies and lack the flow of movement artists have with their own works. Forgers also are said to unconsciously incorporate personal mannerisms into what they make, just as happens with legitimate artists. An expert eye can catch these mannerisms as being inconsistent with the named artist for a particular work without knowing who made it, thus identifying it as a forgery. A third principle speaks to the factor of time, with the claim that forgers work within the visual expectations of their own era, such that certain giveaways in the appearance of the works they create might not be spotted during that era because they are consistent with it. They will, however, be spotted in the future when those giveaways become apparent to minds not conditioned to the same expectations.

These ideas about uncovering fakes bear a degree of credence, but are subject to exceptions and counteracting conditions that deflate confidence in them as effective principles for combating the prevalence of counterfeit art. Forgers have been said to practice long and hard to achieve a freedom of execution like that of the artists they copy. They prepare to assume someone else's identity as an actor does when learning to play a certain role. With repetition, the movements they impersonate seem natural. David Stein's wife describes him as working so quickly and easily that he often finished several fake drawings in an hour (all by the single artist he was intensely focused on at that time). The assumption that fake works can be spotted because of hesitant movements is an overgeneralization that fails to recognize forgers as artists who can learn to be fluid in their movements when they are copying someone else's style. As for noticing forgers' personal mannerisms as giveaways, there are many cases where this has not happened, including those where connoisseurship has authenticated works that science later reveals as false. In other cases, high-profile forgeries by Alceo Dossena, Lothar Malskat, and Han van Meegeren were found out not because of faulty artistic execution, but only when they purposely exposed their own schemes. Reinhold Vasters's fraud was discovered seventy years after his death by someone looking through papers he left in his estate. And Frank X. Kelly's forgeries were known only to Thomas Hoving, who saw them in circulation but never exposed his friend until he had died. This is not to say that forgers are always able to avoid personal mannerisms, although we can expect that the better practitioners are good at doing so. What is suggested is that when a fake is judged by an art expert to be genuine, the forger's personal mannerisms are legitimized for the future when they are found in other fakes. These mannerisms become part of what is acceptable within the oeuvre of the artist being faked.

The point about the influence on our understanding of what constitutes a forger's style also applies against the belief that in the future connoisseurship will spot what it does not in the present. When a fake is designated as genuine and the mannerisms it displays are then accepted to be those of the artist being forged, it will be difficult to overcome that acceptance even with the fresh connoisseurial perspectives the passage of time may bring. The new lens for analysis is countered by prior reinforcement of mistaken understandings that have been written into the past. This liability combines with another to further weaken confidence that fakes will be rooted out over time. Many fakes are produced by forgers who live in the same era as their targets. Consider the twentieth century, when Picasso, Dalí, Chagall, and various other artists were faked prolifically by the likes of Stein, Elmyr de Hory, Guy Ribes, and the Amiel family to name only some examples. Whatever mistakes the forgers may have made, they were not a result of working from the aesthetic of a different time period. The same goes for nineteenth-century forgers who simulated nineteenth-century artists, eighteenth-century forgers for eighteenth-century artists, and so on. Throughout time, many fakes have been made by forgers who are contemporaries of the artists they copied, and those fakes will not be subject to discovery based on a misunderstanding by their creators of the artistic norms of the time in which the artists being copied lived.

It is reasonable to conclude that many fakes go undetected and that this condition will hold in the future. What happens, then, to the ones that are discovered? Some of them are removed from circulation, but others are not. Of those identified in legal proceedings, some are destroyed, especially in countries like France that give strong recognition to the moral rights of artists. Other fakes, as is common in the United States with its emphasis on property rights, are returned to their owners, sometimes with an indelible marking or accompanying document of inauthenticity. Owners who are dishonest are in a position to put those fakes on the market, a practice that forger Geert Jan Jansen, who was also an art dealer, suggests is sometimes followed by dealers when they realize they have been stuck with fakes. The back of a painting or print can be covered so as to hide any markings that were placed there, and a document attesting to its falsity can be destroyed.

Beyond the factor of dishonest owners lies another impediment to rooting out false artworks. The law protects those works through statutes of limitations. Many fakes are beyond the limitation for legal action at the time they are discovered. Time periods vary, but run from about three to ten years in most countries for fraud, the charge typically brought against sellers of fake art. The clock starts running when an item is purchased, and after it expires potential charges are nullified, although in exceptional circumstances courts have allowed actions based on the date a work is detected to be fake. Statutes

of limitations allow many known and suspected forgeries to remain available to be put on the market. Owners have lost their opportunity to sue for restitution, and if they sell them (at a large loss) as the work of copyists, those same fakes may eventually return to the market in the guise of originals. Wolfgang Beltracchi, for instance, claims to have put several hundred paintings onto the market during his time as a forger. Only a few of them appeared in his criminal trial or the civil suits he faced from defrauded collectors, with some others identified as suspicious. The bulk of Beltracchi's fakes were not accounted for when they reached their limitation in 2021 (per the ten-year limitation in Germany for his crimes).

The authenticity of an artwork is generally conceived in terms of who made it, but for many works that determination is confusing. Legal and philosophical considerations often lead to uncertainty and dispute about where credit lies, as more people than the named artist may be involved in the process that produced an object. Participation by someone else can occur contemporaneously with the artist or at a later date. One such process is restoration, which could take place even centuries after a work was completed. When restorers add to a work that has deteriorated, their efforts may be judged to have compromised its authenticity. A purist perspective (à la John Ruskin, and others more recently) says any alteration to an existing piece detracts from its status as an original; it will never again be what it was and should be left alone and enjoyed as it is for as long as it remains. A contrary view sees the piece in developmental terms as having a history that is constantly changing, so restoration is welcome, and seemingly without limitation. Enterprising restorers have capitalized on the latter, as with Bartolomeo Cavaceppi's eighteenth-century sculptural restorations that sometimes added more replacement material than remained of the original object, and painters who buy badly deteriorated canvases by prominent artists and repaint them while still designating them as originals.

Taking into account these philosophical poles, legal and art-historical efforts have been made in determining grounds for authenticity. The focus is on how much material alteration has occurred, the visual outcome, and the methods used. Expert witnesses in US legal cases have hovered in the range of 50 percent or more of repainting on a canvas as compromising its authenticity, whereas a decision in England asserted that 100 percent of repainting would be acceptable as long as it was faithful to what the original artist rendered. During the restoration of Rembrandt's *Danaë* in the 1980s and 1990s after it was splashed with acid by a crazed viewer, the Hermitage Museum exercised great care when inpainting around existing paint, claiming later that the famous work was 100 percent Rembrandt in places and entirely redone in others, and that what viewers see is not "the original" but preserves the spirit of Rembrandt. This cautious approach was in keeping with international

norms that have guided professional restorers for the last half-century. In particular they emphasize documenting all work, and using materials that can be removed in the future and are visible to the naked eye or aided by basic scientific techniques. Many works bearing restoration, however, do not meet these standards, and their value both aesthetically and monetarily on the art market reflects the views of dealers and collectors.

Another practice in which the potential effect on authenticity derives from changes to an artwork over time is the posthumous production of bronzes and prints. Here, as with restoration, the generally accepted standards for determining which works are originals are sometimes disregarded when they conflict with the desires of private collectors, museums, and the general public for the availability of original works to own and enjoy viewing. Important factors include the legal and moral right to produce from existing objects (molds, models, plates), faithfulness to the original object from which the new production is made, and producing in the same medium as the original object.

Degas bronzes and Rembrandt prints demonstrate how normal expectations can be overridden. Degas's famous sculptures were produced by his heirs against his wishes, from deteriorating wax figures that underwent repair (altering some images) and were cast into bronze models, from which molds were made for a further round of casting that created final versions (with reduction in clarity, as well as in size due to shrinkage). Although they are far from meeting conventional qualifications, museums have presented the bronzes as originals, and they have thrilled many millions of viewers. As one expert explained, "the 'scandal' was sanitized over time" as prominent owners invested large sums in the sculptures. With Rembrandt prints, the problem has not been the legal or moral right to produce from original plates, even centuries later. The artist did not oppose posthumous production, and many of his plates were printed from by a succession of owners. However, the quality of the prints declined after the plates were used many times, leaving dark areas where finely wrought details once appeared. The products of these printings are authentically Rembrandt, but the degree of authenticity can be challenged. In keeping with market concerns, this factor should adversely affect prices, but the Millennium prints of eight images pulled in the late twentieth century have sold for more than some of the earlier editions of the same images that have been available on the market at the same time and that are aesthetically more appealing and carry more gravitas. Demand from people who want to "own a Rembrandt" but lack knowledge of how to navigate the market demonstrates again that conventional standards of judgment are sometimes overridden when posthumous products are evaluated.

With restoration and posthumous production, questions arise about authenticity due to people other than the original artist altering completed

works. The processes of collaboration and appropriation also bring concerns about the effect of multiple participants on authenticity, but here they address the initial act of creating an artwork. Collaboration has been a common practice since the Renaissance, with artists sometimes working together as partners and getting equal credit for their efforts, but in another sense the collaborating parties are artists and the studio workers they hire to help in the production process. Today, the latter has developed to a point where, although it has legal sanction, it can be troublesome philosophically and questioned by art lovers. Rubens exemplifies artists from the past who engaged surrogates, but works done entirely by the master commanded higher prices than those done partially by employees. Rodin, too, used studio workers, but their role was to work with a fully completed model by the master to translate it into a new medium (cast into bronze, carve with a pointing machine). More recently, Jeff Koons, Damien Hirst, and Dale Chihuly, among others, have handed the full production process over to employees, while considering the works that result as fully their own. Koons and Hirst are on record with unabashed statements about their impatience and lack of skill for performing the physical labor required. They say their contribution is the intellectual labor of conceiving images that will be completed by others.

The law generally supports the idea that with "works for hire" the person in creative control of the process of artistic production is not required to name employees or to share profits with them, so authenticity is not threatened in this sense. The bar is high for workers to satisfy the conditions necessary to claim coproduction and benefits deriving from it. This outlook is supported by the philosophy of conceptualism as spoken for by artist Sol LeWitt and philosophers Paisley Livingston and Alva Noë, who emphasize that what counts in art are mental constructs rather than their physical expression. Ideas are the essence, acting as architectural plans, whereas execution is a perfunctory exercise. However, conceptualism runs into difficulty as a general policy art. It works to explain the production of large-scale creations that cannot be completed without help, as with architects designing buildings and artists making works of monumental size. But it is problematic for justifying the use of surrogates to do the detailed skill work that many art lovers expect from artists who claim the normal-sized paintings, drawings, and sculptures that carry their names to be authentically theirs. The expectation is that when it is humanly possible to complete the process solo, an artist will demonstrate the desire and the skill to do so. Appealing to a division that privileges concepts to the exclusion of execution fails to recognize that a combination of both is a higher artistic accomplishment.

If artists employing surrogates to perform their physical labor is acceptable legally but otherwise controversial, their use of the intellectual labor of

other artists has been even more contentious. Artists have always borrowed from the images of other artists, but the phenomenon of appropriation art has taken the practice to a new level in recent decades and confronted legal restrictions. Andy Warhol, Robert Rauschenberg, and Sherrie Levine for a while appropriated images, but gave it up to avoid court decisions against them under copyright law that gives artists protection against unauthorized use of their works. However, there is flexibility in the law through the principle of "fair use" to allow freedom of expression and to let existing material be put to new uses rather than isolated under exclusive control. The fair use defense has been applied in a number of cases where appropriation artists were sued. Copyright law (in the United States, with similarity in other countries) presents several factors to be considered, but often the overriding one has been the appropriationist's purpose, which is typically expressed as parody or some other way of changing the meaning of the original work. Jeff Koons lost two cases while claiming parody, after which the concept of "transformative-ness" was endorsed by the Supreme Court in a music industry case where it was determined that an appropriationist does not need to parody but only to make a general comment on culture. Koons won his next case on this basis, and transformativeness evolved further in a suit against Richard Prince, which determined that intended commentary by the appropriationist is not required and what is important is how a work is perceived by viewers. On the other hand are situations in which transformativeness has not held sway. It was out-weighed in two US cases involving appropriated photographs, one of them against Prince, which focused instead on the market effect of the new works on the originals. And in France, Koons lost two cases over appropriation, one in which he appealed to transformativeness and freedom of expression and in the other to transformativeness and parody.

Besides mixed results in asserting fair use as a defense, appropriation art has faced two embarrassing ironies. One is that appropriationists themselves have attempted legal action against artists who used images similar to theirs. Koons threatened to sue the maker of bookends shaped like balloon dogs (à la his famous sculptures) but backed off after unfavorable news coverage. And Hirst claimed infringement in England against a teenage artist selling prints that incorporated an image of his famous glittering skull (which replicated a skull he bought in a taxidermy shop). These leaders of appropriationism failed to respect in the rights claimed by others what they claimed for themselves. Further, with Koons and Hirst known not only for appropriating images but also for hiring out the workmanship to make artworks from those images, art lovers are left to ask why they should respect products carrying the names of people who performed neither the intellectual nor physical labor that created them.

Still another concern about who made an artwork, as it pertains to authenticity, is cultural appropriation. Here the problem does not stem from multiple people being involved in the production process, but from the background of any artist making works identified with an Indigenous group. The United States, Canada, Australia, and other countries have laws against selling works as Indigenous if they are not made by Indigenous artists, so as to protect them against having their culture exploited, their identity usurped, and their income threatened. There have been prosecutions, for instance, in the United States for jewelry claimed to be by American Indians and in Australia for paintings and carvings claimed to be Aboriginal, although critics say enforcement overall has been lax. Although on its surface the matter may seem to be a simple one of fairness for minorities, difficulties arise on several fronts, beginning with what makes a person Indigenous. The determination is based on bloodline, but standards vary by group (or state, province), as in the United States, where the Miccosukee Tribe of Florida requires one-half blood heritage for membership, whereas the Shawnee Tribe of Oklahoma requires one-thirtieth. As one legal scholar has said, "The problem with certifying authentic Indian stuff is that it requires certifying authentic Indians."

Beyond bloodline, other problems address cultural status. Can outsiders produce works that are as authentic in presentation as those of insiders? White artist Elizabeth Durack caused outrage in Australia for paintings she presented as Aboriginal, although she had been steeped in Aboriginal culture throughout her life and one of her paintings was nominated for a prestigious award given for Aboriginal art. American artist Jimmie Durham claimed a Cherokee affiliation that was denied by tribal officials, yet he continued to be an activist for American Indian affairs and has received accolades for his American Indian art (although he has sometimes disputed the label). Another question asks whether insiders are producing authentically Indigenous art, given inevitable cultural assimilation. Australian Aboriginal paintings are made with acrylic paint by artists who do not live the simple lives in the bush that their ancestors did, especially with the presence of modern technology. Do they retain the cultural essence meant to separate their art from that of outsiders? A philosophical perspective spoken for by prominent minority thinkers such as bell hooks and Edward Said emphasizes that the essentialist view of insiders as distinct from outsiders reinforces separation and subordination. Even though it brings pride and income to minority artists, it pushes them to marginalization and emphasizes a notion of primitivism. Another perspective, represented by artist Richard Bell, promotes a revised cultural essence through Urban Aboriginal Art, with works that present the contemporary Aboriginal experience by speaking critically to the legacy of colonialism by white settlers.

To many minds, art forgery is not conceived unequivocally as morally wrong, nor its products as necessarily inferior to originals. While in legal terms it is a crime to sell counterfeit art, there are psychological, economic, and philosophical perspectives that range from mitigating a negative outlook to promoting a positive one about the practitioners of forgery and the products they create. Forgers themselves, when caught, sometimes claim they sold their works as legitimate copies only to have other parties resell them fraudulently as originals. Using this plea, Tony Tetro was convincing enough to earn a hung jury at his trial, and in other cases prosecutors have wrestled with questions about intention. They also face the prospect that collectors who know they own fake artworks may be reluctant to come forward with them out of embarrassment or the immediate financial devaluation they would incur. And those who suspect they own fakes may prefer to remain intentionally uncertain rather than having them checked and occupy a realm of moral limbo when displaying or selling them. Because art forgery is not written into legal codes as a crime, the act is typically charged as a form of fraud (often involving mail or wire fraud), and perhaps other charges are added such as money laundering and (in the United States) tax evasion. Among forgers and fraudulent dealers, prison sentences have ranged from a few months to about eight years (with early release common), although some of the most notorious forgers managed to avoid arrest or were given suspended sentences.

Another claim by forgers when they are caught is that they acted in retribution against critics who panned their work, or from a jaded view of the art industry in general. An attempt some have made to justify their actions in terms of a moral code is the idea that it is not wrong to present a fake to supposedly knowledgeable art professionals, such as auction house personnel, without making a claim about its authenticity; it is their job to figure out authenticity in a buyer-beware business world. Eric Hebborn and Ken Perenyi both played this game, and it helped them to avoid arrest. Still one more rationalization is that forgery is a victimless crime, as in Perenyi's words: "Do I feel guilty about taking money from auction houses? The idea is laughable. . . . This was a world of glamour and money, and plenty of it."

The general public, too, may be enticed by the notion that the victims of art forgery are upper-echelon buyers who can afford their losses, as statements in the press and blogosphere attest. In one journalist's words, "Art forgery is the most moral way to embezzle 16 million Euros." In reality, a large share of fakes are not bought by wealthy collectors but by art lovers who are not in a position to disregard the financial loss when they discover that what they paid several hundred to several thousand dollars for is worth next to nothing. A related attitude about collectors combines them with dealers

and experts—the art establishment in general—as an arrogant elite to be ridiculed for their ineptitude when they are fooled by fakes. Forgers, then, are seen as their debunkers, with some portrayed as antiheroes, and, in the case of Wolfgang Beltracchi, even spoken of as a Robin Hood figure although he did nothing to redistribute the proceeds from his fraud. This attitude carries into fictional accounts in movies and novels, where the makers of fake art, whether in lighthearted or serious, soul-searching portrayals, outwit the prevailing order. Still another perspective respects forgers for their artistic talent, which is transferrable to a legitimate business. Enterprising ones capitalize on news accounts of their exploits, as well as biographies, memoirs, and documentary films, to support their conversion to artists who sell under their own names. In a few cases, their expertise has led to other pursuits: Guy Ribes and David Stein as movie consultants, Brigido Lara as an authentication expert for a museum, and Tom Keating and John Myatt each as a television host of his own series demonstrating how to paint like the masters.

A different approach that puts a positive spin on counterfeit art comes in economic terms, where the thrust is to look beyond the financial losses incurred at the hands of forgers and to focus on other factors. One line of thought sees the making and selling of fakes as a part of the fabric of a social or national group. An example is Italy during the eighteenth and nineteenth centuries, when art dealers did a thriving business passing off forged works at cheap prices to visitors from other countries who were taking the Grand Tour as a rite of passage into adulthood in elite society. The practice of fraud found justification with the local citizenry for maintaining Italy's reputation in the world as a leader in the history of fine art and for bringing in much-needed revenue. A reversal on the immorality of selling fraudulent works asked who was being more dishonorable when a dealer sold a Donatello to a tourist for a few thousand lire and the tourist believed its worth was hundreds of times that amount. The idea of selling fake art to bolster a waning economy, and with the support of local residents who are aware of the practice, can easily carry through in other markets such as Egyptian artifacts in the late-nineteenth and early-twentieth centuries and Pre-Columbian figures.

A broader version of economic thought considers the institution of forgery in general, arguing that the wrongful act of art fraud is part of a larger, positive outcome. Taken as a whole the results are more beneficial than harmful. The school of thought termed "happiness economics," as spoken for by leading proponent Bruno Frey, sees financial gain as well as loss when there are fakes on the market and also finds benefits of other sorts. Not only do forgers and art dealers earn money, it is argued, but artists command higher prices when their profiles are raised due to more works in their name being available to viewers. There is benefit for consumers, who have a greater number

of "original" works to purchase and to enjoy seeing on display in museums. Further, fakes are valuable as a teaching device, and the risk to buyers of being stuck with a fake can be reduced by doing business with respected dealers. Overall, the collective happiness of the whole—owners and viewers of artworks along with art professionals—more than balances the unhappiness of financial loss to those who are victims of forgery. This line of thought is based on the philosophy of utilitarianism, which promotes the "greatest good for the greatest number." It is subject to the standard rebuttal that weighing harm and good is subjective, and harm done to a smaller group may be more substantial than good done for a larger one. Also missing in the formula is consideration of the negative effect of forgery on art history.

The last, and especially perplexing, topic of the book asks about the aesthetic value of a "perfect fake." For all practical purposes, "perfection" here means a level that fools experts but not claiming there are no flaws. Whatever flaws exist have not been noticed and have been accepted as part of the forged artist's style and mannerisms. Does such an artwork approach the status of an original in aesthetic terms? The philosophy of formalism says that the quality of workmanship that went into the object is the key. Observing its formal elements—the look of the thing—tells us what we need to know. A forgery of this quality is just as good as a work by the artist being copied, although it was made by someone else. If the workmanship is so skillful that the falsity is not evident to expert eyes and only revealed in some other way, perhaps by materials science or by the forger personally, why should it not draw a level of respect similar to that accorded an original?

Contextualism, on the other hand, looks beyond an object's form to the mindset from which an artist creates it and viewers approach it. The history of the object's production includes the way the artist thought about constructing it. For an original artist this factor is unique. A forger, on the other hand, works from a mindset that is steeped in copying what is unique to someone else. Shaun Greenhalgh's fake of a Gauguin sculpture looks like an original, but does not derive from the insight, discovery, and innovation that Gauguin carried out. Put in terms of intention, Greenhalgh's intention was of a lesser sort than Gauguin's. As for viewers of the sculpture, they, too, are affected by context. They will see it in terms of what they already know about art. For some this may be a great deal and for others little, but they will all have thoughts and expectations of some sort, and not a blank slate that simply records visual stimuli. Their judgment of an artwork relies necessarily on this precondition, which is then informed in the future by their present experience.

Forgeries infect this experience with falsity. They corrupt the art-historical record by giving us erroneous information and skewing our notions of what various artists accomplished and what culture consisted of over time.

A particularly ominous example because of its scope is Brigido Lara's use of his own iconography to fashion thousands of Mayan and Aztec sculptures and so many Totonac pieces that they may total more than there are originals in existence. It has been said that his inventiveness skewed our perception of a whole period and style of Pre-Columbian art. How does forgery's corruption of art history relate to assessment of a perfect fake—not just any fake, but a most excellent one? A formalist perspective says the more excellent a forgery is, the less it damages our understanding of the past, hence the greater its aesthetic value. If it is faithful to the way an artist worked, with only insignificant flaws, it does little harm to our historical consciousness. A contextualist rejoinder reiterates that the intangibles in an object's history cannot be duplicated, and the closer a forger comes to perfecting copyism, the further away the act of creation is from originality and from the accomplishment of an original artist.

Notes

PART I

1. The presence of these conditions, or more generally of market forces, as underlying the practice of forgery seems to be assumed by many commentators. Art historian Alexander Nagel clearly states that the movement from a copy culture to one in which art forgery occurs involves artistic individuality, collectors, and the art market. However, he believes these conditions, and the resultant appearance of forgery, did not occur until the Renaissance. See Alexander Nagel, "The Copy and Its Evil Twin: Thirteen Notes on Forgery," *Cabinet* 14 (2004). Anthropologist Ross Bowden contrasts tribal societies, where art forgery does not exist, with modern Western societies, where the presence of forgery is linked to a commercial market for art, objects that have the status of collectibles, and a demand for collectibles that outstrips supply. See Ross Bowden, "What Is Wrong with an Art Forgery?: An Anthropological Perspective," *Journal of Aesthetics and Art Criticism*, 57, no. 3 (Summer 1999): 333. Among others a bit further back in time who have made statements about the presence of an art market as necessary for the rise of forgery are art critic Peter Fuller in "Forgeries," *Art Monthly* (October 1976): 8, and Theodore Rousseau, Chairman of European Paintings at the Metropolitan Museum of Art in New York, in "The Stylistic Detection of Forgeries," *Metropolitan Museum of Art Bulletin* 26, no. 2 (1968): 247.

2. Thomas Hoving, *False Impressions: The Hunt for Big-Time Art Fakes* (New York: Simon & Schuster, 1996), 17.

3. Thierry Lenain, *Art Forgery: The History of a Modern Obsession* (London: Reaktion, 2011), 19.

4. This point is fundamental among anthropologists. See, for instance, Claude Lévi-Strauss, *The Savage Mind* (Chicago: University of Chicago Press, 1966), 10.

5. For a discussion of the absence of art forgery in Kwoma society, see Bowden, "What Is Wrong with an Art Forgery?" See also Bowden's book *Creative Spirits: Bark Painting in the Washkuk Hills of North New Guinea* (Melbourne: Oceanic Art, 2006), chapter 7. Bowden confirmed in an email exchange with this author (February 18,

2017) that his recent trips to New Guinea revealed Kwoma attitudes toward artistic creativity remain the same as in his 1999 study.

6. Herschel B. Chipp, "Formal and Symbolic Factors in the Art Styles of Primitive Cultures," *Journal of Aesthetics and Art Criticism* 29 (Winter 1960).

7. Chipp, "Formal and Symbolic Factors," 162.

8. Chipp, "Formal and Symbolic Factors," 164.

9. For instance, see Hoving, *False Impressions*, 24–29; Sepp Schüller, *Forgers, Dealers, Experts: Strange Chapters in the History of Art* (New York: G. P. Putnam's Sons, 1959), 1.

10. Pliny's *Natural History* (33.53, 35.40) notes that Lucius Crassus paid 100,000 sesterces for two cups, while Caesar paid eighty talents for two paintings by Timomaches (35.40).

11. On Roman collections and the art market, see Joseph Alsop, *The Rare Art Traditions: The History of Art Collection and Its Linked Phenomena Wherever They Have Appeared* (New York: HarperCollins, 1982), 194–208. Also Jerome J. Pollitt, "The Impact of Greek Art on Rome," *Transactions of the American Philological Association* 108 (1978): 155–74.

12. For a general account of the tradition of ekphrasis, see Ruth Webb, *Ekphrasis, Imagination, and Persuasion in Ancient Rhetorical Theory and Practice* (Farnham, UK: Ashgate, 2009). For a condensed discussion, with two specific examples, see Carolyn MacDonald, "Greek and Roman Eyes: The Cultural Politics of Ekphrastic Epigram in Imperial Rome," American Philological Association, Chicago, 2014.

13. *The Comedies of Terence and the Fables of Phaedrus*, prologue to the *Fables*, trans. Henry Thomas Riley (London: George Bell & Sons, 1887).

14. Martial, *Epigrams*, 4.39, Bohn's Classical Library (London: George Bell & Sons, 1897).

15. Petronius, *The Satyricon*, 83, trans. W. C. Firebaugh (New York: Boni & Liveright, 1922).

16. Alison Burford, *Craftsmen in Greek and Roman Society* (Ithaca, NY: Cornell University Press, 1972), 210–11.

17. Peter Stewart, *The Social History of Roman Art* (Cambridge: Cambridge University Press, 2008), 22.

18. Michaela Fuchs, *In Hoc Etiam Genere Graeciae Nihil Cedamus. Studien zur Romanisierung der Späthellenistischen Kunst im 1. Jh. v. Chr.* (Mainz: von Zabern, 1999), 49–50.

19. Fuchs, In *Hoc Etiam Genere Graeciae Nihil Cedamus*, 50–51.

20. Gisela Richter, *Engraved Gems of the Greeks and Etruscans: A History of Greek Art in Miniature* (London: Phaidon, 1968), 139–40.

21. Lenain, *Art Forgery*, 65.

22. Michael Squire, "Ars in Their I's: Authority and Authorship in Graeco-Roman Visual Culture," in *The Author's Voice in Classical and Late Antiquity*, ed. Anna Marmodoro and Jonathan Hill (Oxford: Oxford University Press, 2013), 379.

23. Lenain, *Art Forgery*, 72.

24. Duncan Chappell and Kenneth Polk, "Fakers and Forgers, Deception and Dishonesty: An Exploration of the Murky World of Art Fraud," *Current Issues in Criminal Justice*, 30, no. 3 (2009), 7–8; Saskia Hufnagel, "Art Fraud in Germany: Lessons

Learned or the Fast Falling into Oblivion," in *Cultural Property Crime*, ed. Joris Kila and Marc Balcells (Leiden: Brill, 2014), 112.

25. For a discussion of the conventional and skeptical views on Roman art forgery, see William Casement, "Were the Ancient Romans Art Forgers?" *Journal of Art Historiography* 15, no. 2 (December 2016): 1–27.

26. Pliny, *Natural History*, 35.36.

27. Dale Kinney, "Spolia, Damnatio and Renovatio Memoriae," *Memoirs of the American Academy in Rome* 42 (1997): 137.

28. Joseph Alchemeres, "Spolia in Roman Cities of the Late Empire: Legislative Rationales and Architectural Reuse," *Dumbarton Oaks Papers* 48 (1994).

29. Cicero, Letter to Atticus 6.1.

30. Pliny, *Natural History*, 35.36.

31. D. C. Zoli, "L'Uoma di Pietra. Vicende e problemi di una statua romana a Milano," *Classe di scienze morali* 30 (1975).

32. Lanfranco Franzoni, *Verona: Testimonianze archeologiche* (Verona: Edizioni di Vita Veronese, 1965).

33. C. R. Dodwell, *Painting in Europe 800–1200* (Harmondsworth: Penguin, 1971), 103–5. See also Willibald Sauerländer, *Gothic Sculptures in France 1140–1270*, trans. Janet Sondheimer (New York: H. N. Abrams, 1972), 24.

34. E. H. Gombrich, *The Story of Art* (London: Phaidon, 1950), 113–14.

35. John of Salisbury, *Memoirs of the Papal Court*, trans. Marjorie Chibnall (London: Nelson, 1956), 80.

36. Ernst Kantorowicz, *Frederick the Second 1194–1250*, trans. E. D. Lorimer (London: Constable, 1957), 322.

37. Francis H. Taylor, *The Taste of Angels: A History of Art Collecting from Ramses to Napoleon* (Boston: Little, Brown, 1948), 43.

38. For a listing of the Duc de Berry's holdings, see *Inventaires de Jean Duc de Berry*, ed. Jules Juiffrey (Paris: Leroux, 1894).

39. Otto Demus, "A Renascence of Early Christian Art in Thirteenth Century Venice," in *Late Classical and Medieval Studies in Honor of Albert Mathias Friend Jr.*, ed. Kurt Weitzmann (Princeton, NJ: Princeton University Press, 1955). See also Patricia Fortini Brown, *Venice and Antiquity: The Venetian Sense of the Past* (New Haven, CT: Yale University Press, 1996), chapter 1.

40. Demus, "A Renascence of Early Christian Art," 353.

41. Lawrence Nees, "Forging Monumental Memories in the Early Twelfth Century," *Memory and Oblivion: Proceedings of the XXIXth International Congress of the History of Art* (Dordrecht: Kluwer Academic Publishers, 1996).

42. Nees, "Forging Monumental Memories," 773.

43. Alsop, *The Rare Art Traditions*, 402.

44. Lorne Campbell, "The Art Market in the Southern Netherlands in the Fifteenth Century," *Burlington Magazine* 118 (1976): 188–98.

45. Alsop, *The Rare Art Traditions*, 444–45.

46. Neil De Marchi and Hans J. Van Miegroet, "Rules Versus Play in Early Modern Art Markets," *Louvain Economic Review* 66, no. 2 (2000). For further analysis, see

Neil De Marchi and Hans J. Miegroet, "The History of Art Markets," in *Handbook of the Economics of Art and Culture*, ed. Victor A. Ginsburgh and David Throsby (Amsterdam: North Holland, 2006), 1:69–122.

47. Otto Kurz, *Fakes: A Handbook for Collectors and Students* (New Haven, CT: Yale University Press, 1948), 56.

48. Roger Jones and Nicholas Penny, *Raphael* (New Haven, CT: Yale University Press, 1983), 146–47, 196–97.

49. Information on copies and their sales is found in Louisa Wood Ruby, "Drawings, Connoisseurship and the Problems of Multiple Originals," *Journal of Historians of Netherlandish Art Journal* 52, no. 2 (2013).

50. Alessandro Conti, *History of the Restoration and Conservation of Works of Art*, trans. Helen Glanville (Oxford: Elsevier, 2002), 12.

51. Conti, *History of the Restoration and Conservation of Works of Art*, 32–33.

52. Francis Haskell and Nicholas Penny, *Taste and the Antique: The Lure of Classical Sculpture* (New Haven, CT: Yale University Press, 1982), 103.

53. Leonard Barkin, *Unearthing the Past: Archaeology and Aesthetics in the Making of Renaissance Culture* (New Haven, CT: Yale University Press, 1990), 189.

54. Kurz, *Fakes*, 32.

55. Frank Arnau, *The Art of the Faker: 3,000 Years of Deception* (Boston: Little Brown, 1961), 99.

56. Hoving, *False Impressions*, 54.

57. Kurz, *Fakes*, 182–83.

58. Giorgio Vasari, *Lives of the Most Eminent Painters, Sculptors, and Architects*, trans. Gaston du C. De Vere (London: Macmillan, 1972), 9:7.

59. Vasari, *Lives*, 9:12–13.

60. Vasari, *Lives*, 5: 107–9.

61. Vasari, *Lives*, 9:238.

62. Otto Kurz, "Early Art Forgeries: From the Renaissance to the Eighteenth Century," *Journal of the Royal Society of Arts* 121, no. 5198 (January 1973): 79.

63. Richard Hoe Lawrence, *Medals by Giovanni Cavino, the Paduan* (New York: Privately published, 1883), 5–6, https://archive.org/details/medalsbygiovanni00law riala/page/n3/mode/2up.

64. Lenain, *Art Forgery*, 209.

65. For a brief biography of Bol, see "Hans Bol," Museum Boijmans, https://www.boijmans.nl/index.php/en/collection/artists/2919/hans-bol. The original account of Bol's professional life appeared in Karel van Mander's *Schilder-boeck*, published in Haarlem in 1604.

66. Adrian Darmon, "Forgeries, A Long History," http://www.artcult.fr/EN/_Forgeries/Fiche/art-0-1011646.htm?lang=EN.

67. Kurz, "Early Art Forgeries," 85.

68. Vasari, *Lives*, 6:95–96. See also Schüller, *Forgers, Dealers, Experts*, 14–15.

69. For details about Dürer's legal cases and forgery of his work in general, see Lisa Pon, *Raphael, Dürer, and Marcantonio Raimondi* (New Haven, CT: Yale University Press, 2004). See also Fritz Mendax, *Art Fakes and Forgeries*, trans. H. S. Whitman (London: Werner Laurie, 1955), 115–23.

70. Don Felipe de Guevara, *Comentarios de la pintura* (Barcelona: Selecciones Bibliófilas, 1948), 126.

71. Kurz, *Fakes*, 108.

72. Alsop, *The Rare Art Traditions*, 149–50.

73. Edmond Bonnaffé, *Dictionnaire des amateurs français au XVIIe siècle* (Paris: A. Quantin, 1884), 204.

74. Ricardo Nobili, *The Gentle Art of Faking: History of the Methods of Producing Imitations and Spurious Works of Art from the Earliest Times Up to the Present Day* (London: Forgotten Books, 2015), 120. This is a reprint of the 1921 edition by William Brendon & Son. Also available as free download from several sources.

75. Alsop, *The Rare Art Traditions*, 427.

76. Alsop, *The Rare Art Traditions*, 465.

77. *The Diary of John Evelyn*, ed. William Bray (London: M. Walter Dunne, 1901), 19.

78. Jaap van der Veen, "The Art Market in Delft in the Age of Vermeer," in *Dutch Society in the Age of Vermeer*, ed. Donald Haks and Marie Christine van der Sman (The Hague: Waanders, 1996), 130.

79. Hoving, *False Impressions*, 61.

80. See, for instance, Josua Bruyn, "Rembrandt's Workshop: Its Function and Production," in *Rembrandt: The Master and His Workshop*, ed. Christopher Brown, Jan Kelch, and Pieter van Thiel (New Haven, CT: Yale University Press, 1991), 70–71.

81. Mendax, *Art Fakes and Forgeries*, 154.

82. Kurz, *Fakes*, 36.

83. Kurz, *Fakes*, 37.

84. Mendax, *Art Fakes and Forgeries*, 132.

85. Kurz, *Fakes*, 45–46.

86. Wilhelm R. Valentiner, "An Early Forger," *Art in America*, 1 (1913): 195.

87. Arnold Houbraken, *De Groote schouburgh der nederlantsche konstschilders en schilderessen* (Amsterdam: B. M. Israel, 1976), 293–303.

88. See Philip Hooks, *Rogue's Gallery: A History of Art and Its Dealers* (London: Profile Books, 2017), chapter 1.

89. Mark Jones, ed., *Fake? The Art of Deception* (Berkeley: University of California Press, 1990), 139.

90. For details on Cavaceppi and his work, see Seymour Howard, "Bartolomeo Cavaceppi and the Origins of Neoclassical Sculpture," in *Antiquity Restored: Essays on the Afterlife of the Antique* (Vienna: Institute for Art Historical Research, 1990), and Howard's "Ancient Busts and the Cavaceppi and Albacine Casts," *Journal of the History of Collections* 3, no. 2 (1991): 199–217.

91. J. Fleming and H. Honour, "Francis Harwood: An English Sculptor in XVIIIth Century Florence," *Festschrift Ulrich Middeldorf*, ed. Antje Kosegarten and Peter Tilger (Berlin: De Gruyter, 1968).

92. Jones, *Fake? The Art of Deception*, 151–52.

93. Tamara Griggs, "Ancient Art and the Antiquarian: The Forgery of Giuseppe Guerra," *Huntington Library Quarterly* 74, no. 3 (September 2011): 471–503.

94. Mendax, *Art Fakes and Forgeries*, 154.

95. Moritz Thausing, *Albert Dürer: His Life and Works*, trans. Fred A. Eaton (London: John Murray, 1882), 2:95. For alternative versions of what happened to the painting, see Hufnagel, "Art Fraud in Germany," 113.

96. David Goodrich, *Art Fakes in America* (New York: Viking, 1973), 11.

97. *Treasures on Trial: The Art and Science of Detecting Fakes*, exhibition at the Winterthur Museum, April 2017–January 2018, treasuresontrial.winterthur.org.

98. Giulio Mancini, *Alcune considerazione appartamenti alla pittura come di diletto di un gentilhuomo nobile e come introduttione a quello si deve dire* (c. 1621); Abraham Bosse, *Sentiments sur la distinction des diverses manières de peintre, dessein et gravures, et des originaux d'avec leurs copies; Emsemble du choix des sujets des chemins pour arriver facilement et promptement a bien pourtraire* (1649); Giovanni Baglione, *Le vite de pittori, scultori et architetti, dal pontificato di Gregorio XII del 1572: In fine a' tempi di Papa Urbano Ottavo nel 1642* (Rome, 1642). For a summary of Mancini, Bosse, and Baglione, see Lenain, *Art Forgery*, chapter 3.

99. Francisco Pacheco, *Arte de la pintura*, F. J. Sánchez Cantón 1638 (Madrid, 1956), 2:168. Roger de Piles, *L'Ideé du peintre parfait, pour servir de règle aux jugemens que l'on doit porter sur les ouvrages des peintres* (1699); Jean-Baptiste Du Bos, *Réflexions critiques sur la poésie et la peinture* (1719); Jonathan Richardson, *A Discourse on the Dignity, Certainty, Pleasure and Advantages of the Science of a Connoisseur* (1719), and *Two Discourses. I. An Essay on the Whole Art of Criticism as It Relates to Painting II. An Argument in Behalf of the Science of a Connoisseur* (1725).

100. Roger de Piles, *L'Idée du peintre parfait* (Amsterdam: Chez François L'Honoré, 1736), 77–78.

101. Jonathan Richardson, "The Connoisseur: An Essay on the Whole Art of Criticism as It Relates to Painting" in *Two Discourses. I. An Essay on the Whole Art of Criticism as It Relates to Painting. . . . II. An Argument in Behalf of the Science of a Connoisseur; Both by Mr. Richardson* (Paternoster Row, 1725), 185.

102. Mendax, *Art Fakes and Forgeries*, 147.

103. Samuel Foote, *Taste: A Comedy in Two Acts* (New York: D. Langworth, 1813). First published in 1752.

104. John Thomas Smith, *Nollekens and His Times and Memories of Contemporary Artists from the Time of Roubiliac, Hogarth and Reynolds to that of Fuseli, Flaxman and Blake*, ed. Wilfred Whitten (London: John Lane, 1917) 2:89.

105. *Engravers Copyright Act* (1735), 8 Geo. II, c. 3.

106. *The First Modern Museums of Art: The Birth of an Institution in 18th- and Early-19th-Century Europe*, ed. Carole Paul (Los Angeles: J. Paul Getty Museum, 2012).

107. Nicholas Green, "Circuits of Production, Circuits of Consumption: The Case of Mid-Nineteenth-Century French Art Dealing," *Art Journal* 48, no. 1 (1989): 32.

108. Green, "Circuits of Production," 30.

109. "Archive Directory for the History of Collecting in America," Center for the History of Collecting, The Frick Collection, research.frick.org/directoryweb/recordlist.php. Included in estimating the number of galleries in New York in 1900 are files provided to the author that were not online.

110. See Lynn Catterson, "Stefano Bardini and the Art of Crafting Authenticity," Authentication in Art Congress, The Hague, May 7–9, 2014.

111. Eric Hebborn, *Drawn to Trouble: Confessions of a Master Forger* (New York: Random House, 1991), 358–60.

112. Irina Tarsis, "Knoedler Obituary (1857–2011): Select Legal History of the Oldest American Art Gallery," *Center for Art Law*, August 10, 2014, https://itsartlaw.org/2014/08/10/knoedler-obituary-1857-2011-select-legal-history-of-the-oldest-american-art-gallery/.

113. For an extended discussion of nineteenth-century fictional writings about art forgery, see Aviva Briefel, *The Deceivers: Art Forgery and Identity in the Nineteenth Century* (Ithaca, NY: Cornell University Press, 2006).

114. Henry Carl Schiller, "Who Painted the Great Murillo de la Merced?" *Blackwood's Edinburgh Magazine* (August 1870): 133–65.

115. Mark Twain, "The Capitoline Venus," http://americanliterature.com/author/mark-twain/short-story/the-capitoline-venus.

116. Honoré de Balzac, "Pierre Grassou," https://www.gutenberg.org/files/1230/1230-h/1230-h.htm.

117. Nathaniel Hawthorne, "Edward Randolph's Portrait," https://www.ibiblio.org/eldritch/nh/erp.html.

118. Jacob Rothenberg, *"Descensus Ad Terram": The Acquisition and Reception of the Elgin Marbles* (New York: Garland, 1977), 185.

119. John Ruskin, *The Seven Lamps of Architecture* in *The Works of John Ruskin*, ed. E. T. Cook and Alexander Wedderburn (London: George Allen, 1903), 3:244.

120. For examples, with discussion of general practices, see Paul Ackroyd, Larry Keith, and Dillian Gordon, "The Restoration of Lorenzo Monaco's 'Coronation of the Virgin': Retouching and Display," *National Gallery Technical Bulletin* 21 (2000): 34–57; Carol E. Snow, "The Affecter Amphora: A Case Study in the History of Greek Vase Restoration," *Journal of the Walters Art Gallery* 44 (1986): 2–7; Mark Stevenson, "Print Restoration in Northern Europe: Development, Tradition, and Literature from the Late Renaissance to the 1930s," *Studies in the History of Art* 51 (1995): 110–27.

121. Giovanni Morelli, *Italian Painters: Critical Studies of Their Works*, trans. Constance Jocelyn Ffoulkes (London: John Murray, 1900), see especially 34–63, https://babel.hathitrust.org/cgi/pt?id=wu.89037970514&view=1up&seq=6&skin=2021.

122. Carlo Ginsburg, "Morelli, Freud and Sherlock Holmes: Clues and Scientific Method," *History Workshop* 9 (Spring 1980): 5–36.

123. Sigmund Freud, "The Moses of Michelangelo," *The Standard Edition of the Complete Works of Sigmund Freud*, trans. James Strachey (London: Hogarth Press, 1913–14), 12:222.

124. "The Picture-Copying Trade," *American Bibliopolist* 2 (April 1873).

125. Sheridan Ford, *Art: A Commodity* (New York: Press of Rogers & Sherwood, 1888), 36.

126. Gary Tinterow, Michael Pantazzi, and Vincent Pomarede, *Corot* (New York Metropolitan Museum of Art, 1996), 383.

127. Laurie Hurwitz, "If It Doesn't Dance, It's Not Corot," *ARTnews*, June 27, 2012.

128. Tinterow, Pantazzi, and Pomarede, *Corot*, 386.

129. Reynold Alleyne Higgins, *Tanagra and the Figurines* (Princeton, NJ: Princeton University Press, 1987). See also Hoving, *False Impressions*, 72–73.

130. Antoine Zinc and Elisa Porto, "Luminescence Dating of the Tanagra Terracottas of the Louvre Collections," *Geochronometria* 24 (2005): 21.

131. Jean-Jacques Fiechter, *Egyptian Fakes: Masterpieces That Duped the Art World and the Experts Who Uncovered Them* (Paris: Flammarion, 2009): 26.

132. Alfred Clerc, "Lettre à M. De Saulcy sur quelques antiquités égyptiennes et sur le boeuf apis," *Revue Archéologique* (October 15, 1846–March 15, 1847).

133. For a summary of Billy and Charleys, see Jones, *Fake?*, 187; see also "The Billy and Charley Story," http://www.mernick.org.uk/B&C/page1.htm. For a collection of articles on the topic, see www.pewterbank.co.uk/wp-content/uploads/2020/07/Billy-Charley.pdf.

134. See, for instance, "A Small Pewter 'Billy and Charley' Figure," lot 248, in the Bonhams (New Bond Street) Gentleman's Library Sale, January 20, 2010.

135. Angelo de Gubernatis, *Dizionaio degli artisti italiani viventi* (Florence, 1892), 432–33.

136. Roberta J. M. Olson, "'Caveat Emptor': Egisto Rossi's Activity as a Forger of Drawings," *Master Drawings* 20, no. 2 (Summer 1982): 149.

137. Olson, "Caveat Emptor," 150–54.

138. Yvonne Hackenbroch, "Reinhold Vasters, Goldsmith," *Metropolitan Museum Journal* 19–20 (1984/85): 164.

139. Leslie Bennetts, "45 Met Museum Artworks Found to Be Forgeries," *New York Times*, January 12, 1984.

140. "European Manufacture of 'Old Masters' for the American Market," *New York Times*, August 11, 1857.

141. Bastianini's story is told by several chroniclers of art fakes. See Schüller, *Forgers, Dealers, Experts*, 26–35; Kurz, *Fakes*, 148–51; Hoving, *False Impressions*, 194–97.

142. See Jones, *Fake?*, chapter 6; Briefel, *The Deceivers*, introduction; Carol Helstosky, "Giovanni Bastianini, Art Forgery, and the Market in Nineteenth-Century Italy," *Journal of Modern History* 81, no. 4 (December 2009).

143. Fiechter, *Egyptian Fakes*, 80–89.

144. H. Herzer, "Ein Relief des Berliner Meisters," *Objects* (1971): 4–5.

145. For details about Aslanian, see Fiechter, *Egyptian Fakes*, chapters 5 and 6.

146. Lee Lescaze, "The 'Spanish Forger'—A Mystery Show," *Washington Post*, May 21, 1978.

147. For a brief explanation of the Spanish Forger, see "Manuscript Road Trip: The Spanish Forger" (January 18, 2014), https://manuscriptroadtrip.wordpress.com/2014/01/18/manuscript-road-trip-the-spanish-forger. For further discussion, see William M. Voelke, "The Spanish Forger: Master of Chicanery," in Thomas Coomans and Jan De Maeyer, *The Revival of Medieval Illumination: Nineteenth-Century Belgian Manuscripts and Illuminations from a European Perspective* (Leuven: Leuven University Press, 2007), 207–27.

148. See G. Mazzoni, ed., *Falsi d'autore: Icilio Federico Joni e la cultura del falso tra otto e novecento* (Siena: Protagon, 2004).

149. Kurz, *Fakes*, 298–300.

150. Icilio Federico Joni, *Affairs of a Painter* (London: Faber & Faber, 1936).

151. Roderick Conway Morris, "Masters of the Art of Forgery," *New York Times*, July 31, 2004.

152. There are many published accounts of Dossena's career. See, for instance, David Sox, *Unmasking the Forger: The Dossena Deception* (London: Unwin Hyman, 1987). See also "The Aristocrat of Three-Dimensional Forgery," chapter 4 in Lawrence Jeppson, *The Fabulous Frauds: Fascinating Tales of Great Art Forgeries* (New York: Weybright and Talley, 1990).

153. Jeppson, *The Fabulous Frauds*, 203.

154. Jonathon Keats, *Forged: Why Fakes Are the Great Art of Our Age* (New York: Oxford University Press, 2013), 48.

155. Günter Grass, *Die Rattin* (Munich: Luchterhand, 1986), English translation as *The Rat* (New York: Harcourt, 1987).

156. For a summary on Van Meegeren (including a comparison with Wolfgang Beltracchi), see Christa Roodt, "Forgers, Connoisseurs, and the Nazi Past," *Journal of Information Ethics* 24 (2015): 43–62.

157. Biographer Frank Wynne's calculation totals $60 million. *I Was Vermeer: The Rise and Fall of the Twentieth Century's Greatest Forger* (New York: Bloomsbury, 2006), 257–58.

158. Edward Dolnick, *The Forger's Spell: A True Story of Vermeer, Nazis, and the Greatest Art Hoax of the Twentieth Century* (New York: HarperCollins, 2008), 173.

159. Regarding *Christ in the House of Martha and Mary*, see Lord Kilbracken, *Van Meegeren: Master Forger* (New York: Charles Scribner's Sons, 1967).

160. Wynne, *I Was Vermeer*, 152.

161. Lenain, *Art Forgery*, 247.

162. For a detailed discussion of the history of the Ghent Altarpiece, see Noah Charney, *Stealing the Mystic Lamb: The True Story of the World's Most Coveted Masterpiece* (New York: Public Affairs, 2010).

163. An informative source is "Fake—Not Fake: Restorations-Reconstructions-Falsifications: the Preservation of the Flemish Primitives in Belgium, ca. 1930–1950," exhibition at the Groeningemuseum, in Bruges, November 26, 2004–February 28, 2005, www.codeart.nl/guide/exhibitions/fake-not-fake-restauraties-reconstructies-falsificaties-het-conserveren-van-de-vlaamse-in-belgi-ca-1930-1950.

164. For an informative discussion of the complexities of authenticity, see David Scott, *Art: Authenticity, Restoration, Forgery* (Los Angeles: Cotsen Institute of Archaeology Press at UCLA, 2016), especially chapter 1.

165. For a summary of the institutionalization of ideas about art restoration during the twentieth century, see Joyce Hill Stoner, "Changing Approaches in Art Conservation: 1925 to the Present," in *Scientific Examination of Art: Modern Techniques in Conservation and Analysis* (Washington, DC: National Academies Press, 2005), http://doi.org/10.17226/11413.

166. "Code of Ethics and Guidelines for Practice," American Institute for Conservation of Historic and Artistic Works, https://www.culturalheritage.org/about-conservation/code-of-ethics.

167. The population of London in 1900 (over six million) was roughly twice that of Paris. "Greater London, Inner London, and Outer London Population and Density

History," http://demographia.com/dm-lon31.htm; "Ville de Paris: Population and Density from 1600," http://www.demographia.com/dm-par90.htm.

168. Anne Helmreich, "The Socio-Geography of Art Dealers and Commercial Galleries in Early Twentieth-Century London," in *The Camden Town Group in Context*, ed. Helena Bonett, Ysanne Holt, and Jennifer Mundy (London: Tate Research Publication, 2012), www.tate.org.uk/art/research-publications/camden-town -group-anne-helmreich-the-socio-geography-of-art-dealer-and-commercial-galleries -in-early-r1105658. See also Malcolm Gee, *Dealers, Critics, and Collectors of Modern Painting: Aspects of the Parisian Art Market Between 1910 and 1930* (New York: Garland, 1981), 37.

169. For a full treatment of the relationship between Duveen and Berenson, see Colin Simpson, *Artful Partners: Bernard Berenson and Joseph Duveen* (New York: Macmillan, 1986).

170. Data from the Institute of Museum and Library Services, Washington, DC.

171. Rita Kottasz, Roger Bennett, Sharmila Savani, and Rehnuma Ali-Choudhury, "The Role of Corporate Art in the Management of Corporate Identity," *Corporate Communications: An International Journal* 13, no. 3 (2008): 235–54.

172. "Global Art Market Reaches USD 63.7 billion in 2017, with Dealers Taking the Lion's Share," *Art Basel*, artbasel.com/news/global-art-market-reaches -usd-63-7-billion-in-2017-with-dealers-taking-the-lions-share; Rachel Corbett, "Art Market Watch: How Big Is the Global Art Market," *Artnet Magazine*, www.artnet .com/magazineus/news/artnetnews/china-the-worlds-top-art-and-antique-market .asp; Scott Reyburn, "What's the Global Art Market Really Worth? Depends on Who You Ask," *New York Times*, March 23, 2017.

173. Eileen Kinsella, "What Does TEFAF 2016 Art Market Report Tell About the Global Art Trade?" *Artnet News*, March 9, 2016.

174. For examples, see Christophe Spaenjers, William N. Goetzmann, and Elena Mamonova, "The Economics of Aesthetics and Record Prices for Art since 1701," *Explorations in Economic History* 57 (July 2015): 79–94.

175. "The 10 Most Faked Artists," *ARTnews*, June 1, 2005.

176. "The 10 Most Faked Artists."

177. Goodrich, *Art Fakes in America*, 78.

178. Denis Dutton, "Forgeries and Plagiarism," *Encyclopedia of Applied Ethics* (San Diego: Academic Press, 1998).

179. Tinterow, Pantazzi, and Pomerade, *Corot*, 394.

180. The exact number of works seized varies according to the source consulted. Inspector Jack Ellis, who led the investigation for the US Postal Inspection Service, provided the figure of eighty thousand to this author in an interview on April 21, 2021. It conforms with the display "Operation Bogart" in the *Behind the Badge* exhibit at the Smithsonian National Postal Museum, https://postalmuseum.si.edu/exhibition/ behind-the-badge-case-histories-scams-and-schemes/operation-bogart. United States v. Amiel, 95 F.3rd 135 (1996) stipulates seventy thousand. The figure of seventy-five thousand was reported by William Honan, "Federal Agents Seize Etchings as Fakes," *New York Times*, January 31, 1992. Lee Catterall, *The Great Dalí Art Fraud and Other*

Deceptions (Fort Lee, NJ: Barricade Books, 1992), 353–54, gives a breakdown of fifty thousand Dalís, twenty thousand Mirós, twenty-two hundred Picassos, and six hundred fifty Chagalls.

181. FTC v. Magui Publishers, Inc., 927 F2nd 609.

182. Hubertus Butin, "Whatever Is Coveted Will Be Forged—Forgers Set Their Sights on Contemporary Prints," *Print Quarterly* 30 (March 2013): 45.

183. "Dalí Says Thousands of His Signed Prints Are Fake," *Lewiston Daily Sun*, August 10, 1985; Catterall, *The Great Dalí Art Fraud*, 61.

184. Douglas C. McGill, "7 Charged in the Sale of Fake Dalís," *New York Times*, February 28, 1986.

185. David Galenson, "Rodin's Drawngs," *Huffington Post*, December 6, 2017.

186. Dorothy Seiberling, "The Great Rodin: His Flagrant Faker," *Life* (June 14, 1965): 65.

187. Frederick M. Winship, "The Art World: Fake Bronzes Flood Market," *UPI*, August 15, 2002.

188. Schüller, *Forgers, Dealers, Experts*, 85.

189. Schüller, *Forgers, Dealers, Experts*, 86.

190. Jeppson, *The Fabulous Frauds*, 116.

191. "The Faking Game," *Time*, March 10, 1997.

192. This estimate is based on my personal experience with hundreds of paintings attributed to Antoine Blanchard, as well as discussions with other dealers who have expertise on this artist. Howard Rehs, who has compiled a catalogue raisonné of Blanchard's works, has estimated that as few as one in eight to one in ten supposed Blanchard paintings are authentic, www.rehs.com/newsletterarchives.htm?newsletter_no=60.

193. Author's interview with Lee Berthelsen, April 4, 2011. See Johann Berthelsen Conservancy, www.berthelsen.com/authen.html.

194. "Quick Facts About the Highwaymen," floridahighwaymen.com/viewgallery.php3?gallery_id=107.

195. Gary Monroe, *The Highwaymen: Florida's African-American Landscape Painters* (Gainesville: University Press of Florida, 2001); Bob Beatty, *Florida's Highwaymen: Legendary Landscapes* (Orlando: Historical Society of Central Florida, 2001); Catherine M. Enns, *The Journey of the Highwaymen* (New York: Abrams, 2009).

196. Sally Kalson, "Art Collection Is Vast, but Is It the Real Deal?" *Pittsburgh Post-Gazette*, April 11, 2010.

197. www.simpsonscels.com/info/faq.shtml.

198. Amid Amidi, "Most Disney Drawings on eBay Are Forgeries!" *Cartoon Brew*, November 24, 2010, cartoonbrew.com/Disney/most-disney-drawings-on-ebay-are-forgeries-31940.html.

199. Cahil Milmo, "How a Little-Known Welsh Painter Became Britain's Most Forged Artist," *The Independent*, September 3, 2009.

200. Martin Newman, "Art: Beware Copycats . . . Interview with Mandy Wilkinson," *Daily Mirror*, August 31, 2009.

201. Clifford Irving, *Fake: The Story of Elmyr de Hory, the Greatest Art Forger of Our Time* (New York: McGraw-Hill, 1969); Mark Forgy, *The Forger's Apprentice: Life with*

the World's Most Notorious Artist (self-published, 2012); *F for Fake*, film directed by Orson Welles, 1974; Jeff Oppenheim, *Real Fake: The Art, Life and Crimes of Elmyr de Hory* (2017), imbd.com/title/tt1890370.

202. Irving, *Fake*, 228.

203. Irving, *Fake*, 234–35.

204. Irving, *Fake*, chapter 18.

205. See Johannes Rød, "Fakes in the Forger's Oeuvre," December 10, 2010, http://elmyrstory.wordpress.com/2010/12/04/fake-fakes-in-the-forgers-oeuvre.

206. Réal Lessard, *L'Amour du faux* (Paris: Hachette, 1988); Roger Peyrefitte, *Tableaux de chassé; ou, La Vie extraordinaire de Fernand Legros* (Paris: A. Michel, 1976).

207. Anne-Marie Stein, *Three Picassos Before Breakfast: Memoirs of an Art Forger's Wife* (New York: Hawthorn, 1973), 142.

208. Stein, *Three Picassos Before Breakfast*, 78–79, 88.

209. Stein, *Three Picassos Before Breakfast*, 46.

210. Stein, *Three Picassos Before Breakfast*, 174–75.

211. "David Stein (art Forger) – Biography," https://www.liquisearch.com/david _stein_art_forger/biography.

212. "Master Forger Geert Jan Jansen on Trial in France," *Museum Security Network*, https://web.archive.org/web/20051229225528/http://www.museum-security .org/00/170.html.

213. "Geert Jan Jansen," *Fake!* (symposium), http://symposiumstudentenverenig ingou.wordpress.com/geert-jan-jansen.

214. "Geert Jan Jansen."

215. Geert Jan Jansen, *Magenta: Avonturen van een meestervervalser* (Amsterdam: Prometheus, 1998).

216. geertjanjansen.nl.

217. *A Genuine Forger*, documentary film directed by Jean-Luc Léon (Java Films, 2016).

218. *A Genuine Forger;* Guy Ribes, *Autoportrait d'un faussaire* (Paris: Presses de la Cité, 2015).

219. Marc Helfer, "Guy Ribes väärensi Chaagalleja ja Picassoja—Ja eli kuin miljonaari," *Kulttuuricocktail*, December 12, 2015; John Anderson, "A Forger's Impressions of Impressionism: Guy Ribes's Paintings Lend Realistic Touches to 'Renoir,'" *New York Times*, March 22, 2013.

220. Helfer, "Guy Ribes Väärensi Chaagalleja ja Picassoja"; Anderson, "A Forger's Impressions of Impressionism."

221. Scott Verchin, "An Interview with Genius Art Forger Tony Tetro," *Art Market*, April 2016.

222. Author's interview of Tony Tetro, January 25, 2019.

223. tonytetro.com; Meisy Chong, "Tony Tetro," *Acclaim*, March 15, 2014, https://www.acclaimmag.com/art/tony-tetro.

224. tonytetro.com.

225. Mark Seal, "The Prince, the Flash, and the Forger," *Vanity Fair*, April 2020; Michael Kaplan, "The Art Forger Is So Good That His Paintings Tricked the Royal Family," *New York Post*, December 14, 2019; Tessa Solomon, "$136M. in Art on

View at Prince Charles's Home Are My Fakes, Forger Claims," *ARTnews*, November 4, 2019.

226. For an extensive recounting of Myatt and Drewe's forgery operation, see Laney Salisbury and Aly Sujo, *Provenance: How a Con Man and a Forger Rewrote the History of Modern Art* (New York: Penguin, 2009). For a briefer treatment, see Peter Landesman, "A 20th-Century Master Scam," *New York Times Magazine*, July 19, 1999.

227. Salisbury and Sujo, *Provenance*, 292, 302.

228. johnmyatt.com.

229. Salisbury and Sujo, *Provenance*, 292.

230. Andrew Levy, "The Most Devious Person I've Dealt with: Judge Hits Out at Conman Who Tricked Widow Out of £700,000," *Daily Mail*, March 13, 2012.

231. Joshua Hammer, "The Greatest Fake-Art Scam in History?" *Vanity Fair*, October 10, 2012.

232. Duncan Chappell and Saskia Hufnagel, "The Beltracchi Affair: A Comment on the 'Most Spectacular' German Art Forgery Case in Recent Times," *Journal of Art Crime* (Summer/Spring 2012).

233. Hammer, "The Greatest Fake-Art Scam."

234. Ibid.

235. Arne Birkenstock, *Beltracchi: The Art of Forgery* (2014); Wolfgang and Helene Beltracchi, *Selbstporträt* (Reinbek: Rowohlt, 2014) and *Einschluss mit Engeln* (Reibek: Rowohlt, 2014).

236. Alexander Forbes, "What You Need to Know about Master Forger Wolfgang Beltracchi's Latest Antics," *Artnet News*, March 3, 2014.

237. United States v. Glafira Rosales, No. 13 Cr. 518 (S.D.N.Y. July 17, 2013.)

238. Barry Avrich and Melissa Hood, *Made You Look*, Netflix documentary (2020).

239. Colin Moynihan, "Dealer in Art Fraud Scheme Avoids Prison," *New York Times*, January 31, 2017; United States v. Glafira Rosales Order of Restitution, July 5, 2017.

240. "Knoedler Forger Claims Innocence," *Artnet News*, July 16, 2014.

241. Graham Rowley, "Fugitive in Art Fraud Case Deflects Blame in a Filmed Interview," *New York Times*, April 25, 2020.

242. Anderson Cooper, "$80 Million Con," *60 Minutes*, May 22, 2016.

243. Tom Keating (with Frank Norman and Geraldine Norman), *The Fake's Progress: The Story of a Master Faker* (London: Anchor Press, 1977), 263–72.

244. Matthew Sweet, "The Faker's Moll," *Independent*, January 31, 1999.

245. Anne Hodgson, "Tom Keating on Painters," annehodgson.de/2013/08/14/tom-keating-on-painters.

246. Keating, *The Fake's Progress*, 85.

247. Eric Hebborn, *The Art Forger's Handbook* (New York: Overlook Press, 1997).

248. Hebborn, *Drawn to Trouble*, 360.

249. Dalya Alberge, "Art Forger Eric Hebborn Linked to Mafia Boss, Film-Makers Say," *Guardian*, April 14, 2019; Lynda Albertson, "A Film about the King of Counterfeiters, Forger Eric Hebborn," *Association for Research into Crimes Against Art*, April 16, 2019, https://art-crime.blogspot.com/2019/04/a-film-about-king-of-counterfeiters.html.

250. Ken Perenyi, *Caveat Emptor: The Secret Life of an American Art Forger* (New York: Pegasus, 2012), 40.

251. Patricia Cohen, "Forgeries? Perhaps Faux Masterpieces," *New York Times*, July 18, 2012.

252. Perenyi, *Caveat Emptor*, 305, 311.

253. Shaun Greenhalgh, *A Forger's Tale: Confessions of the Bolton Forger* (London: Allen and Unwin, 2017), especially chapter 9.

254. Greenhalgh, *A Forger's Tale*, 351–58.

255. Nigel Bunyan, "Downfall of the Council House Art Fakers," *Telegraph*, November 17, 2007.

256. Cahal Milmo, "Family of Forgers Fooled Art World with Array of Finely Crafted Fakes," *Independent*, November 17, 2007.

257. Paul Harper, "World's Most Infamous Art Forger Legally Sells Fake Lowry-Style Paintings at Auction for Triple the Expected Value," *Sun*, February 21, 2017.

258. Andrew M. Goldstein, "Art Forger Mark Landis on How He Became an Unlikely Folk Hero," *Artspace*, December 27, 2014.

259. Jason Caffrey, "America's Most Generous Con Artist," *BBC World Service*, March 31, 2015.

260. *Art and Craft*, www.artandcraftfilm.com.

261. www.marklandisoriginal.com.

262. Edgar Mrugalla, *König der Kunstfälscher: Meine Erinnerungen* (Berlin: Ullstein, 1993).

263. Anne Hansen, ". . . Edgar Mrugalla?" *Stern*, December 21, 2008.

264. "El 'Rey de los Falsificadores' expone sus falsos cuadros," *Perfil*, October 15, 2007.

265. Ben Hills, "A Brush with Fame," *Sydney Morning Herald*, July 18, 1998.

266. Hills, "A Brush with Fame."

267. "Art Fraudster William 'Billy' Mumford Jailed for Two Years," *Huffington Post*, April 5, 2012.

268. Richard Burgess, "Guilty Plea in Art Forgeries," *Acadiana Advocate*, June 14, 2011.

269. "Art Dealer Sentenced for Counterfeit Art Sales: Counterfeit Clementine Hunter Paintings," US Department of Justice, US Attorney's Office, Western District of Louisiana, January 3, 2012. See also Ruth Laney, "Clementine Hunter Fakes: Scandal in the Art World: The FBI Investigates a Baton Rouge Couple for Selling Fake Clementine Hunter Paintings," *Country Road*, December 2009.

270. Hoving, *False Impressions*, 248.

271. Walter Goodman, "How Fake Art Is Created and Discovered and Why," *New York Times*, December 17, 1991.

272. Antonia Schaefer, "Der scurrile Fälscherskandal aus Niederbayern," *Welt*, November 18, 2014.

273. "Christian Goller," *International Art Market Studies Association*, July 2017, www.artstudies.org/tag/christian-goller.

274. "Le Case d'asta, La Fondazione e i falsi Peretti," *Archivio dell'arte metafisica*, www.archivioartemetafisica.org/le-case-dasta-la-fondazione-e-i-falsi-peretti.

275. "Authentic De Chirico Painting Signaled as a Fake by L'Archivio dell'Arte Metafisica: The Construction of a Fake 'Truth,'" fondazionedechirico.org/wp-content/uploads/2019/06/authentic-de-chirico-painting-signalled-as-a-fake-by-l'archivio-dell'arte-metafisica.pdf; Cristina Ruiz; "Challenge to De Chirico Authentication Board: The Artist's Own Backdated Paintings Add to His Market's Complexities," *Art Newspaper*, September 3, 2013.

276. Laurie Hurwitz, "Paris Art Expert Sentenced in Drawing Forgery Case," *ARTnews*, January 26, 2010.

277. "Christian Parisot Arrested: Modigliani Institute President Involved in Forgery Investigation," *Huffington Post*, January 14, 2013.

278. Milton Esterow, "The Art Market's Modigliani Forgery Epidemic," *Vanity Fair*, May 2017.

279. See Marc Spiegler, "Modigliani: The Experts Battle," *ARTnews*, January 2004.

280. H. de Roos, "What Is an Original Rodin? The Guy Hain Case: Fraud and Forgery," www.rodin-web.org/report_rom/1_11.htm.

281. Brendan Kemmet and Stéphanie Sellami, "Le Copieur de Rodin," *Le Parisien*, June 12, 2015.

282. Thane Peterson, "Mystery of the Giacometti Fakes," *ARTnews*, December 2010.

283. Michael Sontheimer, "'The Art World Is Rotten': Giacometti Forger Tells All," *Spiegel Online*, April 10, 2013.

284. Information provided by Robert Driessen in an email correspondence with the author, August 11, 2019.

285. "Eric Piedoie: The Art of Living of a Forger," *Archyde*, November 17, 2019.

286. "Eric Piedoie."

287. Eric Piedoie, *Confessions d'un faussaire: La Face cachée du marché de l'art* (Paris: Max Milo, 2019).

288. Jesse Lerner, "Brigido Lara: Post-Pre-Columbian Ceramicist," *Cabinet*, Spring 2001; Jonathan Kandell, "Protecting the Pre-Columbian," *Art and Antiques*, May 2014; Kirstin Fawcett, "Brigido Lara, the Artist Whose Pre-Columbian Fakes Fooled Museums Around the World," *Mental Floss*, September 18, 2017.

289. Catterall, *The Great Dalí Art Fraud*, 343–44.

290. Charles Storch, "Foiled by Fakes," *Chicago Tribune*, November 1, 1993.

291. Becky Schlikerman, "Fraudulent Art Dealer Sentenced in Chicago," *Chicago Tribune*, June 8, 2011.

292. United States v. Amiel, Jr., Plea Agreement, No. 08 CR 009-2 (N.D. Ill. October 6, 2010).

293. "What Is Giclée?," https://ryepress.com/what-is-giclee.

294. J. Michael Kennedy, "Not a Pretty Picture," *Los Angeles Times*, January 18, 2007.

295. "Third Defendant in $20 Million Scam That Sold Fake Art Nationwide via TV Auctions Sentenced to Federal Prison," US Attorney's Office, Central District of California, October 26, 2010.

296. Alan Abrams, "Catch Me If You Can," *Forbes*, September 20, 2004, https://www.forbes.com/forbes/2004/0920/302/?sh=7d839ab89741. See also "Earl Washington Woodcuts," www.gatewaygalleries.com/dynapage/PP0301.htm.

297. For an overview of eBay art fraud, see Lizzie Crocker, "Why eBay Is an Art Forger's Paradise," *Daily Beast*, August 19, 2014. See also Amore, *The Art of the Con*, chapter 11, and "How Forgers Sell Fake Art on eBay and Make Big Money," *ArtBusiness.com*, www.artbusiness.com/faketutorial.html.

298. United States v. John Re, case summary, International Foundation for Art Research, http://ifar.org/case_summary.php.docid=1433279608.

299. Lisa Duffy-Zeballos and Sharon Flescher, "Long Island Con Man John Re Sentenced to 5 Years for Fraud That IFAR Helped Expose," *IFAR Journal* 16, no. 1–2 (2015).

300. John Schwartz and Judith M. Dobrzynsky, "3 Men Are Charged With Fraud in 1,100 Art Auctions on eBay," *New York Times*, March 9, 2001.

301. Kenneth Walton, *Fake: Forgery, Lies, and eBay* (New York: Simon Spotlight Entertainment, 2006), 44, 239.

302. Walton, *Fake*, 291.

303. See Amore, *The Art of the Con*, 147.

304. "The Copycat Millions," *Mastermind*, television show, season 4, episode 7, aired November 14, 2006.

305. United States v. Sakhai, No. 04-cr-583, S.D.N.Y. July 6, 2005 (plea agreement).

306. "The Copycat Millions"; Jane A. Levine, "Case Study of Federal Criminal Investigation and Prosecution Involving Art Forgery," paper presented to American Bar Association panel "Fakes and Forgeries: Problems for the International Trade in Art Works," April 6, 2006, 5.

307. R. v. Ivan Liberto and Pamela Yvonne Liberto (2008) VCC 1372; "Libertos in Court over Forged Rover Thomas Paintings," *Herald Sun*, November 9, 2007.

308. Steve Crawshaw, "Forger Is a Genuine Success," *Independent*, October 23, 2011.

309. Maxine Bernstein, "75-Year-Old Portland Art Forger Sentenced to Federal Prison," *Oregonian*, February 16, 2016; Steven Dubois, "Art Forger, 75, Gets Federal Prison Sentence," *Bulletin* (Central Oregon), February 16, 2016.

310. "Artist Jailed in Moscow for Art Forgery," *Two Circles.Net*, March 28, 2013. "Art Forgery Is a Family Affair in Russia," *Worldcrunch*, March 13, 2013.

311. "Padělatel Zrzavého se odvolával na malířova ducha," *TÝDEN.cz*, October 23, 2007; "Czech Art Forger Draws Prison Sentence," *UPI*, October 7, 2009.

312. Katherine Keener, "Finnish Forgeries: The Couple behind a €13 Million Art Scam," *Marketplace*, November 10, 2018; "Finnish Couple Jailed over 13M Euro Art Forgery Scam," *Dunya News*, October 31, 2018.

313. "'Pathetic' Swiss Art Forgers Sentenced to Prison for Giacometti-Switching Parakeet Scam," *Blouinartinfo*, July 7, 2011.

314. Vernon Rapley, "The Police Investigation of Art Fraud," in *Art Crime: Terrorists, Tomb Raiders, Forgers and Thieves*, ed. Noah Charney (London: Palgrave Macmillan, 2016), 35.

315. For a list of these police units, see "Specialized Police Forces," UNESCO, www.unesco.org/new/en/culture/themes/illicit-trafficking-of-cultural-property/partnerships/specialized-police-forces.

316. www.fbi.gov/investigate/violent-crime/art-theft.

317. Sandra Laville, "Met's Art Theft Squad Has to Go Cap in Hand," *The Guardian*, April 20, 2007.

318. Lisa Duffy-Zeballos and Sharon Flescher, "The Mysterious James Brennerman; Did He Exist and Where Did All His Fakes Come From?" *IFAR Journal* 17, no. 4 (2017): 13. See also Duffy-Zeballos and Flescher, "Long Island Con Man."

319. Rex Sorgate, "The End of Authentication," *Message*, July 17, 2014, https://medium.com/message/the-end-of-authentication-cbbfbcb0c49e; see also Danielle Rahm, "Warhols, Pollocks, Fakes: Why Art Authenticators Are Running for the Hills," *Forbes*, June 18, 2013; Georgina Adam, "The High-Stakes Game of Art Authentication," *BBC*, October 21, 2014.

320. Daniel Grant, "New Legislation Would Protect Art Authentication Against 'Nuisance' Lawsuits," *Observer*, June 4, 2014.

321. For a comparative explanation of the collections and their methods of display, see Felicity Kate Strong, "(Re)Framing the F Word: The Case for the Collection and Exhibition of Art Forgery in Australia" (PhD diss., University of Melbourne, 2016), 141–56, minerva-access.unimelb.edu.au/handle/11343/151617.

322. Schüller, *Forgers, Dealers, and Experts*, 33; M. M. van Dantzig, *True or False: An Exhibition Organized and Circulated in Europe by the Stedelijk Museum in Amsterdam, Holland, Circulated in the United States of America by the Corning Museum of Glass, Corning Glass Center, 1953–1954 Season* (Corning, NY: Corning Glass Center, 1953).

323. Guy Isnard, *Le Musée des faux artistiques* (Paris: Salmon Artistique de la Police, 1954).

324. J. Kirk Varnedoe, *Rodin Drawings, True and False* (Washington, DC: National Gallery of Art, 1971).

325. Jones, *Fake? The Art of Deception.*

326. Martin Bailey, "Revealed: One Third of Brooklyn Museum's Coptic Collection Is Fake," *The Art Newspaper*, May 15, 2015; Alexander V. Kruglov, "Late Antique Sculpture in Egypt: Originals and Forgeries," *American Journal of Archaeology* 114, no. 2 (2010).

327. Steven Litt, "'Fakes, Forgeries and Mysteries' Show at Detroit Institute of Arts Takes Viewers on Hunt for Authenticity," *Plain Dealer*, March 28, 2011.

328. Catherine Schofield Sezgin, "The Detroit Institute of Art's Exhibit, 'Fakes, Forgeries, and Mysteries,' Posts Videos on YouTube to Augment Its Painting and Sculpture Exhibit," *Association for Research into Crimes Against Art*, February 6, 2011, art-crime.blogspot.com/2011/02/dias-fakes-forgeries-and-mysteries.html.

329. "Close Examination: Fakes, Mistakes, and Discoveries," https://www.nationalgallery.org.uk/exhibitions/past/close-examination-fakes-mistakes-and-discoveries.

330. Randall Chase, "Winterthur Exhibit Offers Insight into Detecting Art Fraud," *AP News*, April 1, 2017.

331. Donald Myers, *Elmyr de Hory: Artist and Faker*, exh. cat. (Saint Peter, MN: Hillstrom Museum of Art, 2010), https://gustavus.edu/finearts/hillstrom/concertFiles/media/2010_Elmyr_de_Hory_Artist_and_Faker.pdf.

332. Caffrey, "America's Most Generous Con Artist."

333. See, for instance, Graham Young, "Art Faker John Myatt to Open His Biggest Exhibition in Birmingham," *Birmingham Live*, September 28, 2012.

334. Andrew Dodds, "Fakes and Forgeries: Victoria and Albert Museum, UK," *Frieze*, May 1, 2010, http://frieze.com/article/fakes-and-forgeries.

335. *Intent to Deceive: Fakes and Forgeries in the Art World*, exh. brochure (Washington, DC: International Arts and Artists, 2013).

336. Henry Samuel, "Paris Museum's Fakes Exhibition Condemned for 'Vampire' Plagiarism," *Telegraph*, April 24, 2010.

337. Peter Simpson, "*F is for Fake* at SAW Gallery," *Ottawa Citizen*, June 2, 2014.

338. Henrik Dannemand, "AEgte forfalsninger på museum," *Berlingske*, July 27, 2007, https://www.berlingske.dk/kultur/aegte-forfalskninger-paa-museum.

339. Sarah Cascone, "When Is a Rembrandt Not a Rembrandt?" *Art in America*, August 7, 2013.

340. "Why Is This Argentinian Pop-Up Art Exhibition of Latin American Masterpieces Full of Fakes?" *Lonely Planet*, May 12, 2016.

341. Laura Chesters, "Sotheby's Buys Research Firm Orion Analytical in Fight against Fakes," *Antiques Trade Gazette*, December 5, 2006.

342. For a brief but informative summary of scientific techniques used in discovering art forgeries, see Robyn Sloggett, "Art Crime: Fraud and Forensics," *Australasian Journal of Forensic Sciences* 47, no. 3 (2015). For a detailed explanation of techniques in the forensic analysis of paintings, see Jehane Ragai, *The Scientist and the Forger: Insights into the Scientific Detection of Forgery in Paintings* (London: Imperial College Press, 2015).

343. Savage, *Fakes, Forgeries, and Reproductions*, 235, 270.

344. Nicholas Eastaugh, "Authenticity and the Scientific Method," *InCoRM Journal* 1, no. 1 (2009).

345. For an explanation of the pigments Van Meegeren used, see Kilbracken, *Van Meegeren: Master Forger*, 24–27.

346. Hubertus von Sonnenburg, "A Case of Recurring Deception," *Metropolitan Museum of Art Bulletin* 11, no. 3 (Winter 1993/1994).

347. Patricia Cohen, "Suitable for Suing," *New York Times*, February 22, 2012; "Lagrange v. Knoedler—SETTLED," Center for Art Law, November 2, 2012.

348. Philippe Collon and Michael Wiescher, "Accelerated Ion Beams for Art Forensics," *Physics Today* 65, no. 1 (2012): 58; Stefan Rohrs, Andreas Schwabe, Stefan Simon, Karl-Uwe Heussner, and Kurt Osterloh, "Dendrochronological Investigations of Stretcher Frames from Canvas Paintings—Linking Wooden Frames of a Larger Fraud Case to a Common Origin," Authentication in Art conference, The Hague, Netherlands, May 7–9, 2014.

349. Keating, *The Fake's Progress*, 224–25.

350. "Mattis Claim Against Rosenblum for Lewis Hine Photographs," Case Summary, International Foundation for Art Research, www.ifar.org/case_summary.php?docid=1184603465; Ralph Blumenthal, "Shadows Cast by Forgery: The FBI Investigates Complaints About Lewis Hine Prints," *New York Times*, August 16, 2001.

351. Sox, *Unmasking the Forger*, 89.

352. Fiechter, *Egyptian Fakes*, 141–48.

353. For an explanation of the varieties of X-ray technology, microscopy, and mass spectrometry, see Ragai, *The Scientist and the Forger*.

354. Jai Li, Lei Yao, Ella Hendriks, and James Z. Wang, "Rhythmic Brushstrokes Distinguish Van Gogh from His Contemporaries: Findings via Automated Brushstroke Extraction," *IEE Transactions on Pattern Analysis and Machine Intelligence* 34, no. 6 (June 2012); Michelle Sipics, "The Van Gogh Project: Art Meets Mathematics in Ongoing International Study," *SIAM News* 42, no. 4 (May 2009); Lei Yao, Jai Li, and James Z. Wang, "Characterizing Elegance of Curves Computationally For Distinguishing Morriseau Paintings and Their Imitations," IEEE International Conference on Image Processing, 2009; James M. Hughes, Daniel J. Graham, and Daniel N. Rockmore, "Quantification of Artistic Style Through Sparse Coding Analysis in the Drawings of Peter Brueghel the Elder," *Proceedings of the National Academy of Science* 107, no. 4 (January 2010).

355. Richard P. Taylor, Adam P. Micolich, and David Jonas, "Fractal Analysis of Pollock's Drip Paintings," *Nature*, June 3, 1999; Randy Kennedy, "The Case of Pollock's Fractals Focuses on Physics," *New York Times*, December 2, 2006; "Researchers End Debate Over Fractal Analysis of Pollock's Art," *Science Daily*, November 26, 2007.

356. Information on the cost of scientific testing of artworks was provided by Jennifer Mass of Scientific Analysis of Fine Art, Berwyn, Pennsylvania; Duane Chartier of the International Center for Art Intelligence, Culver City, California; and Douglas Komen of Great Masters Art, Science, and Engineering, Rancho Santa Fe, California.

357. Michael Kimmelman, "ART: Absolutely Real? Absolutely Fake?," *New York Times*, August 4, 1991.

358. See Vassilis Lambrinoudakis, "Some Observations on the Authenticity of the Getty Kouros," in *The Getty Kouros Colloquium* (Los Angeles: J. Paul Getty Museum, 1993), 31–33; and Giorgios Dontas, "The Getty Kouros: A Look at Its Artistic Defects and Incongruities," in *The Getty Kouros Colloquium*, 37–38.

359. www.getty.edu/art/gettyguide/artObjectDetails?artobj=12908; Christopher Knight, "Review: Something's Missing from the Newly Reinstalled Antiquities Collection at the Getty Villa," *Los Angeles Times*, April 19, 2018.

360. Avrova Fine Arts Investment Limited v. Christie, Manson and Woods Ltd. (2012) EWHC 2198 (Ch). See also Konstantin Akinsha, "Judge Decided It Was a Fake, but Some Scholars Say that a Russian Painting Sold at Christie's Is Genuine," *Artnet News*, February 5, 2013.

361. Eastaugh, "Authenticity and the Scientific Method."

362. See "Applications of TL Dating," www3.nd.edu/~nsl/Lectures/phys178/pdf/chap3_11.pdf; David Cycleback, "Thermoluminescence Testing in Ancient Artifacts Authentication and Fake Detection," https://davidcycleback.com/2017/08/05/thermoluminescence-testing-in-ancient-artifacts-authentication-and-fake-detection.

363. Steve Schlackman, "Using Synthetic DNA to Fight Art Forgery," *Art Law Journal* (November 16, 2015); Tom Mashberg, "Art Forgers Beware: DNA Could Thwart Fakes," *New York Times*, October 12, 2015.

364. Milko den Leeuw interview with David Yermack, Authentication in Art, *AIA Newsletter*, February 2017, authenticationinart.org/pdf/newsletter/aia-newsletter-february.pdf; "Blockchain to Frame Art Forgers: Adapting Blockchain to Authenticate Valuable Artworks," *Cosmos*, February 25, 2019.

PART II

1. *Collins English Dictionary*, 12th ed. (2014), s.v.

2. *American Heritage Dictionary of the English Language*, 5th ed., "Forgery."

3. 18 U.S.C. 2320; 18 U.S.C. 2319; 17 U.S.C. 506. See also www.legalmatch .com/law-library/article/forgery-laws.htm.

4. FBI New York Press Office, "Long Island Art Dealer Indicted in Massive Art Fraud, Money Laundering, and Tax Scheme: Glafira Rosales Charged with Knowingly Selling Fake Artworks Purportedly by Renowned Artists in $30 Million Scheme," July 17, 2013, http://www.justice.gov/usao-sdny/pr/long-island-art-dealer-indicted -massive-art-fraud-money-laundering-and-tax-scheme.

5. "United States of America v. José Carlos Bergantiños-Diaz, Jesus Angel Bergantiños Diaz, and Pei-Shen Qian," US District Court, Southern District of New York, No. 14 Cr. 217 at 38 (S.D.N.Y. March 31, 2014).

6. US Attorney's Office, Southern District of New York, "Three Defendants Charged in Manhattan Federal Court in Connection with $33 Million Art Fraud Scheme," April 21, 2014, www.justice/gov/usao-sdny/pr/three-defendants-charged -manhattan-federal-court-connection-33-million-art-fraud-scheme.

7. United States of America, Plaintiff-Appelle, v. James Kennedy, Defendant-Appellant, US Court of Appeals, Seventh Circuit No. 12-2630 (August 9, 2013).

8. Paul Dean, "An Artist of Talent and, Some Say, Genius, Tony Tetro Is Charged With Forging the Works of Chagall, Miró, Dalí. But He Claims Only to Be: The Repro Man," *Los Angeles Times*, January 20, 1991.

9. G. Luther Whitington, "Detectives Find Most Prolific Art Forger," *UPI*, August 10, 1986.

10. Weisz v. Parke-Bernet Galleries, 67 Misc. 2nd 1077 N.Y. Civ. Ct. 1971.

11. Noah Charney, *The Art of Forgery: The Minds, Motives, and Methods of Master Forgers* (London: Phaidon, 2015), 17.

12. Theodore Tedesco, *Index of Literature in the English Language That Describes Postal Stamp Forgeries, Fakes, Reprints, Fraudulent Postal Markings and Other Obliterations* (Bellefonte, PA: American Philatelic Research Laboratory, 2014).

13. "Fakes, Forgeries and Reproductions," The Pewter Society, http://www .pewtersociety.org/identifying-and-collecting-pewter/collecting/fakes-forgeries-and -reproductions.

14. Brian Innes, *Fakes and Forgeries: The True Crime Stories of History's Greatest Deceptions: The Criminals, the Scams, and the Victims* (Pleasantville, NY: Reader's Digest, 2005), 1.

15. Anthony Amore, *The Art of the Con*, 13.

16. Stuart Kelly, "Forged: Why Fakes Are the Great Art of Our Age by Jonathan Keats—Review," *Guardian*, June 28, 2013.

17. Spurlock Museum, University of Illinois, www.spurlock.illinois.edu/explora tions/research/collecting/fdf. Although this site is no longer viable, the text was written for a project with students in local schools titled "Careful Collecting: Fakes and Forgeries."

18. David Scott, *Art: Authenticity, Restoration, Forgery* (Los Angeles: Cotsen Institute of Archaeology Press at UCLA, 2016), 88.

19. David Cycleback, "The Difference Between a Fake and a Forgery," https://davidcycleback.com/2013/01/30/the-difference-between-a-fake-and-a-forgery.

20. Kurz, *Fakes*; Nelson Goodman, *Languages of Art: An Approach to a Theory of Symbols* (Indianapolis: Hackett, 1976); Lenain, *Art Forgery*; Keats, *Forged*; Sándor Radnóti, *The Fake: Forgery and Its Place in Art* (Lanham, MD: Rowman & Littlefield, 1999).

21. Dean, "An Artist of Talent."

22. Dean, "An Artist of Talent." See also Alan Citron, "'Smoking Gun' Tape Unveiled in Art Fraud Case," *Los Angeles Times*, March 16, 1990.

23. Catterall, *The Great Dalí Art Fraud*, 136.

24. Citron, "'Smoking Gun' Tape."

25. Scott Hays, "The Greatest Living American Art Forger," *Orange Coast*, 2000.

26. Hebborn, *Drawn to Trouble*, 335–36.

27. Perenyi, *Caveat Emptor*, 256–57.

28. Ibid., 303.

29. For instance, for a statement of Bastianini's being misunderstood as a forger, see Kathryn C. Johnson, *Fakes and Forgeries*, exh. cat. (Minneapolis: Minneapolis Institute of Arts, 1973). A contrary view that labels Bastianini as a forger is found in John Pope-Hennessy, "The Forging of Italian Renaissance Sculpture," *Apollo* 115 (1974). For a detailed explanation of changing trends in assessing Bastianini's work as forgery, see Anita Fiderer Moskowitz, *Forging Authenticity: Bastianini and the Neo-Renaissance in Nineteenth-Century Florence* (Florence: Olschki, 2013), chapter 4.

30. Anita Moskowitz, "Masterpiece or Master Fraud? The Sculpture of Giovanni Bastianini," *Florentine*, September 12, 2013, https://www.theflorentine.net/2013/09/12/masterpiece-or-master-fraud.

31. Moskowitz, "Masterpiece or Master Fraud?"

32. Anita Moskowitz, "The Case of Giovanni Bastianini–II: A Hung Jury?" *Artibus et Historiae* 27, no. 54 (2006): 201–4.

33. Denis Dutton, "Art Hoaxes," *Encyclopedia of Hoaxes*, ed. Gordon Stein (Detroit: Gale Research, 1993), 21, archive.org/details/encyclopediaofho0000stei/ppge/20/mode/2up.

34. Radnóti, *The Fake*, 116.

35. Michael Wreen, "Forgery," *Canadian Journal of Philosophy* 32, no. 2 (2002): 152.

36. The roots of anti-intentionalism trace to New Criticism in literary criticism, along with reader-response theory, structuralism, semiotics, and hermeneutics. Key figures include Richard Rorty, Stanley Fish, Roland Barthes, Michel Foucault, and Jacques Derrida.

37. Rosalind Krauss, "Sense and Sensibility: Reflections on Post 60's Sculpture," *Artforum* 12, no. 3 (November 1973).

38. Krauss, "Sense and Sensibility."

39. Roland Barthes, "The Death of the Author," *Aspen* 5–6 (1967).

40. Michel Foucault, "What Is an Author?" in *Language, Counter-Memory, Practice: Selected Essays and Interviews with Michel Foucault*, ed. Donald F. Bouchard (Ithaca, NY: Cornell University Press, 1977), 138.

41. For a detailed explanation of various perspectives on intentionalism and anti-intentionalism, see Paisley Livingston, *Art and Intention: A Philosophical Study* (New York: Oxford, 2005).

42. Livingston, *Art and Intention.*

43. Hebborn, *Drawn to Trouble*, 119–22.

44. Monaghan v. Commissioner, 1981 T.C. Memo. 280, 42 T.C.M 27.

45. Ferrari v. Commissioner, 931 F. 2nd 54 (4th Cir. 1991).

46. De Balkany v. Christie Manson and Woods, Ltd. (1997) Q.B. 16 Tr. L. 163 (Eng.).

47. Conti, *History of the Restoration and Conservation of Works of Art*, 263.

48. Mark Sagoff, "On Restoring and Reproducing Art," *Journal of Philosophy* 75, no. 9 (1978): especially 459.

49. Martin Heidegger, "The Origin of the Work of Art," in *Martin Heidegger: Basic Writings*, ed. David Farrell Krell (New York: Harper & Row, 1977). For a good explanation of Heidegger's view vis-à-vis that of Mark Sagoff, see Ami Harbin, "Authentic Art and Creative Preservation," *Le Panoptique* (June 1, 2008).

50. Rafael De Clercq, "The Metaphysics of Art Restoration," *British Journal of Aesthetics* 53, no. 3 (2013): 14.

51. Sagoff, "On Restoring and Reproducing Art," 457.

52. Sidney Alexander, "The Restoration of Michelangelo's *Pietà*," *American Artist* 37 (July 1973): 56.

53. Mac Carey, "Fifteen Blows with a Sledgehammer: The Restoration of the Pieta," http://www.stpetersbasilica.info/Docs/Pieta%20Restoration.htm.

54. John Russell, "Healing a Disfigured Rembrandt's Wounds," *New York Times*, August 31, 1997.

55. For a brief but informative summary of the collaboration between Rubens and Brueghel, see Alan Riding, "Partners? You Paint the Figures, and I'll Do the Rest," *New York Times*, December 23, 2006. For more detail, see Anne T. Woollett, Ariane von Suchtelen, and Tiarna Doherty, *Rubens and Brueghel: A Working Friendship* (Los Angeles: Getty Research Institute, 2006).

56. A good summary of Rubens's studio practices is John A. Parks, "Masters: Rubens' Drawings: The Marks of a Prolific Master," *Artistsnetwork*, https://www.art istsnetwork.com/art-history/masters-rubens-drawings-the-marks-of-a-prolific-master.

57. Mendax, *Art Fakes and Forgeries*, 152–53.

58. "Auguste Rodin: Production Techniques," Victoria and Albert Museum, https://www.vam.ac.uk/articles/rodin-production-techniques.

59. www.gilbertandgeorge.co.uk; www.komarandmelamid.org; www.oldenburg vanbruggen.com; www.dmstarn.com; www.zhoubrothers.com; www.boylefamily.co .uk.

60. www.theartguys.com.

61. Bob Colacello, *Holy Terror: Andy Warhol Close Up* (New York: Cooper Square Press, 1990), 478.

62. Richard Dorment, "What Is an Andy Warhol?" *New York Review of Books*, October 22, 2009.

63. John Powers, "I Was Jeff Koons's Studio Serf," *New York Times Magazine*, August 17, 2012.

64. David Cohen, "Inside Damien Hirst's Factory," *Evening Standard*, August 30, 2007.

65. Andrew Johnson, "A Damien Hirst Original," *Independent*, September 14, 2008.

66. Elizabeth Burns Coleman, "Aboriginal Painting: Identity and Authenticity," *Journal of Aesthetics and Art Criticism* 59, no. 4 (Autumn 2001): 388.

67. Cohen, "Inside Damien Hirst's Factory."

68. Dorment, "What Is an Andy Warhol?"

69. For this point as well as a detailed discussion of French and British copyright law as they apply to art, see Stina Teilmann-Lock, *British and French Copyright: A Historical Study of Aesthetic Implications* (Copenhagen: Djoef, 2009).

70. US Code, Title 17, Chapter 2: 201, "Ownership of Property." For a detailed explanation of the "work made for hire" doctrine, including arguments against it, see James J. Mastroianni, "The Work-Made-For-Hire Exception to the Visual Artists Rights Act of 1990 (VARA): Carter v. Helmsley-Spear, Inc.," *Sports and Entertainment Law Journal* 4, no. 2 (1997): 417–53.

71. Committee for Non-Violence v. Reid, 490 U.S. 730 (1989).

72. For Chihuly v. Kaindl, as well as Kaindl's and Rubino's responses, see www .robertkaindl.com/ChihulyArtGlassLawsuit.htm.

73. Kyle-Beth Hilfer, "Lawsuit Could Clarify What Is Original in the Art World," *Intellectual Property Strategist*, *Law Journal Newsletters* (2006), www.lawjournalnewsletters.com/sites/lawjournalnewsletters/2006/09/29/lawsuit-could-clarify-what-is-original-in-the-art-world.

74. Regina Hackett, "Chihuly Settles Copyright Lawsuit," *seattlepi*, August 3, 2006, www.seattlepi.com/ae/article/Chihuly-settles-copyright-lawsuit-1210845.php.

75. Moi v. Chihuly 17-2-14150 Superior Court of Washington, King County, June 17, 2017.

76. Regarding Chihuly's condition as well as his working methods, see Kirk Johnson, "'Chihuly Art': A Legacy Under Siege," *New York Times*, August 22, 2017.

77. Moi v. Chihuly Studio, Inc., http://www.leagle.com/decision/infdco 20190621e55.

78. Sol LeWitt, "Paragraphs on Conceptual Art," *Artforum* (Summer 1967).

79. LeWitt, "Paragraphs on Conceptual Art."

80. Alva Noë, "How to Love a Fake," *National Public Radio*, November 15, 2013.

81. Noë, "How to Love a Fake."

82. Charles Thompson, "Stuck Inn XI: The Art Damien Hirst Stole," *3:AM Magazine*, September 14, 2010.

83. Livingston, *Art and Intention*, 75–89.

84. Livingston, *Art and Intention*, 84.

85. Livingston, *Art and Intention*, 86.

86. Livingston, *Art and Intention*, 83.

87. Salisbury and Sujo, *Provenance*, 11.

88. Roy A. Perry, "Present and Future: Caring for Contemporary Art at the Tate Gallery," in Miguel Corzo, ed. *Mortality Immortality: The Legacy of 20th-Century Art* (Los Angeles: Getty Conservation Institute, 1999), 44.

89. See, for instance, Jean Lipman and Richard Marshall, *Art About Art* (New York: Whitney Museum of American Art, 1978), 6–7.

90. Hilton Kramer, "An American in Paris at 62: Robert Motherwell Is at the Height of His Fame," *New York Times*, June 19, 1977.

91. R. G. Collingwood, *The Principles of Art* (London: Oxford University Press, 1938), 319.

92. Collingwood, *The Principles of Art*, 320.

93. David Walker, "The Art of the Steal: Warhol Didn't Get Away With It; Why Should Richard Prince?" *PDNPulse*, May 10, 2012.

94. "Andy Warhol and the Art of Appropriation," *Revolver Gallery*, www.revolver warholgallery.com/andy-warhol-art-appropriation.

95. Morton Beebe, "Beebe v. Rauschenberg and Artists' Rights: The Story of Morton Beebe's Landmark Lawsuit Against Robert Rauschenberg Concerning Artists' Rights," www.mortonbeebe.com/beebe-v-rauschenberg-and-artists-rights; Greg Allen, "Beebe v. Rauschenberg, The First Big Appropriation Lawsuit," greg.org/archive/2012/06/27/beebe-v-rauschenberg-the-first-big-appropriation-lawsuit.html.

96. Mark Memmott, "Shepard Fairey and AP Settle Copyright Dispute Over 'Hope' Poster," *NPR*, January 12, 2011; Frank James, "Obama 'Hope' Poster Not Credible: AP," *NPR*, October 20, 2009.

97. US Constitution, Article 1, Section 8, Clause 8.

98. United States Senate Committee on the Judiciary, "Copyright Law Revision" (Washington, DC: US Government Printing Office, 1960).

99. At least half a dozen countries have followed the United States in adopting the standard of "fair use" (Bangladesh, Israel, Korea, the Philippines, Taiwan, Uganda), whereas at least thirty-five others are modeled after the "fair dealing" standard of the United Kingdom. However, there is often a blend, with "fair dealing" countries incorporating aspects of the "fair use" approach. See Jonathan Band and Jonathan Gerafi, *The Fair Use/Fair Dealing Handbook*, infojustice.org/wp-content/uploads/2015/03/fair-use -handbook-march-2015.pdf.

100. 17 US Code 107.

101. Rogers v. Koons 960 F. 2d 301 (2nd Cir. 1992).

102. United Feature Syndicate, Inc. v. Koons 817 F. Supp. 370 (S.D.N.Y. 1993).

103. Campbell v. Acuff-Rose Music 510 U.S. 569 (1994).

104. Blanch v. Koons 467 F. 3d 244 (2nd Cir. 2006).

105. Cariou v. Prince 714 F. 3d 694 (2nd Cir. 2013).

106. Ben Depoorter and Robert Kirk Walker, "Unavoidable Aesthetic Judgments in Copyright Law: A Community of Practice Standard," *Northwestern University Law Review* 343 (2015).

107. Bleistein v. Donaldson Lithography Co. 1888 U.S. 239 (1903).

108. Depoorter and Walker, "Unavoidable Aesthetic Judgments."

109. Kienitz v. Sconnie Nation 766 F. 3d 756 (7th Cir. 2014).

110. Graham v. Prince No. 15-CV-10160 (S.D.N.Y. July 18, 2017).

111. For a discussion of natural right vis-à-vis copyright law and art, see Darren Hudson Hick, "Finding a Foundation: Copyright and the Creative Act," *Texas Intellectual Property Law Journal* 17, no. 3 (Spring 2009).

112. See Teilmann-Lock, *British and French Copyright*, 45–54.

113. Catherine Muyl, "French Court Finds Jeff Koons Appropriated Copyrighted Photograph That 'Saved Him Creative Work,'" May 2, 2017, www.jdsupra.com/legalnews/french-court-finds-jeff-koons-75017.

114. Consorts Bauret c/ J. Koons No. 15/01086 (Paris District Court 2017); Azmina Jasani, "Appropriation Art Takes Another Hit in European Courts," Art@Law, https://www.artatlaw.com/appropriation-art-takes-another-hit-european-courts; Kim Wilsher, "Jeff Koons Plagiarized French Photographer for Naked Sculpture," *Guardian*, March 9, 2017.

115. Alex Marshall, "Jeff Koons Is Found Guilty of Copying. Again," *New York Times*, November 8, 2018; "Jeff Koons Is Found Guilty of Plagiarism in Paris and Ordered to Pay $168,000 to Creator of an Ad He Appropriated," *Artnet News*, November 9, 2018.

116. Kate Taylor, "In Twist, Jeff Koons Claims Rights to 'Balloon Dogs,'" *New York Times*, January 19, 2011.

117. Sam Whiting, "Jeff Koons' Balloon-Dog Claim Ends with a Whimper," *SFGate*, February 4, 2011.

118. Guy Adams, "Jeff Koons Bites Back at 'Copies' of Balloon Dog," *Independent*, January 27, 2011.

119. Mike Masnick, "Jeff Koons Drops Silly Lawsuit over Balloon Dog Bookends . . . But Not Before Helping to Sell a Bunch," *Techdirt*, February 4, 2011.

120. Kate Winston Smith, "Hirst to Sue BA Over Adverts," *Independent*, June 28, 1999.

121. "Damien Hirst Threatened to Sue Teenager Over Alleged Copyright Theft," *Daily Mail*, December 12, 2008.

122. "Artists Flout Copyright Law to Attack Damien Hirst," *Telegraph*, February 13, 2009.

123. Cat Weaver, "Is a Cease and Desist About Irony, Hypocrisy or Legal Strategy?," *Hyperallergic*, March 10, 2011.

124. Cariou v. Prince.

125. Andrew Gilden and Timothy Greene, "Fair Use for the Rich and Fabulous?" *University of Chicago Law Review* 80 (2013): 102.

126. Patricia Failing, "Unraveling the Mysteries of Degas's Sculpture," *ARTnews*, May 1, 2011.

127. Besides the article by Failing in note 126, summary histories of the Degas bronzes can be found in Clare Vincent, "Edgar Degas (1834–1917): Bronze Sculpture," *Heilbrun Timeline of Art History*, Metropolitan Museum of Art, www.metmuseum.org/toah/hd-dgsb.htm; and James Adams, "Is She the 'Real' Thing?" *Globe and Mail*, October 4, 2003. A detailed presentation of Degas's sculptures is Suzanne Glover Lindsay, Daphne S. Barbour, and Shelley G. Sturman, *Edgar Degas Sculpture* (Princeton, NJ: Princeton University Press, 2011).

128. "Edgar Degas," askART auction Records, for instance, https://www.askart .com/Artist_Export.aspx?S=1&QID=885553&ALL=3129741;https://www.askart.com/ Artist_Export.aspx?S=1&QID=885484&ALL=3679047.

129. Roger J. Crum, "Degas Bronzes?" *Art Journal* 54, no. 1 (Spring 1995): 96.

130. Crum, "Degas Bronzes?" 95.

131. Among others is longtime critic Gary Arsenau, "Degas Bronze Forgeries: The ABCs of One of the Largest Art Frauds of the 20th/21st Century," http://garyarsenau .blogspot.com/2007/05/all-degas-bronze-sculptures-are-fake.html.

132. Berne Convention for the Protection of Literary and Artistic Works (Paris Text, 1971), https://www.law.cornell.edu/treaties/berne; "Berne Convention," Copyright House, http://copyrightthouse.org/countries-berne-convention.

133. For a summary of the Berne Convention, see "Summary of the Berne Convention for the Protection of Literary and Artistic Works (1886)," World Intellectual Property Organization, www.wipo.int/treaties/en/ip/berne/summary_berne.html; for a summary of the origin of moral rights, and how they apply in the United States, see Stephanie C. Ardito, "Moral Rights for Authors and Artists," *Information Today* 19, no. 1 (January 2000); for French law in regard to Rodin, see "Respecting Rodin's Moral Right: A Warning to Collectors about the Notion of Authenticity," Musée Rodin, https://www.musee-rodin.fr/en/professionnals/respecting-Rodins-moral-right.

134. Gary Tinterow, "A Note on Degas's Bronzes," in Jean Sutherland Boggs, *Degas*, exh. cat. (New York: Metropolitan Museum of Art and National Gallery of Canada, 1988).

135. "Statement on Standards for the Production and Reproduction of Sculpture: Part II: Standards for Sculptural Reproduction and Preventive Measures against Unethical Casting," College Art Association (2013).

136. "Statement on Standards for the Production and Reproduction of Sculpture."

137. William Cohan, "A Controversy over Degas," *Artnet News*, April 1, 2010.

138. Patricia Failing, "Unraveling the Mysteries of Degas's Sculpture."

139. William Cohan, "Brass Foundry Is Closing but Debate over Degas' Work Goes on," *New York Times*, April 4, 2016.

140. See Walter Maibaum, "Edgar Degas: The Sculptures," degassculpturepro ject.org/edgar-degas-the-sculptures-exhibition-catalog-essay.pdf; Maibaum, "Posthumous Bronzes and the Plasters from Which They Were Cast: A Case Study on Determining Authenticity Based on Physical Evidence, www.degassculptureproject. org/Case_Study_--_Plaster_Authentication.pdf; "Questions and Answers: The Sculpture of Edgar Degas," www.degassculptureproject.org/degas-questions-and-answers -april-2019.pdf; Gregory Hedberg, "Degas' *The Little Dancer, Aged Fourteen*: The Unknown Version," bhartex.com/degas_the_little_dancer_unknown_firstversion_Hedberg.pdf; Hedberg, *Degas' Little Dancer Aged Fourteen: The Earlier Version That Helped Spark the Birth of Modern Art* (Stuttgart: Arnoldsche Verlagsanstalt, 2016).

141. See Patricia Failing, "The Degas Debate: Analyzing the Controversial Plasters," *ARTnews*, June 5, 2013; Failing, "Unraveling the Mysteries of Degas's Sculpture"; William D. Cohan, "A Controversy over Degas."

142. "Sculptures," Frederic Remington Art Museum, https://fredericremington .org/sculptures-c32.php.

143. Hakim Bishara, "A Paris Court Sentences Two Art Dealers for Counterfeiting Rodin Sculptures," *Hyperallergic*, April 24, 2019.

144. Article 123-1 of the French Intellectual Property Code says authors hold the rights to their works during their lifetime plus seventy years. Article L.121-1 of the code gives authors perpetual rights to their works, which may be conferred to others in their will. Article 8 of Decree 81-255 (established in 1981) requires that "any facsimile, molding, copy or other reproduction of a work of art or collectible" must be designated as such. Article 2.5 of the 1993 decree stipulates that first editions of Rodin bronzes must come from molds and plasters held by the Musée Rodin and that the editions are limited to twelve in number.

145. "Rodin Thinkers to the ROM: We Think Not, Thank You," *Globe and Mail*, October 20, 2001.

146. Darren Hudson Hick, *Artistic License: The Philosophical Problems of Copyright and Appropriation* (Chicago: University of Chicago, 2017), 41.

147. James Adams, "Is She the 'Real' Thing?" *Globe and Mail*, October 4, 2003.

148. Adams, "Is She the 'Real' Thing?"

149. Anna Rohleder, "Rembrandt's Dirty Secrets," *Forbes*, February 14, 2001.

150. Erik Hinterding, *Rembrandt as an Etcher: The Practice of Production and Distribution* (Ouderkerk aan den IJssel: Sound and Vision, 2006), 1:124–29.

151. For a brief history of the plates, see "The History of Rembrandt's Copper Etching Plates," Masterworks Fine Art Gallery, news.masterworksfineart.com/2019/06/12/the-history-of-rembrandts-copper-etching-plates; see also "The Original Copper Etching Plates of Rembrandt's," Candlewood Yankee Fine Arts, candlewoodyankeefineart.wordpress.com/2013/06/10/the-original-copper-etching-plates-of-rembrandts. For a more detailed study, see Erik Hinterding, "The History of Rembrandt's Copperplates, with a Catalogue of Those That Survive," *Simiolus: Netherlands Quarterly for the History of Art* 22, no. 4 (1993–94).

152. Elizabetta Lazzaro, "Assessing Quality in Cultural Goods: The Hedonic Value of Originality in Rembrandt's Prints," *Journal of Cultural Economics* 30, no. 1 (May 2006).

153. Hinterding, "The History of Rembrandt's Copperplates," 278.

154. Hinterding, "The History of Rembrandt's Copperplates," 280.

155. "Rembrandt," Jan Stevens Galleries, https://jsgalleries.com/product-category/artists/rembrandt. This gallery sells the full set of eight Millennium Rembrandt prints, with prices for each on the gallery website.

156. See for instance, Millennium prints listed by Archived Auctions, archivedauctions.com/s/1144427/022100-rembrandt-millennium-posthumous-etching.

157. John Walsh, "The Scandalous Outing of Eddie Burrup," *Independent*, July 26, 2000.

158. Ben Goldsmith, "A Positive Unsettlement: The Story of Sakshi Anmatyerre," *Griffith Law Review* 9, no. 2 (2001).

159. Hazel Cills, "Art World Denounces Artist Jimmie Durham for Claiming to Be Cherokee," *Jezebel*, June 29, 2017; America Meredith, "Why It Matters That Jimmie Durham Is Not a Cherokee," *Artnet News*, July 7, 2017.

160. Shanifa Nasser, "Toronto Gallery Cancels Show after Concerns Artist 'Bastardizes' Indigenous Art," *Canadian Broadcasting Corporation*, April 28, 2017; Alexander Nazaryan, "White Painter Loses Art Show over Cultural Appropriation Debate," *Newsweek*, May 5, 2017.

161. "White Woman Accused of Appropriating Maori Culture With Her Chin Tattoo. 'It's Not Acceptable,'" *Yahoo Lifestyle*, May 25, 2018.

162. Lorena Muñoz-Alonso, "Dana Schutz's Painting of Emmett Till at Whitney Biennial Sparks Protest," *Tribes*, March 21, 2017, tribes.org/web/2017/3/28/dana-schutzs-painting-of-emmett-till-at-whitney-biennial-sparks-protest.

163. Sheila Regan, "After Protests from Native American Community, Walker Art Center Will Remove Public Sculpture," *Hyperallergic*, May 29, 2017.

164. "'Authentic' Aboriginal Art—ACCC v Australian Dreamtime Creations," Arts Law Centre of Australia, https://www.artslaw.com.au/article/authentic-aboriginal-art-accc-v-australian-dreamtime-creations; Christine Adler, Duncan Chappell, and Kenneth Polk, "Frauds and Fakes in the Aboriginal Art Market," *Crime, Law, and Social Change* 56 (September 2011): 189–207.

165. 18 USC 1159.

166. 18 USC 1159.

167. "Three New Mexicans Charged with Fraudulently Selling Filipino-Made Jewelry as Native American-Made," US Department of Justice, October 29, 2015; Maraya Cornell, "Biggest Fake Native American Art Conspiracy Revealed," *National Geographic*, March 15, 2018; "United States Response to Defendant Nael Ali's Formal Objections to Presentence Report (Doc. 115) and Sentencing Memorandum," Case No. 1:15-cr-3762-JCH, US District Court, New Mexico.

168. Frances Madeson, "Do the Laws on Counterfeit Native Art Go Far Enough?" *High Country News*, July 21, 2017.

169. US Attorney's Office, District of New Mexico, "Owner of Old Town Albuquerque Jewelry Stores Sentenced to Six Months for Fraudulently Selling Filipino-Made Jewelry as Native American-Made," August 28, 2018.

170. US Attorney's Office, District of New Mexico, "Federal Grand Jury Indicts Five in Connection with International Scheme to Fraudulently Import and Sell Filipino-Made Jewelry as Native American-Made," February 2017.

171. Madeson, "Do the Laws on Counterfeit Native Art Go far Enough?"

172. Barbara Huron, "Canada Needs a Law Protecting Indigenous Art from Appropriation," *Ricochet*, May 10, 2017; "Selling Fake Indigenous Art Should Be Illegal, MPs Told," *Guardian*, April 9, 2018; Tom Lodewyke, "Lawyers Call for Legislative Protection for Indigenous Artists," *Lawyers Weekly*, June 23, 2017.

173. Nasser, "Toronto Gallery Cancels Show after Concerns."

174. Regan, "Walker Art Center Will Remove Public Sculpture."

175. *Jimmie Durham: At the Center of the World*, Hammer Museum, January 29–May 7, 2017, https://hammer.ucla.edu/exhibitions/2017/jimmie-durham-at-the-center-of-the-world; the exhibition was shown at the Whitney Museum of American Art, November 3, 2017–January 28, 2018, https://whitney.org/exhibitions/jimmie-durham.

176. Sheila Regan, "Jimmie Durham Retrospective Reignites Debate over His Claim of Native Ancestry," *Hyperallergic*, June 28, 2017.

177. Caitlin Gibson, "A White Artist Responds to the Outcry over Her Controversial Emmett Till Painting," *Washington Post*, March 23, 2017.

178. Bruce Ziff and Pratima V. Rao, *Borrowed Culture: Essays on Cultural Appropriation* (New Brunswick, NJ: Rutgers University Press, 1997), 3.

179. For discussion of property and cultural appropriation, see Rosemary J. Coombe, "The Properties of Culture and the Politics of Possessing Identity: Native Claims in the Cultural Appropriation Controversy," *Canadian Journal of Law and Jurisprudence* 6, no. 2 (July 1993). See also Naomi Mezey, "The Paradoxes of Cultural Property," *Columbia Law Review* 107, no. 8 (December 2007).

180. Mezey, "The Paradoxes of Cultural Property."

181. "Indian Ancestry and How to Enroll or Register in a Federally Recognized Tribe," http://www.native-american-online.org/blood-quantum.htm.

182. "Kinship and Identity," in *Essentially Yours: The Protection of Human Genetic Information in Australia* (ALRC Report 96), https://www.alrc.gov.au/publication/essentially-yours-the-protection-of-human-genetic-information-in-australia-alrc-report-96/36-kinship-and-identity.

183. For a book-length discussion of the evolution of Aboriginal art beginning in the 1970s, see Fred R. Myers, *Painting Culture: The Making of an Aboriginal High Art* (Durham, NC: Duke University Press, 2002).

184. The quote appears on the website of the Museum of Contemporary Art Australia (Sidney), announcing Mawurndjul's exhibition of July 6–September 23, 2018.

185. *Elizabeth Durack: Art and Life Selected Writings*, ed. Perpetua Durack Clancy (Redland Bay, Queensland: Connor Court Publishing, 2016), 246–47.

186. James O. Young, "Authenticity and Appropriation," *Frontiers of Philosophy in China* 1, no. 3 (September 2006): 475.

187. James O. Young, *Cultural Appropriation in the Arts* (Oxford: Wiley Blackwell, 2010), 39–40.

188. bell hooks, *Yearning: Race, Class, Gender and Cultural Politics* (Cambridge, MA: South End Press, 1999), 19.

189. Kwame Anthony Appiah, "The Case for Contamination," *New York Times*, January 1, 2006.

190. These ideas are interwoven in Kwame Anthony Appiah, *The Ethics of Identity* (Princeton, NJ: Princeton University Press, 2005).

191. Edward Said, *Culture and Imperialism* (New York: Vintage Books, 1993), 32.

192. Katrina Chapman, "Positioning Urban Aboriginal Art in the Australian Indigenous Art Market," *Asia Pacific Journal of Art and Cultural Management* 4, no. 1 (February 2006). Chapman notes the original source of the quote as Benjamin Genocchio, "Opinion," *Australian*, March 14, 2001.

193. Cassandra Lehman-Schultz, "How Super Laws are Killing the Market for Indigenous Art," *Conversation*, October 31, 2013.

194. "Selected Statistics," Creative Spirits, https://www.creativespirits.info/aboriginalculture/arts; "Chapter 3—The Benefits of Indigenous Art," Parliament of Australia, Parliamentary Business, www.aph.gov.au/parliamentary_business/committees/senate/environment_and_communications/completed_inquiries/2004-07/indigenousarts/report/c03.

195. "Australian Aboriginal Art," *Telegraph*, February 3, 2009; Simon Thomsen, "An Aboriginal Painting Just Set a New Australian Record for a Female Artist," *Business Insider Australia*, November 17, 2017.

196. For a summary of Urban Aboriginal Art, see Chapman, "Positioning Urban Aboriginal Art."

197. Milani Gallery, milanigallery.com.au/artwork/scientia-e-metaphysica-bells -theorem.

198. Richard Bell, "Bell's Theorem, Aboriginal Art: It's a White Thing," www .kooriweb.org/foley/great/art/bell.html.

199. Bell, "Bell's Theorem, Aboriginal Art."

200. For information on proppaNOW, see proppaNOW.wordpress.com; Margo Neale, Learning to Be Proppa: Aboriginal Artists Collective proppaNOW," *Artlink Magazine*, March 2020.

PART III

1. Grace Duffield and Peter Grabosky, "The Psychology of Fraud," *Trends and Issues in Crime and Criminal Justice* (March 2001).

2. Dolnick, *The Forger's Spell*, 285. See also Kilbracken, *Van Meegeren: Master Forger*, 183.

3. Dolnick, *The Forger's Spell*, 287.

4. Wynne, *I Was Vermeer*, 55–56.

5. Wynne, *I Was Vermeer*, 66.

6. Wynne, *I Was Vermeer*, 59.

7. Keating, *The Fake's Progress*, 83, 86.

8. Keating, *The Fake's Progress*, 79.

9. Hebborn, *Drawn to Trouble*, 344.

10. Hebborn, *Drawn to Trouble*, 177.

11. Hebborn, *Drawn to Trouble*, 348.

12. Hebborn, *Drawn to Trouble*, 348.

13. Dean, "An Artist of Talent."

14. Ashleigh Elson, "Master Forger Turns Art Dealer," *Radio Netherlands*, November 15, 2007.

15. Alec Wilkinson, "The Giveaway," *New Yorker*, August 26, 2013.

16. Cohen, "Forgeries? Perhaps Faux Masterpieces."

17. Cohen, "Forgeries? Perhaps Faux Masterpieces."

18. Kilbracken, *Van Meegeren*, chapter 7. See also Wynne, *I Was Vermeer*, 178.

19. Dean, "An Artist of Talent."

20. Ribes, *Autoportrait d'un Faussaire*.

21. Hammer, "The Greatest Fake Art Scam."

22. Corey Kilgannon, "A Sea Toy James Bond Would Envy," *New York Times*, November 18, 2007.

23. Irving, *Fake*, 137, 167, 175.

24. Keating, *The Fake's Progress*, 88–89.

25. Hills, "A Brush with Fame."

26. Sarah Maslin Nir, Patricia Cohen, and William K. Rashbaum, "Struggling Immigrant Artist Tied to $80 Million New York Fraud," *New York Times*, August 16, 2013.

27. Salisbury and Sujo, *Provenance*, 302.

28. Charney, *The Art of Forgery*, 112.

29. Greenhalgh, *A Forger's Tale*, 9.

30. Duffield and Grabosky, "The Psychology of Fraud."

31. Duncan Chappell and Saskia Hufnagel, "Case Study 3: A Perspective from the Fakery Frontline—An Interview with an Art Forger," in *The Palgrave Handbook on Art Crime*, ed. Saskia Hufnagel and Duncan Chappell (New York: Palgrave Macmillan, 2019), 369.

32. Chong, "Tony Tetro."

33. Colette Bancroft, "Art Forger Lived High Life by Mastering Fakes to Foist on Collectors," *Tampa Bay Times*, September 14, 2012.

34. Sontheimer, "Giacometti Forger Tells All."

35. Hebborn, *The Art Forger's Handbook*, 177, 184, 188; Hebborn, *Drawn to Trouble*, 355, 357–58.

36. Charles V. Ford, *Lies, Lies, Lies: The Psychology of Deceit* (Washington, DC: American Psychiatric Press, 1996), 31–33, 135–36.

37. Salisbury and Sujo, *Provenance*, 260.

38. Salisbury and Sujo, *Provenance*, 282–84.

39. Christine Cunningham, "Businessman John Drewe Jailed for Eight Years Following Fraud Trial at Norwich Crown Court," *Eastern Daily Press*, March 12, 2012; Andrew Levy, "The Most Devious Person I've Dealt With": Judge Hits Out at Conman Who Tricked Widow Out of £700,000" *Daily Mail*, March 13, 2012.

40. Mark Forgy's *The Forger's Apprentice* provides De Hory's life story as the forger told it, as well as the truth (as much as has been uncovered).

41. For a brief description of antisocial personality disorder, see Ford, *Lies, Lies, Lies*, 105–10. See also Neel Burton, "The 10 Personality Disorders," *Psychology Today*, May 29, 2010.

42. *A Genuine Forger.*

43. "How to Fool the Experts and Laugh Your Way to the Bank," www.youtube.com/watch?v-OY0RbS0T36c.

44. "A Forger of Art Tells All," *CBS News*, March 3, 2013.

45. Hammer, "The Greatest Fake-Art Scam."

46. Lothar Gorris and Sven Robel, "Confessions of a Genius Art Forger," *Spiegel Online*, September 3, 2012.

47. Birkenstock, *Beltracchi: The Art of Forgery.*

48. Gorris and Robel, "Confessions of a Genius Art Forger."

49. Gorris and Robel, "Confessions of a Genius Art Forger."

50. Arnau, *The Art of the Faker*, 264.

51. Arnau, *The Art of the Faker*, 266.

52. Fiechter, *Egyptian Fakes*, 197.

53. Keating, *The Fake's Progress*, 84–85.

54. Keating, *The Fake's Progress*, 160, 165–66, 183.

55. Milton Esterow, "Fakers, Fakes, and Fake Fakers," *ARTnews*, November 20, 2013.

56. Stein, *Three Picassos Before Breakfast*, 77–78.

57. Irving, *Fake*, 233.

58. Beckett, *Fakes*, 16.

59. Hebborn, *Drawn to Trouble*, 259.

60. For a discussion of Hebborn's theory of the fundamental grammar of art, as well as of Keating's supernaturalism, see Lenain, *The Art of Forgery*, 300–310.

61. Hebborn, *Drawn to Trouble*, 296.

62. United States of America v. Donald Austin, U.S. Court of Appeals 7th Circuit, no. 94-2541, May 5, 1995.

63. US Attorney's Office, District of Connecticut, "Madison Gallery Owner Sentenced to 57 Months in Prison for Selling Fraudulent Artwork," January 16, 2015.

64. Justin Jones, "A Pastor's Holy Mistake: Selling an Art Forgery," *Daily Beast*, May 20, 2014.

65. Patrick Barkham, "Dealer Convicted of Fraud as the Aboriginal Art World Fights Back," *The Guardian*, February 23, 2001.

66. Balog v. Center Art Gallery—Hawaii, Inc., 745 F. Supp. 1556 (D. Hawaii. 1990).

67. UCC 2-725.

68. See, for instance, Alan Feld, "Art Fakes and the Statute of Limitations," in *Fakebusters II: Scientific Detection of Fakery in Art and Philately*, ed. Richard J. Weiss and Duane Chartier (New York: World Scientific Publishing, 2004).

69. Amore, *The Art of the Con*, 158.

70. Michael Sontheimer, "Art Forger All Smiles After Guilty Plea Seals Deal," *Spiegel Online*, March 9, 2012.

71. Philip Oltermann, "Russian Avant-Garde Forgery Case Ends in Convictions and Disappointments," *The Guardian*, March 16, 2018.

72. Wynne, *I Was Vermeer*, 8.

73. Wynne, *I Was Vermeer*, 7.

74. Wynne, *I Was Vermeer*.

75. United States v. Zabrin, No. 07 CR 521-5, Plea Agreement (N.D. Ill., filed January 5, 2010).

76. United States of America, Plaintiff-Appellee v. Donald Austin, Defendant-Appellant, No. 94-2541, May 5, 1995.

77. US Attorney's Office, District of Connecticut, "Madison Gallery Owner Sentenced to 57 Months."

78. "Vilas V. Likhite: Fraud and Fake Art Sales," Crime Alert, City of Los Angeles, lapd-assets.lapdonline.org/assets/pdf/Artca_vilaslikhite.pdf; "Ex-doctor Is Found Guilty in Art Scam," *Boston Globe*, April 29, 2006.

79. "The Scam Doctor," *Art Law Blog*, theartlawblog.blogspot.com/2006/07/scam-doctor.html.

80. Luis Ferré-Sadurní, "Art Forger Is Accused of Selling Fake Prints. Again," *New York Times*, June 10, 2017; Manhattan District Attorney's Office, "DA Vance: Repeat Scammer Sentenced to 5½-to-11 Years in Prison for Counterfeit Art Scheme," October 11, 2017.

81. Perenyi, *Caveat Emptor*, 76, 122, 126, 137.

82. United States v. Zabrin; for further discussion, see Hillel Levin, "Confessions of Art Fraud King Michael Zabrin," *Chicago Magazine*, November 2011.

83. Robert Mendick, "Banned eBay Forger Back to His Old Tricks," *Telegraph*, June 13, 2015.

84. Robert Mendick, "The Telegraph Exposes Amateur Artist Who Faked Lenkiewicz Paintings on eBay," *Telegraph*, July 6, 2014.

85. Mendick, "Banned eBay forger"

86. Robert Mendick, "Art Forger Goes Straight Selling £5,000 fakes," *Telegraph*, May 7, 2016.

87. For instance, see CLK Gallery, http://clkart.co.uk/product-category/artists/david-henty; https://www.forestgallery.com/david-henty.

88. "The Gentle Art of Forgery," *60 Minutes*, August 8, 1976, youtube.com/watch?v=e1nOweWPjFU.

89. Stein, *Three Picassos*, chapter 23.

90. Beckett, *Fakes*, 18.

91. Jesse Hamlin, "Master (Con) Artist Painting Forger Elmyr de Hory's Copies Are Like the Real Thing," *San Francisco Chronicle*, July 29, 1999.

92. For Beltracchi, see Birkenstock, *Beltracchi: The Art of Forgery*; for Ribes, *A Genuine Forger*, documentary; for De Hory, *F Is for Fake*; for Tetro, *Tony Tetro the World's "Greatest" Living Art Forger*; for Landis, *Art and Craft*; for Greenhalgh, *The Artful Codgers*, bbc.co.uk/programmes/b05yxb3t; for Hebborn, *Eric Hebborn: Portrait of a Master Forger*, youtube.com/watch?v=8jKbbajb5pE; for Jansen, *The Forgery* (in Dutch), docsonline.tv/documentary/the-forger.

93. Jonathan Lopez, *The Man Who Made Vermeers: Unvarnishing the Legend of Master Forger Han van Meegeren* (New York: Harcourt, 2008); Dolnick, *The Forger's Spell*.

94. Jeppson, *The Fabulous Frauds*, 229.

95. For information about both cases, see "The Destruction of Fakes," Art@Law, December 9, 2013, https://www.artatlaw.com/the-destruction-of-fakes.

96. Tom Rowley, "Fake or Fortune—Or Going Up in Flames?" *Telegraph*, February 3, 2014.

97. United States v. Amiel Jr.

98. Karen Abidi, "Artists Gain Legal Clout with Ruling on Destruction of Fakes," *Age*, June 3, 2010; Marion Maneker, "Aussie Artists Get Fakes Destroyed," *Art Market Monitor*, June 4, 2010.

99. Dolnick, *The Forger's Spell*, 20.

100. Rowley, "Fake or Fortune."

101. Randy Kennedy, "Three 'Fake' J. M. W. Turner Paintings Authenticated," *New York Times*, September 24, 2012.

102. Wynne, *I Was Vermeer*, 229–30.

103. "Art Forger Eric Hebborn Collection Sells for Thousands," *BBC News*, October 23, 2014.

104. Steve Crawshaw, "Forger Is a Genuine Success," *Independent*, January 23, 1993.

105. Daniel Grant, "What Happens to Confiscated Art Fakes?" *Huffington Post*, September 29, 2010.

106. Grant, "What Happens to Confiscated Art Fakes?"

107. Anonymous statement, http://isteve.blogspot.com/2013/08/art-forger-exploited.html.

108. "Art Forgery: An Art of Its Own," *Stolen from a Different Cloth*, https://stolenfromadifferentcloth.wordpress.com/2016/10/07/art-forgery-an-art-of-its-own.

109. Michael Hodges, "The Art Crime of the Century: How a Brilliant British Forensic Investigator Trapped an Audacious Forger who Conned Hollywood Star Steve Martin out of a Fortune," *Daily Mail*, May 2, 2015; see also Jessica Franses, "Master Forgers or Modern Day Robin Hoods, Princes of Thieves?" Jessica Franses Art Law, jessicafranses.com/master-forgers-modern-day-robinhood-princes-thieves.

110. Noah Charney, "The Art of the Fake: Forgers Are the Art World's Antiheroes," *Salon*, November 26, 2017.

111. Both stories are presented in Radnóti, *Fake*, chapter 1.

112. Paul Jordan-Smith, *The Road I Came: Some Recollections and Reflections Concerning Changes in American Life and Manners Since 1890* (Caldwell, ID: Claxton Printers, Ltd.), 221.

113. Jordan-Smith, *The Road I Came*, 223.

114. Jordan-Smith, *The Road I Came*, 224.

115. Rachel Gould, "The Hoax Art Movement That Fooled the Art World Establishment," *Artsy*, September 25, 2018.

116. Jordan-Smith, *The Road I Came*, 228.

117. Alma Whitaker, "International Art Hoax Bared by Los Angeles Author," *Los Angeles Times*, August 14, 1927.

118. Jordan-Smith, *The Road I Came*, 225.

119. Henry Keazor, "Six Degrees of Separation: The Foax as More," in *Faking, Forging, Counterfeiting: Discredited Practices at the Margins of Mimesis*, ed. Daniel Becker, Annalisa Fischer, Simone Niehoff, Florencia Sannders, and Yola Schmitz (New York: Columbia University Press, 2017), 29–37.

120. www.sonypictures.com/movies/thelastvermeer.

121. B. A. Shapiro, *The Art Forger* (Chapel Hill, NC: Algonquin Books, 2012).

122. Dominic Smith, *The Last Painting of Sara de Vos* (New York: Farrar, Straus and Giroux, 2016).

123. Helstosky, "Giovanni Bastianini, Art Forgery, and the Market in Nineteenth-Century Italy," 814.

124. Helstosky, "Giovanni Bastianini," 813.

125. Helstosky, "Giovanni Bastianini," 822.

126. I. M. Palmarini, "Fabbrica di oggetti antichi: aneddoti, curiosità, spigolature," *Il Marzocco*, December 1, 1907, 2, vieusseux.it/coppermine/displayimage.php?album=275&pid=14064#top_display_media.

127. Fiechter, *Egyptian Fakes*, 31, 36.

128. Hoving, *False Impressions*, 73.

129. The term has appeared in the German media portrayals, with the American press questioning its appropriateness. See Hammer, "The Greatest Fake Art Scam in History," and Amy Brady, "Long Cons: 'Beltracchi' Exposes a Forger, but Also the Art World's Value," *Village Voice,* August 18, 2015. See also Franses, "Master Forgers or Modern Day Robin Hoods, Princes of Thieves?"; Maria Magdalena Ziegler, "From Art Forgers to Fake Art History," http://arsmomentum.wordpress.com/2017/12/26/art-forgers-fake-art.

130. See Brady, "Long Cons"; Bettina Kolb, "How Beltracchi, the World's Most Famous Art Forger, Plays with the Market," *DW*, August 8, 2015, dw.com/en/how-beltracchi-the-worlds-most-famous-art-forger-plays-with-the-market/a-18436266.

131. Jacob Holley-Kline, "Art and Commerce Are the Rich Man's Game in 'Beltracchi: The Art of Forgery'" *Northern Light*, November 20, 2017.

132. John Soltes, "Interview: Director Explores Infamous Art Forger Wolfgang Beltracchi," *Hollywood Soapbox*, August 20, 2015, www.hollywoodsoapbox.com/interview-director-explores-infamous-art-forger-wolfgang-beltracchi.

133. Charney, "The Art of the Fake."

134. Wilkie Collins, *A Rogue's Life*, https://www.gutenberg.org/cache/epub/1588/pg1588-images.html, chapter 4. The novella first appeared in serialized form in the magazine *Household Words* in 1856

135. For a comprehensive view of Frey's perspective on the economics of happiness, see, for instance (among his many books), *Happiness: A Revolution in Economics* (Cambridge, MA: MIT Press, 2010), and Bruno S. Frey and Alois Stutzer, *Happiness and Economics: How the Economy and Institutions Affect Human Well-Being* (Princeton, NJ: Princeton University Press, 2001). For a brief layman's overview of happiness economics, see Ben S. Bernanke, "The Economics of Happiness," graduation address, University of South Carolina, May 8, 2010, www.bis.org/review/r100511a.pdf.

136. Bruno S. Frey, "Some Considerations on Fakes in Art: An Economic View," in *The Economics of Copying and Counterfeiting*, ed. Gianfranco Mossetto and Marilena Vecco (Milan: Franco Angeli, 2004).

137. Frey, "Some Considerations on Fakes in Art," 24.

138. Frey, "Some Considerations on Fakes in Art," 25.

139. Goodman, *Languages of Art*, 99. The quoted statement appeared in Aline B. Saarinen, "Masterpieces of Forgery," *New York Times Book Review*, July 30, 1961.

140. For this quote and a more detailed account of Mancini's view, see Lenain, *Art Forgery*, 204–8.

141. Lenain, *Art Forgery*, 209.

142. Piles, *L'Idée du peintre parfait*, archive.org/details/lidedupeintrepar00flib/page/n3/mode/2up.

143. Bosse, *Sentimens sur la distinction*, 56.

144. Bosse, *Sentimens sur la distinction*, 64.

145. Bosse, *Sentimens sur la distinction*, 60–62.

146. Richardson, "An Essay on the Whole Art of Criticism," in *Two Discourses*, 185–86.

147. Richardson, "An Essay on the Whole Art of Criticism," 186.

148. Richardson, "An Essay on the Whole Art of Criticism," 177.

149. Richardson, *A Discourse on the Dignity*, 138.

150. Hans Tietze, *Genuine and False: Copies, Imitations, Forgeries* (New York: Chanticleer Press, 1948), 72.

151. Max Friedländer, *On Art and Connoisseurship* (Boston: Beacon Hill Press, 1960), 260–61.

152. Friedländer, *On Art and Connoisseurship*, 261. Friedländer first used this expression in an article published in 1909.

153. Goodman, *Languages of Art*, 103.

154. Goodman, *Languages of Art*, 106.

155. Goodman, *Languages of Art*, 110.

156. Friedländer, *On Art and Connoisseurship*, 235.

157. Friedländer, *On Art and Connoisseurship*, 240.

158. Friedländer, *On Art and Connoisseurship*, 259.

159. Kurz, *Fakes*, 317.

160. George Savage, *Forgeries, Fakes, and Reproductions: A Handbook for the Art Dealer and Collector* (New York: Praeger, 1963), 5.

161. Hebborn, *Drawn to Trouble*, 362.

162. Hebborn, *Drawn to Trouble*.

163. Hebborn, *Drawn to Trouble*, 361.

164. Hoving, *False Impressions*, 102–8.

165. Arthur Koestler, "The Aesthetics of Snobbery," *Horizon* 8 (1965): 50.

166. Alfred Lessing, "What Is Wrong with a Forgery?" *Journal of Aesthetics and Art Criticism* 23, no. 4 (1965): 70.

167. Clive Bell, *Art* (London: Chatto & Windus, 1914), 59.

168. Jack W. Meiland, "Originals, Copies, and Aesthetic Value," in *The Forger's Art: Forgery and the Philosophy of Art*, ed. Denis Dutton (Berkeley: University of California Press, 1983), 126; Thomas Kulka, "Forgeries and Art Evaluation: An Argument for Dualism in Aesthetics," *Journal of Aesthetic Education* 39, no. 3 (Autumn 2005), 70.

169. Goodman, *Languages of Art*, 112.

170. Denis Dutton, "Artistic Crimes," in Dutton, *The Forger's Art*, 186–87.

171. Goodman, *Languages of Art*, 122.

172. Arthur Danto, *The Transfiguration of the Commonplace: A Philosophy of Art* (Cambridge, MA: Harvard University Press, 1981), 44.

173. Dutton, "Artistic Crimes," 183.

174. Dutton, "Artistic Crimes," 182.

175. M. W. Rowe, "The Problem of Perfect Fakes," *Philosophy and the Arts: Royal Institute of Philosophy Supplement; 71*, ed. Anthony O'Hear (Cambridge, MA: Cambridge University Press, 2013), 172.

176. Quoted from Griggs, "Ancient Art and the Antiquarian," 493.

177. Griggs, "Ancient Art and the Antiquarian," 492.

178. See Francis Sparshott, "The Disappointed Art Lover," in Dutton, *The Forger's Art*, 249; Charney, *The Art of Forgery*, 236–41.

179. Also noted by Charney, *The Art of Forgery*, 240.

180. Mimi Crossley and E. Logan Wagner, "Ask Mexico's Masterly Brigido Lara: Is It a Fake?" *Connoisseur*, June 1987, 100.

181. Crossley and Wagner, "Ask Mexico's Masterly Brigido Lara," 101.

182. Sherri Irvin, "Forgery and the Corruption of Aesthetic Understanding," *Canadian Journal of Philosophy* 37 (2007): 299.

PART IV

1. For 10 percent, see Noah Charney, "The Secret Lives of Works of Art: What Percentage of a Museum's Holdings Are Likely to Be Fakes?" *Salon*, April 2, 2017; for 50 percent, see "Over 50 Percent of Art Is Fake," *Artnet News*, October 13, 2014.

Index

Page numbers in *italics* refer to illustrations.

127, 161, 164 (Crespo, 161, 164; in
nineteenth-century Italy, 34, 214;
Sakhai, 66–67, 73, 161, 162; Sawicki,
88; Snell and Crouzet, 127; Wacker,
73–74; Zabrin, 164, 165–66; Legros
and Lessard, 151); Piedoie as, 63;
Rubens as, 25; Stein as, 49
art forgers: aliases/pseudonyms, 46, 48,
49, 57, 62, 154, 174; as antiheroes,
debunkers, and Robin Hood figures,
173–75, 178–80, 214, 251n129;
channeling of forgery targets, 145,
157–59; motives, 4, 146–52, 176
(financial, 4, 30, 147, 148, 150,
151–52, 179, 182; pride, 4, 149–50,
152; revenge, 4, 39, 147, 149, 150,
151–52); psychological profiles, 152–
57; recidivism, 4, 146, 164–65. *See
also* celebrity forgers
Art Forger's Handbook, The (Hebborn),
55, 152–53
Art Forgery (Lenain), 8, 87
art forgery, acts of: art market as
precondition for, 7–8, 13, 23, 217n1;
damage to art history, 146, 184,
190, 197–98, 200–202, 215, 216;
damage to the art market, 44, 150,
181–82; definitions and terminology,
2, 3, 5, 82–87, 91–92; emergence
in ancient Rome, 8, 9–11, 204;
fictional accounts of, 30, 175–76,
214; fraudulent intent, 9, 16, 82–86,
90–92, 175; as gamesmanship/sport,
18–19, 149–50, 155; nineteenth-
century surge, 28, 31–35, 177;
reemergence during the Renaissance,
2, 8, 18–19, 173, 184, 204, 217n1;
satirical treatments of, 10, 27, 29,
204; volume of, 203–4. *See also* art
forgers; art forgery, objects of
art forgery, criminality of, 4, 71, 150,
152, 160–72; mitigated culpability,
72, 146, 152, 159, 172–84 (art
forgery as victimless crime, 146,
152, 172–73, 178, 213; happiness

economics, 181–84, 214–15); prison
sentences, length of, 4, 38, 39, 49,
50, 52, 53, 54, 55, 57, 62, 63, 64, 65,
67, 88, 146, 152, 160–61, 162, 163,
165, 166, 213; recidivism, 4, 146,
164–67; statute of limitations, 53, 56,
161–62, 207–8. *See also* mail fraud;
money laundering; tax evasion; wire
fraud
art forgery, objects of: aesthetic value
of, 4, 91, 146, 187–88, 193–94,
202, 215, 216; destruction of, 4, 50,
62, 64, 73, 169–71; detection of
(by connoisseurship, 2, 11, 18, 25,
26, 27, 31–33, 61, 76, 78, 96, 101,
175, 185–91, 206–7; by scientific
methods, 11, 32, 53, 61, 73–80,
163, 205; time factor, 187–88, 205,
206. *See also* anachronistic elements;
dendrochronology; forensic analysis;
material and visual anomalies;
materials analysis; pattern analysis;
thermoluminescence; X-rays);
exhibitions and museums of, 3,
70–73, 80, 237n29; hoaxes, 175;
returned to owners, 4, 171, 207;
sold as known forgeries, 4, 171–72;
volume of, 203–4. *See also* perfect
fakes
Art Guys, The, 103
artificial aging of an artwork, 14, 20,
24, 30, 39, 55, 89, 197; smoking
to achieve, 18–19, 21, 24; artificial
craquelure, 24, 61
Art Institute of Chicago, 174, 196
art market: auction, 1, 27–28, 33, 43,
73; in copyright law, 114, 115,
116–17, 211; happiness economics,
181–84, 214; history of, 10, 16,
19, 25, 26, 27, 28, 32, 34, 42, 176;
precondition for forgery, 2, 7–8, 13,
21, 205, 217n1; value of, 43, 44,
46–47, 141, 205
Art of Forgery, The (Charney), 84
Art of the Con, The (Amore), 85–86

About the Author

William Casement is a philosopher and writer who left a successful career as a professor to become an art dealer and owner of a large gallery in Naples, Florida, where for twenty-five years he represented American and European paintings and sculptures. He holds a PhD in philosophy from Georgetown University and has written two previous books along with several dozen articles that range from scholarly analyses to guest newspaper columns spanning the fields of philosophy, history, literature, education, and politics as well as art. Experiences in confronting forgeries firsthand as a dealer led to a long-term scholarly study of the topic, resulting in various publications including, among others, an examination of art forgery in ancient Rome, an analysis of the nature of art forgery in philosophical and legal terms, and a personal account of numerous occasions of being asked to authenticate paintings by a widely forged artist, along with writing *The Many Faces of Art Forgery*.